WARHOL HEADLINES

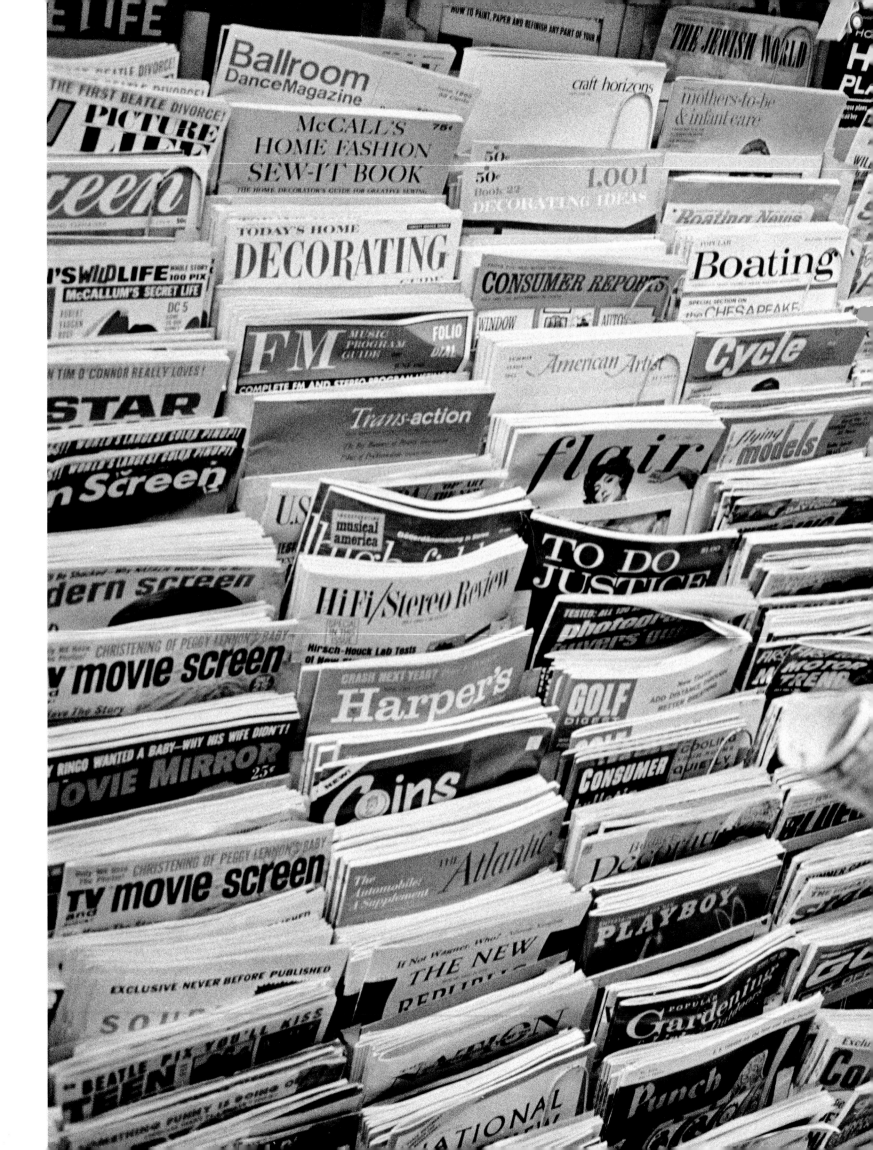

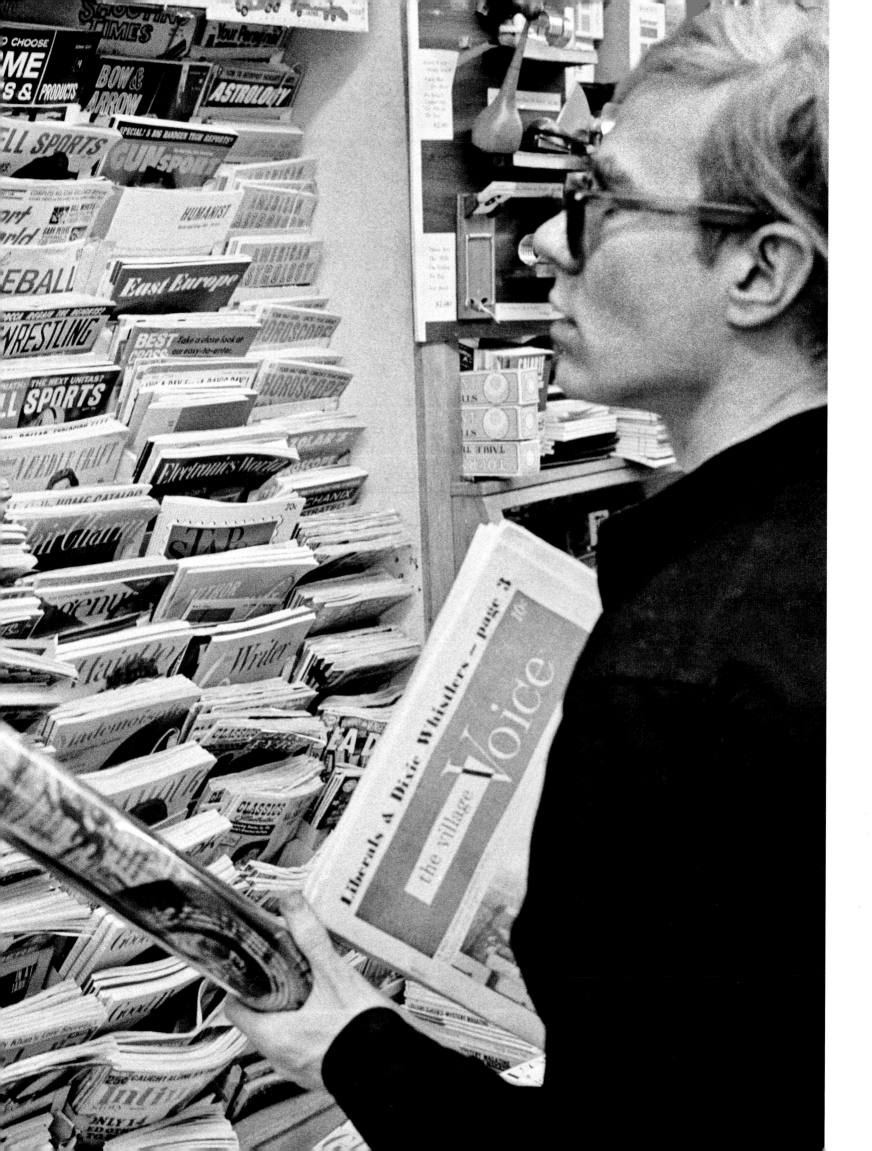

NATIONAL GALLERY OF ART, WASHINGTON
SEPTEMBER 25, 2011 – JANUARY 2, 2012

MUSEUM FÜR MODERNE KUNST, FRANKFURT
FEBRUARY 11 – MAY 13, 2012

GALLERIA NAZIONALE D'ARTE MODERNA, ROME
JUNE 11 – SEPTEMBER 9, 2012

THE ANDY WARHOL MUSEUM, PITTSBURGH
OCTOBER 14, 2012 – JANUARY 6, 2013

WARHOLH

NATIONAL GALLERY OF ART
WASHINGTON

DELMONICO BOOKS · PRESTEL
MUNICH BERLIN LONDON NEW YORK

MOLLY DONOVAN
WITH JOHN J. CURLEY,
ANTHONY E. GRUDIN,
JOHN G. HANHARDT,
CALLIE ANGELL, *AND*
MATT WRBICAN

EADLINES

THE EXHIBITION IS ORGANIZED
BY THE NATIONAL GALLERY OF ART,
IN ASSOCIATION WITH THE ANDY
WARHOL MUSEUM, PITTSBURGH,
THE GALLERIA NAZIONALE D'ARTE
MODERNA, ROME, AND THE MUSEUM
FÜR MODERNE KUNST, FRANKFURT.

THE TERRA FOUNDATION FOR
AMERICAN ART IS THE FOUNDATION
SPONSOR OF THE INTERNATIONAL
TOUR OF THE EXHIBITION.

THE EXHIBITION IN WASHINGTON IS
MADE POSSIBLE BY THE EXHIBITION
CIRCLE OF THE NATIONAL GALLERY
OF ART.

THE EXHIBITION IS SUPPORTED
BY AN INDEMNITY FROM THE
FEDERAL COUNCIL ON THE ARTS
AND THE HUMANITIES.

Library of Congress
Cataloging-in-Publication Data

Donovan, Molly, 1966–
Warhol : headlines / Molly Donovan ;
with John J. Curley ... [et al.].

 p. cm.

Catalog of an exhibition held
at the National Gallery of Art,
Washington, D.C., and three other
institutions between Sept. 25, 2011,
and Jan. 6, 2013.
Includes bibliographical references
and index.

ISBN 978-3-7913-5160-5
(hardcover: alk. paper)

ISBN 978-0-89468-373-2
(softcover: alk. paper)

1. Warhol, Andy, 1928–1987 —
Themes, motives — Exhibitions.
2. Newspapers — Headlines — Art —
Exhibitions. I. Warhol, Andy,
1928–1987. II. Curley, John J.
III. National Gallery of Art (U.S.)
IV. Title.

N6537.W28A4 2012
700.92—dc22 2011013695

Produced by the Publishing Office,
National Gallery of Art, Washington
www.nga.gov

Judy Metro, editor in chief
Chris Vogel, deputy publisher
Wendy Schleicher, senior designer
Tam Curry Bryfogle, senior editor
Sara Sanders-Buell, photography
rights coordinator
Mariah Shay, production assistant
John Long, assistant production
manager
Daniella Berman, publishing
coordinator

Typeset in Univers LT Std and
Garamond Premier Pro. Printed
on 175 gsm Satimatt Naturelle by
Arnoldo Mondadori Editore S.p.A.,
Verona, Italy

Hardcover published in 2011 by
the National Gallery of Art, and
DelMonico Books, an imprint of
Prestel Publishing, a member
of Verlagsgruppe Random House
GmbH.

Prestel Verlag
Neumarkterstrasse 28
81673 Munich
Germany
Tel: 49 89 242908 300
Fax: 49 89 242908 335
prestel.de

Prestel Publishing Ltd.
4 Bloomsbury Place
London WC1A 2QA
United Kingdom
Tel: 44 20 7323 5004
Fax: 44 20 7636 8004

Prestel Publishing
900 Broadway. Suite 603
New York, NY 10003
Tel: 212 995 2720
Fax: 212 995 2733
E-mail: sales@prestel-usa.com
prestel.com

Front: Andy Warhol, Daily News,
c. 1967, screenprint on paper, The
Andy Warhol Museum, Pittsburgh;
Contribution The Andy Warhol
Foundation for the Visual Arts, Inc.

Back: Andy Warhol, A Boy for Meg
[2], 1962, oil and egg emulsion on
canvas, National Gallery of Art,
Washington, Gift of Mr. and Mrs.
Burton Tremaine

Back flap: Andy Warhol with Baby
Jane Holzer on the set of The Chelsea
Girls, 1966. Photo by Santi Visalli

Pages ii – iii: Warhol perusing a rack
of periodicals, 1965. Photo by Bob
Adelman

Page viii: Warhol, asked where he
wanted to be photographed for a
book project in 1964, said, "Let's go
to 42nd Street and I could get lost in
the crowd." Photo by Ken Heyman

Pages x – 1: Warhol reading a newspa-
per in his Silver Factory, 1965. Photo
by Bob Adelman

Pages 86 – 87: Warhol in the Factory
during work on the triptych Fate Presto,
1981. Photo by Michele Bonuomo

Pages 194 – 195: Andy Warhol in his
Factory with Jackie Curtis and Paul
Morrissey, 1970. Photo by Timm
Rautert

Page 206: Andy Warhol reading the
Village Voice in his Silver Factory,
1966. Photo by Gretchen Berg

CONTENTS

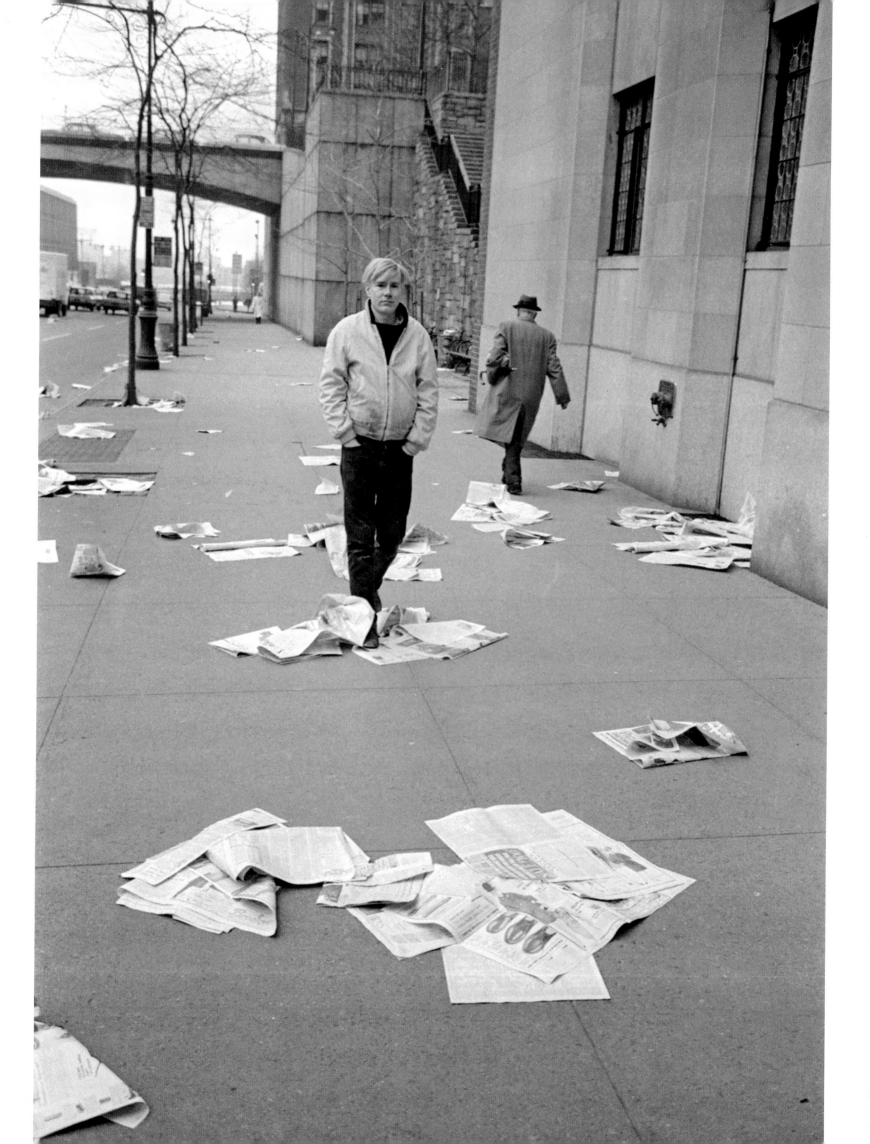

FOREWORD

Andy Warhol's *A Boy for Meg* (1962), in the collection of the National Gallery of Art, was the first headline painting to leave the artist's studio. Based on the front page of a New York tabloid, this canvas came to the Gallery in 1971 as a generous bequest from Mr. and Mrs. Burton Tremaine. These legendary collectors, accompanied by Ivan Karp of the Leo Castelli Gallery, bought the painting in May 1962 directly from Warhol's cramped New York studio in his residence at 1342 Lexington Avenue. Nearly fifty years later, the present exhibition brings together this painting with three other early hand-painted canvases and a fascinating variety of works centering on the headline theme and spanning the artist's entire career. Offered for the first time as a coherent group, the almost eighty headline works shown here include paintings, drawings, silkscreened canvases, prints, photographs, and time-based media. Featuring Warhol's favorite subjects of celebrity and disaster, they create a complex narrative that incorporates his own life story and reflects our shared desires and fears.

This first exhibition at the National Gallery to focus on Warhol owes its conception to Molly Donovan, associate curator of modern and contemporary art at the Gallery. She and her colleagues have organized a thoroughly researched and visually compelling presentation of Warhol's headline art, alongside some of the source materials that inspired the art. While the works may seem familiar because of their vernacular sources (primarily New York tabloid newspapers), the artist explored the headline theme in myriad ways — provocatively and at times playfully revising, cropping, repeating, and flipping both texts and images. The exhibition as well as the catalogue will greatly enhance our appreciation and understanding of Warhol's artistic practice, giving new insights into this prolific artist's work.

Vital partners from the very beginning of this undertaking have included our colleagues at the Andy Warhol Museum in Pittsburgh, who facilitated the study, loans, and presentation of many works of art and archival materials in their museum's collection. The exhibition would simply not have been realized without them. Given the ability of Warhol's art to communicate across national, cultural, and even language boundaries, we are delighted that this show will travel to the Museum für Moderne Kunst, Frankfurt, and the Galleria nationale d'arte moderna, Rome. Along with the Warhol Museum, which will present the exhibition at the close of its tour, these participating venues have enabled research and offered assistance with critical loans, and they deserve our sincere thanks.

The Terra Foundation for American Art understood right away the importance of the exhibition and its international tour, providing essential early support. We are deeply grateful to Elizabeth Glassman, president of the Terra Foundation, for championing this project. The Terra is joined by The Exhibition Circle of the National Gallery of Art, a group of generous donors whose sustained gifts supply additional funding for our exhibition program. We would also like to thank Alice M. Whelihan and the Federal Council on the Arts and the Humanities for granting an indemnity to the exhibition.

Without the generosity of the many lenders, both private and institutional, who have agreed to part temporarily with their works of art, *Warhol: Headlines* would not have been possible. We extend our profound gratitude to all of the lenders for sharing their treasures and allowing us to tell the story of Warhol's headline works in such an intriguing and powerful way.

EARL A. POWELL III
DIRECTOR
NATIONAL GALLERY OF ART
WASHINGTON

WHERE'S WARHOL? TRIANGULATING THE ARTIST IN THE HEADLINES

MOLLY DONOVAN

"He just gets you and you can't get away," said Viva, one of Andy Warhol's Silver Factory stars, shortly after the artist was nearly killed by gunshot in 1968.[1] Warhol's headline works, like the tabloids on which they are based, produce a similar effect. They "get" us. We are stopped short by Warhol's sketched and painted translations of published headlines, which he cropped and edited for emphasis. We are pulled in by his readymade silkscreen transfers of entire front pages. We follow his focus on the news, zooming in and out, creating our own oblique connections. Often our associations relate to the artist himself. Looking back to the mid-1950s, we see Warhol altering headlines to refer to himself and allowing us to find his hand at work in their depiction. Then, by August 1962, he disappears, having hidden himself within the indexical and mechanical means of the photograph or silkscreen. Yet he is still present, the auteur behind the camera or screen, his style instantly recognizable in its seeming impersonality. Warhol's headline works — from paintings and drawings to prints, photographs, sculpture, and time-based media — reveal an artist managing to be everywhere and nowhere at the same time. He came at us from many angles in a variety of media and dispersed himself into them. He was as constant and ubiquitous as the twenty-four-hour news cycle itself.

Warhol formed his ideas about newspapers while working as a commercial illustrator in New York in the 1950s, watching editors and journalists select and present the news. His works of art that feature headlines show how he took on the roles of both editor and author, selecting published stories that he then retold in various formats. He plucked headlines out of the stacks of newspapers and source materials that he scoured daily, some of which he saved in his Time Capsules without using them in his art. But those headlines that Warhol elevated to the status of art come together to create a recursive narrative that intersects his own life story at times and weaves one entwined epic account. He turned predigested material, whether mundane or sensational, into something both grand and personal.

The myriad works of art in which Warhol used or referenced news headlines throughout his career are defined and presented here as a coherent body for the first time.[2] These headline works (that is, works based on the heading or title for a news story, on the front page or not) were realized in a range of formats, from two-dimensional to televised. They chart in real time the great shift in the technological means employed by the media to deliver the news from the 1950s until the artist's death in 1987. During this period, the definition of "headline" jumped the boundaries of the printed page to join the televised news, a point perfectly illustrated today by the television program entitled *CNN Headline News*. Underscoring this shift, Warhol's headline works demonstrate that the "medium is the message," as Marshall McLuhan proclaimed in his hallmark text of 1964, *Understanding Media: The Extensions of Man*.[3] They also emphasize the message itself. Headlines, after all, demand to be read, just as the spoken news demands to be heard.[4]

FIG. 1 *THE PRINCTON LEADER*, C. 1956, BALLPOINT INK ON PAPER, 42.5 x 35.2 CM, COURTESY THE BRANT FOUNDATION, GREENWICH, CONNECTICUT. SEE ALSO PL. 1

FIG. 2 FRONT PAGE OF *THE PRINCETON LEADER* [PRINCETON, KY], AUGUST 23, 1956, SCAN FROM MICROFILM. SEE ALSO P. 177, DOC. 1

Newsweek's cover story of December 21, 2009, "Why We Can't Look Away: Understanding Our Craven Celebrity Culture," restates the point Warhol made in his first headline works more than fifty years earlier: that celebrity is linked to narrative.[5] Media-created narratives detail the ups and downs of media-made stars, and although Warhol might seem to be complicitous in perpetuating the frenzy, in fact he often interrupted it. First, by removing certain stories from their original context and turning them into works of art, he short-circuited the narrative and invented an alternative story. And by selecting similar news stories time and again, he pointed to the recycled nature of the news, its combination of superficial change and endless, underlying repetition — a combination typical of commercial products. In short, he pointed to the commodity status of the news and to our status as its consumers. Second, Warhol physically altered the original headlines by cropping, repeating, obscuring, and reorienting them in his transcriptions. Such alterations give weight to his decision making as editor and author, but they give scope to the viewer's role as well: when Warhol crops a word, deletes several words, or leaves a blank space, he invites us to fill in our own news story, to become the author, or subject, of the news ourselves. Third, in a series of fateful events, Warhol himself figured not only as celebrity but also as tragic hero of the news. Throughout his career he was a star in a media-created narrative. Ultimately, Warhol implicates both himself and the viewer in this narrative, redefining it from something apparently objective (the news) into a story fueled by our own desires and fears.

MIMETIC DESIRE: AS DON QUIXOTE

"If you want to know all about Andy Warhol, just look at the surface: of my paintings and films and me, and there I am. There's nothing behind it."[6] Starting with Warhol's first headline works, a few cracks may be found in that surface. According to Charles Lisanby, who knew Warhol well in the 1950s and 1960s, the artist was unable to "verbalize anything" but could "express himself…graphically."[7] (Certainly, Warhol concealed any speaking abilities from the public.)[8] The first headline drawings, all dating from around 1956 to 1962, either preceded or were made alongside his earliest hand-painted headline canvases.[9] These drawings break down into two groups: those drawn freehand (pls. 1 – 6, 12), and those likely enlarged and traced from their original sources with the assistance of an opaque projector (pls. 7 – 11).[10] These early works, before Warhol hid himself behind the silkscreen and the camera, reveal his interests and humors at specific moments.

Arguably Warhol's first headline work, *The Princton Leader* from about 1956 (fig. 1) makes known the personal nature of his art through the sly introduction of biographical information.[11] Warhol based the drawing on a newspaper he obtained from Lisanby, a native of Princeton, Kentucky.[12] Using ballpoint pen on paper, he transcribed stories from the front page of the August 23, 1956, edition of the *Princeton Leader* (the only small-town source for Warhol's headline works; see fig. 2). But under the headline "Local Man Completets [*sic*] Apprenticeship as a Plumber, Steam Fitter," he inserted Lisanby's name in place of the real subject, Norval L. Oliver. In

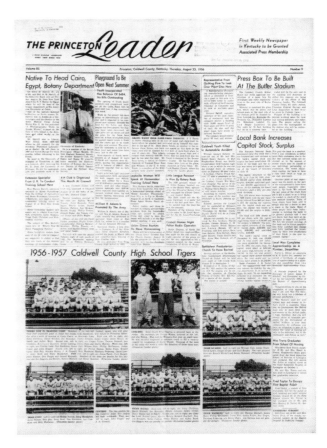

fact, Lisanby worked as a set designer and art director for CBS-TV in New York City. Warhol's reference to Lisanby, a well-heeled professional from a wealthy family who likely never wielded a plumber's wrench, shows an impish Warhol.[13] It also establishes his keen awareness of social stratification at the time, including his own standing as the son of poor immigrant parents and his ambition to rise in stature and become a star.

The newspaper provided a level playing field where people of all backgrounds appeared under one heading. Although this issue of the *Princeton Leader* had numerous headlines in large bold type, none was placed in a dominant position under the masthead: there was no hierarchy. Warhol, acting as author and editor of his own fictionalized account, omitted many of the stories from the original source (along with the "e" from "Princeton" in the banner). Curiously, he excluded the grim "Caldwell Youth Killed in Automobile Accident," the very sort of story he would feature in his Death and Disaster paintings beginning in 1962. Instead, he zeroed in on upbeat news such as "Native to Head Cairo, Egypt, Botany Department" or "Miss Travis Graduates from School of Nursing." He also left prominent open spaces in the bottom left and bottom center columns.

Unlike other articles on the *Princeton Leader*'s front page that day, "Local Man Completes Apprenticeship" addressed national sociopolitical concerns. The headline does not reveal this, however. Further reading is required. The article quotes a letter that the apprentice plumber and steamfitter received from the U.S. secretary of labor, James P. Mitchell, praising him as a skilled craftsman and telling him he had "an obligation to pass on to others the value of training not only to the individual but to the community and the nation as well." Mitchell, a Democrat serving under Republican president Dwight D. Eisenhower, was nicknamed the "social conscience of the Republican Party."[14] His letter of affirmation to those working in the "skilled crafts" might well have interested Warhol (the son of an émigré blue-collar worker), who was just then rising in status from successful commercial illustrator to fine artist.[15] Interestingly, the misspelling of "Princeton," the rough or incomplete rendering of the halftone images, and the uneven lines suggest a conscious *de*-skilling on Warhol's part compared to his refined commercial work of the same period, with his delicate "blotted-line" drawings (see pp. 27 – 28, figs. 2, 3).[16]

Parallel to this theme of politics and class runs another, more personal subtext, one that in its triangulated configuration calls to mind a psycho-literary theory put forward by René Girard in the mid-1960s. For a time in the 1950s Lisanby was the object of Warhol's desire, but after they traveled the world together in the summer of 1956, Warhol returned home heartbroken, his romantic wishes unfulfilled.[17] Warhol's desire for Lisanby was direct, but with the artist's solicitation of the newspaper, a third element was introduced. The rendering of the

Princeton Leader became an expression of Warhol's "mimetic desire," a term coined by Girard to describe great works of fiction involving a triangular relationship between subject, model, and object.[18]

According to this theory, the "subject" is essentially a student, an ambitious person who learns to copy the desires of others, not for the intrinsic qualities of the desired "object," but because others desire that object. The subject understands that what others want, and indeed seem to have, he or she should also want. In this way, desire is acquired through observation rather than being generated internally. Warhol wants the fame and accomplishment he attributes to Lisanby (however tongue-in-cheek): he wants to appear in the newspaper. Thus in *The Princton Leader*, we can identify Warhol as the subject of mimetic desire.

The middle player in Girard's theory — the "model" — determines the desirable object for the subject. In giving Warhol the *Princeton Leader* newspaper, an object on which the artist would lavish his attentions, Lisanby takes on the role of the model. No longer object of a direct linear desire, Lisanby becomes (in the triangular configuration of mimetic desire) the mediator of Warhol's longing. As Girard described it, where a straight line between subject and object is present, "the mediator is there above that line," implied and "radiating toward both the subject and object."[19] The mediation can be either internal or external. Someone accessible to the subject, such as a friend, can provide internal mediation, but for someone beyond the reach of the subject — socially or historically — the mediation is external.[20] As Warhol's friend, Lisanby represented an internal model, yet as someone socially and romantically inaccessible to Warhol, he also provided an external model. And that is where newspaper headlines came in — as the object of the artist's desire.

Headlines provided an ideal focus for Warhol's art and desire, because they were not only readily accessible but also seemingly unattainable, since becoming the subject of a news story was not easy. He himself described his pop practice in terms of its internal/external nature: "It's just like taking the outside and putting it on the inside, or taking the inside and putting it on the outside."[21] The headlines became one of Warhol's key themes as he made the transition from commercial illustration to fine art production in the late 1950s to early 1960s, through 1968 when he was shot and nearly killed, until his death in 1987. Newspaper headlines thus became an object of Warhol's desires (signifying his fame as an artist) as well as his fears: the exciting yet precarious environment he realized in the form of the Silver Factory in the 1960s sometimes made its way into the tabloids. Warhol, the publicly introverted artist, privately looked outward for his sources.[22]

Accepting Girard's tripartite configuration, then, Warhol was the subject, Lisanby the model, and newspa-

per headlines the object of mimetic desire. That is, Warhol initially may have desired Lisanby for his position in a higher social order, for his job in the burgeoning world of television, and for his proximity to famous figures (which others desired) like stage designer Cecil Beaton, who knew the even more famous Truman Capote, whom Warhol worshipped from afar.[23] This desire, beyond his reach at the time, was triangulated through Warhol's substitution of Lisanby's name in his *Princton Leader* drawing. The drawing provides an illustration of mimetic desire that can inform our understanding of Warhol's subsequent headline works. The headline itself became the object of Warhol's desires, a sign of his own celebrity and fame, something the media ultimately helped him achieve. Girard introduced his theory of mimetic desire with the words of Cervantes's Don Quixote to his squire, Sancho Panza: "I think that, when a painter wants to become famous for his art he tries to imitate the originals of the best masters he knows." Among Warhol "masters" were the newspaper editors and authors who wrote the headlines.

THE MULTIFACETED MIRROR: A MODERN ECHO

Another triangular relationship involving unrequited love — that of Narcissus, the nymph Echo, and the reflecting pool — can deepen our appreciation of Warhol's headline works. In Ovid's account, Echo was deprived of her speech, able only to repeat the last spoken words of others, so that when she came upon Narcissus and fell in love with him, she could not initiate communication. Narcissus harshly rejected Echo; and owing to his cruelty, the goddess Nemesis doomed him to a fate of hopeless self-love. When Narcissus (whose name derives from the Greek *narcosis*, meaning sleep or numbness) stooped beside a spring to quench his thirst, he became transfixed by his own reflection. Held by vain admiration for his own likeness in the reflecting pool, yet failing to recognize himself, Narcissus became repeatedly frustrated by his efforts to hold or kiss his image in the water, only to have it slip away. Eventually, Narcissus surrendered this pursuit, bid his reflection goodbye, and died. Echo's body withered from her rejection, yet her voice lived on, "hidden in the hills."[24] For Warhol's headline works, this tale may be remapped with Girard's theory of triangular desire in mind: the figure of Narcissus represents us, the viewers, as "subject," staring at our own image yet not recognizing it; the newspaper headlines as "object," replacing the reflecting pool; and Warhol as "model," standing in for Echo.

The Narcissus myth and its symbol, the mirrored surface, became an emblem of the 1960s in America.[25] Warhol referenced the Narcissus and Echo myth often: from the silver (mirrored) ground in his Tunafish Disaster paintings (pl. 19) and the silver paint with which he had his *Thirteen Most Wanted Men* mural covered in an act of censorship (see figs. 12, 13); to his Silver Factory, Mylar *Silver Clouds* (1966), and numerous films that feature

mirrors (including *Lupe, Space, My Hustler, Bike Boy, Poor Little Rich Girl*, and *Soap Opera*);[26] to Nico, his star with the Velvet Underground, singing, "I'll be your mirror! I'll be your mirror! I'll be your mirror!" in the intermedia performances Warhol produced called the "Exploding Plastic Inevitable" (EPI).[27] Unlike the two-dimensional reflecting pool of Narcissus, Warhol's mirrored surfaces were decidedly multifaceted, in the manner of the mirrored ball that hung from the ceiling or sat on the floor for the EPI performances. This mirror replicated the eruption of simultaneous cross-media activity, sending reflections out continuously from the turning center.

Many newspapers, such as the *New York Daily Mirror*, which served as the source for *129 Die in Jet* (see pl. 16 and p. 183, doc. 10), incorporate the word "mirror" into their masthead, casting the news media as a reflective surface.[28] How fitting that Warhol would choose this particular kind of mirror as source material! McLuhan related the media mirror to the Narcissus myth, reminding us that it was not only Narcissus's self-love but his failure to recognize the image in the reflecting pool as his own that ultimately brought about his demise.[29] Accepting McLuhan's interpretation, then we, as part of the contemporary media-obsessed public, fill the role of Narcissus — with the media reflecting back to us our own image, which we do not recognize as ourselves. This accounts for one way that Warhol's headline works "get" us: Warhol is telling us that the headlines *are* us.

The various roles in the Narcissus myth rotate between Warhol and his art. For example, one critic likened Warhol's works, in their "narcotic beauty," to mirrors, and Warhol to Narcissus[30] — something that Warhol encourages us to believe through his repeated insistence that we look no further than the surface to find him. Much has also been made of Warhol as a mirror, to which Warhol responded, "I'm going to look in the mirror and see nothing. People are always calling me a mirror, and if a mirror looks into a mirror, what is there to see?"[31] Warhol thereby likens himself to a void — ideal for the man who perfected the blank stare. As Gretchen Berg, an early interviewer recalled, "Andy was such a powerful presence; he had an enormously magnetic personality," adding that talking to him was like "being hypnotized."[32] Unlike a mirror, however, which reflects without discrimination, Warhol as artist was clearly selective, as evidenced by the boxes of potential and rejected sources in his archives. In fact, the stories featured in his works — as mesmerizing as the artist himself — were twice vetted, first having been chosen by newspaper journalists. In Todd Gitlin's words: "Media are mobile spotlights, not passive mirrors of the society; selectivity is the instrument of their action.... A story is a choice, a way of seeing an event that also amounts to a way of screening from sight."[33] Warhol, like the mirrored ball in his EPI productions, took excerpts from the news and transformed them into a dazzling expanse of echoes and reflections.

More recent readings of Warhol often break down, roughly, into either passive (artist-as-reflective-surface) or active (artist-as-epic-hero).[34] Hal Foster describes the bifurcated readings of Warhol's work as either "simulacral," underscoring its deliberately superficial treatment and its blank surface as devoid of intention, or as "referential," linked to the social history in which it was made.[35] Warhol's use of the inclusive newspaper headline may in fact harmonize these opposing aspects of his art.

Given that language is the basis for Warhol's headline works, Echo's part in the myth should be recovered as well.[36] In doing so, we might reconsider Warhol as a heroic modern version of Echo. He certainly repeated words from the media — whether written or spoken — decisively echoing that language.[37] Yet unlike Ovid's Echo, an unoriginal repeater, lacking discrimination, Warhol not only chose his text-filled headline sources carefully, he also distorted their content at times. His representations rouse us from our trance and prompt us to recognize our reflection in the media, and in his art. Although Echo's tainted reputation as a rejected figure, lacking self-identity, was a quality Warhol appeared to embrace publicly, in private he conveyed a strong sense of self and purposeful direction.[38] David Bourdon captured this seeming contradiction in Warhol: "He appeared simultaneously shy and self-assured, reticent in talking about himself but confident of who he was and not at all hesitant to put himself forward."[39]

Despite the often scathing criticism of his work, Warhol broke with Echo's fate as a rejected lover and pursued his art with vigor, deflecting — as would Perseus with his mirrored shield — any negative press, which he faced from the beginning of his career as a fine artist.[40] In 1962 Dore Ashton wrote a review of Warhol's Stable Gallery show that specifically denigrated his newspaper-related works: "Where Rauschenberg took the daily newspaper, and in his transfer paintings, made of it a trampoline for his imagination, Warhol simply lifts the techniques of journalism and applies them witlessly to a flat surface."[41] Yet Warhol's choice of flat surfaces can be seen as pointed: by applying silkscreen ink and acrylic paint onto canvas through a flat screen (a nearly textureless and expressively neutral technique), he depicts the image of a "preflattened" subject (drained of feeling or meaning).[42] In another account of the same exhibition, the critic Michael Fried wrote, "I am not at all sure that even the best of Warhol's work can much outlast the journalism on which it is forced to depend.[43] Fried's doubts, linking the longevity of Warhol's work to the here-today/gone-tomorrow nature of the news, have long been put to rest. Clearly, Warhol's headlines have existed independently from their sources since their making. They operate beyond simple monuments to the ephemeral by creating new narrative spaces that relay attractive yet cautionary tales, half-warning us against becoming like Narcissus.

THE TABLOIDS

Tabloid images and headlines were a theme for Warhol throughout his life. He was born during the golden age of the sensationalized tabloid, on August 6, 1928, eight months after Tom Howard's surreptitious photograph of Ruth Snyder's execution in an electric chair at Sing Sing Penitentiary appeared on the front page of the "extra" edition of the *New York Daily News* (January 13, 1928) with the one-word headline, "Dead!" (fig. 3). Warhol began his own Electric Chair series thirty-five years later, in 1963, based on a press image from World Wide Photo, dated January 13, 1953, that showed the Sing Sing electric chair in which convicted spies Julius and Ethel Rosenberg would be executed on June 19 of that year (fig. 4).

Warhol's own name first appeared in the news in 1946 when he was a young art student and received a drawing award from Carnegie Institute of Technology (now Carnegie Mellon). The prize, announced in two Pittsburgh dailies, was mentioned in the *Pittsburgh Press* under the heading "Artist-Huckster Sketches Customers and Wins Prize: Series of Drawings Shows Everything from Idle Rich to Scrambling Poor" (see p. 26, fig. 1). The artist understood at the tender age of eighteen how to provoke the press through his work and maximize coverage. He was "press-ready."

Following his use of the small-town *Princeton Leader* in his early drawing of around 1956, Warhol moved on,

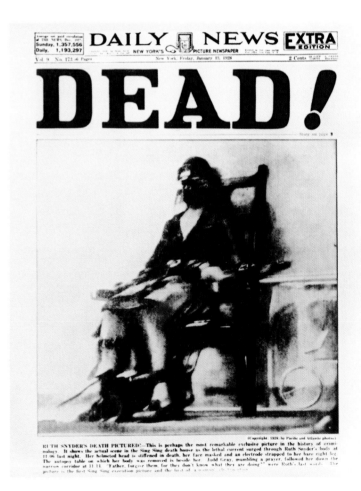

3

FIG. 3 FRONT PAGE OF *NEW YORK DAILY NEWS*, JANUARY 13, 1928, WITH PHOTOGRAPH BY TOM HOWARD OF RUTH SNYDER'S EXECUTION BY ELECTRIC CHAIR

FIG. 4 ANDY WARHOL, *SILVER DISASTER #6 [DOUBLE SILVER DISASTER]*, 1963, SILKSCREEN INK, SILVER PAINT, AND SPRAY PRINT ON LINEN, 106.7 x 152.4 CM, PRIVATE COLLECTION

with few exceptions, to New York tabloids and sensational headlines. He found little interest in making art from more reputable papers like the *New York Times*.[44] Rather, Warhol was explicitly attracted to the melodramatic language and images of tabloids such as the *New York Daily News* and *New York Post* as well as the *National Enquirer* (the latter of which rose steadily in its readership during the 1950s and 1960s).[45]

In choosing tabloid subjects, Warhol consistently reaffirmed that people are both noble and common, gay and straight, black and white; for such newspapers provide a screen on which society scandals receive equal treatment alongside natural occurrences like the birth of a baby to "celebrity" royals or tragedies involving ordinary people. We are all drawn to the news tabloids — willingly or not — and yet, like Narcissus, we often see only an Other, allowing the stories to rivet our attention but failing to see ourselves. This is just as much the case today as in the late 1950s and early 1960s, when Warhol began making art from the banners and images of the tabloid newspapers.

Warhol's headline works also point to the paradox of the tabloids. On the one hand, their sensationalized contents appeal to our base instincts, reaching us more viscerally than do mainstream news outlets. On the other hand, their "yellow journalism" taints our regard for the tabloids so that we mistrust them as exaggerated and untruthful. This accounts for another way that Warhol's

headline works "get" us: it is not their truth but their potential for half-truth or complete falsehood that forces us to puzzle out which stories are fact, which are fiction, and which fall in the middle — in the works of art as well as in the tabloids on which they are based.[46] Thomas Crow pressed this idea, arguing, "Warhol held, however tenuous the grip, to an all-but buried tradition of truth-telling in American commercial culture."[47] Or we may acknowledge the fiction and elect to embark on the mythic media journey — an indulgence in pure escapism.

Readers of today's tabloid news delight in the half-truths of the stories and Photoshopped pictures we find there. Warhol expressed similar interest in a dubious headline and photograph on the cover of the *National Enquirer* from September 22, 1963 (fig. 5). In an interview with Gene Swenson that year, he referred to this issue, a copy of which he saved, asking: "Did you see the *Enquirer* this week? It had 'The Wreck that Made Cops Cry' — a head cut in half, the arms and hands just lying there. It's sick, but I'm sure it happens all the time."[48] The image is an obvious fabrication, at least to twenty-first-century eyes: a still life comprising two ghoulish Halloween masks cut apart and reassembled. Did Warhol fall for this? Did he not see the forgery? Or have we simply fallen for Warhol, believing his every line?

Warhol's media savvy gave him an understanding of the tabloid news that poked fun at itself sometimes. Another *National Enquirer* issue (July 22 – 28, 1962), also

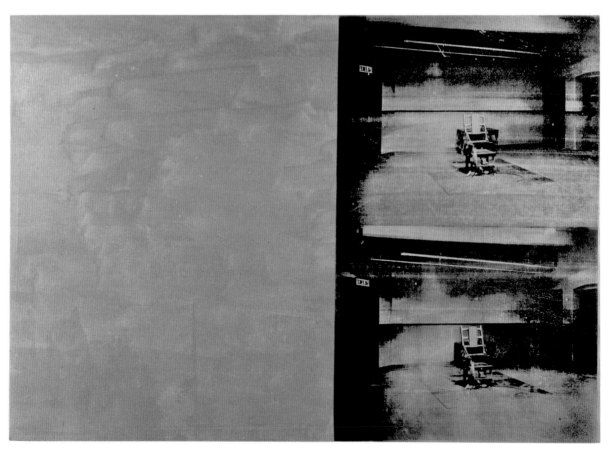

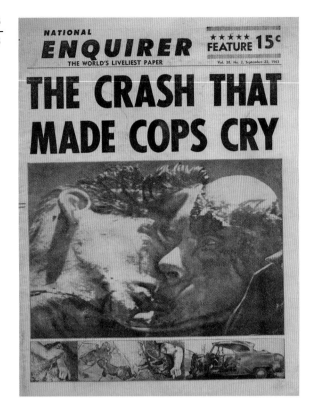

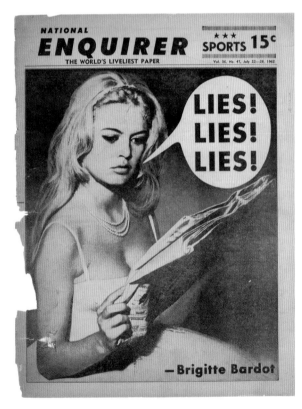

kept by Warhol, shows Brigitte Bardot reading the newspaper with the headline/word balloon "Lies! Lies! Lies!" (fig. 6). Warhol's apparent fondness for this headline may relate to the way the tabloid seems to indict itself — an admission of some guilt at presenting untruths. As we cycle through stories in search of the truth in the news, our challenge is to recognize the real celebrity, the real disaster, the real story. The more intimate the details, the closer we feel to the subject (or the object of our desire). It is the intersection of fact and fiction that Warhol must have found compelling in the headlines. His focus on the tabloid genre signals a clear questioning of the pretense of representing the truth, whether in the content of the media or in the medium of art.

Warhol's choice in the late 1950s and early 1960s to feature the tabloid, a medium often criticized for its hyperbolic misrepresentation of the news, dovetailed with the widening "credibility gap" between the government and the mainstream press, a breach epitomized by the Bay of Pigs debacle in 1961.[49] Yet throughout the 1960s the press became a tool for those who understood how to leverage its power — those like the Students for a Democratic Society and activists such as Abbie Hoffman, who realized that police arrests would lead to news coverage.[50] During Warhol's lifetime the mistrust between government and the press was most evident from 1972 to 1974 as a result of the Watergate scandal, which cast a long shadow. The artist's headline works collate the cultural gaps of his era without resolving them: by bringing the tabloid headlines into his art, he folded together "high art" and middle- or lower-class culture, politics and gossip, fact and fiction.[51] These forms combined Warhol's many facets as well. As his friend the filmmaker Paul Morrissey noted: "Andy's biography should really be written from his press clippings. I mean, tell his story as it appeared in the gossip columns and everything. That's closer to the truth."[52]

WARHOL AS EDITOR AND AUTHOR

Through practice as a commercial illustrator in the 1950s, Warhol fine-tuned his eye and developed a keen ability to use words and imagery to grab the reader's attention. The newspaper's printed page provided a natural source of inspiration for him in the late 1950s and early 1960s as he moved into a career in the fine arts.[53] Warhol often drastically cropped or reconfigured the images from his source materials, in comic-strip paintings like *Saturday's Popeye* (fig. 7) and in his advertising-based paintings. Unlike the former mode (abandoned in 1961) and the latter mode (abandoned in the 1960s and resumed in the 1980s), his works enlisting the headlines remained constant throughout his career.[54] In these works he began to frame and crop not just the images but the printed words, taking them away from their original context, and yet always focusing his seemingly casual editing on eye-catching elements.

FIG. 5 COVER OF *NATIONAL ENQUIRER*, SEPTEMBER 22, 1963, THE ANDY WARHOL MUSEUM, PITTSBURGH; FOUNDING COLLECTION, CONTRIBUTION THE ANDY WARHOL FOUNDATION FOR THE VISUAL ARTS, INC.

FIG. 6 COVER OF *NATIONAL ENQUIRER*, JULY 22–28, 1962, THE ANDY WARHOL MUSEUM, PITTSBURGH; FOUNDING COLLECTION, CONTRIBUTION THE ANDY WARHOL FOUNDATION FOR THE VISUAL ARTS, INC.

FIG. 7 ANDY WARHOL, *SATUR-DAY'S POPEYE*, 1961, CASEIN ON COTTON, 208 × 99.1 CM, LUDWIG COLLECTION—LUDWIG FORUM FÜR INTERNATIONALE KUNST, AACHEN

Four related drawings from 1961 illustrate this point (pls. 6–9). For three of the works, Warhol cropped different elements from the same newspaper page. The fourth drawing, which depicts most of the original page, provides the key to identifying the source for the other three drawings and links them as a group. Warhol included the alarming subject-and-verb combination "Liner Hijacked" in one work and most of an equally unsettling verb, "Seize," in another. The drawings are all based on the front page of the late edition of the *New York Daily News* from January 24, 1961, with the headline, "Pirates Seize Ship with 900," and the subhead, "Cruise Liner Hijacked in Caribbean; Planes, Warships Rushed to Rescue" (see p. 180, doc. 5). This story reported the attack by a group of Spanish and Portuguese rebels on a passenger ship to protest the reigns of the dictators Francisco Franco of Spain and António Salazar of Portugal. The three cropped drawings were likely made by tracing the source, whose image Warhol would have transferred to paper using an opaque projector. The fourth was drawn freehand, and Warhol sensationalized the story by adding three zeros to the passenger count so that it reads: "Pirates Sieze [*sic*] Ship with 900000." The exaggeration was likely intentional, not a mistake, given the premeditation such a change in composition required. Was Warhol making fun of the hyperbolic tabloids?

Two other stories Warhol rendered in *Pirates Sieze Ship* (pl. 6) include large sketches of halftone images: on

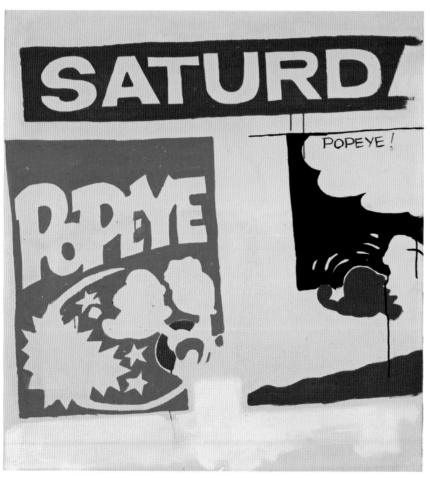

the left is an attractive young woman that we assume is a celebrity until we consult the caption on the source (p. 180, doc. 5), telling of her death after an abortion deemed criminal because she had not been pregnant (Warhol left this off the drawing); and on the right, an uncommonly awkward photograph of President John F. Kennedy appearing to wipe his brow, taken from a UPI telephoto image. Warhol depicted the same image of President Kennedy (from a wider view) in another drawing of 1961, below a headline from the *Journal American* of January 23, 1961, "Trains Run Tomorrow as Tugmen End Strike" (pl. 5 and p. 179, doc. 4). In another disturbing headline drawing, *Food Kill* (pl. 11), for which he cropped and reconfigured the headline "Frozen Food Can Kill You" from the *National Enquirer* of March 26, 1961, Warhol's encryption is once again revealed only by comparison to its source (p. 180, doc. 6).

In a drawing from 1958 Warhol depicted a front page from the *National Enquirer*, with the misspelled "Ennguirer" in the masthead (pl. 2).[55] While many reasons have been offered for Warhol's numerous misspelled words — from intentionality, to dyslexia, to the broken English spoken by his immigrant parents — a definitive explanation is difficult to provide.[56] This "problem," evident in his free-hand drawings, likely found its "solution" when Warhol enlarged the headline sources using the opaque projector and traced the letters (see pls. 6, 7). Misspellings defined Warhol's career, for even his professional name was constructed in and by the media: "Warhol," came about when *Glamour* magazine in 1949 dropped the last letter from his proper surname, "Warhola," in crediting his illustrations for the story titled, "Success Is a Job in New York." Perhaps a degree of self-reference, then, lies behind Warhol's spelling errors.

Tabloid headlines attracted Warhol in part through their punch and brevity. Their composition sometimes followed a grammatical pattern such as *subject – verb – object* (recalling Girard's tripartite configuration, *subject – model – object*). Examples include "Pirates Seize Ship" and "Judge Blasts 'Lynch Mob'" (pls. 6, 55). Other headlines used a simpler *subject – predicate* formula, as in "Zaccaro Indicted" (pl. 47), and still others made use of a celebrity's own words: "It's True Eddie — We're Going to Have a Baby!" (pl. 12), "LBJ to Kremlin: Y'All Come" (pl. 25), and "Madonna: 'I'm Not Ashamed'" (pls. 71, 74, 75, 77).

While newspapers provide what seems a democratic forum, a story elevated to headline status does impose a hierarchical structure on the news, giving decreasing priority from the top to the bottom of the page. Warhol renders this stratification in his *Journal American* drawing of 1960 (pl. 4), once again leaving large blocks of the paper blank on the lower half: the stories there are "empty" and unimportant. This drawing, with its modular format, presents compartmentalized stories: the lead article covers the stabbing of twenty-nine-year-old Martin Luther King Jr. by a demented woman as he autographed

copies of a book at Blumstein's department store in Harlem, New York. Just below is an account of Cold War antagonisms between President Eisenhower and Soviet premier Nikita Khrushchev, followed by the stabbing death of a Caucasian husband and wife whose dying words described their killer as "a different color," though their eight-year-old (Caucasian) son became the prime suspect. It is not clear what initially caught Warhol's attention on this page, but the confluence of all the information became his subject, representing his own obsession with the variety in the news. Form and layout also became content in *The (Wall Street) Journal* (pl. 3), with Warhol moving a graph from page 23 of the September 3, 1953, *Wall Street Journal* to the front page, then apparently tearing the paper in two in a jagged graphlike line (p. 178, doc. 2).[57]

EARLY HEADLINE PAINTINGS

Four headline paintings from 1961 and 1962 — *A Boy for Meg [1]*, *A Boy for Meg [2]*, *Daily News*, and *129 Die in Jet* (listed in the order of their making) — constituted Warhol's own news flash that his career as a fine artist had begun (pls. 13–16).[58] His process demonstrates the path he pursued on his way from roughly rendering by hand to a seemingly slick solution in silkscreen, arrived at a few

months after he finished *129 Die in Jet*. The choice of newspaper headlines — sharp, graphic formulations — was perfectly suited to grab the viewer's attention at first glance. As in his drawings, Warhol employed an opaque projector to enlarge and project the newspaper page onto the support. He then traced the images and lettering in pencil and paint and used a toolbox of implements that included rubber stamps and sponges as well as brushes to finish the paintings.

Warhol painted his first headline-themed canvas, *A Boy for Meg [1]*, in late 1961, based on the front page of the *New York Post* from November 3 of that year (pl. 13 and p. 181, doc. 7). The newsworthy subject of this painting was the birth of a first child — a son — to Great Britain's Princess Margaret.[59] Warhol made a second painting, *A Boy for Meg [2]*, in early 1962 based on the same source (pl. 14). Together, the works demonstrate a significant stylistic transformation in the span of a few short months: from the expressive rendering in the first canvas to the precise delineation and near erasure of the artist's hand in the second one. Warhol attributed this shift, primarily, to his "editors," starting with filmmaker Emile de Antonio ("De"), who offered critical feedback on a pair of Coke bottle paintings (figs. 8, 9), each made in a different style, around the same time as the two versions of *A Boy for Meg*:

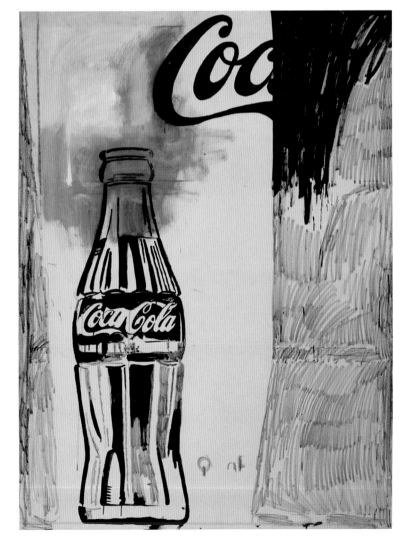

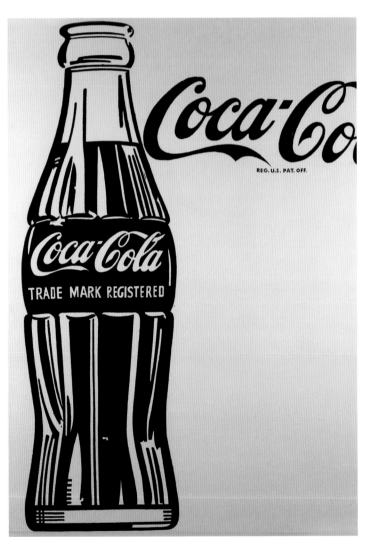

At five o'clock one particular afternoon the doorbell rang and De came in and sat down. I poured Scotch for us, and then I went over to where two paintings I'd done, each about six feet high and three feet wide, were propped, facing the wall. I turned them around and placed them side by side against the wall and then I backed away to take a look at them myself. One of them was a Coke bottle with Abstract Expressionist hash marks halfway up the side. The second was just a stark, outlined Coke bottle in black and white. I didn't say a thing to De. I did not have to—he knew what I wanted to know. "Well, look, Andy," he said after staring at them for a couple of minutes. "One of these is a piece of shit, simply a little bit of everything. The other is remarkable—it's our society, it's who we are, it's absolutely beautiful and naked, and you ought to destroy the first one and show the other." That afternoon was an important one for me.[60]

Warhol did not stop there. He solicited opinions from others in his select group of critics to determine the direction his art should take. Ivan Karp, who worked for gallery owner Leo Castelli, was also invited to critique the two styles. As Warhol recalled, "I like to show both to people to goad them into commenting on the differences, because I still wasn't sure if you could completely remove all the hand gesture from art and become noncommittal, anonymous."[61] In expressing doubts about his ability to eliminate any evidence of his hand, the artist also hints at his ambivalence about his desire to achieve that goal. While Warhol would have us believe that his decision to pursue gestureless painting was made by others, we should recall his apparently autonomous act of de-skilling in early drawings as a way of hiding any artistic bravura. In addition, he acknowledged his desire to remove all personal touch from his art when he turned to silkscreen in August 1962 in an effort to create a machine aesthetic: "The rubber stamp method I'd been using to repeat images suddenly seemed too homemade; I wanted something stronger that gave me more of an assembly-line effect."[62] Where did Warhol's own true ambitions lie regarding these matters? He posed more questions than he answered, ensuring our continued fascination with his suspenseful narrative. One consistent practice is his Girardian embrace of the desires of others rather than acknowledging his own intentions.

The two versions of *A Boy for Meg* are the first paintings in which Warhol used the front page of a newspaper as a readymade composition. When Donna De Salvo asked him in 1986 why he decided to include the full page, he responded, "Oh, because I was going to do the whole newspaper, so this was just the cover."[63] Warhol's conception of painting the whole newspaper benefited from the example of Marcel Duchamp, whose readymades were found objects "promoted to the dignity of art through the choice of the artist."[64] A significant difference arises, however, between Warhol's *trans*cription of

his original source material, the literal rewriting of text and copying of images to create a new form on canvas or another surface, and Duchamp's *in*scription onto the objects he chose, or named, as art.[65] Even for his "assisted readymades," as in *Bicycle Wheel* (1913), with two prefabricated parts brought together, the actual source material in Duchamp's work becomes the art. By contrast, Warhol reproduces the source material and then leaves it behind, elevating it to archival status, but not to the level of art. The original newspaper that inspired Warhol's *A Boy for Meg* paintings, which is kept in his archive, bears the artist's marks in the form of test patches of paint. This artifact shows how he sought to match the blue of the banner, the middle tones of Princess Margaret's photographic image, and the black text (p. 181, doc. 7).

The first *A Boy for Meg* painting resembles the artist's drawings of that time, with its sketchy, expressive qualities. In reproduction, the work reads almost like a drawing—until we register the scale and medium. Warhol even evokes the paper support on which the news was originally printed by painting an area of translucent yellow from the left edge of the canvas (where the weather column appears) across part of the newspaper's name, fading out to the right of center. Warhol abandoned his rendering of the yellowed ground in *A Boy for Meg [2]* and subsequent headline paintings, although in *Daily News* of 1962 he used a cream-colored paint on the neutral ground to cover captions he had initially transcribed below the images (pl. 15). On the left half of that work (depicting the back page), for example, under the halftone of the horse with its mouth open, the caption faintly reads beneath the paint, "See me in the Derby." Warhol's second thought directs us to the large headlines and graphic images rather than to the fine print.

In *A Boy for Meg [1]*, after indicating the yellowish paper and blue banner in paint, Warhol shifted to wax crayon to render the photographic images of Frank Sinatra and Princess Margaret, applying an array of single-direction marks. As in other early paintings and drawings, he left a large area open at the bottom, omitting both pictorial detail (Margaret's dress) and textual data (the word "Meg"). Warhol creates a blank, allowing us to insert another name—including our own or the artist's—in "A Boy for..." and thus complete the headline in the mind's eye. In *A Boy for Meg [2]*, in addition to making a stylistic change, Warhol made a physical change, using a larger canvas to accommodate more information from the original source. He added the name "Meg," the rest of Princess Margaret's dress, and nearly all of the text and images from the source, except a few captions and the subhead, "Fifth in Line for Throne." That text is visible only on the verso of the source, folded around a photograph of a soup can by Edward Wallowitch that Warhol used as backing for the newspaper (fig. 10).

The *Daily News* canvas stands alone as the only two-page spread among all of Warhol's headline works (pl. 15)

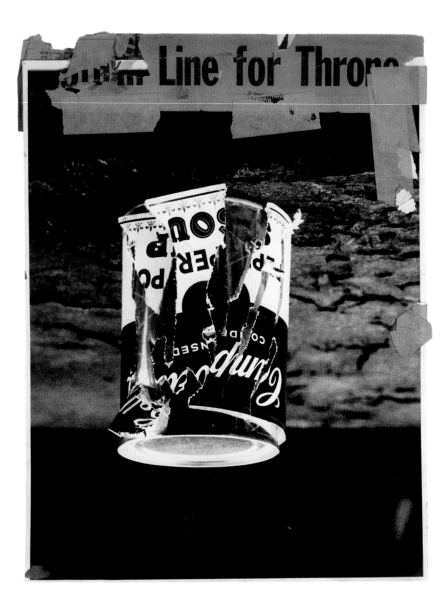

latter two works, enabling the eye to take in the single, front-page banner and image at a glance. In them, we see the imperfect tensions in Warhol's handwrought yet consolidated style as he moves another step closer to a machinelike refinement.

Warhol's Death and Disaster theme emerged fully in the painting *129 Die in Jet* (pl. 16). By the time this canvas was painted—sometime after June 4, 1962, the date of the source—the artist appears to have found an ideal subject to express the urgency he sought from the news banner, headline, and image.[66] As Warhol tells the story, the idea for the painting came from his friend, Metropolitan Museum of Art curator Henry Geldzahler: "We were having lunch one day in the summer…and he laid the *Daily News* out on the table. The headline was '129 DIE IN JET.' And that's what started me on the death series—the car crashes, the Disasters, the Electric Chairs."[67] In fact, the publication was the *New York Mirror* rather than the *Daily News*, and while Warhol gave credit to Geldzahler, essentially disclaiming his own choice of the Death and Disaster series, the artist had gravitated on his own to alarmist headline subjects for his art at least two years before with the "Woman Stabs Rev. King in Harlem" drawing in 1960 (pl. 4) followed by the "Pirates Seize Ship" drawings in 1961 (pls. 6–8). Also, according to Taylor Mead, Warhol's fear of flying prompted him to drive from New York to Los Angeles to attend the opening of his exhibition of Elvis Presley and Elizabeth Taylor paintings at Irving Blum's Ferus Gallery in 1963.[68] Finally, the gripping headline story of *129 Die in Jet* represented not only an international disaster involving a devastating airliner crash at Orly Airport near Paris but also a particular tragedy for the American art world, with 106 members of the Atlanta Art Association among those who perished.

In both *A Boy for Meg [2]* and *129 Die in Jet* Warhol employed a technique akin to sponging to approximate the grainy texture of the photographic halftones. Meg's hat and neck area, in the former, and the grounds of the airport, in the latter, bear these marks most clearly. Warhol began to silkscreen his paintings in August 1962, abandoning hand-painted elements in his canvases for ten years.[69] In 1963 he remarked to Gene Swenson, "I think it would be so great if more people took up silkscreens so that no one would know whether my picture was mine or somebody else's."[70] Signaling another step toward obscuring authorship of his paintings—like his earlier de-skilling of his craft and his attempt to assign credit to others for his choice of style and subject—Warhol's embrace of the silkscreen technique made it increasingly difficult to discern his hand in his work.

The sensational subject of the silkscreened Tunafish Disaster paintings—the death of two women (Mrs. McCarthy and Mrs. Brown) after sharing a can of botulism-contaminated tuna fish—presented Warhol with ready

(placing him a step closer to his ambition to paint the entire newspaper). With its multiple images, this work presents a greater range of middle tones and textual information. The left side, representing the back page of the *New York Daily News* from March 29, 1962, illustrates human-interest stories along with sports coverage (p. 182, doc. 8). The right side, representing the front page of the same newspaper, spotlights a Hollywood story in large, bold type, with figures silhouetted against a dark background. Warhol tested different shades of gray on the cardboard backing of the source (p. 182, doc. 9) before reproducing the halftone images of Elizabeth Taylor and Eddie Fisher on the canvas. He even tried out a herringbone-shaped rubber stamp on the backing as a way to render the texture of Taylor's garment. In addition to the opaque projector, used for all four early headline paintings, Warhol appears to have relied more heavily on pencil marks to sketch in the complex composition of *Daily News*. By contrast, for *A Boy for Meg [2]* and *129 Die in Jet*, scant evidence of pencil underdrawing suggests the images were traced more directly in paint. Higher contrast accompanies the painted image in the

FIG. 10 *COLLAGE (A BOY FOR MEG)* (VERSO), 1961, FRONT PAGE OF *NEW YORK POST*, NOVEMBER 3, 1961, TAPED AND WRAPPED AROUND A PHOTO-GRAPH BY ED WALLOWITCH, THE ANDY WARHOL MUSEUM, PITTSBURGH; FOUNDING COL-LECTION, CONTRIBUTION THE ANDY WARHOL FOUNDATION FOR THE VISUAL ARTS, INC.

FIG. 11 ANDY WARHOL, FRAME ENLARGEMENT FROM *BLOW JOB*, 1964, 16MM FILM, BLACK AND WHITE, SILENT (41 MINUTES AT 16 FRAMES PER SECOND), COURTESY THE ANDY WARHOL MUSEUM, PITTSBURGH

material.[71] Although the story recommended itself for the front page of the tabloids, Warhol culled it from page 76 of the *Newsweek* magazine from April 1, 1963 (p. 185, doc. 13). Only one of the eleven paintings in the series includes the deadpan heading "Two Tuna Sandwiches," qualifying it for inclusion among Warhol's headline works (pl. 19). Together with the full text, the headline is repeated on either side of the canvas, surrounded by enlarged images of Mrs. McCarthy and Mrs. Brown, the can of A&P brand chunk light tuna, and the terrifying caption, "Seized shipment… Did a leak kill…." Warhol left yet another blank space, in the center of the work, which reveals the hand-painted silver ground. Mimicking the basic compo-sition of the magazine source, with text framing the cen-tered illustrations, Warhol surrounded this empty space with blocks of text, screening over it multiple images of the two victims and the tuna can. The narrow rectangu-lar silver "mirror" in the middle draws us in and invites us to envision ourselves as part of the composition. The common lunch and the common-looking women with common names met with a dreadful end that elevated them not only to the pages of *Newsweek* but to Warhol's "silver screen."

SCREEN TESTS: UNLIKELY CELEBRITIES

Warhol's fascination with Hollywood materialized in his 472 Screen Tests made in the Silver Factory between 1964 and 1966. The subjects for his Screen Tests were drawn from regulars at the Factory as well as visitors such as musician Bob Dylan, artists such as James Rosenquist, and various art world figures. In three of these Screen Tests, his subjects are reading what appear to be newspa-pers. These films feature the French *nouveau réaliste* artist Arman; arts writer for the *New York Times* Grace Glueck;

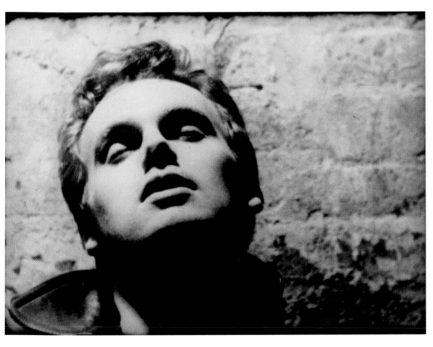

and director of the Jewish Museum in New York, Alan Solomon; and they take Warhol's interest in blanks to a logical extreme (pls. 20 – 22). The newspaper is cut out of the camera's frame, yet its presence is implied by the sitters' concentrated downward gaze and by the relatively wide sweep of their eyes, as if searching for an interesting article. Early in her Screen Test, Grace Glueck raises the paper to turn or reposition the pages, offering a glimpse of it.

Callie Angell, who identified the presence/absence of the newspaper in these three Screen Tests, questioned whether the sitters knew they were being filmed. She sug-gested that Warhol may have used a zoom lens from across the room, making public a private act of reading.[72] Unlike most of Warhol's other Screen Tests, not one of these three subjects ever looked at the camera; each fixed his or her gaze on the reading material. These apparent surveillance films raise questions about the nature of these "screen tests," given the sitters' lack of complicity in the performance. And they implicate the artist, camera, and the audience as voyeurs.[73] Because we the audience finish the image, we must ask ourselves whether the absence of a viewer, and therefore the absence of voyeur-ism, would negate the work.

In these films Warhol revisits the triangular struc-ture we have seen elsewhere in his work: with the sitter as subject, the film as model, and the viewer as object. This configuration evokes another of Warhol's films — namely, *Blow Job*, also from 1964, in which the presumed pleasur-ing agent occupies space entirely outside the picture frame, raising ontological questions for the spectator (fig. 11). As Peter Gidal observed, Warhol here prompts us to wonder whether the implied action is actually taking place or is merely being acted out by the subject.[74] Does our inability to see the action make it less real? As in *Blow Job*, these three Screen Tests assert an agent — the newspaper — outside the frame, which, despite our inability to see it, does not make it less real. By keeping the news-paper headline out of view, however, Warhol focuses our attention on the head of the sitter — framed, focused, and well lit. In so doing, Warhol emphasizes the recep-tion and *processing* of the news by three art world intellec-tuals. He offers the head of the figure as the anatomical analogue to the headline of the newspaper.

By April 1964 Warhol was moving closer to one of the objects of his desire, recognition in the media: he received considerable negative press for his *Thirteen Most Wanted Men* mural, mounted on the façade of the New York State Pavilion designed by Philip Johnson at the World's Fair in Flushing Meadow (fig. 12). He had silk-screened onto panels all twenty-two mug shots of the "Thirteen Most Wanted" fugitives from a New York City police department booklet dated February 1, 1962, which he then organized in a loose grid, with gaps between images and an open area along the bottom. Accounts of

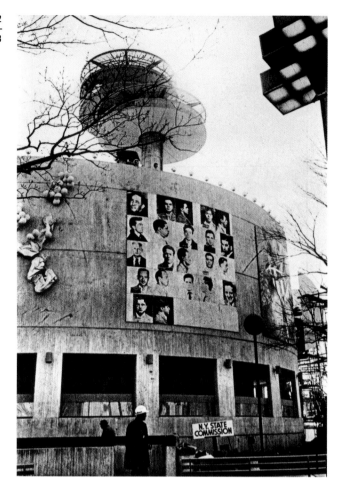

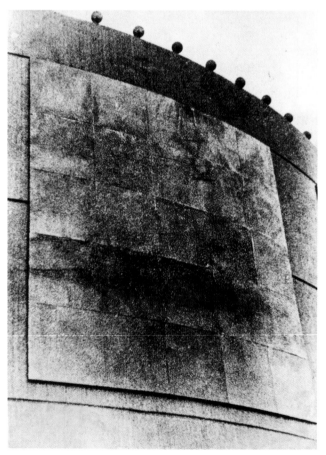

the objections to this work, which seemed to have touched a collective nerve, appeared in various newspapers. Four stories in the New York tabloids and mainstream press covered the controversy: "Mural Is Something Yeggstra" by Richard Barr and Cyril Egan Jr. in the *New York Journal American* of April 15, 1964; "Fair's 'Most Wanted' Mural Becomes 'Least Desirable'" by Mel Juffe in the same publication, dated April 18, 1964; "Fair Mural Taken Off, Artist to Do Another" by Emily Genauer in the *New York Herald Tribune* of April 18, 1964; and a mention by Grace Glueck in the *New York Times* of July 19, 1964. In response to the furor, Warhol authorized the New York State department of public works to paint over the mural "in a color suitable to the architect" (fig. 13).[75]

As he expanded his intermedia practice, Warhol left almost no medium untouched, including vinyl records. In 1966 he collaborated on an ESP-Disk, a New York label featuring largely free jazz and noncommercial underground productions. Warhol and a few Factory cohorts (Gerard Malanga and Ingrid Superstar) joined the Velvet Underground, poets Allen Ginsberg and Peter Orlovsky, alto saxophonist Marion Brown, and others in contributing their sound pieces to the *East Village Other* "publication" of *Electric Newspaper — Hiroshima Day — USA vs Underground* in 1966 (pl. 23). Warhol's offering, entitled "Silence," amounts to eleven seconds of ambient noise. The content of the piece, an open environment filled with a collage of sounds, is the audio corollary to the open spaces in Warhol's visual works. The title recalls John Cage's famous *4'33"* of 1952, which instructs the performer to refrain from playing the piano for four minutes and thirty-three seconds.

The *Electric Newspaper*'s subtitle, "Hiroshima Day," refers to the twenty-first anniversary of the atomic bombing of Hiroshima. The date coincided not only with Warhol's birthday but also with the wedding of Luci Baines Johnson, daughter of President Lyndon Baines Johnson and "Lady Bird" Johnson, on August 6, 1966, and media recordings that relate to the wedding as well as interviews with the first daughter and her husband bleed through many pieces on the disc. The happy event celebrated by the president's family is contrasted with the devastation wreaked on the Japanese people in 1945. Parallels between Hiroshima Day and the Vietnam War are also drawn on the back of the jacket cover in a free verse text written by the editor of the *East Village Other*, Allen Katzman: "EXTRA! EXTRA! READ ALL ABOUT IT! LUCI GETS HERS — FINALLY; HIROSHIMA DAY AUGUST 6; U.S.A. VS UNDERGROUND. Somewhere planes fly now spraying viet purple people with napalm nectar; the jolly jowled poison of a president's smile splashes across the mass media consciences of America; the underground flies through the echo chamber of total technocracy to pay homage to history. All the news unfit to print is pre-

FIG. 12 ANDY WARHOL,
THIRTEEN MOST WANTED MEN,
NEW YORK STATE PAVILION,
NEW YORK WORLD'S FAIR, 1964

FIG. 13 *THIRTEEN MOST
WANTED MEN* MURAL PAINTED
OVER, NEW YORK STATE
PAVILION, NEW YORK WORLD'S
FAIR, 1964

FIG. 14 ANDY WARHOL,
STRICTLY PERSONAL, 1956,
BALLPOINT INK ON PAPER,
61 x 45.7 CM, PRIVATE
COLLECTION

cipitated in the ear." The phrase "All the news unfit to print" takes direct aim at Adolph S. Ochs's famous slogan for the *New York Times*, asserting the need for the alternative press, something in which Warhol willingly participated in 1966.[76]

HEADLINES AND WARHOL AS BRAND NAMES

At their best, newspapers create settings to engage the reader. In McLuhan's words, "Environments are not passive wrappers but active processes."[77] Yet passive consumers consistently fall for the promise a headline offers on the wrapper, buying the newspaper and "buying" the tease of access to new information, despite repeated disappointment. Particularly in the tabloids the sensational headline projects a sense of urgency, tempting a consumer to purchase the publication in order to read the inside story — which often fails to deliver on its promise. But by then it is too late. We have already turned over our money and our attention. Warhol understood the inextricable link between the news and the money that underwrites it.

The newspaper media ably fed the desires of post–World War II consumer culture for goods as well as information, offering a codependent advertising/news nexus.[78] In his headline works Warhol appropriated the headline-as-brand-name meant to sell newspapers and turned it into text-as-aesthetic-object for sale. The references to newspaper advertising in Warhol's paintings began in 1961.[79] But in an early drawing, *Strictly Personal* (fig. 14), based on the classified section of the *National Enquirer*, Warhol highlighted the ways in which individuals "buy" and "sell" one another like commodities in the newspaper's pages. The drawing captures headline-like appeals such as "Alone in New York," "Seeks Buxom Girl," and "Bohemian Gent."

News and ads together provide a media meal for a hungry readership that consumes it, digests it, and incorporates it into the larger social body. In one of Warhol's I. Miller advertisements (January 1957), the artist contributed literally to such a body, offering the skirt, legs, and feet of a figure selling shoes on the bottom half of the page, which (whether owing to chance or to the layout editor's skill) combined with several portrait busts of women and their accompanying society news on the top half (see p. 27, fig. 2). The reader logically links the two halves, imagining how the women pictured in the news above would complete their look (as would the reader herself) by buying the elegant shoes depicted in the ad below. This page in the *New York Times* clearly pitched its product to upwardly mobile women. In contrast, the *Daily News* and *New York Post* that Warhol recapitulated in his headline works targeted a female audience of a lower economic class.

In 1966 Warhol and David Dalton, a British teen who assisted at the Factory, presented the commercial aspect of the news up front. They collaborated on an issue

14

of *Aspen Magazine* (pl. 24), producing a "newspaper" under the banner *The Plastic Exploding Inevitable*, a take-off on Warhol's earlier intermedia extravaganza with the Velvet Underground, the "Exploding Plastic Inevitable." For this work, Warhol and Dalton collaged an assortment of ads, stock indices, political cartoons, and underground publication matter to create the "text" on the front page of the newspaper. They distilled the most important "news" down to the ads and commentary that normally run behind the front pages and underwrite its production. In this way, they literally turned the paper inside out.

By 1967 Warhol's Silver Factory scene had become its own hot commodity, selling cool stylishness and providing content for the news media advertising machine. The Factory abrogated gender and class distinctions, creating a space where transvestites, heiresses, speed freaks, wealthy art collectors, rock musicians, and Harvard graduates alike mixed together. That year the *Daily News* incorporated this sensationalized Warhol "brand" in an ad campaign, reclaiming the tabloid news from Warhol and marketing itself to the loftier readership of the *New Yorker*. The September 9 issue of the magazine featured high society model and Warhol Factory superstar "Baby" Jane Holzer in a seemingly unposed black-and-white pho-

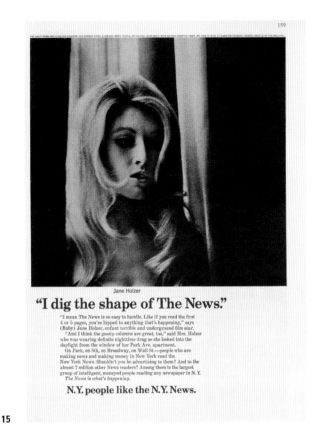

Jane Holzer

"I dig the shape of The News."

"I mean The News is so easy to handle. Like if you read the first 4 or 5 pages, you're hipped to anything that's happening," says (Baby) Jane Holzer, enfant terrible and underground film star.

"And I think the gossip columns are great, too," said Mrs. Holzer who was wearing definite nighttime drag as she looked into the daylight from the window of her Park Ave. apartment.

On Park, on 5th, on Broadway, on Wall St.—people who are making news and making money in New York read the New York News. Shouldn't you be advertising to them? And to the almost 7 million other News readers? Among them is the largest group of intelligent, moneyed people reading any newspaper in N.Y. *The News is what's happening.*

N.Y. people like the N.Y. News.

15

tograph, framed cinematically between two black bands. The colloquial line "I dig the shape of The News" appears below her image in a large font suggestive of tabloid headlines (fig. 15). The not-so-subliminal invitation, of course, is to "dig the shape" of Jane Holzer. The caption quotes her further: "I mean The News is so easy to handle. Like if you read the first 4 or 5 pages you're hipped to anything that's happening…. And I think the gossip columns are great, too." Nowhere is Warhol's name mentioned. But any reader who was "hipped" in 1967 likely knew Holzer's connection to the pop artist. The text makes clear that it is soliciting not readers but advertisers for the *Daily News,* to whom it would deliver those "making the news and making money in New York" in 1967. Yet this ad's publication in the *New Yorker* also suggests that a new readership for the *Daily News* was emerging, one that was educated, professional, and art savvy. According to the ad copy, it was reaching "the largest group of intelligent, moneyed people reading any newspaper in N.Y.," including men as well as women.[80]

About this time Warhol made a series of screenprints to appear as ads on the side panels of *Daily News* delivery trucks (pl. 25), although they were never displayed this way.[81] The screenprints derived from the *Daily News* final edition from Monday, November 19, 1967, with the headline, "LBJ to Kremlin: Y'All Come." Geometric blocks of eye-popping Day-Glo colors served as background for the black type on white paper. Over this, Warhol laid a commercial graphic design pattern, registered upside down and backward (evident in the reproduction of the word "Take" at the bottom right) and obscuring nearly all text

but the *Daily News* banner (see p. 186, doc. 15a). Related commercial patterns would be used again for the cover of Warhol's *Flash* portfolio (pl. 26 and pp. 186–187, docs. 15b, 16).[82] Warhol thus covers the headline, making it illegible. Was this perhaps turnabout for the press-fueled censorship of his *Thirteen Most Wanted Men* mural?

1968: LIKE ODYSSEUS

The year 1968 marked a critical passage for Warhol. In art, he made an important print portfolio, weaving connections between its two-dimensional surface, the media, and film. In life, his nearly fatal shooting was defined, in part, through its treatment in the newspaper headlines. And if we are to believe Warhol's words, this moment also marked a step in his shift toward televised media.

Warhol's print portfolio, *Flash — November 22, 1963,* was named for the "news flash" texts Phillip Greer wrote for the portfolio based on Teletype wire service reports of the assassination of President John F. Kennedy on that fateful Friday (pl. 26). The work was commissioned by book publisher Alexander Racolin of Racolin Press and was made in early 1968. The clamshell cover for the portfolio bears the screenprinted image of the *New York World – Telegram* front page from November 22, 1963, with the headline "President Shot Dead" (p. 185, doc. 14). Eleven Teletype texts by Greer, screenprinted in black ink on white paper, provide "wrappers" that house eleven screenprints of a range of images relating to the assassination. Like the texts on the wrappers, which echo information throughout, the images contain repeating elements yet are each different from one another: they are rendered in a variety of two-tone, mostly monochromatic color combinations, in shiny and matte finishes, in both positive and negative versions. Most prominently featured is a smiling likeness of Kennedy taken from his 1960 campaign poster. The hues of these images read like a Technicolor chart, and the dimensions of their paper support, roughly 20 inches square, evoke a 1960s television screen, appearing to replay the televised news of the assassination in stills. The portfolio also references the frame-by-frame analysis of the famous amateur movie of the assassination taken by Abraham Zapruder. *Life* magazine's purchase of the Zapruder film enabled its editors to explore the horrific incident over at least three illustrated feature articles reproducing still images (see pp. 53 – 55, figs. 7, 11, 12), which offered readers renewed chances to learn the "truth."

By rendering several images in the negative with bright colors, Warhol also replayed the assassination as we might see it in flashback with our eyes shut, a disturbing afterimage forced on viewers by the media. Warhol later gave a detached response in *POPism:* "I'd been thrilled having Kennedy as president; he was handsome, young, smart — but it didn't bother me that much that he was dead. What bothered me was the way the television and radio were programming everybody to feel so

sad. It seemed like no matter how hard you tried, you couldn't get away from the thing."[83] That Warhol presented a news item four and a half years after the fact, however, speaks to society's insatiable desire to make sense of Kennedy's end. The texts wrapping each of the portfolio's images emphasize the packaging of this event, and the headline on the clamshell cover acts as a label on a consumer product, enticing viewers to buy it.

The press reported both general and specific threats of violence in the 1960s,[84] and Warhol was destined to become a victim. Eerily, the subject and frame-by-frame format of his *Flash* portfolio, completed in early 1968, prefigured Warhol's own flickering thoughts a few months later when he regained consciousness after being shot by Factory hanger-on, Valerie Solanas:

As I was coming down from my operation, I heard a television going somewhere and the words "Kennedy" and "assassin" and "shot" over and over again. Robert Kennedy had been shot, but what was so weird was that I had no understanding that this was a *second* Kennedy assassination—I just thought that maybe after you die, they rerun things for you, like President Kennedy's assassination.... I couldn't distinguish between life and death yet, anyway, and here was a person being buried on the television right in front of me.[85]

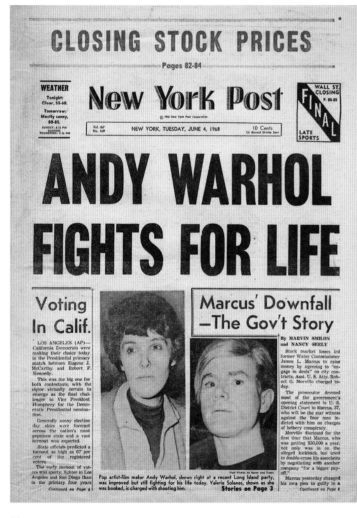

On June 3, 1968, Solanas, an unstable writer, aggrieved over Warhol's refusal to support her work, had entered the Factory and shot the artist at point-blank range. In the emergency room of Columbus Hospital, he was pronounced clinically dead, yet doctors managed to revive him after massaging his heart. As he lay in critical condition, a blaring headline in the *New York Post* the next day read: "Andy Warhol Fights for Life" (fig. 16).

This event makes it impossible to separate Warhol's life and work when discussing the artist's theme of newspaper headlines. He was already famous, but from that instant forward, his prominence in a riveting news media narrative became enmeshed with his work. In a later meditation Warhol made this connection explicitly: "I was the headline of the *New York Daily News*— 'ACTRESS SHOOTS ANDY WARHOL,' six years to the day from the June 4, 1962, '129 Die in Jet' disaster headline…for my painting."[86] Warhol thus acknowledged the attainment of the great object of his desire — recognition in the newspaper headlines — as well as the fusion of his life and art through the headlines.

During the 1960s Warhol witnessed the demise of several tabloid newspapers, including the *New York Daily Mirror*, which closed in 1963, followed by the *Journal American* in 1966, both of them owned by the Hearst publishing empire. He saved an article from the *Village Voice* of April 28, 1966, about the closing of the *Journal American*.[87] Following the gradual loss of his beloved tabloid newspapers, Warhol would go on to write a good deal about his own near-death experience and would turn his attention to the next object of his desire — television:

Before I was shot, I always thought that I was more half-there than all-there—I suspected that I was watching TV instead of living life. People sometimes say that the way things happen in the movies is unreal, but actually it's the way things happen to you in life that's unreal. The movies make emotions look so strong and real, whereas when things really do happen to you, it's like watching television—you don't feel anything. Right when I was being shot and ever since, I knew that I was watching television.[88]

Warhol identified television as a provider of constant mediation between himself and real life. David Joselit has written of "Warhol's conviction that 'TV' and 'life' mutually de-realize one another." (Joselit also points out that Warhol differentiated between film and television, as in the passage above.) Film and television now joined the tabloids — resulting in another type of triangular structure — as the dominant media of Warhol's headline works.[89] Whatever the medium, the headlines stayed with Warhol. But the newspaper tabloids, unlike time-based media, remained the enduring source of comfort and material for his art throughout his career — even as some tabloids went out of business. Warhol was constantly

pictured holding newspapers. He particularly loved the New York tabloids, saying after a trip to London in 1986, "It was good to see the good old New York papers again."[90]

Warhol's career after 1968 is crucial to understanding his role vis-à-vis the media. Was he a victim of the media thanks to his success, which they broadcast, or did he imperil himself by pursuing success and recognition in the media, or both? Was he willing or unwilling? Whatever one concludes, his miraculous survival and return to productive life in 1968 marked a second "transfiguration," as Arthur Danto calls Warhol's earlier makeover from a commercial artist to a fine artist.[91] Much has been made of Warhol's shooting in 1968 as a watershed in his career, with critics of the artist's later work declaring him essentially dead after that. To ignore his career after the attempt on his life, however, is to miss the consistency with which he pursued his work with and through the media.

A notorious hypochondriac, Warhol quite naturally used the news media to tune in to the threats of contemporary life. Assassinations, Cold War anxieties, race riots, and antiwar sentiments combined with technological advances, led by the television news, to rocket the media forward as critical information providers. The artist's skill at monitoring, manipulating, mastering, and dislodging the media message can be seen as a survival strategy. Surviving the times meant confronting the distant facts of tragedy reported in the media and claiming them as his own. He represented them powerfully in his headline works, which warn of inevitable fate yet heroically affirm life too, reminding us that as we survive tragedies, we live to read about them the next day.[92]

McLuhan describes the fisherman in Edgar Allan Poe's "Descent into the Maelstrom" as surviving the storm by learning from and cooperating with it[93] — in a sense mimicking it while retaining a critical distance. Poe's fisherman could well represent Warhol. Theodor Adorno and Max Horkheimer attribute similar qualities to the classic epic hero, Odysseus. Their view could easily apply to Warhol's edgy existence as the knowing, surviving epic hero for contemporary times: "The knowledge in which [Odysseus's] identity consists and which enables him to survive draws its substance from the experience of the multifarious, the diverting, and disintegrating, and the knower who survives is at the same he who entrusts himself most recklessly to mortal danger, on which he hardens and strengthens himself."[94] The individual stories Warhol told through his headline works serve essentially as discrete myths, and the role of mythmaker is an apt characterization for an artist whose work regenerates the very media sources from which it draws, perpetuating a cycle of repeated narratives. The retelling of a tale by a mythmaker often includes elaborated, deleted, or new elements — an altered original. Yet when combined and considered as a whole, these elements may form an epic narrative.

Warhol's skillful use of language, honed in the art of the sound bite, simultaneously projected him into the press and protected him from it. His succinct statements became another signature,[95] consistent with his well-known avoidance of direct verbal expression in public. Indeed, his most famous statement might not have been his at all, but rather that of Pontus Hultén, former director of the Moderna Museet in Stockholm. Hultén's colleague, Olle Granath, recalls that when reviewing textual elements for the 1968 Warhol show at the their museum, Hultén asked him about a "missing quotation" — namely, "In the future, everyone will be world-famous for 15 minutes." Granath, who had just reviewed everything published by or about Warhol, replied that if it had been in the material he "would have spotted it" — to which Hultén retorted, "If he didn't say it, he could very well have said it. Let's put it in."[96] Thereafter, "Warhol's" famous quotation had legs, as they say in the news business.

ARISTOCRACY OF NEWSPAPER PUBLISHING

Warhol moved from the (Silver) Factory on 47th Street in the winter of 1968 to a work space at 33 Union Square West. Following the attempt on his life, he understandably closed his new studio to all but a few trusted assistants. There he concentrated on making films and on launching *Interview: A Monthly Film Journal,* which made its debut in November 1969. Warhol would refer to *Interview* as his "newspaper."[97] Ultimately, the publication provided his own media site in which to mix art, celebrity, and fashion. Explanations for his decision to found this magazine range from his desire to obtain a press pass that would satisfy his Weegee-like paparazzo inclinations[98] to his intention "to give Brigid (Berlin) something to do."[99]

Berlin met Warhol in "1963 and a half" and maintained her status as a confidante until he died.[100] Early in her tenure at the Silver Factory, she was given the moniker Brigid "Polk" for her skill at administering "pokes" (amphetamine injections) to herself and other denizens of the Factory. She was among the 'B's in Warhol's *Philosophy of Andy Warhol (From A to B and Back Again)* and one of the people to whom he dedicated the book: "To beautiful Brigid Polk, for being on the other end." The "other end" referred to their countless phone conversations, tape recorded by both Warhol and Berlin. She would often call the artist with her "fast-breaking news!" after which the two would discuss the contents of "Page Six" (gossip in the *New York Post*) and the headlines.

The newspaper world was second nature to Berlin. Her father, Richard E. Berlin, ran the Hearst media empire for three decades, and she roller-skated in Hearst Castle at San Simeon as a child. Berlin was a mainstay in Warhol's films, including *The Chelsea Girls,* and she became a favorite of later filmmakers such as John Waters for her uninhibited style. Warhol hired Berlin, among others, to clip articles in which he was mentioned

for his scrapbooks (see pp. 58–84). After he was shot, she became the gatekeeper at his new Factory, sitting at the reception desk and preventing undesirables from entering.[101]

Berlin proved the ideal news anchor and/or talkshow host for three video "entries" in Warhol's Factory Diaries, made in his studio in the 1970s (pls. 27–29). In "Brigid Testing for Talk Show," produced on June 10, 1974, she sat at a desk holding papers, bespectacled for seriousness's sake, looking like Barbara Walters yet remaining true to herself.[102] With a typewriter click-clacking in the background, Berlin's opening statement, "Major breaking stories of this moment…," was followed by her critical commentary on President Richard Nixon's six-day trip to the "Far East" (Moscow) for the SALT II (Strategic Arms Limitations Treaty) talks with Soviet leader Leonid Brezhnev, in which she asserted that Nixon should not have left the country owing to discussions of his likely impeachment.[103] Largely unscripted theater of the absurd, the Berlin performance prefigured Jane Curtin's comical newswoman character on *Saturday Night Live*'s "Weekend Update" segments.[104] Vincent Fremont, who worked closely with Warhol starting in 1971 and produced the Factory Diaries, *Andy Warhol's T.V.*, and *Andy Warhol's Fifteen Minutes*, wrote, "For years he (Warhol) always joked that he should marry Brigid Berlin because her father ran the Hearst Empire and he could have a TV station."[105]

Warhol's obsession with celebrity news extended to the wealthy newspaper tycoons and their families. In addition to the Hearsts, whom he followed through Berlin, Warhol gained access to and an eventual commission from Charles Cowles — then publisher of *Artforum* and son of Gardner Cowles Jr. of the Cowles family publishing empire — to make his mother Jan's portrait in 1968. In 1976 Warhol produced a portrait of Gardner Cowles as well (pl. 31). As was his usual practice starting around 1970, Warhol based this portrait on instant photographs he took with a Polaroid Big Shot (see pl. 30), and he incorporated the sitter's hands, as he often did in portraits of men.[106] In addition to this gendered signifier, Warhol included the newspaper to identify Cowles with his publishing business.

BLACK-AND-WHITE TRUTHS

Warhol spectacularly harnessed numerous call-to-action headlines in his black-and-white silkscreen paintings of the 1980s, beginning with his monumental triptych, *Fate Presto* (1981), literally translated from Italian as "hurry up" (pl. 33). This work took as its subject the front page of the daily paper from Naples, Italy, *Il Mattino* ("the Morning"), from November 26, 1980, urging a quick response to the human tragedy following a catastrophic earthquake in the Neapolitan region (p. 189, doc. 19). Naples-based art dealer Lucio Amelio had brought together a pantheon of artists, including Warhol, Joseph Beuys, and Cy Twombly, to create works relating to the disaster.

(Warhol had met Beuys a year earlier in Italy through Amelio and had also made a headline collage of the German artist; see pl. 32.) Commissioned by Amelio, who gave Warhol the copy of this newspaper, *Fate Presto* is the largest of all the artist's headline works. Each of three monumental canvases presents the original front page of *Il Mattino* in a different register: one positive with black text on an off-white ground; one ghost version with pure glossy white text and a sprinkling of "diamond dust" on a matte white ground; and one negative with black glossy text on a matte black ground. With *Fate Presto*, Warhol returned emphatically to his Death and Disaster headlines of the 1960s, though silkscreened here instead of hand-painted. Owing to this headline — and to Warhol's iconic work of art, which extended its life in the popular imagination — the expression "fate presto" has entered the Neapolitan vernacular as a plea for urgent social action.[107]

Fate Presto launched Warhol into other socially conscious tabloid headline paintings, likewise silkscreened, although significantly smaller in scale. *Daily News (Artist Could Have Been Choked)* (pl. 58) and *Daily News (Gimbels Anniversary Sale)* (pl. 59) again paired advertising — for the Gimbels department store — and news: of the death of twenty-five-year-old graffiti artist Michael Stewart, reportedly at the hands of police. Warhol's reason for making a painting of this particular page likely related to the disturbing story about Stewart, a friend of Warhol's friend and fellow artist Keith Haring. The work draws our attention to the strikingly, but not surprisingly, diminutive space allotted to the story of an individual's wrongful death relative to the large department store ad alongside it. In the latter painting, the silkscreen process registers such a degree of slippage that, except for the headline, the article's text is mostly illegible. Warhol also silkscreened this news page onto Mylar, crumpled it, then flattened it out to make a new work (pl. 60).

Another series of paintings from around 1983, all titled *New York Post (Judge Blasts Lynch)* (pls. 56, 57), derives from a headline of April 1, 1983, reading, "Judge Blasts 'Lynch Mob'" (see p. 190, doc. 22). The article highlighted the sentencing of the first among a group of white teenagers who beat a black transit worker to death in 1982. Yet Warhol cropped the word "mob" out of the image, leaving the reader to puzzle out the meaning. Once again, comparison to the original source expands our understanding. This work revisits the subject of Warhol's Race Riot paintings of 1963. Unlike the earlier series, however, his renderings of *Judge Blasts Lynch* combine the agonizing story with seemingly redemptive overtones, including a decorated egg at the top right and the caption "Act of Humility," referring to Pope John Paul's washing the feet of a twelve-year-old homeless boy in preparation for Easter (Warhol cropped out the image). In addition to the paintings, Warhol made prints of this work, intended as "holiday gifts" (pl. 55).[108]

17

FIG. 17 ANDY WARHOL,
AIDS/JEEP/BICYCLE, C. 1985,
ACRYLIC ON CANVAS, 294.6 x
457.2 CM, PINAKOTHEK DER
MODERNE, BAYERISCHE
STAATSGEMÄLDE-
SAMMLUNGEN, MUNICH

A third group of black-and-white paintings, also with a source from 1983, comprises three separate canvases: *New York Post, Front Page (Marine Death Toll)* (pl. 61), *New York Post, Page Two (Grim Marine Toll Hits)* (pl. 62), and *New York Post, Page Three (172 — Could Top 200)* (pl. 63). Based, as the titles make clear, on the first three consecutive pages of a *New York Post* edition (from October 24, 1983), these works go further toward fulfilling Warhol's avowed intent to make a work about every page of the newspaper. The traumatic story worthy of such extensive coverage was the terrorist attack on the U.S. Marine barracks and a building that housed French military forces in Beirut, Lebanon, on October 23, 1983.[109] As with the *Gimbels Anniversary Sale* painting mentioned earlier, Warhol screened the image from *Page Three* on Mylar and crumpled it, but this time he left it that way, turning it into a sculpture (pl. 64).

Warhol also took a number of black-and-white photographs treating the subject of the newspaper headline — in whole or in part, in or out of focus. In a self-portrait from around November 20, 1978, which shows the artist behind his cluttered desk in the third Factory location at 860 Broadway, he holds a copy of the *New York Post* with the headline "400 Die in Mass…," referring to the Jonestown, Guyana, mass murder/suicide. This is an early snapshot among a large group of works that chronicle Warhol's encounters with current headlines, which in turn are part of a surprisingly broad photographic enterprise. Between 1982 and 1987 Warhol shot more than 124,000 35mm frames[110] using a variety of compact automatic cameras that allowed him to capture a subject spontaneously and surreptitiously. With few exceptions, photography formed the basis of Warhol's art, yet he was not well known as a photographer at the time — except perhaps for his photo-booth strips taken in the 1960s (see pls. 17, 18). Those works include strips that feature writers Sandra Hochman and Donald Barthelme reading sensationalist news headlines (Hochman with *National Enquirer*'s "Killer I Hired Strangles My Husband," and Barthelme with *National Insider*'s "She's a He") that Warhol made for an article in the June 1963 issue of *Harper's Bazaar*, entitled "New Faces, New Forces, New Names in the Arts" (p. 184, doc. 12).

Warhol's photographs of headlines may be divided into categories: images that show newspapers inside vending boxes (pls. 42, 43, 46, 54), advertised on sandwich boards (pls. 52, 53), strewn about as detritus outdoors (pl. 40), scattered in interior settings (pls. 35, 39, 44, 50), and held by strangers (pls. 38, 41, 51). From these, Warhol selected a number of images (pls. 44, 46) to become more ambitious works, making either four or six large duplicate prints and sewing them together to form a grid (pls. 45, 47–49). These stitched photographs revisit Warhol's repetition of imagery in works from the 1960s, while literally puncturing the tradition of "straight," unmanipulated photography practiced by so many earlier twentieth-century masters.[111] They also create dizzying new stylistic realities that approach abstraction — quite a twist given the expectation that news photographs present objective truth.

Warhol's black-and-white photographs also document his travels, not only around New York but abroad, including trips to China in October 1982 (pl. 48) and London in July 1986 (pls. 52, 53). Together, these images demonstrate the ubiquity of newspapers in Warhol's daily life between 1978 and 1987, and they underscore the rippling effect the headlines played in society at large and in his personal circle. In one snapshot Warhol caught his longtime manager, Fred Hughes, on a couch with a newspaper (pl. 36), and in another, he pictured his one-time boyfriend, Jon Gould, reading a *New York Post* headline on the Capitol Hill sex scandal of 1982–1983 involving congressmen and their pages.

Gould was among many of Warhol's friends who died of AIDS-related causes in the mid-1980s (in September 1986), including Mario Amaya (in June 1986)[112] and Ted Carey (in August 1985). *AIDS/Jeep/Bicycle* is Warhol's only work to address the AIDS pandemic directly (fig. 17).[113] It takes its title from a headline in the *New York Post* of August 30, 1985, around the time of Carey's death. The truncated headline "AIDS Fu," a faintly rendered date, and a cropped masthead are all that appear from the original source. (A photocopy of the partial source in his archive reads vertically, "AIDS Furor / school board / with disease.") This joins a collage of hand-painted images of a Jeep advertisement from the *New York Post*, July 25, 1985, in green, along with a bicycle in blue.[114] The sober, faint, and fragmented banner and headline appear in black on the white ground. It is the most ghostly and personal of all Warhol's Death and Disaster headline paintings. For this work, he returned to his old practice and hand-painted the image on canvas.

POLYCHROMY: CELEBRATING MADONNA

Collaborations with the young up-and-coming artist Jean-Michel Basquiat brought the hand-painted headline image and significant color back into Warhol's art, energizing the fifty-six-year-old's practice. In two of their many paintings from 1984–1985 (pls. 69, 70), Warhol began the process: with the hand-painted headline, "Ailing Ali in Fight of Life," from the *New York Post* of September 19, 1984, in one work (see p. 191, doc. 24); and with "Plug Pulled on Coma Mom" from an unknown newspaper source in another work. Basquiat then "edited" Warhol, altering, painting over, and obscuring the lettering with several of his signature motifs, including the milk bottle and crown in the second work. In this game, which recalls the Dada exercise known as exquisite corpse, Basquiat had the "last word" — which suited both artists, by all accounts.

Artist Keith Haring, like Basquiat, was a "Warhol baby." Both belonged to a younger generation that venerated the artist they called "Papa Pop." Warhol, in turn, enjoyed the new ideas that emerged from working along-

18

headlines as a prelude to his art. In the public spaces of late-1970s New York he inscribed his pluralistic art on the surfaces of newspaper vending machines, architectural spaces, and in the subways.[117] His claim on public space owed much to Warhol's example. As Warhol wrote in 1975: "Before media there used to be a physical limit on how much space one person could take up by themselves…[but] with media you can sit back and let yourself fill up space on records, in the movies, most exclusively on the telephone and least exclusively on television….I always think that quantity is the best gauge on anything…so I set my sights on becoming a 'space artist.'"[118]

Warhol's strategy to fill space with his persona and his art achieved its triumph through television, which promoted his brand name and replicated the practice of the media. *Andy Warhol's T.V.* began on a cable access television channel, the regional Madison Square Garden Network, and featured artists, friends, and a variety of celebrities from the film, music, and fashion worlds. In one outtake of *Andy Warhol's T.V.*, Haring named Burroughs as a further inspiration for his headline works (see pl. 66), speaking of Burroughs as the spark for his first street interventions in 1979:

I was walking around…and we found this stack of *New York Post*s—at this time, most of the work I was doing then was with cutouts…by accident…. We were reading William Burroughs all the time, doing cut-ups all the time, so the first thing I did was take the seven headlines home and cut them up, all the words separately, and rearranged them to come up with about seven slogans: "Reagan Slain by Hero Cop," "Pope Killed for Freed Hostage," "Reagan's Death Cop Hunt Pope," in the *National Enquirer*…."Humiliation Victim" had a dog with a little cart with two wheels…. These things were Xeroxed and put back up on the street as handbills. I did it outside this one bar, and a guy came screaming out saying, "Someone shot Ronald Reagan!" I would put them on top of the little things they sell newspapers out of, right over the glass so people thought they were real headlines. A lot of them were destroyed pretty quickly, were gone fast. I put a lot of them up during the Democratic convention in New York. That was one of the first real effective things I did in the street as far as making people think [figs. 19, 20].[119]

side them. Haring wrote a text called "Painting the Third Mind" about Warhol's collaborations with Basquiat, describing their "mutually beneficial arrangement."[115] Its title refers to a book coauthored by the Beat writer William S. Burroughs and the artist/poet Brion Gysin in 1965, *The Third Mind*, which remained unpublished until 1978, the year Haring enrolled at the School of Visual Arts in New York City and likely read it. Burroughs and Gysin were known for their "cut-up" technique, literally cutting up myriad texts, many from the newspaper headlines, and reassembling them to form new narratives with unpredictable new meanings (fig. 18). "Painting the Third Mind," which describes a collage of ideas resulting from a collaboration of two entities, posits yet another triangular structure in Warhol's art near the end of his career.[116]

Like Warhol, Haring was born and raised in Pennsylvania and received his early art training in Pittsburgh before moving to New York, where he too seized upon

For Burroughs, the act of cutting up texts represented a release, an external action to which he assigned a temporal quality. In his words, "When you cut into the present, the future leaks out."[120] This applies nicely both to Haring's ephemeral interventions and to Warhol's cut-and-pastes of textual information in his headline works: they both operate against assigned, fixed meanings.[121]

Warhol and Haring invented their own cut-up project, making several headline paintings that featured their

FIG. 18 WILLIAM SEWARD BURROUGHS AND BRION GYSIN, *THE THIRD MIND (PRIMROSE PATH?)*, C. 1965, GELATIN SILVER PRINTS, TYPESCRIPT, NEWSPRINT, AND INK ON PAPER, 24 x 17 CM, LOS ANGELES COUNTY MUSEUM OF ART, LOS ANGELES. PURCHASED WITH FUNDS PROVIDED BY THE HIRO YAMAGATA FOUNDATION

FIGS. 19–20 KEITH HARING, *UNTITLED*, 1980, COLLECTION KEITH HARING FOUNDATION, NEW YORK

friend, the young singer Madonna, on the occasion of her marriage to actor Sean Penn in 1985. In Warhol's diary entry for Monday, August, 5, 1985, he noted: "And I want to do a Madonna headline—the *Post* one: 'MADONNA ON NUDE PIX—SO WHAT?'—and use a photograph of her from a different day that would fit right in, but Keith wants to use a photo *he* took of her and Sean Penn. Which is kind of grey. But I'll do it both ways. We're doing a painting together for her wedding present."[122]

The artists collaborated on a suite of at least six paintings: three based on the metro edition of the *New York Post* from Tuesday, July 9, 1985, picturing Madonna with the headline, "Madonna: 'I'm Not Ashamed'" (see pls. 71, 74, 75, and p. 192, doc. 25); and three from the final edi-

tion of the same newspaper on the same day with the headline, "Madonna on Nude Pix: So What!" (see pls. 72, 73, 76 and p. 193, doc. 26). A modified cut-up technique applies to the former work, where the artists cut the original image of a young woman out of the source[123] and replaced it with a silhouetted photograph of the engaged couple attributed to Haring, leaving the original caption, "Staying Cool," underneath (see p. 193, doc. 27). Like Warhol's *Princton Leader* drawing, the cut-up Madonna painting replaces the original subject with one known to Warhol. If Warhol's mimetic desire played any part in this work, it was for Madonna as a beautiful, youthful, rising star. As she ascended the pop music charts, she perfectly illustrated Burroughs's dictum about releasing the future. Her thank you note to Warhol said it all. Expressing gratitude for the gift of the paintings, Madonna wrote, "We're going to hang them…as a tribute to the newspaper that made our career."[124] She went on to use the headline "Madonna: 'I'm Not Ashamed'" in a backdrop for live concert performances in 1987.[125]

PATTERN RECOGNITION: ANTICIPATING JON STEWART AND STEPHEN COLBERT

The headlines Warhol highlighted over the course of his career fall into recognizable patterns. He chose stories not only for their immediacy and topical nature but also for their ability to transcend time. As McLuhan stressed, identifying patterns is crucial to survival and understanding in the face of information overload.[126] Warhol had the insight to seize upon stories in the 1950s that belong to patterns still familiar in the media today as reliable sellers.

Celebrity was an important theme in Warhol's headline works from the beginning. For example, he took a keen interest in the tragic figure of 1950s heartthrob crooner Eddie Fisher, making the early drawing *It's True Eddie* (pl. 12), the iconic *Daily News* painting depicting Fisher and Elizabeth Taylor in 1962 (pl. 15), and the silkscreen paintings titled *Men in Her Life*, also in 1962, showing Taylor, her then-husband Mike Todd, Fisher, and his then-wife Debbie Reynolds. Warhol clearly searched for just the right headlines relating to Fisher between December 1961 and November 1962, for he did not use all that he found. At least two other tabloids featuring Fisher reside in Warhol's Time Capsules, with the headlines "Eddie Fisher Tells How…They Tried to Tear This Dress Off of Liz" (front page of the *National Enquirer*, December 10–16, 1961) and "Eddie Flees Clinic, Press" (front page of *New York Mirror*, March 30, 1962). The second headline bears traces of black paint across the lower left side, indicating its likely presence in the artist's studio and the possibility that he considered it for his art. Additional Elizabeth Taylor headlines were also saved, such as: "Liz Taylor Tells…Her Most Shocking Physical Experience!!!" (front page of the *National Insider*, March 24, 1963).

Another of Warhol's headline obsessions (one that still confronts us in every supermarket checkout line) was celebrity births, among many subsets of the celebrity category. Warhol began tracking this theme with *It's True Eddie*, whose subheading reads, "We're going to have a baby! That's how Debbie broke the news to me, says crooner."[127] Another early drawing announces the impending birth of a child to Kay Spreckles and Clark Gable (fig. 21).[128] Royal babies were also clearly of interest to Warhol, given the number of works he made on that theme, including his first headline paintings, *A Boy for Meg [1]* and *A Boy for Meg [2]* (pls. 13, 14). And nearly fifty years later the cover of the *National Enquirer* from April 14, 2008, blared, "Baby for Jen! She's Adopting—and It's a Boy," a false report on star Jennifer Aniston; while an article on page 7 of the same issue, "It's a Boy for Gwen—No Doubt!" gave the rumored sex of the baby expected by star Gwen Stefani (which turned out to be true) (figs. 22, 23). This pattern continues, as we remain caught in the same media cycles as Warhol.[129]

Warhol also zeroed in on the shame associated with scandal. A still from Warhol's film *Allen* shows Allen Ginsberg holding a newspaper with the headline "I'm Not Ashamed" (see p. 50, fig. 4), concerning the scandal-prone actress Joan Collins. More than twenty years later the headline Warhol and Haring selected when nude pictures of Madonna emerged after she appeared on the cover of *Time* magazine (May 27, 1985) reads, "Madonna: 'I'm Not Ashamed'" (see p. 192, doc. 25). This pattern goes on as well, with Channing Tatum in February 2011 quoted in the *Daily Mail* as saying "I'm Not Ashamed of My Stripper Past."[130]

In the span of Warhol's own career, the demarcations between tabloids and mainstream news outlets became blurred, a trend that has accelerated into the present. Tabloids have enjoyed incremental increases in credibility, including the *National Enquirer,* which broke the major national news stories involving John Edwards's scandals in 2007 and 2008.[131] In an episode of Comedy Central's *Colbert Report* (August 17, 2010), satirical news host Stephen Colbert interviewed Barry Levine, executive director of the *National Enquirer*. Referring to the Edwards story, he asked Levine, with tongue in cheek, "Do you ever worry with this new credibility that you might be held to a new standard?" At the same time, mainstream news outlets add sensationalist tone and tactics to their reportage, compromising their truth and integrity. In July 2010 a major public furor erupted when Shirley Sherrod, an African American employee of the U.S. department of agriculture, was represented as racist by the airing of an excerpted, out-of-context video on Fox News and forced to resign from her job.[132]

FIG. 21 ANDY WARHOL,
UNTITLED, 1962, GRAPHITE
AND GOUACHE ON PAPER,
72.7 x 55.2 CM, WHITNEY
MUSEUM OF AMERICAN
ART, NEW YORK; PROMISED
GIFT OF EMILY FISHER
LANDAU, 2010

FIG. 22 COVER OF *NATIONAL
ENQUIRER*, APRIL 14, 2008

FIG. 23 PAGE 7 OF *NATIONAL
ENQUIRER*, APRIL 14, 2008

FIG. 24 COVER OF *NEW YORK
POST*, FEBRUARY 23, 1987,
THE ANDY WARHOL MUSEUM,
PITTSBURGH

Meanwhile, the genre of comedic, "fake" news programs, including the *Colbert Report* and Jon Stewart's *Daily Show*, strives to derail the media narratives.[133] They too have gained in credibility and access, owing in part to their availability via the Internet, as mainstream news outlets reference them with increasing frequency.[134] In the pilot program of the *Colbert Report* on October 17, 2005, Colbert introduced the term "truthiness" in his segment on language, *The Wørd*, meaning the "truth" a person claims to know intuitively "from the gut" without regard to evidence, logic, intellectual examination, or facts.[135] This term, coined originally to criticize political figures, has been extended logically to the media itself, largely through Colbert's usage.[136] Warhol somehow anticipated it all, and he lived it early on. Like the headlines that he defined through his art, Warhol surrounds us, "gets" us, and reflects us to this day.

Warhol would again become the subject of the headlines in 1987 when he died from complications after gallbladder surgery at the age of fifty-eight (fig. 24). Memorializing the artist, Mark Lancaster identified the impact Warhol had made in the television headlines:

In current television news programmes, a number of visual 'headlines' is presented, a moment before the subject of the 'headlines' is announced. If the image of a painting appears, it almost certainly means it has been sold for a high price or has been stolen. If the image of an artist, necessarily well known, appears, it almost certainly means that artist is dead. A photograph of Andy Warhol appeared as the last 'headline' of the BBC1 news at 6:25 p.m. on Sunday 23rd February 1987. The power of this image ironically made us know that Andy was dead a split-second before a voice said so.[137]

24

BREAKING IT DOWN: WARHOL'S NEWSPAPER ALLEGORIES

JOHN J. CURLEY

Andy Warhol saved newspapers. One of the earliest clippings in his vast Pittsburgh archive is a page from the *Pittsburgh Press* dated November 24, 1946. His reasons for saving it seem obvious: he had won an art prize while at Carnegie Tech (now Carnegie Mellon University), and the paper published a brief article about this on the second page of that day's edition along with two photographs, one featuring the artist and the other reproducing one of his drawings (fig. 1). For perhaps the first time, Warhol saw his name in print.[1] His gesture of preservation is not unique, of course. Before the digital era it was commonplace to save newspapers from personally important days (like this example) or those recording historic events such as the moon landing or President Kennedy's assassination. Warhol's newspaper page does have significance outside his own award; it features sixteen other stories, some alarmist ("Society Called an 'Insane Asylum' by Tech's Psychology Professor"), some tragic ("Metallurgist Shot While Hunting"), and others mundane ("Christmas Parade Saturday Morning"). The entire page is a frenetic field of activity from around Pittsburgh and the world. But Warhol's prominent visual position here is emblematic of his later work: an artist deeply embedded within the culture of the newspaper.

1

Warhol, however, went beyond saving newspapers. He also depicted them in paint. For example, his *Daily News* from mid-1962 (pl. 15) represents the unfolded and flattened front and back pages of the popular New York tabloid, its title adopted as the title of his painting. On the right, the headline "Eddie Fisher Breaks Down"—referring to the popular entertainer's nervous breakdown as his marriage to Elizabeth Taylor was ending—floats above Warhol's painted translation of a photograph of the couple from happier times. On the left half of the canvas, the artist painted the back page's sports headline and four ostensibly unrelated photographs. While the act of painting a newspaper is its own act of preservation, it also transcends the private and particular concerns of a lone individual putting aside a page of newsprint for posterity. Why would an artist in 1962 paint

FIG. 1 PAGE FROM THE *PITTS-BURGH PRESS*, NOVEMBER 24, 1946, FEATURING A PHOTO-GRAPH OF WARHOL AND A REPRODUCTION OF ONE OF HIS DRAWINGS, THE ANDY WARHOL MUSEUM, PITTS-BURGH; FOUNDING COLLEC-TION, CONTRIBUTION THE ANDY WARHOL FOUNDATION FOR THE VISUAL ARTS, INC.

FIG. 2 PAGE 93 OF THE *NEW YORK TIMES*, JANUARY 6, 1957, FEATURING I. MILLER ADVER-TISEMENT

the front and back pages of a tabloid on a canvas over eight feet wide and six feet tall? Why this particular day and this particular paper? What, if anything, does the work say about the state of painting in relation to the mass media and broader political issues?

As a work of art, *Daily News* communicates something beyond the specificity and topicality of its source pages. Yet exactly what it communicates remains a puzzle. Is it a readymade, a history painting, or some combination thereof? Whatever the answer, viewers are compelled to search for significance in Warhol's transformation of throwaway newsprint into a major painting. As such, *Daily News* enters into the realm of the allegorical. In traditional allegory, a specific set of representations signify something beyond what is immediately apparent. A skull in a still-life painting becomes a stand-in for human mortality, for instance. Warhol's headline paintings rethink allegory for the media age, locating interpretive meaning within the disposable and cheap form of the newspaper. They also explore allegory beyond its traditional notions and suggest, following Walter Benjamin's argument, its inadequacy.[2] In other words, Warhol's headline paintings dramatize the attempts — and subsequent failures — of both contemporary painting and the mass media to structure or give narrative to everyday life.

This essay addresses two aspects of this allegorical understanding of *Daily News* and other examples of Warhol's headline works from the early 1960s. First, it considers how Warhol analyzes the visual mechanics of the newspaper page and the ways its various sections interact to create meaning outside of individual components — a perspective gleaned from his commercial experience in the 1950s. Second, the photographs in the headline paintings call attention to a paradox in print media: despite the fact that such images were expected to represent unproblematic "truth," they were often visually ambiguous or otherwise misleading. Warhol mediated this contradiction directly in his allegorical, painted transformations of photography in the headline works of 1960 – 1962, setting the stage for his turn to the photo-silkscreen process in the second half of 1962. The headline works from this period, then, are a fulcrum in Warhol's career. They allowed him to explore the artistic ramifications of his commercial work while also pointing toward his signature photomechanical technique. Both of these allegorical aspects extend to questioning the relation between artistic practice and topical politics. What, if anything, can these works reveal about painting's relationship to momentous events of the period like the Cold War?

2

GOOD NEWS, BAD NEWS

Warhol's drawings and paintings based on newspaper pages derived from his long engagement with New York dailies dating back to the 1950s. The artist had moved to New York City to pursue a career in commercial art after graduating from Carnegie Tech in 1949 with a degree in pictorial design, a hybrid of fine arts and industrial design training. Warhol achieved great success in this regard, and his work was soon in high demand.[3] In 1955 the upscale shoemaker I. Miller & Sons hired him to refine and make over the company's timeworn image, commissioning him to create advertisements that would be "the freshest and newest thing in the newspapers," to quote the I. Miller art director in 1956.[4] The assignment turned out to be Warhol's most sustained and successful client relationship. His award-winning drawings had tremendous visibility — each reproduced more than a million times — as they appeared regularly in the Sunday edition of the *New York Times*.[5] An example from January 1957 is typical of the campaign, with its half-page format featuring Warhol's distinctive style of a broken, faint contour — known as his "blotted line" (fig. 2). The placement in this example is also typical: below the photographs and reports of that particular week's socialite engagements and weddings. This context was vital for meaning, as the wealthy brides helped to elevate the status of his drawn shoes.[6]

Before finding a home within the society pages, however, Warhol's I. Miller advertisements were sometimes located alongside more traditional news. In one example from 1955, his blotted-line drawing was published next to an article titled "6 Die as Bus Hits Stalled Truck" (fig. 3). On this page the advertisement was a distraction to the news, minimizing a violent event through the promise of consumption. About a decade later Marshall McLuhan would ponder this relationship of advertisements and editorial content on the newspaper page: "Ads are *news*. What is wrong with them is that they are always *good* news. In order to balance off the effect and to sell good news, it is necessary to have a lot of bad news."[7] Advertisements, for McLuhan, depended on catastrophe for their power. Of course, they could also work *with* editorial content — one reinforcing the other — as did the majority of Warhol's I. Miller advertisements found in the society pages.[8] Either way, Warhol's shoe drawings in the *New York Times* stressed the interdependence of advertisements and editorial content. Despite their separation, the respective components of a newspaper combined to create additional meanings.

While in the midst of working on the I. Miller campaign and other newspaper assignments in late 1958, Warhol saved an example of "bad news" from a front page of the Hearst-owned *New York Journal American*, which he eventually copied in a 1960 drawing (pl. 4).[9] Warhol's clumsy rendition recaps that violent and eventful day: the stabbing of Martin Luther King Jr. ("Woman Stabs Rev. King in Harlem") and rising Cold War tensions ("Ike Blasts 'Abusive' Soviet Note") both dominated the headlines here.[10] Considering his commercial newspaper work in 1958, it is remarkable that he saved this page and then chose to draw it once his concerns turned toward representations of popular subject matter. These actions suggest two things about Warhol's insights into newspapers

around 1960. First, he understood the interrelationships among the various components of a newspaper page. By drawing such a page in ink, Warhol could view it compositionally and emphasize its formal, gridlike structure — that is, how its parts fit together and function visually in a page layout. Like the blotches in a late Cézanne landscape, the distinct, individual components of a newspaper page can demand and relinquish attention. Each is part of a larger matrix, but each can also assert its own identity, similar to the way Warhol's I. Miller drawings related to the full newspaper page. Second, this drawing dramatizes the artist's awareness of the relationship between his commercial work in newspapers and larger social and political events; a stabbing and the Cold War's nuclear anxiety were the dialectical foil to his elegant shoes. If this *Journal American* page shows headlines, Warhol's I. Miller advertisements might be described as "counter-headlines." Instead of efficiently delivering prominent news content, they distracted and encouraged an individual consumer's desire. Warhol's artistic efforts around 1960 revealed a newfound aim to make these ideas a formal theme in the realm of high art.

While Warhol had one-person shows in the 1950s in small art galleries that showcased the same languid, decorative style of his commercial art, he switched gears in 1960 and attempted to break into the more rarefied New York art world occupied by the likes of Robert Rauschenberg and Jasper Johns. But he did so by using the already familiar techniques and subject matter of commercial art.[11] Whatever Warhol's motivations may have been — a desire for fame, a critical rejoinder to his commercial work, or a combination — this new world afforded the artist some distance from which he could dispassionately observe his commercial surroundings, including the daily newspaper.[12] His first works in the pop vernacular were painted copies of newspaper advertisements and comic strips, complete with brash flourishes and sloppy drips redolent of abstract expressionism and Rauschenberg's combine paintings. Considering their newsprint origins, these paintings must be viewed as a response to Warhol's own I. Miller work.[13]

If the I. Miller advertisements exuded an effortless elegance and refinement achieved through Warhol's blotted-line technique and generous use of white space, then these early, clumsy, pop paintings are the visual antithesis. The differences extend to the source material — often the minuscule advertisements found in the margins of tabloids like the *Daily News* and the *National Enquirer*. To an even greater degree than his work for I. Miller, a painting like the first version of *Before and After* from 1961 (fig. 4) suggests the notion of counter-headlines. Headlines demand to be seen, but the tiny ads that were his source nearly disappear into the background. Through increased scale (*Before and After [1]* is almost six feet tall), Warhol brought mass media marginalia into visibility, thus calling attention to overlooked, perhaps even subliminal, aspects of the newspaper page.

FIG. 3 PAGE FROM THE *NEW YORK TIMES*, OCTOBER 16, 1955, FEATURING I. MILLER ADVERTISEMENT, THE ANDY WARHOL MUSEUM, PITTSBURGH; FOUNDING COLLECTION, CONTRIBUTION THE ANDY WARHOL FOUNDATION FOR THE VISUAL ARTS, INC.

FIG. 4 ANDY WARHOL, *BEFORE AND AFTER [1]*, 1961, SHIVA CASEIN ON PREPRIMED COTTON DUCK, 172.7 x 137.2 CM, THE METROPOLITAN MUSEUM OF ART, NEW YORK. GIFT OF HALSTON, 1981

FIG. 5 PABLO PICASSO, *GUERNICA* (DETAIL), 1937, OIL ON CANVAS, MUSEO NACIONAL CENTRO DE ARTE REINA SOFIA, MADRID

Daily News (1962) is among Warhol's largest painted treatments of this theme. Here, the artist explored the connection between the central and marginal in a single image, demonstrating that the sensational front page is physically part of the back page in the popular tabloid form. This back page is both outside and inside, both minor and compulsory—not the object of immediate focus, but still essential to the front headline's very existence. Warhol, however, was no mere formalist investigating the structural layout of a newspaper in *Daily News*. He was also interested in how the content on both pages was distinct yet related. The physically adjacent pages here could also suggest mental connections between areas usually considered in isolation, not unlike the relationship of an I. Miller advertisement to a bus crash. Confronted with the painting, viewers might try to link the Elizabeth Taylor cover story (about the actress leaving Eddie Fisher, her fourth husband, for Richard Burton, her fifth) with the captionless images on the back: a child in a wheelchair, what appears to be an important diplomatic negotiation (it was actually Egypt's president Gamal Abdel Nasser with boxer Floyd Patterson), and a strikingly foreshortened horse's head with the mouth open wide, vividly recalling Picasso's terrified equine figure in *Guernica* (fig. 5).[14]

These back page images suggest a pervading uneasiness, an anxiety connected to, yet separated from, the voyeuristic cover story. Eddie Fisher's travails became an allegorical displacement for the anxiety intimated on the back page and reported explicitly throughout the tabloid. Inside this particular issue were stories about a violent labor strike in Warhol's native Pittsburgh and the continuing trial of the captured Nazi Adolf Eichmann in

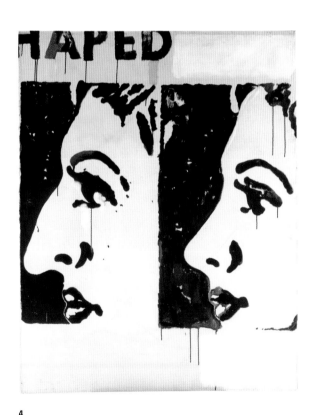

Jerusalem.[15] The breakdown referred to on the front page, in other words, might also be construed as both societal and semiotic: the former in terms of a celebrity breakup taking precedence over more weighty concerns, and the latter because of the disjunction between the canvas's two halves. By considering a newspaper against the grain—flattening it out and taking in its various images and text as one afocal field—Warhol acknowledged larger social anxieties and a public means of repressing them through celebrity gossip.[16]

Many other such "breakdowns" survive in Warhol's Pittsburgh archives. The artist often tore articles from newspapers and magazines, going out of his way to keep adjacent advertisements visible. For example, he salvaged an undated article with the headline "Pizza Eater Slain at Store," taking care to include the advertisement featuring a woman's leg adorned with a lace-up boot (fig. 6)—perhaps a nod back to his own history of marketing footwear. These clippings became readymade collages that posited connections across newspaper borders, here linking consumerism with death. Warhol returned to these themes with enthusiasm in his late work. For instance, the two paintings *Daily News (Artist Could Have Been Choked)* and *Daily News (Gimbels Anniversary Sale)* from about 1983 (pls. 58, 59) juxtapose news of an attack on an artist and a nuclear protest with a laundry list of discounts at a Gimbels department store sale. Although the image was silkscreened, Warhol nevertheless continued to explore the ways in which advertising and disturbing editorial content work both together and in opposition on the printed page. These 1983 examples are especially poignant after the 1968 attempt on Warhol's life. Was his shooting the McLuhan-esque "bad news" that sold products on that fateful day?

The broad visual consideration across the newspaper surface evident in Warhol's *Daily News* of 1962 derives, in part, from the artist's commercial art training. The breakdown literally written into the headline can narra-

6

tivize the eroding of section or page borders. Yet this breaking down can also be construed as *artistic* in nature, as the painting addresses period discussions of contemporary art as well, showing—however stealthily—the overlap of an accepted critical understanding of painted space and lowly newspaper space. That is, Warhol's *Daily News* locates similar formal impulses in both high modernism and the mass media.

In 1960 Clement Greenberg still dominated the New York art world, despite an increasing backlash.[17] When he began writing criticism in the late 1930s, he was a socialist who noted the radical implications of an avant-garde art that conceived itself as isolated from the mass diversions of the population, which he called "kitsch."[18] Greenberg advocated art that investigated its own formal properties and thus kept its distance from narrative and the sensational strategies of cheap magazines and tabloids.[19] Although his politics had become increasingly conservative and anti-Communist in the 1950s, his proscriptions for a hermetic art remained unchanged.[20] Greenberg celebrated paintings that emphasized the flatness and marked the limits of the canvas with an allover, antihierarchal deployment of pigment. Interventions by Johns and Rauschenberg in the middle to late 1950s called the critic's restrictions into question—finding flatness in everyday forms like an American flag (Johns) and exposing connections between gestural brushstrokes and everyday scraps like newspapers (Rauschenberg). Despite these reprisals, Greenberg was still a major force in American art circles in the early 1960s.

Greenberg's criticism became more flexible at this time with the introduction of "opticality" (canvases that could maintain their status as painting while playing tricks with perception), but pictorial flatness and an allover treatment of surface remained the hallmarks of his criticism.[21] Warhol's headline works, considering their own formal properties, engage this modernist discourse. While examples like *A Boy for Meg [2]* or *129 Die in Jet* (pls. 14, 16) register the flatness of the newspaper page, *Daily News* emphasizes it further by canceling the shallow

depth implied by the folding of front over back cover that is depicted in other newspaper paintings. And by placing important visual information across the entire surface, including two large headlines, *Daily News* participates in that allover, afocal quality so vital to Greenberg. Perceptive critics at this time recognized Warhol's modernist strategies, noting that his work from the early 1960s, behind its smokescreen of vulgar subject matter, took abstract expressionist painting seriously.[22] Thus, *Daily News* conflated high-minded ideas of abstract painting and a frivolous headline, finding this combination in a mass media form, readymade. As such, the painting not only shows Eddie Fisher's breakdown and the others to which I have referred but also breaks down the separation between high and low culture. Going further, *Daily News* can demonstrate the ways that Greenberg's ideals, when adapted to a newspaper, can call attention to the perceptual mechanics of the mass media. Read afocally, the newspaper page becomes a constellation in which new meanings are forged allegorically through combinations. In 1966 Warhol and David Dalton's fantastical newspaper design for the small journal *Aspen* made such ideas explicit (pl. 24).[23] Their newspaper page collaged and piled together comics, stock prices, grocery store advertisements, and numerous references to Cold War anxiety. The same ideas, albeit more sublimated, structure *Daily News*.

ABSTRACTION IN PHOTOGRAPHY

Daily News is instructive in another way as well: its "breakdown" also reveals Warhol's understanding of photography. His copying of newspaper photographs by hand played a decisive part in his shift to the silkscreen process in mid-1962. As is clear in his *Journal American* drawing, Warhol dismantled photographic language into something akin to a schematic diagram: a series of lines that dramatically lessened the medium's usual iconic clarity. By manually reproducing these low-quality newspaper photographs, Warhol showed that he understood that ambiguity—even abstraction—could reside within photography. Considering the persuasive ideological work that such press photographs were often called upon to perform, Warhol's headline paintings highlight the political repercussions of this published illegibility. That he created these works during some of the hottest years of the Cold War only adds to their urgency: as the conflict was partly a battle of images, with each ideological side attempting to manage perception relative to more complex realities, photography was one of the Cold War's most crucial battlegrounds.[24] An ambiguous photograph could be a dangerous thing.

A second look at the main photograph in *Daily News*—the one with Eddie Fisher and Liz Taylor—reveals such uncertainty. Warhol's painted copy of the photograph on the front page lacks the medium's usual sharpness. The facial features of the couple, and especially Fisher's ear, are more schematic than mimetic; Warhol

FIG. 6 "PIZZA EATER SLAIN AT STORE," CLIPPING FROM ANDY WARHOL ARCHIVES, DATE UNKNOWN, *TIME CAPSULE 21*, THE ANDY WARHOL MUSEUM, PITTSBURGH; FOUNDING COLLECTION, CONTRIBUTION THE ANDY WARHOL FOUNDATION FOR THE VISUAL ARTS, INC.

FIG. 7 LARRY POONS, *DAY ON A COLD MOUNTAIN*, 1962, SYNTHETIC POLYMER, PENCIL, AND FABRIC DYE ON LINEN, 203.2 x 203 CM, HIRSHHORN MUSEUM AND SCULPTURE GARDEN, SMITHSONIAN INSTITUTION, GIFT OF JOSEPH H. HIRSHHORN, 1966

FIG. 8 FRANK STELLA, *POINT OF PINES*, 1959, ENAMEL ON CANVAS, 215.27 x 277.18 CM, COLLECTION OF THE ARTIST

FIG. 9 FRANK STELLA, *SABINE PASS*, 1962, ALKYD ON CANVAS, 30.5 x 30.5 CM, BROOKLYN MUSEUM, GIFT OF ANDY WARHOL 72.167.2

translates photography's language of graduated tones into something more linear, more handmade.[25] Furthermore, the photograph does not correspond to the headline: it depicts Eddie and Liz together in the past, when in reality, as the headline states, the former was in a New York hospital recovering, and the latter was in Rome (with Richard Burton). The page presents something like a "before-and-after" construction (not unlike the painting of this name; see fig. 4), with the headline referring to the present and the photograph registering what Fisher had lost. Warhol's omission of the caption to this photograph in the final painting—which is clearly visible in the original newspaper source (p. 182, doc. 9)—only heightens the disjunction between the large text and the single image.[26]

Roland Barthes in his groundbreaking essay "The Photographic Message" from 1961 (not published in English until 1977) located a degree of semiotic confusion and abstraction in photographs, especially press photographs.[27] He discussed the essential function of captions and the ways in which they situate and naturalize the photographic message. This linguistic control of the image, then, compensated for the image's inherent ambiguity. Warhol may not have known Barthes's writing, but he certainly understood from his days working in commercial art the importance of captions in directing the interpretation of images; his often ambiguous I. Miller drawings each featured a caption that delivered the sales pitch. In fact, for *Daily News* Warhol initially penciled in parts of all the captions from the original newspaper page, but he later painted over them—calling attention to the omission with an additional layer of now-yellowing pigment.[28] He intentionally chose, therefore, to leave these captions out of the final work of art. Without such interpretive control, the photographs in *Daily News* can each assume greater allegorical significance.[29] Erasing or overpainting a caption liberates an image, allowing it to absorb other meanings. In this system Warhol's painted horse, without a linguistic identifier, could more readily convey a sense of *Guernica*-like anxiety, wrenching it away from its original connotations of horse racing.[30]

Thus freed, these anchorless images can take on properties often associated with abstract painting. Warhol's shallow rendition of the decorative pompoms on Liz's sweater flatten the space, perhaps in dialogue with the contemporary spotted canvases by Larry Poons, such as his *Day on a Cold Mountain* of 1962 (fig. 7).[31] But an even more obvious reference to popular painted abstraction resides within *Daily News*'s central image: the diagonal stripes behind the couple are a clear quotation from period paintings by Frank Stella, like *Point of Pines* from 1959 (fig. 8). Not only had Stella's striped paintings been well known in New York art circles ever since his black paintings appeared in the Museum of Modern Art's *16 Americans* exhibition in December 1959, but Warhol himself had visited Stella's studio on a number of occasions,

including a stop on March 22, 1962, just a week before the publication of the source issue for his *Daily News* canvas.[32] Warhol's keen interest in Stella is confirmed by his purchase, that same year, of miniaturized versions of six paintings from the latter's Benjamin Moore series, including *Sabine Pass* (fig. 9).[33]

It is essential to note that Warhol did not artificially add Stella-esque stripes to his painted version of the photograph but found them, again readymade, in the original newspaper image. His canvas emphasizes its own flatness—that much-discussed and

lauded trait of Greenbergian painting—and also contains a specific reference to Stella's abstraction.[34] This detail in the published photograph was perhaps another contributing factor in Warhol's decision to paint this particular front page.

This unmistakable allusion to Stella in Warhol's *Daily News* begs an important question: what was Warhol suggesting about the relationship between newspaper photography and abstract painting? Photography has historically had a tendentious relationship to newsprint. Before the development and widespread use of the mechanical halftone process, photographs were manually copied by engravers for printing—maintaining an illusory indexical connection to the original photograph while still clearly tied to the human hand. American Civil War photographs were published in this way in the 1860s, for instance. And even when fully mechanical (halftone printing became standard around 1900), the picture quality was at best slightly blurry, at worst nearly unintelligible.[35] Early examples of such printing often carried a significant disclaimer that highlighted its mediated, subjective nature: "halftone plate engraved by [name]."[36] The process improved throughout the twentieth century, which is evident in the source for Warhol's *Daily News*. The original halftone is legible, despite the flattening and generalization of the image.

This clarity far exceeded that of more time-critical images transmitted over a long distance during this period through telephone wire, a method known as the "wirephoto" or "radiophoto." This technology had been around since the turn of the century, enabling images to be sent around the world nearly as fast as text.[37] The process came into its own for picture-starved newspaper readers during World War II and was in use until the digital revolutions of the early 1990s. Basically, a photograph was placed around a cylinder, spun, and read line by line, breaking each narrow horizontal strip into a large number of regularized bits, like a grid. The equipment would then transmit the tonal value of each pixel sequentially, requiring a machine at another newspaper to reconstitute the traditional pictorial language. Wirephotos, therefore, depended on a process of translation: from image to code back to image, or, to put it another way, from representation to abstraction back into representation.

Wirephotos provided quick and efficient images for newspaper publication in an increasingly globalized world, a place where topicality and immediacy outweighed legibility, but their pictorial quality was far from ideal. Something literally was lost in translation, and period editors often complained about the poor resolution of wirephotos.[38] As McLuhan suggested in *Understanding Media*: "The individual news item is very low in information, and requires completion or fill-in by the reader, exactly as does the TV image, or *the wirephoto*" (italics mine).[39] Along these lines, photo editors often manually touched up these photographs with pen and india ink and with ink washes in order to clarify essential information before publication.[40] Indeed, many news photographs were fundamentally ambiguous without such linguistic or artistic intervention.

The Associated Press's first transmitted photograph in 1935 depicted a plane crash in the Adirondack Mountains; such disasters demanded pictorial immediacy.[41] It should not be surprising that the source photograph of the plane crash in Warhol's headline painting *129 Die in Jet* (1962) was also a wirephoto, published on the front page of the *New York Mirror* on June 4, 1962 (p. 183, doc. 10). Warhol explicitly marked this technology of image transmission in the painting by copying an original part of the caption just below his hand-painted rendition of the photograph: "(UPI RADIOTELEphoto)," United Press International's branding of the wirephoto process (fig. 10). When compared with the source, it becomes clear that Warhol consciously erased the narrative aspects of the text, leaving only this part of the credit line. With this partial caption, then, Warhol emphasized the transmitted nature of the photograph.[42]

Following the visual limitations of wirephotos, Warhol's painted copy of this image is considerably more blurry and atmospheric than those in his other headline paintings; one need only compare it with the primary image in *Daily News*. Without its anchoring headline, viewers might have difficulty interpreting the picture as the remains of a jet. Instead of displaying linear elements, Warhol composed the image in *129 Die in Jet* more through gradations.[43] The figures and wreckage are simply blocked out in black and deep shades of gray. This tonal articulation is also evident in the bottom left corner of the painted version of the photograph, where Warhol applied paint with something like a sponge.[44] The crispness of detail often associated with photography is nowhere to be seen here. In fact, the washed gray surface recalls examples of some American abstraction, evoking an early Barnett Newman painting like *Death of Euclid*, 1947 (fig. 11), or Jasper Johns's contemporaneous fields of monochromatic gray. Instead of literally finding an abstract painting in a news photograph, as in *Daily*

10

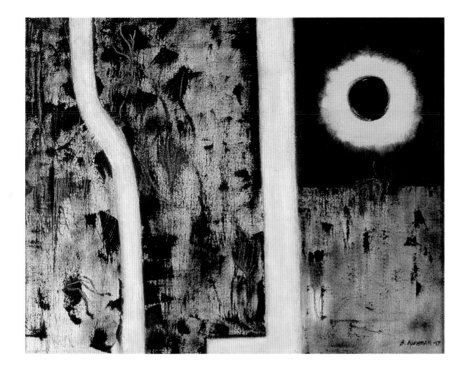

News's reference to Stella, Warhol here used a readymade image — already blurred — to suggest further links between high modernist abstraction and press photography. He recognized that designations of abstraction and figuration lie on a continuum, especially with regard to mass media images. Thus, *129 Die in Jet* erodes another binary that defined Greenberg's criticism as well as artistic practice more broadly during the Cold War: abstract painting in the capitalist West and figuration in the socialist East.

By conflating abstract painting and newspaper photography, Warhol's painted intervention works on at least two levels. Not only did he again locate avantgarde visual tropes in the mass media, but he also called into question the reliability of the newspaper photograph — or at least impelled viewers to look more closely at such photographs. This was especially important when ambiguous images carried potentially devastating political consequences. The aerial images that spurred the Cuban Missile Crisis — impossible for an average reader to interpret without captions — emerged just a couple of months after Warhol's *129 Die in Jet*.[45] In 1950 Jackson Pollock argued that his drip paintings, which became the emblematic art of the postwar period, were appropriate for the modern age of "the airplane, the atom bomb, the radio."[46] In other words, how could traditional representational practices capture a world of supersonic mobility, invisible waves, and instantaneous destruction? Warhol proved Pollock right, in one sense. These new times did require abstraction, but Warhol located it — readymade and structurally intact — within the reproductive technologies that constructed and narrated contemporary history. Abstraction in *129 Die in Jet* is decidedly not the result of artistic expression and agency, as it is in Pollock's work. The air crash in Paris, which was a result of chance (that is, an accident), produced an ambiguous

image in New York that reflects new technologies of transportation and image making.[47] As the worst single-plane, civil air disaster to that date, this subject was an appropriate choice for Warhol to use in registering visual and societal contingencies.[48]

While *129 Die in Jet* is an "art disaster" — that is, a painting about a disaster — the work also fits this description in another way. More than 100 of the 129 passengers (eventually 130) to die on the flight were members of the Atlanta Art Association, returning home from visiting art museums throughout Europe — a kind of Grand Tour for the jet age.[49] Much of the disaster's coverage in the American press emphasized this group, which was a coherent center for grief, to be sure.[50] This art-disaster aspect of the crash was not intimated in Warhol's rendition of the front page of the *New York Mirror*, but might this context tell us something further about the work? With the transatlantic transmission of images — like the cover wirephoto — why take people to works of art when the works themselves could make the trip, whether by phone line, art magazine, or jet plane?[51] Can one consider Warhol's painting to be about these very issues of image transmission? His silkscreen copies of the *Mona Lisa* in the wake of its late 1962 visit to America from Paris would assume a new aspect in this regard — especially *Colored Mona Lisa*, which, according to Nan Rosenthal, "looks like an early proof from a high-speed press" (fig. 12).[52] What if the plane carrying the real *Mona Lisa* from Paris had crashed? Would it matter?

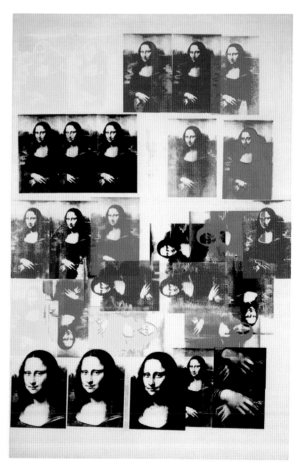

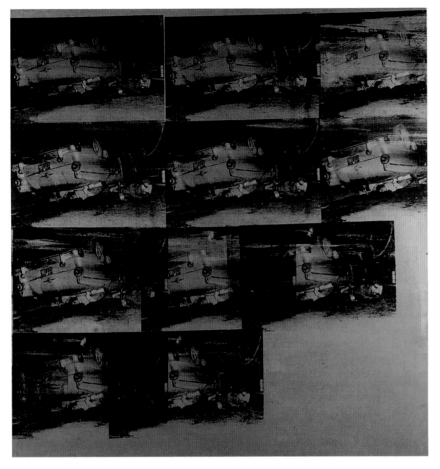

13

and sponging emphasized the wirephoto qualities in *129 Die in Jet*. Both paintings require viewers to look through a kind of translucent screen to see the image, calling attention not only to its mediation but also to the interpretative mysteries this sometimes engenders. With the silkscreen, however, Warhol could recreate the abstraction located within the reprinted press photograph — but do so through a means that artistically, or symbolically, approximated the mechanical and repetitive nature of the mass press. In other words, abstraction and ambiguity were inherent to the replication process itself.

Furthermore, Warhol's own transmission apparatus — the silkscreen — was not dissimilar to the wirephoto process, at least in terms of how each broke the photograph into a grid for easy mechanical replication. As the negative of a copied photograph was printed onto the silkscreen in a gluelike substance, each small, regularized opening in the fabric was either open or closed, creating a semblance of the original image when ink was forced through. As its own process of transmission, the very act of a newspaper's replication of images became an inspiration for one of Warhol's most radical and influential artistic practices.

Along these lines, many of Warhol's source images for the so-called Death and Disaster silkscreens of late 1962 and the first half of 1963 are from the artist's own collection of photographs, which were the actual sources for publication, likely from the files of a defunct newspaper.[56] This press context is clear looking at the source for *Orange Car Crash (5 Deaths 11 Times in Orange)* (fig. 14), as the attached caption provides facts and explains its newsworthiness. Considering the similarities between Warhol's process and the press's own process for printing transmitted photographs, might one argue that Warhol

It goes without saying that *129 Die in Jet* records a specific moment in history. As such, it and other headline paintings constitute a kind of history painting — but a history painting for the age of media transmission.[53] Instead of articulating and forging a shared set of values for a large public attending an exhibition, like the French Salon, Warhol's paintings demonstrate the ways that the medium had been, in some ways, usurped by the mass media.[54] By painting a wirephoto, and thus highlighting its inherent semiotic difficulty, Warhol revealed the fragility of a consensus built through pictorial ambiguity. Images could not manage and keep at bay emerging social and ideological contradictions; a blurred image could hint at broader ideas of uncertainty and doubt. Warhol's imperfect renditions of photographs thus symbolically muddled Cold War certainty, anticipating the battle over representations in the press that fueled protests in 1968 across the United States and Europe.[55] By the end of the decade, images of atrocities, whether committed by American forces in Vietnam or by the Soviet army in Prague, exposed the ideological bankruptcy of the each side's promises.

The blurred, sponge-painted surface of *129 Die in Jet* was a mere prelude to Warhol's more direct exploration of photography and abstraction: his turn to silkscreening in the summer of 1962. In a painting like *Orange Car Crash (5 Deaths 11 Times in Orange)* (fig. 13), Warhol focused on the reproduced or transmitted status of the image, in much the same way that his hand-painted blurs

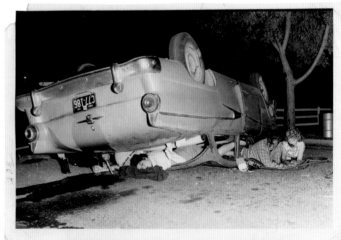

14

FIG. 13 ANDY WARHOL, *ORANGE CAR CRASH (5 DEATHS 11 TIMES IN ORANGE),* 1963, ACRYLIC AND SILKSCREEN INK ON LINEN, 219.7 × 208.9 CM, GALLERIA D'ARTE MODERNA, TURIN

FIG. 14 PRESS PHOTOGRAPH, SOURCE FOR *ORANGE CAR CRASH (5 DEATHS 11 TIMES IN ORANGE),* THE ANDY WARHOL MUSEUM, PITTSBURGH; FOUNDING COLLECTION, CONTRIBUTION THE ANDY WARHOL FOUNDATION FOR THE VISUAL ARTS, INC.

was, in some senses, operating his own counter-media? This might explain why he altered the original caption when titling related paintings, increasing the carnage from two deaths to five. In addition, many images Warhol chose to silkscreen were too graphic or explicit for mainstream newspapers, again suggesting his operation as an underground, guerrilla press.

Warhol heightened the underlying ambiguity in press photography, exploring and exposing its indeterminacy. In so doing, he raised important concerns about allegory as an interpretive mode. The legibility of an allegory depends on the narrative certainty of substitution: one thing stands in for another. Walter Benjamin studied the way in which these substitutions, however, were always uncertain and incomplete. For the critic, the mode was inherently unstable, full of representational ambiguity.[57] Warhol's imperfect copies of photographs — their own loss emphasized through painted transmission — likewise speak to allegory's uncertainty. His headline and silkscreen paintings substitute questions for what are usually understood as answers, trading notions of photographic truth for the ambiguity of semi-abstraction. These works, then, not only address the allegorical potential of newspapers but also the inability of images more broadly — their "breakdown" — to conceptualize social experience, be they photographs or paintings.

WARHOL AS HEADLINE

In paintings like *Daily News* and *129 Die in Jet* Warhol examined the ways in which the terms of modernist painting overlapped with the visual forms of the mass media. In other words, the tenets of high modernism were also operative in the form of the newspaper. Whether literalizing flatness or the ways abstraction is inherent in photographs, Warhol's headline paintings transcend their immediate, throwaway status. Painting these pages and transforming ephemeral newsprint into a work of art allows viewers to *interpret* the contents, locating allegorical content within the realm of mass cultural materials. Warhol not only dismantled the separation of high and low but also demonstrated that the lessons of modernism could actually reveal much when applied to the operations of mass culture.

I introduced this essay with coverage of Warhol in a 1946 issue of the *Pittsburgh Post*, highlighting the page's virtual collage of unrelated articles. But this artifact is also instructive as an early example of what happened when Warhol appeared in the mass press himself: *he* could become the headlines. Starting at the end of 1962, Warhol began receiving significant national press attention,[58] and his profile and media presence continued to increase over the next twenty-five years, peaking in the aftermath of his 1968 shooting and 1987 death.

In some ways, the headline paintings became unnecessary as Warhol's own media profile increased. Moving from the anonymous margins of advertising to the mainstream, even launching his own *Interview* magazine in 1969, Warhol-as-headline could directly address the relationship between art and a culture of celebrity distraction, commerce, and the mass media. This reversal recalls another of Walter Benjamin's works, "The Author as Producer." In the name of transforming the media apparatus, Benjamin challenged his "author" to enter the realm of production — that is, the mass press — abandoning a position of critical distance.[59] Of course, Warhol's "producer" had none of Benjamin's dogmatic Marxist proscriptions of liberating the capitalist mass media. Nevertheless, Warhol's press ubiquity continued an investigation, albeit from a different perspective, of the relationship between important historical events and his own artistic practice. In his memoir of the 1960s, *POPism*, Warhol recognized this shift: "As I've said, I was the headline of the *New York Daily News* — 'ACTRESS SHOOTS ANDY WARHOL' — six years to the day from the June 4, 1962, '129 DIE IN JET' disaster headline that I'd silkscreened for my painting [*sic*]. The picture on the front page of the June 4, 1968, final was of Valerie in custody, holding a copy of the day's early edition in her hand. The caption quoted her correcting, 'I'm a writer, not an actress.'"[60] The way Warhol describes it, the actual front page was like one of his headline paintings, admitting its own ambiguity — with its photo caption "correcting" the headline.

In the 1980s Warhol resumed his headline paintings, and they began to register his fame. The mention of an artist in trouble in *Daily News (Artist Could Have Been Choked)* from about 1983 (pl. 58) likely referred to a surrogate self; it also mapped out the connections among a media-worthy artist, a department store advertisement, and an article about a protest against nuclear weapons. Warhol silkscreened another newspaper front page around 1983, *New York Post, Front Page (Marine Death Toll)* (pl. 61). News of a car crash that killed TV news anchor Jessica Savitch appeared above the massive headline about the deadly bombing of the Marine barracks in Beirut, the largest, single-day military loss of American life since the Vietnam War.[61] Warhol's choice to silkscreen pages 2 and 3 of the paper on separate canvases (pls. 62, 63), pages that further detailed the carnage of the bombing, turned the announcement of Savitch's death into a kind of counter-headline. A single death of a TV celebrity could distract from — or provide a locus for — an unfathomable loss abroad. The painting's (and the *Post*'s) reference to "TV's Jessica Savitch" once again registers Warhol's own awareness of media, especially relative to tragedy. That same year he would expand his exploration of the crux of medium and culture with his television show *Andy Warhol's T.V.*

MYTH AND CLASS IN WARHOL'S EARLY NEWSPRINT PAINTINGS

ANTHONY E. GRUDIN

Attempts to come to terms with Warhol's relationship to mass culture have returned periodically to the idea of the mythic.[1] As Robert Smithson put it in 1972, "By turning himself into a 'Producer,' Warhol transforms Capitalism itself into a Myth."[2] Responding in December 1962 to Warhol's first show at the Stable Gallery, Michael Fried made myth the linchpin of his analysis:

An art like Warhol's is necessarily parasitic upon the myths of its time, and indirectly therefore upon the machinery of fame and publicity that markets these myths; and it is not at all unlikely that the myths that move us will be unintelligible (or at best starkly dated) to generations that follow. This is said not to denigrate Warhol's work but to characterize the risks it runs — and, I admit, to register an advance protest against the advent of a generation that will not be as moved by Warhol's beautiful, vulgar, heart-breaking icons of Marilyn Monroe as I am. These, I think, are the most successful pieces in the show, far more successful than, for example, the comparable heads of Troy Donahue — because the fact remains that Marilyn is one of the overriding myths of our time while Donahue is not, and there is a consequent element of subjectivity that enters into the choice of the latter and mars the effect. (Epic poets and pop artists have to work mythic material as it is given: their art is necessarily impersonal, and there is barely any room for personal predilection.)[3]

Fried's account was characteristically suggestive and illuminating. It was the first critical response to emphasize the mythic dimension of Warhol's pop practice and also among the first to address his homosexuality, if only implicitly. The myths Fried cited have proven remarkably resilient, while Warhol's "personal predilections" tended for many years to fade from the critical spotlight, as predicted.[4] But Fried's characterization of the artist's attitude toward these myths remained indistinct. The work was said to be "necessarily parasitic" on the myths from which it drew, and it was described as most successful when least informed by the artist's subjectivity. Just as it was necessarily parasitic, it was also "necessarily impersonal." Fried implied that Warhol's work was strongest when it reduced itself to a transparent conduit for larger cultural myths. He recognized these myths as sometimes being "beautiful, vulgar, [and] heart-breaking," but in this brief review he neither investigated the deeper meaning of this pathos nor posed hypotheses about its special salience in Warhol's painting. Finally, and perhaps most important, Fried took the works' ability to reproduce these myths successfully as a given; he did not address the mis-registrations and blemishes that pervaded Warhol's silkscreened images.

Forty-one years later, and fifteen years after the artist's death, Arthur Danto offered an extended account of the role of myth in Warhol's work.[5] For Danto, myth had an essentially pacificatory function. His essay begins by recalling Columbia University in 1968, when a group of students — who "looked and acted the part of Cuban revolutionaries, fighting alongside Fidel in Oriente province" — sat mesmerized by the performance of Buffalo Bob Smith and Howdy Doody: "tonight they were children again, singing with Howdy Doody, innocent of the injustices in the dark world around them."[6] Myths, thus, were the stories or images that produced a community out of what would otherwise have been a disparate conglomeration of individuals: "A community is defined by the images its members do not have to find out about, but who know their identity and meaning immediately and intuitively. If twenty-year olds in 1968 knew Howdy Doody in this immediate and intuitive way, irrespective of their class and their racial backgrounds, the central community to which they belonged transcended differences between class and race."[7]

Myth's function, for Danto, was precisely to "transcend" class and race differences, thereby depoliticizing its subjects. The Columbia University students were pacified by song — and more specifically by their own willingness to sing along, to regurgitate the songs of their youth under the direction of an unctuous pseudo-cowboy and his marionette. As Danto phrased it: "Warhol's political gift was his ability to make objective as art the defining images of the American consciousness — the images that expressed our desires, our fears, and what we as a commonality trusted and mistrusted."[8] Put another way, Warhol's work artistically recapitulated American myths and thereby extended their reach from the television set and the tabloid to the museum and the boardroom. As in Fried's account, the works' ability to reproduce these myths successfully was never called into question.

There are two elements in Fried's and Danto's approaches to myth in Warhol that may occlude important aspects of the artist's work. First, neither critic addressed the ideological function of the myths that Warhol borrowed. They agreed that these myths brought people together — that they were "exemplary" and "overriding" (Fried) or able to transcend "differences between class and race" (Danto) — but they chose not to examine these functions more critically.[9] Second, both critics disregarded the ways in which Warhol's reproductions of mythic images constantly telegraphed their own incompletion and impossibility, or the "precisely pinpointed defectiveness that gives his work its brilliant accuracy," as David Antin put it in 1966.[10] The manufactured imperfections in Warhol's work should tell us something about the ways in which myths are produced and consumed in American culture. As recent investigations of this artist's identity have demonstrated, it was often his conspicuous

inability to reproduce mythic ideals that made his artistic production remarkable.[11]

Warhol's early newsprint paintings addressed two distinct forms of myth, both of which targeted, and were therefore associated with, working-class audiences.[12] The first form, noted by Fried, Danto, and others, is iconographic. Motifs derived from comic books, tabloid papers, and tawdry magazines may now appear universally "American," but in their own time they were widely disparaged as vulgar or déclassé. In 1962 Max Kozloff described them as "the pinheaded and contemptible style of gum chewers, bobby soxers, and worse, delinquents."[13] The second form of myth was participatory: audiences, particularly working-class audiences, were urged to believe that they could plausibly become the cultural producers of myths themselves. The working class's perceived fondness for popular culture — for brand names and celebrities and comic books — was a key element in Warhol's contemporary scene, one that he was constantly incorporating into his work and his persona. But the work and the persona were also informed by a countertendency, less immediately apparent but nevertheless irreducible: a working-class suspicion that the world of popular culture, despite its promises to the contrary, was being channeled to them unilaterally, without the possibility of the consumers ever really participating in its production. It is this ambivalence between enthusiasm and skepticism, absorption and alienation, that permeates Warhol's style and is often mischaracterized as irony or cynicism.

Writing in 1957, Roland Barthes defined myth as "speech *stolen and restored*" and argued that it was the task of the mythologist to uncover this theft: "Holding as a principle that man in a bourgeois society is at every turn plunged into a false Nature, [mythology] attempts to find again under the assumed innocence of the most unsophisticated relationships, the profound alienation which this innocence is meant to make one accept."[14] Myths, for Barthes, were steeped in "profound alienation" because they were built by one class and consumed by another, and because they were intended for consumption alone; their audiences were allowed to hear but not to speak, to see but not to reproduce.[15] And yet during the years leading up to Warhol's emergence as a pop artist in the early 1960s, the possibility of amateur participation in the world of visual culture was actively marketed as an alternative to cultural passivity and an escape from financial hardship.

Advertisements for this promise were ubiquitous in low- and middle-brow publications, including comic books, magazines, tabloids, and the entertainment sections of newspapers. They offered a range of solutions to the problem of cultural passivity: correspondence courses, contests, and devices of technological reproduction such as cheap cameras, sound recorders, and projectors. In the face of these promises, Warhol's work from this period

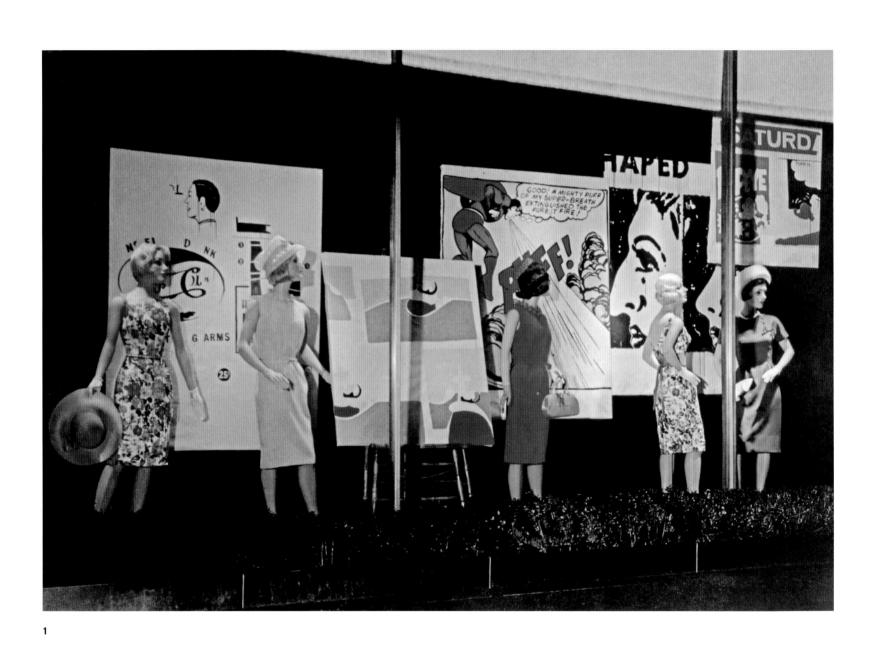

1

FIG. 1 BONWIT TELLER
WINDOW DISPLAY WITH FIVE
PAINTINGS BY ANDY WARHOL,
NEW YORK, APRIL 1961

FIG. 2 ANDY WARHOL,
SUPERMAN, 1961, CASEIN AND
WAX CRAYON ON COTTON
DUCK, 170.2 x 132.1 CM, PRIVATE
COLLECTION

took up the cheapest and most accessible images available — images marketed to and associated with a working-class demographic — and tested the possibilities of their everyday, amateur reproduction. Could real culture, "mass" culture (Popeye, the Little King, and the tabloid advertisements and headlines) be convincingly remade at home, even with the aid of these new reproductive technologies? Was participation in these powerful new myths — creative production and reproduction — now actually available for the audiences to whom they were directly targeted and with whom they were most clearly associated? In early Warhol, the inability to reproduce the imagery of one's contemporary surroundings successfully is as much a marker of class and powerlessness as the borrowed imagery itself.

MASS-CULTURAL PARTICIPATION

During 1961 and 1962, as Warhol worked toward a distinctive pop style, his art famously seemed to diverge into two separate and apparently incompatible representational approaches: the first was gestural, messy, slapdash; the second was neat, hard-edged, practically mechanical. Warhol would bring friends and critics into his studio and present them with two versions of the same motif, displayed side by side. Emile de Antonio and Ivan Karp both told him to pursue the hard-edged style and leave the gestural behind. As de Antonio is said to have put it: "the abstract one is a piece of shit, the other one is remarkable — it's our society, it's who we are, it's absolutely beautiful and naked, and you ought to destroy the first one and show the other" (see p. 10, figs. 8, 9).[16] For a while at least, Warhol appears to have followed their advice. The two versions of *A Boy for Meg* presented in *Warhol: Headlines* exemplify this trajectory: the first painting revels in its own inability to reproduce something as visually straightforward as the front page of a newspaper (pl. 13); the second seems to be the first painting in the history of art to base itself strictly on the mechanically aided and naturalistic depiction of a newspaper's front page (pl. 14).[17]

A closer look at the visual record, however, reveals that Warhol's decision to pursue a hard-edged style was neither as immediate nor as definitive as it has been made out to be. This misinterpretation has been convenient. The decisively hard-edged Warhol is far easier to assimilate to the Duchampian tradition of art-about-art, to "Art's heroic-comic quest for [its] own identity," as Danto has described it.[18] But the evidence we have of Warhol's actual working method contradicts this orderly narrative. It suggests instead that in at least five early and important cases the artist was adding rather than subtracting gesturalist imperfections in the final stages of his working process. At its best and most incisive, Warhol's art was not fundamentally an art about fine art; it was an art about the nature and possibility of mass-cultural participation within capitalism.

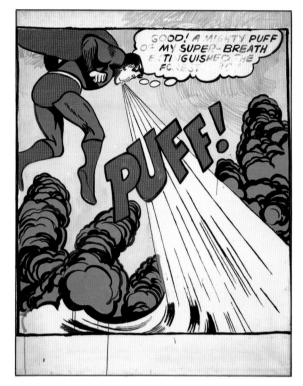

2

In April 1961 the first known exhibition of Andy Warhol's pop paintings was assembled, fittingly, in the window of the upscale Manhattan department store Bonwit Teller (fig. 1). A surviving photograph shows five overlapping paintings displayed at various heights in front of a dark backdrop, each matched with a smartly dressed mannequin. These five works (and many others from this period, including the first version of *A Boy for Meg*) were built upon the same basic structure: a simple two-dimensional motif, seemingly amenable to reproduction, which — despite the apparent aid of mechanically reproductive technologies, including a Photostat machine — was only incompletely and anxiously reproduced. Three of the paintings were based on comics (*Superman* on a comic book [fig. 2], *Little King* and *Saturday's Popeye* [fig. 3 and p. 9, fig. 7] on newspaper comic strips); the other two — *Advertisement* and *Before and After (1)* (fig. 4, and p. 29, fig. 4) — drew on newspaper advertisements. All told, then, four of the five paintings took their motifs from newspaper sources. Notably, Warhol seems to have altered all five of these paintings after they left Bonwit Teller and before they entered the art market.

The alterations Warhol made to the paintings in the final stages of their production are unusual and noteworthy: in every case, he added either new imperfections that blatantly failed to render accurately the colors or shapes they were supposed to mimic (scrawling lines, for example, and dribbling blocks of color) or new "corrections" that clearly telegraphed their supplementary and defective status. The scribbles are particularly notable in *Superman*. In each of the five areas where the wax crayon scrawling appears, it follows, or attempts to follow, one basic rule: never cross a contour line (fig. 2). It colors between the lines behind Superman's cape, along the top

margin, and across the cold blue background. The specific areas retouched in this final version were literally marginal, displaced from the painting's ostensible subject, which is Superman's body and its action. This displacement emphasizes the painting's key shift: away from an emphasis on the physical irreproducibility of the mass-produced masculine ideal, and toward an emphasis on the cultural irreproducibility of mass-produced visual ideals in general.[19] More than anything else, these crayoned additions resemble a printed panel half-converted by its young reader into a coloring book, a common and revealing mass-cultural scenario replayed over and over on comic books, comic strips, nursery-rhyme books, newspapers, and advertisements as a result of an apparently acute and insatiable childhood desire to reproduce the culture with which one is confronted.[20]

Early on, in works like *Superman*, Warhol found ways to visualize the suspicion that the possibility of reproduction is somehow at least partly foreclosed by the mass-cultural object. The incomplete erasure of the "thought-bubble" text reiterates the same suspicion: letters and words, the image's most legible and presumably most replicable elements, are rendered, in the painting's final version, irreproducible. Similar wax crayon scrawls were late additions to the upper left corner of *Advertisement* (see fig. 4). They also seem to have been late additions to

numerous other paintings from this period (including *Wigs*, *Make Him Want You*, the *Dick Tracy* paintings, *Batman*, and *Nancy*) and to a number of Warhol's contemporaneous newspaper-based drawings (see, for example, pls. 1, 2, 9, 11). In *Little King* (fig. 3) and *Saturday's Popeye* the added imperfections took the form of sloppy drips, which mar two pink faces in *Little King* and a bulging bicep in *Popeye*. These "finishing touches"— the very last marks to be added to each canvas — paradoxically connote haste and incompletion.

The final additions of white paint in *Before and After* exemplify a second tendency: faulty correction (see p. 29, fig. 4). They seem intended to hide the mole beneath the left-hand figure's eye, to widen and adjust the white of her eye, and to soften the contours of her lashes. But the white paint is a poor match for the neutral background and only partly covers the dark paint it is meant to correct. It is the paintbrush here, not the cosmetic surgeon's scalpel, that struggles to reproduce the ideal form. This same drama is perhaps best summarized in *Advertisement*, a pithy catalogue of the marketing of physical improvement (fig. 4). The "before and after" faces reappear, in miniature, alongside an offer of "strong arms" from Anthony Barker. Above these are ads for Pepsi-Cola and for a "Rupture Easer," which promised to treat hernias. In the upper left is an ad for hair coloring, with the dye dripping down the figure's neck like blood or errant contour lines. None of these ads has been reproduced completely, and most are less than half finished. Words and even hand-drawn letters are left incomplete, as are the borders of boxes and the oval of the Pepsi logo. It is as though the painting is suspended between a desire to reproduce the motifs accurately and a recognition that the task is ultimately impossible. The painting's motifs are similarly suspended — between the promises of physical perfection somehow attained through a twenty-five-cent pamphlet and the realization of the emptiness of that promise. And, crucially, these twin suspensions are staged with what have to be recognized as contemporary and distinctly working-class props. Warhol borrowed these images from contemporary tabloid magazines; three have been identified as deriving from the late March and early April issues of the *National Enquirer* in 1961 (fig. 5).[21] Although the heavily ethnic profile in the before-and-after image is unmistakable, Pepsi's contemporary image as "oversweet bellywash for kids and poor people" is now less legible.[22]

On first glance, *Before and After* and *Advertisement* are paintings, respectively, about cosmetic surgery and the unbearable pressures of normative cultural ideals. But as in *Superman*, these pressures — toward perfection and the aesthetic ideal — are displaced in the paintings onto the brushwork itself, which constantly makes a show of its losing battle to reproduce flat, two-tone images borrowed from down-market media. And this losing battle seems to have been the thing Warhol most wanted to

FIG. 3 ANDY WARHOL, *LITTLE KING*, 1961, CASEIN ON COTTON, 116.8 x 101.6 CM, PRIVATE COLLECTION

FIG. 4 ANDY WARHOL, *ADVERTISEMENT*, 1961, WATER-BASED PAINT AND WAX CRAYON ON COTTON, 177.2 x 133 CM, HAMBURGER BAHNHOF — MUSEUM FÜR GEGENWART, NATIONALGALERIE, STAATLICHE MUSEEN, BERLIN

FIG. 5 SOURCE COLLAGE FOR ADVERTISEMENT PAINTINGS FROM EARLY 1961, PHOTOSTAT, THE ANDY WARHOL MUSEUM, PITTSBURGH; FOUNDING COLLECTION, CONTRIBUTION THE ANDY WARHOL FOUNDATION FOR THE VISUAL ARTS, INC.

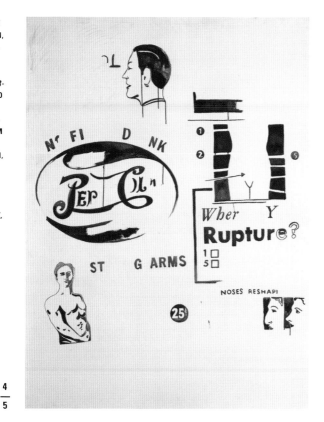

calculated addition to the works' style. The final additions to these paintings, their scrawls and counter-scrawls, were in fact concerted efforts to qualify rather than finalize their claims to cultural reproducibility.

The first version of *A Boy for Meg* is characterized by a similar set of displaced frustrations. Yes, the front page that Warhol chose to reproduce is dominated by celebrities and their allure. The two sexual tendencies juxtaposed in the painting—one reproductive (a birth announcement), the other lurid and animalistic ("Rat Pack")—enliven the drama, and the missing direct object in "A Boy for…" subtly substitutes a homoerotic potentiality for a reproductive certainty. But in this first version, the reproductive drama is as artistic as it is sexual in nature. Warhol again seems intent on making visual the hidden challenges of amateur mass-cultural reproduction. Everything is scrawled and unfinished, words and letters start out legible and convincing and quickly end up sketched and broken. One scrawl fails to convey what it is meant to, a second rougher scrawl comes in to finish the job and fails, information shades off into noise. And throughout, the artist's failure to complete the simple task is constantly reiterated; he seems to have given up halfway again and again and, finally, to have judged the whole project impossible to finish.

"EXCEPT LIKE A TRACING"

What might have prompted this rhetoric of thwarting and incompletion? Why would Warhol have chosen to take up the culture's most basic and reproducible images and then to emphasize precisely the difficulties or impossibilities of reproducing them? These questions only become thornier when one remembers that during the months surrounding the Bonwit Teller exhibit and leading up to his *A Boy for Meg* paintings—from early 1961 until November 3, 1961—Warhol was regularly producing illustrations and advertisements for the *New York Times*. He did three bylined illustrations in February (one of them a full page for the *New York Times Magazine*; see fig. 6), two in March, two in April, and three in September and October. During the 1950s Warhol's unattributed illustrations for the Bonwit Teller department store had been even more prominent. A former assistant described him as "the busiest commercial artist at that point, making a tremendous top-notch salary."[23] What did it mean, then, for a newspaper and advertising illustrator of this standing to imply in his paintings that newspaper and advertising imagery was somehow irreproducible? In his work as an illustrator of advertisements, was Warhol not effectively disproving this assertion on a regular basis?

For answers to these questions we need to consider a set of discourses with which Warhol would have been intimately familiar through his voracious appetite for mass culture but which have been ignored in the critical and art historical responses to his work. The historical

emphasize. Again and again, it is the defective capstone that simultaneously completes and undoes these paintings. The Bonwit Teller photograph thus offers an unusual perspective on Warhol's early production and proves that imperfection in these works was neither an accidental by-product of the reproductive process nor an abstract expressionist holdover; it was an intentional and

Bold Strokes in Black and White

6

relevance of the shift from physical to cultural emulation in paintings like *Superman* and the two versions of *A Boy for Meg* can be better understood by examining the context in which Warhol found his borrowed imagery — by returning, for example, to the printed advertising that accompanied and subsidized the comic book from which *Superman* was taken: the April 1961 edition of *Superman's Girl Friend: Lois Lane*.[24] This thirty-six-page issue contained six and a third pages of advertising, pages that provide insight into the book's readers and their priorities, as well as the publisher's expectations. One and a third of these pages were dedicated to announcements for other comic books. Three other pages advertised employment opportunities: selling seeds, "popular Patriotic and Religious Mottoes," and "White Cloverine Brand Salve." The two other full-page third-party advertisements were at least superficially more conventional in that they attempted to sell merchandise rather than to recruit salespeople. The comic's most obviously pertinent ad appeared on its penultimate page and stood out among all the pages in its complete lack of color (fig. 7). Every word was emphasized, but the uppermost lines read: "I don't care what your age is! … Just RUSH me your LAST CHANCE COUPON below checking the KIND of HE-MAN BODY YOU DESIRE FAST…. SKINNY OR FAT, I'LL BUILD YOU INTO A NEW ATHLETIC STREAMLINED MIGHTY-MUSCLED HE-MAN as I have for 35 years re-built MILLIONS like you!" The accompanying pictures drove the point home: the teacher and his pupils had achieved the masculine ideal, and the reader was only one postcard away from achieving the same. The Jowett Institute of Body Building would take care of the rest. Unsurprisingly, the ideal celebrated in this advertisement shared much in common with the figure of Superman as he appeared in the comic.

The issue's cover also turned on the image of the male ideal, integrating this ideal into broader issues of cultural participation (fig. 8). In this image, Lois Lane stands on a television set as a host with a microphone informs her that his computer has selected her "ideal husband." There, behind a dividing wall, is Clark Kent, anonymous in his single-button suit and rep tie. But Lois has a different image in mind, which is visible to the reader as a thought bubble above her head: Superman, his muscles rippling. The four figures' heads form a pyramid, with Superman at its apex; the masculine ideal presides over the entire scene, and the studio audience in the foreground consumes the resulting comedy and melodrama. The image must have immediately appealed to Warhol when he saw it on the newsstand.

This cover image clearly relied on the same myth of masculinity that fueled the Jowett Institute of Body Building's appeal. But the cover encapsulated this myth within a larger myth: the possibility of mass-cultural participation. After all, the entire premise of the cover involved two comic book heroes allowing their purported love lives to be filmed and broadcast on television. The resulting entertainment was provided by the gap between the contestant's expectations (Superman) and the reality she encountered on set (Clark Kent). It was this discrepancy that was consumed both by the studio audience depicted in the foreground and by the comic book's potential buyers as they scanned the newsstand. The promise of cultural participation within the period's

7

FIG. 6 "BOLD STROKES IN
BLACK AND WHITE," ILLUS-
TRATION IN THE *NEW YORK
TIMES MAGAZINE*, FEBRUARY 26,
1961, P. SMA92

FIG. 7 ADVERTISEMENT FOR
JOWETT INSTITUTE OF BODY
BUILDING, PUBLISHED IN
*SUPERMAN'S GIRLFRIEND LOIS
LANE*, APRIL 1961, P. 33

FIG. 8 COVER OF *SUPER-
MAN'S GIRLFRIEND LOIS LANE*,
APRIL 1961

FIG. 9 ADVERTISEMENT FOR
ART INSTRUCTION, INC., PUB-
LISHED IN *SUPERMAN'S GIRL-
FRIEND LOIS LANE*, APRIL 1961,
INSIDE COVER

8

artistic productivity and reproductivity: the dream of creating and recreating contemporary visual culture. By the early 1960s Warhol was already a poster child for exactly this promise; his facility as a draftsman had provided him with an escape from poverty and admission to the center of social prestige. In a 1977 interview with Glenn O'Brien, he even claimed that his childhood teachers had submitted his drawings to a correspondence art school contest:

Warhol: If you showed any talent or anything in grade school, they used to give us these things: "If you can draw this," where you'd copy the picture and send it away.

O'Brien: Famous Artists Schools?

Warhol: Uh, yeah.

O'Brien: Did you send them away?

Warhol: No, the teachers used to.

O'Brien: Did they say you had natural talent?

Warhol: Something like that. Unnatural talent.[26]

"Unnatural talent." The promises made by these schools were distinctly anti-Kantian; they tied artistic productivity directly and unapologetically to economic success.[27] And the schools communicated, even in their advertising, a basic paradox of mass-cultural production and reproduction: skill could only be reliably gauged by copying

dominant medium would apparently be enough to convince these otherwise extraordinary figures to forfeit their dignity and privacy, while the spectacle of failure that attended this promise was sufficiently entertaining to fuel an entire TV genre.

This same promise of cultural participation was brilliantly marketed by this comic book's first advertisement, printed inside its front cover, for a correspondence art school called Art Instruction, Inc. (fig. 9). Three rough sketches — the heads of a sad clown, a woman, and a dog — took up the bulk of the page, and the reader was invited to emulate: "*Draw your choice* of any one of these heads — clown, girl, or boxer. Draw it any size except like a tracing. Use pencil. Everyone who enters the contest gets a professional estimate of his talent…. Contest sponsored to uncover hidden talent." The winner was promised a $495 scholarship.

This ad, which appeared again and again with varying illustrations in comics, magazines, and newspapers throughout the 1950s and 1960s, did not need to rely on the masculine ideal that figured so prominently throughout the rest of the issue.[25] Instead of espousing any single cultural ideal, it sold the possibility of profitably participating in the production and reproduction of visual-cultural ideals. This possibility was clearly a false promise for most of the comic's readers, but it was a false promise that carried great allure. Like the multiple ads in this issue for amateur business schemes, this one was selling productivity rather than consumption, but unlike those advertisements, this one was specifically predicated on the idea of

9

advertisements were a false correction of the cultural world into which they were introduced. This world was founded on the passivity of the consumer, which might eventually be seen as a limiting factor in that consumer's satisfaction and pleasure. The spectacle of the consumer's own cultural participation promised to correct this constitutive passivity.

Comics targeting a female audience often included opportunities for readers to mail in drawings of outfits and hairstyles, some of which were then to be included, with credit to their creators, in future issues (fig. 11).[30] In a very few cases these promises yielded real opportunities: the consumer of images aced the correspondence school, landed a job on Madison Avenue, and became a producer of images — Lois Lane ceased to be her ideal and became instead her product.[31] But even this rare scenario did not fully correct the problem, because to the degree that the consumer became the successful manipulator of images, she was unlikely to believe in them fully.

The class-based marketing of these fantasies of cultural productivity was made directly apparent in numerous advertisements for both Art Instruction, Inc., and its rivals. During the late 1940s Art Instruction's small advertisements were dominated by a simple tag line: "Art-

preexisting visual-cultural icons, but this copying could never be allowed actually to duplicate the original. Readers were told to "draw it any size except like a tracing."[28]

These promises and challenges were extended into newspapers as well, and they sometimes blurred the lines between various forms of advertising. An unusual example appeared on facing pages of the comics in the January 31, 1960, *Chicago Daily Tribune* (fig. 10).[29] Half of the right-hand page was taken up with a comic-style ad for Betty Crocker called "The Case of the Teen-Age Problem," in which two matronly ladies proposed frozen pizza dough and sauce as the key ingredients in the ideal high school party meal. Half of the left-hand page was occupied by an ad for Art Instruction, Inc., labeled "How a commercial artist works." In this second ad, also illustrated in comic-strip style, an agent and an illustrator collaborated on the facing page's pizza ad: "Thanks to the artists, this Betty Crocker ad is an eye-catcher in the comic section of Sunday's newspapers." The initial Betty Crocker ad was disguised as a comic strip in order to sell pizza, while the Art Instruction ad borrowed the same style in order to sell the promise of a career producing these very ads. The line between art and business in comics was presented as essentially porous, as was the distinction between artist and reader. The reader was encouraged to make the transition from passively consuming the spectacle of the comic book world and its advertised goods to passively consuming the spectacle of her or his own future participation as a creator of that world and its advertisements. In this respect, the Art Instruction

12

ists Make Money."[32] The Washington School of Art's contemporary headline was "Draw for Money / Be An Artist!"[33] A Famous Artists Schools advertisement printed in the *Los Angeles Times* in 1959 was entitled "What went wrong for the kid who loved to draw?" (fig. 12). The words here were superimposed over a layered image. Larger and more central, but in a faded tone, a boy surrounded by inks and paints and seen only from the waist up is shown drawing a brush across a large piece of paper. Off to the right of the page a standing man appears superimposed over the right half of the boy's body and the table. The man is clad in recognizably working-class clothing, including a work coat, and he carries a black lunch box, the contemporary Madison Avenue emblem of the laborer. The boy painting was meant to be understood as the working man's past self, less real than his adult self, but more vital and free. The ad's text drove the point home:

With our training, Wanda Pichulski gave up her typing job to become fashion artist for a local department store.

Stanley Bowen, father of three, was trapped in a low-paying job. By studying with us, he was able to throw over his job to become an illustrator with a fast-growing art studio, at a fat increase in pay!

John Busketta was a pipefitter's helper in a gas company. He still works for the same company but now he's an artist in the advertising department at a big increase in pay.[34]

Another Famous Artists Schools ad distributed during the late 1950s and early 1960s delivered a similar message: "They DREW their way from 'Rags to Riches'— Now they're helping others do the same."[35] The opening line: "Albert Dorne was a kid of the slums who loved to draw. He never got past the seventh grade. Before he was 13, he had

to quit school to support his family. But he never gave up his dream of becoming an artist."[36]

Crucially, however, the correspondence art school was not the only promised route to cultural participation and remuneration during this period. Interspersed with the art school ads, sometimes sharing the same pages, were ads for a number of mechanical shortcuts: cheap cameras, oil painting services, recording devices, and the "Magic Art Reproducer." This last was a small optical device that employed a mirror to transfer an image onto the horizontal surface beneath it, a smaller and cheaper version of the device Warhol had used to produce many of his early pop paintings (fig. 13).[37] The "de luxe" model (and only model) was marketed for $1.98 in comic books, magazines, tabloids, and the back pages of newspapers. The pitch was familiar: "Have fun! Be popular! Everyone will ask you to draw them. You'll be in demand! After a short time, you may find you can draw well without the 'Magic Art Reproducer' because you have developed a 'knack' and feeling artists have — which may lead to a good paying art career."[38] Warhol would spend the rest of his career testing mechanical reproductive devices against the claims to mass-cultural participation they promised. The opaque projector was soon replaced by screen presses,

13

tape recorders, Polaroids, video cameras. Each machine promised amateur cultural participation freed from the burden of training. In his artistic production, Warhol took these promises at their word.

MARKETING THE MYTH OF CULTURAL PARTICIPATION

There are important links to be drawn between the style of painting Warhol adopted for his paintings of the early 1960s and the particular image world from which he borrowed their motifs. Too often the gesturalism apparent in Warhol's work from this period has been interpreted either as a remnant of the abstract expressionist style or as the sign of personal discomfort.[39] Likewise, the world of comic strips and tabloid ads that these paintings take as their subject has been reduced in significance, either to the manipulation and construction of physical inadequacies or to the emergence of a generalized mass-produced visual culture. These readings overlook the complexity of Warhol's image world and the persistence of imperfection and mis-registration as stylistic strategies in his work. Even when the gestural seemed to disappear from Warhol's work later in 1961, imperfect reproduction remained a consistently dominant element of his style. When Warhol claimed that he wanted to be a machine, his words emphasized his distance from this ideal of reproduction and reproducibility as much as his proximity; he never claimed to *be* a machine, only to *want* to be one. As Claes

14

Oldenburg pointed out in 1964, "Andy keeps saying he is a machine and yet looking at him I can say that I never saw anybody look less like a machine in my life."[40]

The scrawled-out sections of *Superman* and the promised riches of Art Instruction, Inc., were, in this respect, two sides of the same coin. Culture was being sold during this period (as it is to this day) as an arena for both consumption and production. Images like Superman were built to appeal to viewers sexually and psychologically, and they spurred all sorts of physical emulation and frustration. But the appeal of these images was also harnessed to sell the very possibility of their visual — rather than physical — reproduction. Successful visual reproduction at least intimated the possibility of a connection to the ideal. It meant that the artist had the power, if not to become the desirable figure, then at least to produce his or her image. Concurrently, it promised a lucrative escape from the passive consumption of images, an entry into action and agency ("You'll be in demand!"). Like Lois Lane and Clark Kent on the studio set, the new artist would be granted the opportunity to contribute to the "common culture." The placement and rhetoric of the correspondence art school and Magic Art Reproducer advertisements show that these promises were expected during Warhol's time to have special appeal for working-class readers, who were thought to be more credulous than their wealthier counterparts and more desperate for social mobility. But cultural reproduction was in many ways as fraught and improbable as physical reproduction. Even a perfect duplication of an image of Superman or Dick Tracy was ultimately only a counterfeit unless it carried the necessary and legitimate trademark. Warhol's biography made him particularly attuned to these issues, but in his art he raised them as a cultural rather than a personal dilemma.[41] It is this shift from the personal, physical, and sexual to the cultural, visual, and sociological that was inaugurated in the comic-strip paintings and that took its fullest form in the "brand image" art that followed.[42]

A painting like *Carat*, 1961 (fig. 14), effectively summarizes these concerns. The script along the inside of the painted ring is emblematic. It is as though the entire possibility of mass-cultural replication rests on Warhol's ability to paint an "s" that looks mechanically engraved, as though the forever-postponed duplication of this feat, the second "s" in "happiness," might truly bring about emotionally the word it would complete materially. And yet even here, in a seemingly universal or even bourgeois symbol like the diamond ring, closer attention to Warhol's source material reveals another story. The ring advertisements that Warhol copied were printed on a regular basis in working-class tabloids like the *New York Daily News*. One example from July 1, 1959, occupied a tiny corner of the page (fig. 15). Beneath it an ad for mineral oil with the headline: "Woman Screams As Feet Burn!" To the right, a Macy's ad: "You Can't Go to Hawaii

FIG. 14 ANDY WARHOL,
CARAT, 1961, WATER-BASED
PAINT ON LINEN, 132.7 x
121.9 CM, DAROS COLLECTION,
SWITZERLAND

FIG. 15 ADVERTISEMENTS
IN *NEW YORK DAILY NEWS*,
JULY 1, 1959, P. 9

15

This Summer? Never Mind, Macy's Brings Hawaii to You." The ring itself was part of "New York's Largest Discount Display." It was available on credit for $2.75 down, $2.00 weekly.

This was what Warhol found in American myths: not merely the universal appeal of superheroes or of bodily perfection, or the personal pathos of his own distance from these ideals, but the power these myths held for the disadvantaged and the ways in which cultural participation was marketed to them alongside consumption. As one radical put it in 1967: "The spectacle is a drug for slaves. It is designed not to be taken literally, but to be followed from just out of reach."[43] The smudged and unfinished pearls in the second — cleaner — version of *A Boy for Meg* tell this same story. They are the painting's pivot point: the objects that both signify status and reveal its irreproducibility. Of course, these small disasters can be entertaining. In a paradoxical reversal, amateurishness is recouped in Warhol as entertainment value; it is the work's rhetorical inability to reproduce the spectacle that gives it its spectacular pathos and charm.

DEEP GOSSIP: THE FILM, VIDEO, AND TELEVISION WORLDS OF ANDY WARHOL

JOHN G. HANHARDT

Fame and gossip were essential parts of Andy Warhol's life. As he put it in 1975, "A good reason to be famous…is so you can read all the big magazines and know everybody in all the stories. Page after page it's just all the people you've met. I love that kind of reading experience and that's the best reason to be famous."[1] Warhol's films, together with his later videotapes and television productions, were a means to explore and create radical retellings of the stories "behind the headlines."[2] The present publication considers the uncanny ways that news events and popular culture become larger-than-life forces in people's lives, with the headline serving to highlight those events.

The term "deep gossip" in the title to this essay is taken from Henry Abelove's book of the same name, which describes gossip as deep "whenever it circulates in subterranean ways and touches on matters hard to grasp and of crucial concern."[3] For Warhol, gossip appears in unexpected ways through language and actions among the participants in his films and videotapes. It is a means to express what is felt but not easily comprehended. The headlines and their placement in the films, both casually and explicitly, capture the language and expression of deep gossip.

Warhol's fascination with popular culture began in Pittsburgh, where he grew up and first experienced the world of fantasy on the radio and in the movies. After moving to New York City in 1949, he avidly consumed the tabloids filled with news and gossip about celebrities and the entertainment world. The newspaper can be viewed as a dramatic form of storytelling whose narrative unfolds through current events. Both the spread of newspapers and tabloid journalism in the early part of the twentieth century and the reading of news on the radio served as models for the live broadcasting of events on television by midcentury. Today gossip and news are delivered around the clock on the Internet. Within this history of technology and literary forms, the "headline" is a rhetorical strategy that calls attention to itself, a distillation of and advertisement for the story. It is an abbreviated form of public gossip. Warhol's headline works, a unique facet of his large and complex production, reveal his attraction to the visible yet overlooked signs that shape and inform our urban landscape. As he explained in 1980:

It was Henry [Geldzahler] who gave me the idea to start the Death and Disaster series. We were having lunch one day in the summer at Serendipity on East 60th Street and he laid the *Daily News* out on the table. The headline was '129 DIE IN JET.' And that's what started me on the death series — the car crashes, the Disasters, the Electric Chairs….

(Whenever I look back at that front page, I'm struck by the date — June 4, 1962. Six years — to the date — later, my own disaster was the front page headline 'ARTIST SHOT').[4]

This essay, treating Warhol's time-based media in relation to headlines, comprises two parts. The first pulls together research notes left by Callie Angell when she died in 2010. The best way to look at how Warhol incorporated the newspaper headline into his films is through Angell's extensive research. Curator of the Andy Warhol Film Project at the Whitney Museum of American Art in New York, Angell was preparing an essay for the present catalogue that was to address the integration of headlines into Warhol's films, videos, and television. In 2006 she completed the first volume of the Andy Warhol film catalogue raisonné. That publication — the first catalogue raisonné of films by a major artist — reflects the importance of the moving image to the history of twentieth-century art,[5] and Angell's landmark research and her lectures and publications have transformed Warhol studies. The second part of the essay presents my own consideration of Warhol's video and television production related to the headline theme.

THE HEADLINE IN WARHOL'S FILMS

Angell took an integrated approach to Warhol as an artist, locating his art within the context of his time and following various themes through his subject matter and his working methods. Although her contribution to this catalogue remained unfinished at her death, it offers tantalizing glimpses into how headlines and the media both casually and strategically figured into Warhol's on-screen action. In her research, Angell pursued Warhol's early interest in print, radio, and television, which she traced through his Time Capsules, now housed at the Andy Warhol Museum in Pittsburgh. Warhol's Time Capsules consist of boxes in which he collected, year by year, a wide assortment of things, including correspondence, printed news, and gossip. Angell considered the Time Capsules in connection with her investigations into Warhol's filmmaking techniques and working methods. A central tenet of Angell's approach was to consider the paintings, prints, drawings, and films as part of a larger whole — and as works that informed and shaped one another. This framework shed light on the way Warhol's various film projects interpreted the circulation of news events, from the Kennedy assassination to gossip about the private lives of movie stars.

Angell felt that despite Warhol's enigmatic reputation, he was not particularly difficult to understand or interpret.[6] In the film *Uptight #3* (fig. 1), for instance, shot by Danny Williams and Barbara Rubin for Andy Warhol Enterprises in 1966, we follow Warhol and the Velvet Underground to a television studio for a taping of the *David Susskind Show*. A camera on the bus caught Warhol

1

reading a newspaper with the headline "Hedy Lamarr Arrested" (for shoplifting). It is a moment that captures the headline as subtext and source for Warhol's filmmaking, since it led directly to the subject of his next film, *Hedy*.

One thread in Warhol's films particularly intrigued Angell, according to Claire Henry, Angell's curatorial assistant for the Andy Warhol Film Project:

I think that what excited Callie the most about the *Warhol: Headlines* project is that it gave her an opportunity to revisit a line of research she had been very keen to pursue in the last few years: Warhol's interest in the Kennedy assassination and the number of times this topic appeared in his work. As examples, we have the Jackie silkscreens, the images for which were taken from the December 6, 1963, issue of *Life* magazine; the gun silkscreens; the *Flash* portfolio; the films *Billy Klüver, Jill, Jill at Billy Klüver's*, and *Since*. I think it is interesting and perhaps not accidental that, if placed chronologically (in order of the filming date), which we have done here, the films of Callie's *Headlines* list more or less begin and end with a discussion of the Kennedy assassination. In 1963, the group that assembled at [Klüver's] place heard about Oswald's assassination on the car radio as they drove to the Klüver home in New Jersey. Once there, they watched the broadcast of Kennedy lying in state at the Capitol. In 1966, Warhol makes the film *Since*, which is a reenactment of the assassination and was based on images of the [Abraham] Zapruder film published in *Life* magazine. Callie must have derived great satisfaction from seeing this thread of a theme wend its way through Warhol's thoughts for more than four years during the 1960s.[7]

Angell had teased out, in chronological order, the films in which Warhol incorporated the actual headline as well as other media sources.[8] She identified various modalities by which Warhol recognized and responded to events through headlines, news reports in magazines, on radio, and on television. All were inscribed into the

filmmaking process that unfolded through the performances of the actors — both improvised and scripted — that were filmed by Warhol. His handling of the 16mm Bolex film camera, most often on a tripod, constituted a revision and expansion of film language. He worked against the grain of linear logic and disrupted narrative closure; his was a personal and exploratory cinema. Warhol's largely unacknowledged presence behind the camera became the locus of attention, and as the film proceeded, he focused on gestures and actions, abruptly zooming in and out of the scene, panning across and framing the shot to create a cinema that felt both intuitive and deliberate.

It is not possible to synthesize all of Callie Angell's research and writing for the *Warhol: Headlines* project, nor can we tie together the loose ends in the wonderful prose style that made her insights seem effortless expressions of her extensive knowledge. What we offer here is a partial list of the films she was studying, presented in chronological order, followed by extended excerpts from a lecture she delivered in 2002 on Warhol's movie *Since*. Her lecture notes, again, are not a finished text, but they offer fresh perspectives on Warhol's filmmaking process and his response to media coverage of current events.

The earliest work on Angell's list is *Billy Klüver* (1963), filmed at Billy Klüver's home in New Jersey two days after the assassination of John F. Kennedy (fig. 2). Klüver was an electrical engineer at Bell Labs who cofounded (with Robert Rauschenberg) Experiments in Art and Technology (E.A.T.) and collaborated with artists, including Warhol, to help them incorporate new technologies into works of art. In the film, a group including Warhol, Klüver, Jill Johnston, Olga Adorno Klüver, John Giorno, and Naomi Levine is watching televised coverage of the funeral. This, as Claire Henry has noted, represents Warhol's fascination with Kennedy as well as with the way television formed and represented the event for the world.

Soap Opera (1964) is an intriguing look at another aspect of television's allure for Warhol. He created a film based on his favorite soap opera, *Love of Life*, which, he told a reporter at the time, he had watched every day for fifteen years. The planned film was to have 16mm black-and-white sound commercials made for television inserted into the improvised narrative. One of the episodes includes a performer reading a tabloid with the headline "I Still Love Frank Sinatra" (fig. 3).

Allen features Allen Ginsberg and other Beat writers at the Factory during the late summer of 1964. Ginsberg is seated on a toilet reading the *National Enquirer*, and we can see the headline "I Am Not Ashamed," referring to Joan Collins "living in sin" with the married British actor Anthony Newley (fig. 4).

FIG. 2 ANDY WARHOL, FRAME
ENLARGEMENT FROM *BILLY
KLÜVER*, 1963, 16 MM FILM,
BLACK AND WHITE, SILENT
(4.5 MINUTES AT 16 FRAMES
PER SECOND, 4 MINUTES AT
18 FRAMES PER SECOND),
COURTESY THE ANDY WARHOL
MUSEUM, PITTSBURGH

FIG. 3 ANDY WARHOL, FRAME
ENLARGEMENT FROM *SOAP
OPERA*, 1964, 16 MM FILM,
BLACK AND WHITE, SILENT
AND SOUND (PRESERVED
VERSION 46.8 MINUTES AT
24 FRAMES PER SECOND),
COURTESY THE ANDY WARHOL
MUSEUM, PITTSBURGH

FIG. 4 ANDY WARHOL, FRAME
ENLARGEMENT FROM *ALLEN*,
1964, 16 MM FILM, BLACK AND
WHITE, SILENT (25 MINUTES
AT 16 FRAMES PER SECOND,
22 MINUTES AT 18 FRAMES
PER SECOND), COURTESY THE
ANDY WARHOL MUSEUM,
PITTSBURGH

FIG. 5 ANDY WARHOL, FRAME
ENLARGEMENT FROM *CAMP*,
1965, 16 MM FILM, BLACK AND
WHITE, SOUND (67 MINUTES
AT 24 FRAMES PER SECOND),
COURTESY THE ANDY WARHOL
MUSEUM, PITTSBURGH

FIG. 6 COVER OF *CONFIDEN-
TIAL* MAGAZINE, OCTOBER 1965.
THE ANDY WARHOL MUSEUM,
PITTSBURGH; FOUNDING COL-
LECTION, CONTRIBUTION THE
ANDY WARHOL FOUNDATION
FOR THE VISUAL ARTS, INC.

Camp (1965) is a variety review staged and filmed by Warhol at the Factory. Near the end of the film, after the "acts" have been presented, Jack Smith produces a copy of *Confidential* magazine and displays the cover for the camera (figs. 5, 6); its headlines read "Britain Bans Bawdy Book: Is It Secret Life of Prince Philip?" and "The Battle of the Bare Bosoms." Inside the magazine, the article "Those Underground Films — Blue Movies Disguised as Art" mentions films by both Warhol and Smith, highlighting the fact that these filmmakers, and the avant-garde cinema, had become the subject of tabloid gossip. Their work had become inscribed in the medium — the tabloid — that they loved to appropriate.

Uptight #3 (1966) follows Warhol and the Velvet Underground to various events or Exploding Plastic Inevitable (EPI) multimedia environments that Warhol and colleagues created around performances of the Velvet Underground. As Angell observed, the Uptight films are themselves a kind of performance, as the filmmakers Danny Williams and Barbara Rubin moved about with their cameras and lights asking, "Are you uptight?" Williams and Rubin also traveled with Warhol and the Velvet Underground on a bus, where everyone napped, talked, or, in Warhol's case, read a tabloid headline (see fig. 1).[9]

What becomes clear in reading Angell's notes is that a variety of events delivered through the tabloids, watched on TV, and heard on radio were refashioned by Warhol through scripts by Ronald Tavel (in many cases) as well as the improvised performances and the filmmaking process itself. The following edited excerpts from Angell's lecture on *Since* (1966) — which she delivered prior to a screening of the film at Princeton University on November 15, 2002 — give some idea of this process. Here we can follow the network of forces that circulated through Warhol's films as he responded to the Kennedy assassination, arguably the major headline news of the 1960s.

5
6

SINCE THE ASSASSINATION

CALLIE ANGELL

Since (1966) is the 67-minute film, notorious in Warhol folklore, in which the Kennedy assassination is reenacted at the Factory. This film was never completed and never released, and it is likely that Warhol considered *Since* to be unsuccessful.... But Warhol's failures are sometimes his most interesting work, because that's when you get a chance to see him thinking.

Since was shot at the Warhol Factory, probably in late November and early December of 1966.... Apparently encouraged by the success of *The Chelsea Girls*, in the late fall of 1966 Warhol began to increase the rate of film production at the Factory, rapidly shooting numbers of reels and sequences of reels intended for some undefined but very ambitious expanded film project. Over the next few months, this project would solidify into the concept of a 24- or 25-hour-long movie — which would be completed a year and a half later as Warhol's magnum opus, the 25-hour, 82-reel, multiscreen, superimposed film ★ ★ ★ ★ *(Four Stars)*, which was projected only once, in December 1967....

★ ★ ★ ★ *(Four Stars)* was constructed from multiple multireel sequences, each with a different cast, a different narrative, a different title, and usually shot in different locations. A number of the sequences included in ★ ★ ★ ★ *(Four Stars)* were edited and released under their own titles as separate films: *Bike Boy, I a Man, The Loves of Ondine, Nude Restaurant, Tub Girls,* and *Imitation of Christ. Since* was one of the first sequences to be shot for ★ ★ ★ ★ *(Four Stars)*, and one of the longest....

The star of *Since* is Ondine, who was probably Warhol's favorite film star. Ondine, whose real name was Robert Olivo, was one of the amphetamine queens at the Factory; he was a highly intelligent, articulate, and overtly gay performer who specialized in improvising sharp-edged, witty monologues that could last literally for hours, especially when he was on speed. His performance as Pope Ondine in *The Chelsea Girls* is considered the highlight of that film; Warhol at one point said he thought it was the best thing he ever shot. Following up on his success in *Chelsea Girls*, Warhol apparently con-

ceived *Since* as a vehicle for Ondine, much like Warhol's tape-recorded novel *a: a novel*, which is a transcription of twenty-four hours of Ondine talking. The basic premise throughout *Since* is that Ondine is pretending to be President Lyndon Johnson, sitting on the toilet at the Factory, giving what he calls toilet-side chats, receiving presidential visitors, chatting with his family, including his wife "Looney Bird," played by Ingrid Superstar, and occasionally injecting himself with amphetamine. In some of these reels Ondine does not even bother to pretend, but drops the presidential role completely and simply sits in the bathroom talking to the camera as himself....

...The assassination reels, which were the last reels shot for *Since*, are quite different from the others. For one thing, there is a very large cast, and the scenario and even the set seem to have been elaborately prepared, even though the film itself is extremely — and I think purposefully — chaotic. As in many Warhol films, there is no scripted dialogue, and the actors have no lines to learn, but instead are given some kind of minimal instruction about the situation they are supposed to improvise on camera. All of this is staged quite casually, and since each reel is shot, like all Warhol films from this period, in one continuous 1,200-foot, 33-minute-long take, the narrative pretext on screen simply collapses for periods of time, and you see people milling around, goofing off, acting bored, and so on. Ondine, as usual, is wittier than anyone else, and the camera spends most of the time paying attention to him — rather ahistorically, I should point out, since Lyndon Johnson was hardly a central figure in the action of the Kennedy assassination.

...Warhol's film version of the assassination is, of course, a farce — I myself think this is a very funny film: the cast sitting on the Factory couch pretending it's the presidential limousine while Ondine, camping it up in the role of LBJ, makes remarks like "Dallas is so lovely this time of year," and Jack Kennedy, who is played by a woman, Mary Woronov, keeps saying "Put the top up. Put the top up." Compared to the solemnity of Warhol's other works dealing with the Kennedy assassination —

specifically the "Jackie" portraits of 1964—and to the reverence with which they are usually discussed, this film comes across as totally irreverent, practically profane. It would have seemed especially shocking in 1966. I find it useful to think about this film, like much of Warhol's art, as a work in which a number of different things are going on at different levels at the same time. On the one hand, *Since* is an outrageous farce much in the vein of Warhol's earlier spoofs of Hollywood scandals like *More Milk Yvette, Lupe,* and *Hedy*; it is also a movie which relies on Ondine's brilliant ability to carry an entire film all by himself. But at the same time, it is a work in which you can see Warhol trying out some new ideas about the representation of the Kennedy assassination, and about the representation of violence, in the medium of film. And many of these ideas seem to point to Warhol's interest in another film—certainly the most famous film of the Kennedy assassination—and that is, of course, the Zapruder film....

...There is an interesting mythical relationship between the Warhol films and the Zapruder film. The first Zapruder still images were published in *Life* magazine in black and white in November 1963, right after the assassination. On October 2, 1964, shortly after the publication of the Warren Commission report, which was the official government investigation into the assassination, *Life* magazine published a cover story, which included selected frames from the Zapruder film printed in color (fig. 7). A year later, on November 25, 1966, shortly before Warhol shot his assassination film, *Life* published another cover story, "Did Oswald Act Alone? A Matter of Reasonable Doubt," in which they questioned the conclusions of the Warren Commission by inviting Governor John Connally of Texas, who had been in the limousine with Kennedy and had been wounded himself, to reexamine the Zapruder film. You see Governor Connally scrutinizing enlarged frames from the Zapruder film, and sequenced images from the film have their frame numbers printed next to them. Arrows point to specific frames corresponding to key moments in the assassination, which had been carefully timed by the Warren Commission—and even in reenactments staged by the FBI—to coincide exactly with the time sequence preserved in the film itself.

These pages from *Life* magazine bear a strong resemblance to some of Warhol's paintings from the early 1960s—sequences or strips or grids of repeated photographic images laid out in a way that seems to imply the passage of time. The filmic preoccupations and cinematic idioms of Warhol's paintings are phenomena that significantly predate both the Kennedy assassination and his own films—many of his early movie star portraits, suicides, and early disaster paintings were made in 1962 or early 1963. Another work where you get to see Warhol thinking is a painting called *Seven Cadillacs* from 1962 (fig. 8), in which an image of a car has been silkscreened seven times on a vertical canvas, each time moving a little

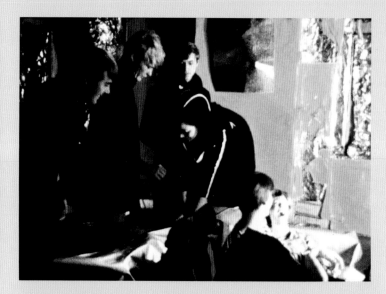

9 | 10

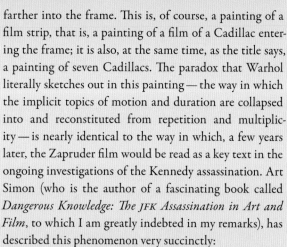

farther into the frame. This is, of course, a painting of a film strip, that is, a painting of a film of a Cadillac entering the frame; it is also, at the same time, as the title says, a painting of seven Cadillacs. The paradox that Warhol literally sketches out in this painting—the way in which the implicit topics of motion and duration are collapsed into and reconstituted from repetition and multiplicity—is nearly identical to the way in which, a few years later, the Zapruder film would be read as a key text in the ongoing investigations of the Kennedy assassination. Art Simon (who is the author of a fascinating book called *Dangerous Knowledge: The JFK Assassination in Art and Film*, to which I am greatly indebted in my remarks), has described this phenomenon very succinctly:

The status of Zapruder's imagery as evidence hinged on an irrevocable contradiction: the simultaneous demand that it be film and stop being film. Put simply, the film must be slowed down to be legible; its twenty-two seconds go by too fast for its vital content to be adequately studied. As a result, it speaks its own impossibility as film. Yet the precise temporal measurements it has to offer concerning the logistics of the shooting demand that it also always speak at 18.3 frames per second. Its status as evidence relies simultaneously on duration and its arrest, film and still frame.[10]

Since contains multiple, repeated versions of the assassination, which seem to represent the repetitiveness of the media coverage of this event. They also suggest a series of different, tongue-in-cheek assassination theories, a single gunman, a second gunman, a variety of different weapons, and so on. At one point, Billy Name gives the direction that the assassination should be performed in slow motion, and the gunman comes skipping through the set waving a banana in a rather swishy way (fig. 9). Another version is staged several times as an attack by two assassins wielding giant inflatable Baby Ruth bars. Of course,

11

the idea that forensic analysis of Warhol's version of the Kennedy assassination would uncover nothing more than a bunch of pop art imagery like bananas and enormous Baby Ruth bars is a nice joke on Warhol's part—perhaps a joke directed at researchers like me, but also a joke about the seriousness of the assassination investigations themselves.

Warhol is careful, however, to include other well-known imagery from what might be called the iconography of the assassination. For example, the terrible moment when Jackie Kennedy crawled onto the back of the limousine is enacted by Susan Bottomly crawling along the back of the Factory couch (figs. 10, 11). And the shooting of Lee Harvey Oswald by Jack Ruby is enacted twice as well (figs. 12, 13). The Warhol crew went to some trouble to get the black-and-white look of the moment just right, with a lot of men in jackets pressing around. The blood in this scene was carefully prepainted on the floor by Billy Name. And the film crew is a constant presence throughout the film, holding lights and microphones, walking in

FIGS. 9–10 ANDY WARHOL, FRAME ENLARGEMENTS FROM *SINCE*, 1966, 16 MM FILM, COLOR, SOUND (PRESERVED VERSION 67 MINUTES AT 24 FRAMES PER SECOND), COURTESY THE ANDY WARHOL MUSEUM, PITTSBURGH

FIG. 11 PHOTOGRAPH IN *LIFE* MAGAZINE, OCTOBER 2, 1964, 46

FIG. 12 PHOTOGRAPH IN *LIFE* MAGAZINE, OCTOBER 2, 1964, 50. PHOTO BY JACK BEERS

FIG. 13 ANDY WARHOL, FRAME ENLARGEMENT FROM *SINCE*, 1966, COURTESY THE ANDY WARHOL MUSEUM, PITTSBURGH

FIG. 14 ANDY WARHOL, FRAME ENLARGEMENT FROM *SINCE*, 1966, COURTESY THE ANDY WARHOL MUSEUM, PITTSBURGH

front of the camera and crowding into the action, so much so that the filmmaking process itself becomes representative of the press attention surrounding this traumatic public event. Another iconic moment is represented by Roger Trudeau, playing the dead Kennedy, lying down in a red turtleneck, with the date November 22, 1963, placed on his chest, in a kind of collage or superimposition (fig. 14). Chaotic as it is, a great deal of work went into this film.

The film was never shown, except perhaps in private screenings at the Factory, but Warhol did not abandon this subject matter completely. In fact, I would like to suggest, briefly, that *Since* can be usefully thought of as the direct precursor to another work in a completely different medium: and that is the print portfolio titled *Flash — November 22, 1963*, which Warhol produced in

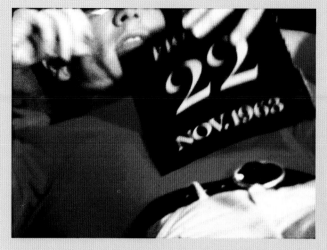

14

1968 (pl. 26). This is a series of eleven screenprints published in a limited portfolio accompanied by a printed Teletype text in the style of the wire service news reports at the time of the assassination. You will hear some of these wire service reports being read out loud in *Since* — for example, Johnson's proclamation of a national day of mourning. The prints themselves are a series of collaged or superimposed images appropriated from popular culture — Kennedy's image from a campaign poster, the presidential seal (see p. 188, doc. 17), a photograph of Jackie in Dallas that Warhol used in his silkscreened portraits of her, an ad for a rifle of the kind Oswald used, and a photograph with an arrow pointing to the book depository window from which he shot the president. Two of the prints contain the image of a set of clapper boards from a movie production superimposed over the faces of Lee Harvey Oswald and John Kennedy. This specifically cinematic symbol could be a direct reference to the Zapruder film, or to Warhol's own assassination film. In any case, this image identifies Oswald and Kennedy as the two main stars in this particular drama and frames the assassination itself as a deliberately constructed or manufactured narrative....

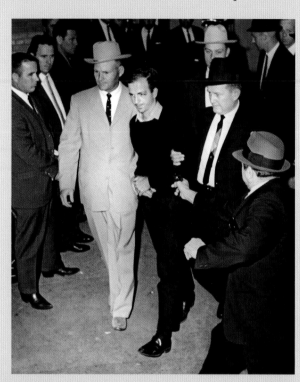

12
—
13

...In both works, Warhol's assassination is a repetitive collage of chaotic images, his version of a moment of public crisis whose truth is perpetually concealed beneath the condensed layers of its own media representations. Whether this is solemn or whether it is ridiculous seems almost incidental to Warhol's interest in it, and to his profound understanding of the ways in which media work, in both the strictest technical sense as well as the broadest metaphorical terms.

THE PLAY OF THE TELEVISUAL: ANDY WARHOL'S VIDEO AND TELEVISION PRODUCTION

Broadcast television became, over the course of Andy Warhol's lifetime, a significant medium in terms of the global spread of the moving image, flourishing between the heyday of movies and the launch of the Internet. Video and television also became part of Warhol's art practice as he explored the televisual imaginary in a remarkable body of work that ranged from experimental videos to his own TV show, in which he also starred.

Warhol's fascination with the instant recording capacity of video—showing on the television screen in real time what the camera is recording—is evident as early as 1965, when he introduced an early video recording system into his filmmaking. A videotape of Edie Sedgwick playing on a monitor within his double-screen film *Outer and Inner Space* is a remarkable demonstration of Warhol's understanding of the electronic medium. He played here with the way the monitor could reframe the performer within the larger frame of the film screen. It is a compelling example of his effort to break the closed fiction of the film narrative, as an off-screen voice engages Sedgwick in multiple conversations and performances through the prerecorded videotape and on film.

Warhol did not commit to using video in a sustained way and in relation to television until the early 1970s, when he acquired the improved and readily available Sony Portapak video recorder and player. This reel-to-reel, ½-inch, more portable system allowed Warhol to pursue his growing interest in the production of videotapes and television projects. It is worth noting that this investment in video followed the development in 1969 of his publishing venture *Interview*, a tabloid-format magazine featuring interviews with and stories about models, photographers, artists, actors, and the fashion world. The success of *Interview* encouraged Warhol to break out into video and television, calling on contacts he made through the magazine and synergy between the magazine and his nascent plans for television. The acquisition of the video-production equipment made Andy Warhol T.V. Productions both an integral part of the Studio and a key strategy in Warhol's transformation of himself into an instantly recognizable public figure.

Warhol initially used the video camera to videotape in his home (including footage of his mother) as well as in the Studio. By 1973 the Studio had more than one Portapak, used to record the Factory Diaries, systematically documenting daily activities in the Studio, such as Andy painting, his associate Fred Hughes on the telephone, or famous visitors like David Bowie, who improvised before the camera. Vincent Fremont joined the Studio full time in 1971 and became a principal facilitator of Warhol's interest in video and television. Video intrigued Warhol because its silent presence effortlessly captured what was happening in front of the camera. As Fremont noted, Warhol would have wished cameras to be rolling all the time.[11]

Warhol's intuitive understanding of video was part of an obsession with the popular culture in which he grew up, and he saw it playing an increasingly powerful role in the public sphere. The glamorous world of movie stars and the spectacle of fashion became not only the subject of his art but a scene he wanted to join as an on-screen personality. He did this through his TV shows and by becoming a runway model at fashion shows. His early films were a radical deconstruction of cinema's codes and a transformation of cinematic imaginary. But in his videotapes and television productions, he created a new televisual style, a blend of the rhetorical codes of broadcast television that he forged into a distinctive discourse through his mix of professionalism and amateurism. Warhol's video and television work demonstrates how he brought the narrative of the soap opera as well as television news, gossip, and current events into his art practice and directly into the mass medium of television. In a sense, he was creating his own "headlines" as he shifted his attention to the electronic medium of video and television.

Through his videotape and TV productions, Warhol placed himself into the flow of the events and entertainments beamed into our homes and imaginations through television. The performers in his productions, including Warhol himself, were not acting for the camera but saw themselves as being inscribed into the mass medium of TV, creating scenes for a "reality" television that was ahead of its time. An early expression of Warhol's interest in developing ideas and scripts for television was *Vivian's Girls*, from 1973, a show loosely structured around a group of models and drag queens who were living together. It starred Brigid (Polk) Berlin, Candy Darling, Nancy North, Paul Palmero, and others. Although never completed, the show gave Warhol a chance to explore the genre of the TV soap opera. This project led to the video *Phoney* (1973), which featured telephone conversations between Darling and others. *Fight*, a subsequent production (1975), centered on a couple arguing within the restricted space of an apartment. Improvised by Charles Rydell and Brigid Berlin, its titanic yelling matches are hilarious, over-the-top performances. Warhol essentially stripped down the television soap opera narrative into these intense confrontations.

Another aspect of his effort to transform television was the development of test ideas for a talk show in 1974. In these pieces Berlin plays various roles. In one "Brigid Testing for Talk Show" segment (pl. 27), she presents TV as therapy and talks directly to the viewer as she delivers "good news." Another piece, in which Berlin talks about money, begins with her preparing for the shoot and being coached by Fremont and Warhol off camera (pl. 28). Again she creates a diverting monologue that moves in all directions and across multiple topics. In a third piece she plays a news anchor trying to engage her imagined viewers and to elicit newsworthy quotes from on-camera guests Cyrinda Foxe and Ronnie Cutrone (pl. 29). Each

of these pieces mines Berlin's uninhibited and charismatic personality as she draws out of herself a personal and comedic reflection on, and verbal description of, her own life. These pieces also continually refer to the news on the TV networks and in the newspapers. Shot in close-up, some with off-camera direction from Warhol, they are all charged with the unexpected. What will Berlin say? In her unpolished expression of opinion and self, she evokes the candor and live scenes that television in its earliest years appeared to offer. As David Antin has noted, early television production manuals observed that staged "mistakes" on taped programs helped provide the illusion and support the myth of live TV.[12] Warhol understood this capacity of the medium to give a sense of the unexpected that, unlike the scenes and situations he set up in his films, were placed within the frame of the intimately scaled television set in the viewer's home. These experimental narratives appropriate the conventions of television narrative codes that Warhol turned inside out by elaborating a key rhetorical strategy — the argument or the personal commentary — and making that the center of the action.

Warhol had an extraordinary set of individuals working at the Studio as well as friends who became caught up in these television projects. By 1977 he was focused on cultivating ideas and projects for television as part of his production company. He began in earnest to develop a television show about fashion and celebrities with the working title *Fashion* (1979 – 1980). He hired Don Munroe, who worked in Bloomingdale's in-house video department, to direct all the television shows, with Vincent Fremont as producer (Warhol himself was executive producer). Each show ran for thirty minutes and focused on one fashion designer. This was followed by *Andy Warhol's T.V.* (1980 – 1982), with a segmented format covering various subjects. The show ran on Manhattan Cable Television, on which Warhol had bought a half-hour time slot. He then shopped the concept and program around the television industry in the area and found a home in 1983 on Madison Square Garden Network, a sports cable channel seen in New York, New Jersey, and Connecticut. The channel bought twelve shows, nine of which were completed. The shows featured fast-paced interviews and fashion segments. Senator Daniel Patrick Moynihan (episode 2) was interviewed by his daughter Maura Moynihan on his visit to Afghanistan (pl. 65). In an outtake from episode 5, Keith Haring talked about the newspaper headlines that he cut up for his first street interventions (pl. 66). These features are a remarkable source of information about the period, but most important, they reveal Warhol's effort to present himself in a news and pop-cultural television magazine format, a media celebrity promoting his name and face as an iconic presence. For the first time, an artist was seeing television as a means to extend his personal fame and brand on his own terms.

The degree to which Warhol imagined himself as a performer and personality surged when Andy Warhol T.V. Productions developed its first pilot, *Andy Warhol's Fifteen Minutes* for MTV, a national cable station. This new concept of a music channel transformed the cable television industry, and it became home to Warhol's final TV production. Originally planned for fifteen minutes, the show was expanded to a half-hour and featured Warhol's distinctive mix of pop celebrities, fashion designers, and musicians. Each episode was introduced with a Brady Bunch–style grid of the celebrities who were to appear, including Warhol. Segment followed segment without elaborate bridges, with Warhol as master of ceremonies, a role he handled with a casual and ironic detachment but also an absolute fascination for the people he was attracting to the program and the stage he was creating for himself through the medium of television. For example, episode 2 combined a discussion of war with music and fashion segments (pl. 67). In episode 3 Warhol discussed a favorite late-night activity: watching "old news" (pl. 68). Once again news, current events, music, movies, fashion stars, and models mixed it up in a format that presaged today's hundreds of cable channels and the constant online streaming of news and music videos. This series began in 1985 and continued until Warhol's death in 1987.

In addition to pieces produced by Andy Warhol T.V. Productions (including music videos with Ric Ocasek and The Cars and short pieces for *Saturday Night Live*), Warhol also appeared in modeling jobs and advertisements (for the videotape manufacturer TDK in Japan), further promoting himself as a personality. This culminated in his appearance on the hit TV series *The Love Boat* in 1985, playing himself, the celebrity-artist. Warhol's self-fashioning through television was a deliberate effort to place himself in the public sphere and the popular imagination and to become a celebrity in the very medium — television — that so captivated him.

Warhol rediscovered himself on television. The mass medium became a mirror in which he could rebuild himself as a performer and as an on-screen personality. In a sense, Warhol made himself and his name a headline that gained instant recognition, fame, and notoriety as he moved with ease and an ironic distance through the worlds of fashion, art, celebrity, and power. In the process, he fulfilled Walter Benjamin's recognition, from the early part of the last century, of that instant in which the image consolidates itself as a sign of value and power through publicity: "News service and idleness. Feuilletonist, reporter, photographer constitute a gradation which waiting around, the 'get ready' succeeded by the 'Shoot,' becomes ever more important vis-à-vis other activities."[13] So Warhol, the consummate artist and transformer of popular culture in the late twentieth century, fulfilled his dream of being in the news.

HEAPS OF HEADLINES: THE WARHOL STUDIO SCRAPBOOKS

MATT WRBICAN

As a preteen in the years 1938–1941, Warhol famously kept a scrapbook of photographs of the Hollywood stars who captured his imagination. Twenty years later, as he morphed from a busy commercial artist whose drawings were printed alongside newspaper headlines into a fine artist and filmmaker worthy of headlines himself, Andy Warhol began to collect the news articles that charted his own success (he is said to have paid friends and associates fifty cents to a dollar for such clippings rather than hire an agency). Midway through the project, he noted: "Nothing's missing. I'm everything my scrapbook says I am."[1] Many of Warhol's clippings were arranged in a series of thirty-four scrapbooks that he and his employees created over approximately two decades.[2]

Housed at the Andy Warhol Museum in Pittsburgh, the Warhol Studio Scrapbooks reveal not only Warhol's abiding obsession with his own career but the passion with which he pursued it. Their formats fall into two basic sizes — described as "large" and "small" — and they are identified by number or title. Eight large scrapbooks, which are extremely fragile, hold newspaper clippings from between 1966 and 1987. These articles were attached to pages of brittle black paper using cheap rubber cement, which over time has effectively made them unreadable and largely inaccessible except in microfilm. Generally too delicate to handle safely, many of the original clippings have also come loose and flutter away as each page is turned. This unfortunate situation has necessarily limited the scope of this photo-essay to the small scrapbooks.[3] The group of twenty-six small albums contains photographs and press clippings that were slipped into black pages with transparent plastic sleeves, thus avoiding the need for adhesive, which damaged the newsprint in the large scrapbooks.

The small scrapbooks are either numbered 1 through 15 (skipping no. 5 for unknown reasons) or given such titles as "Photo Album/Factory Stars," "Interview Publicity 80/81," and "A.W.T.V" to indicate volumes dedicated to the stars of Warhol's films in the 1960s, publicity for his publishing venture *Interview* magazine, and his television programs of the 1980s, respectively. The earliest items in the small scrapbooks date to 1961 (though most are dated after 1965), and coverage goes forward to the artist's unexpected death in 1987. The series was continued by Warhol's successor, the Andy Warhol Foundation for the Visual Arts, Inc., until the collection was physically passed to the Andy Warhol Museum in early 1994. The order has been maintained, although many of the original small scrapbook binders and pages have been replaced with superior (though nearly identical) materials for the long-term preservation of the contents. In the seven years following Warhol's death, an additional twelve volumes were added to the series (eight small and four large).

This brief photo-essay offers a sampling of Warhol's small scrapbooks. It focuses on some of the best-known American articles, several interesting rarities, and a number of stories that were published overseas, demonstrating the ever-growing appeal of the artist and his work. The articles are presented in chronological order when the date of publication is known, but Warhol's scrapbooks were used as a reference tool for the artist, his associates, and guests and are not in strict chronological sequence owing to frequent and often careless handling. The few undated clippings have been inserted approximately where they should fall based on the general date of the story's subject.

Warhol wrote: "Don't pay any attention to what they write about you. Just measure it in inches." Alas, in the current context we must pay attention to what was written. Sorry, Andy.

"Built-In Obsolescence: Art by Andy Warhol," by Gregory McDonald, photographs by Gilbert Friedberg, *Boston Sunday Globe Magazine*, October 23, 1966, Warhol Studio Scrapbook, Vol. 2 small, page 39

Essentially an illustrated review of Warhol's solo exhibition at the Institute of Contemporary Art in Boston, the story bears a headline that makes an obvious connection between the mass-produced commercial subjects of his work and their sources in the world of everyday commerce (with the constant need for evolving fashion to drive it). Warhol surely would have appreciated this understanding of his work, although if he had read beyond the headline, his disappointment might have been palpable until the very end. After lumping Warhol with various social problems that have no solution, accusing him of being unoriginal, describing his physical presence in unflattering terms, and expanding in agreement on Warhol's stated belief of his work's insignificance, the writer finally comments: "After Warhol there will come other artists to celebrate with us, make conscious and intense, those things of our immediate world, including ourselves, which have only the most limited existence."

"Narcissus in Hades," by Brian O'Doherty, photographs by Billy Name, *Art and Artists* [London], February 1967, Warhol Studio Scrapbook, Vol. 4 small, pages 2 and 3

This important early article in the British arts press, written by the critic/artist known as Patrick Ireland, is concerned primarily with Warhol's film *The Chelsea Girls*. The evocative headline alludes to the beautiful, mirror-obsessed denizens of Warhol's Factory and the dark dramas they played out in Warhol's films. The layout opens with Billy Name's portrait of the Warhol superstar International Velvet (Susan Bottomly, who later made it to the cover of *Esquire* magazine). This issue of *Art and Artists* also included Christopher Finch's article, "Warhol Stroke Poussin."

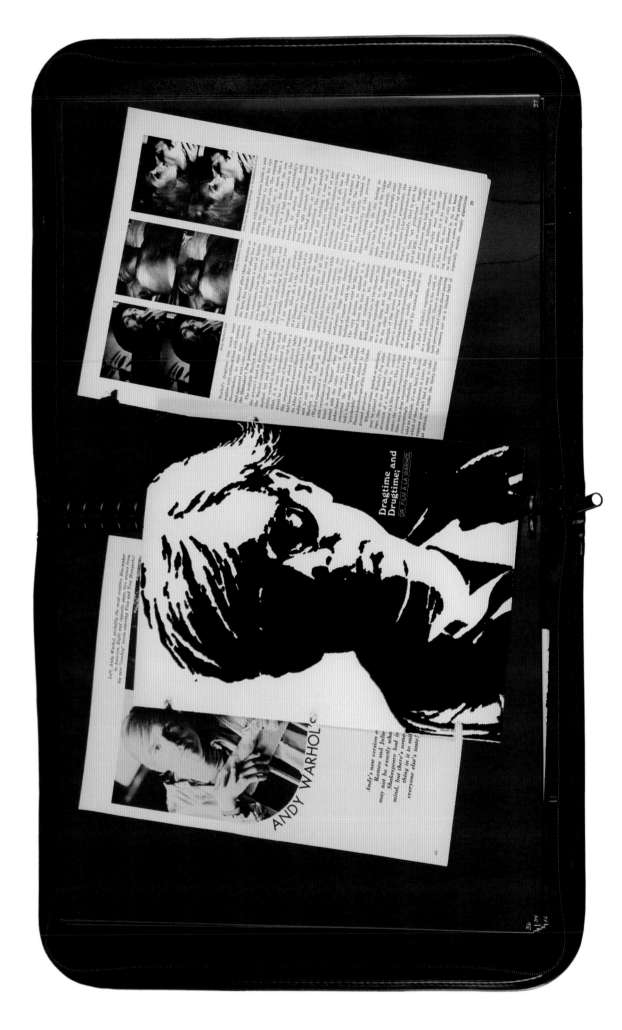

"Dragtime and Drugtime; or, Film a la Warhol," by Parker Tyler, illustration by Steven Richter, *Evergreen Review* [New York], vol. 11, no. 46 (April 1967), Warhol Studio Scrapbook, Vol. 4 small, page 37

With the switch of a single letter, this headline cleverly links two major subjects of Warhol's films. Tyler had reviewed a show of Warhol's drawings in 1956 for *Art News*. He wrote several books on film and art and was the longtime partner of Warhol's friend Charles Henri Ford, the poet and publisher of *View* magazine. It is said that Warhol was with Ford when he bought his first movie camera in 1963.

"Nothing to Lose," text and photographs by Gretchen Berg, *Cahiers du Cinéma in English* [New York], May 1967, Warhol Studio Scrapbook, Vol. 6 small, page 34

This is the famous interview from which many of Andy Warhol's best-known quotations are taken. The artist never actually said most of the "quotes" attributed to him in this soliloquy-like essay, but the title chosen for the *Cahiers* reprint does come straight from his own mouth.[4] Gretchen Berg was frustrated by Warhol's responses to her thoughtful questions in the original interview and sought to make the piece more interesting to the reader. She skillfully removed all trace of herself, combining her well-phrased questions with his monosyllabic answers to create a hybrid. In the process she made Warhol sound more articulate than he wished. He preferred to play his game of "um, yes," or "um, no."[5]

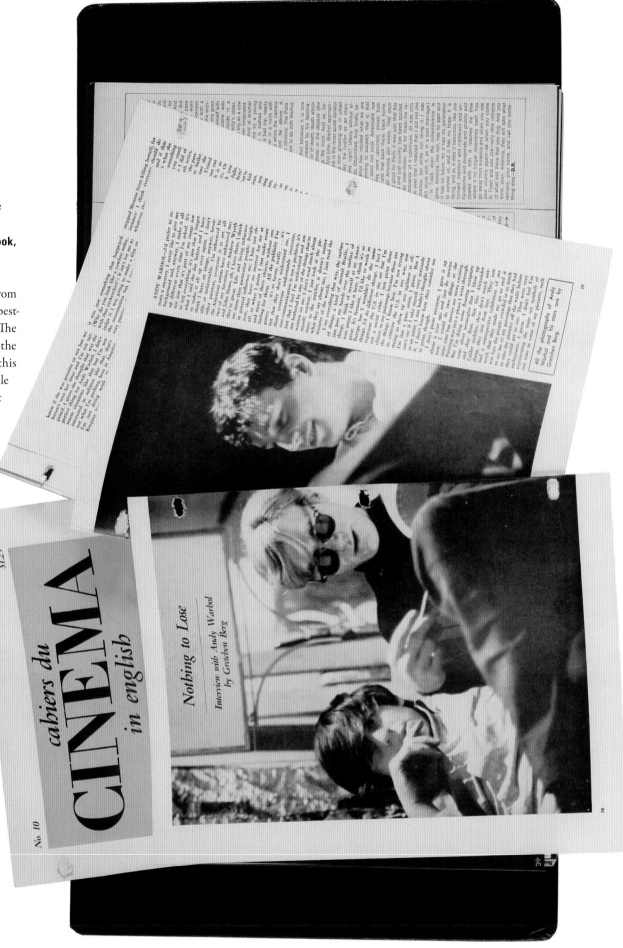

"New York Art and the Velvet Underground," by Jonathan Richman, *Vibrations* **[Boston], September 1967, Warhol Studio Scrapbook, Vol. 6 small, page 70**

Written by a man who three years later would front the band Modern Lovers and go on to make his own headlines, this article discusses the shared qualities of Warhol's rock-and-roll band and the New York art scene. Warhol's copy of the article, however, is missing Richman's brilliant hand-drawn chart prophesying the eternal rise of the Velvets' influence as other popular musicians of the time (Jimi Hendrix, Jefferson Airplane, and the genre of "Art Rock") crash and burn. In Richman's sketched graph, the Beatles remain on top, and The Who's mutating path has more flowing branches than the Mississippi River Delta. Richman was about sixteen years old when he wrote this article; it was published a few months before he sent Warhol a fan letter that included an example of his own skill at silkscreening.[6]

"Enigma of a Headline Maker," by Michael Thomas, photographs by Nat Finkelstein, *Penthouse* [London], vol. 2, no. 6 (1967), Warhol Studio Scrapbook, Vol. 4 small, page 13

The headline encapsulates Warhol's playful strategy for his outward persona, one that simultaneously confounded and grabbed the public's attention. These two sides become evident throughout the article, which presents a casual if perplexing record of a day's events in Warhol's Factory. The piece's introduction asks, "Is he fooling or does he mean it? Why doesn't he answer when you ask him? Who is he, anyway?"

"Amerikkalaiset Taiteentekijät: Me Mymme Elämäntapaa" (American artists: We sell a lifestyle), author unknown, photographs by Nat Finkelstein, Unidentified Finnish publication, c. 1967–1968, Warhol Studio Scrapbook, Vol. 2 small, pages 42 and 43

Probably published in conjunction with the Warhol exhibition in 1968 that traveled to four cities in northern Europe (though none in Finland), this seems to be a general story about Warhol and the Velvet Underground. Nat Finkelstein's photographs of the band date from 1966.

"Was ist Wahr an Warhol?" (What is true of Warhol?), by Urs Hausmann, photographs by Lee Kraft, *Twen* [Munich], August 8, 1968, Warhol Studio Scrapbook, Vol. 2 small, pages 50 and 51

Warhol's work achieved acclaim and popularity in Germany as early as 1965, when his Flowers paintings were shown in Essen. His early pop paintings of commercial products, stars, and tragedies (like electric chairs, car crashes, and suicides) were more readily accepted in Germany than in America, and many of his best paintings from that period found homes in German collections.

"Warhol Tries Making TV Ad; Finds It's 'Fun,'" by Bill Hutchinson, *Advertising Age* [New York], October 7, 1968, Warhol Studio Scrapbook, Vol. 2 small, page 64

Following his first public appearance after recuperating from the attempt on his life,[7] Warhol accepted a commission to make a television commercial for the Schrafft's restaurant chain (of which Warhol was a frequent patron). The result was titled "The Underground Sundae," and it received an award from the American Institute of Graphic Arts.

"Andy Warhol: O Anjo Diabólico"
(The black angel), by Lucas Mendes,
photographs by Jack Mitchell,
Manchete (Headline) [Rio de Janeiro],
January 30, 1971, Warhol Studio
Scrapbook, Vol. 3 small, page 26

HEADLINE. What better name for a popular magazine? This particular headline derived from the title of a pulp paperback published in Brazil in 1965. It also recalls the Velvet Underground's notorious "Black Angel's Death Song," though the band was beyond Warhol's orbit at this time.[8] In a teaser on the table of contents, the magazine referred to Warhol as "the Pope of Pop" (that clipping is kept in a separate scrapbook). About this time the epithet "pope" was also applied to Warhol's superstar Ondine (Bob Olivo) for his frequent role as confessor to New York's underground scene.[9]

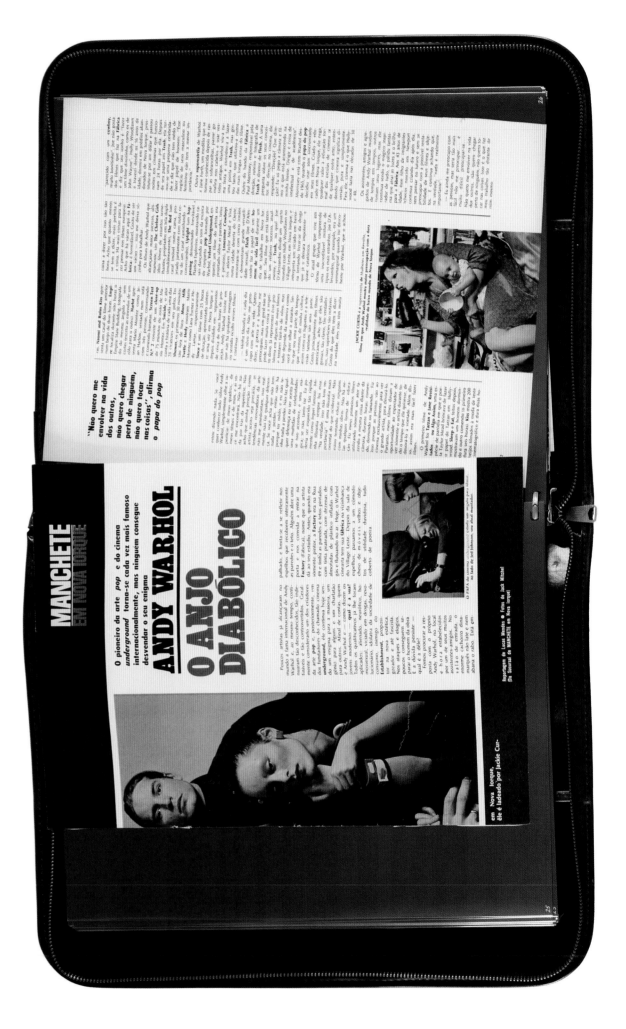

"Warhol's Gang's All Here; Plan More Fun, More Profit," by Paul Sargent Clark, *The Hollywood Reporter*, July 13, 1971, Warhol Studio Scrapbook, Vol. 7 small, page 58

While most of Warhol's films were shot in New York, director Paul Morrissey shot the Warhol studio's production *Heat* in Hollywood, starring young hunk Joe Dallesandro and Oscar nominee Sylvia Miles in an updating of Billy Wilder's *Sunset Boulevard* (1950).[10] Paul Sargent Clark points to the new focus for Warhol's films: to make money. Before *Heat*, it was primarily the earnings from Warhol's paintings and prints that supported his filmmaking ventures, most of which were not financially successful, although they generated a lot of opinions.

"Andy Warhol: Le Pape du Pop"
(The Pope of Pop), by Louis Wiznitzen,
photographs by Henriette Grindat,
TV Radio je vois tout (I see all TV
and radio) [Switzerland], October 14,
1971, Warhol Studio Scrapbook,
Vol. 3 small, pages 1 (color), 2 and 3
(black and white)

The press assigned Warhol many
labels over the years, including a
variety of royal titles. This article
provides a thoughtful and up-to-the-
moment accounting of Warhol's pop
phase, discussing his paintings, music,
books, films, and personal mode of
dress. Illustrated with photographs
of the Warhol retrospective that was
drawing huge crowds to the Whit-
ney Museum of American Art in
New York at the time, the article
notes that the French writer
Alfred Jarry (who inspired Dada-
ists with his absurd play *King
Ubu*) would feel at home with
Warhol.

"Porno Pork," text and photographs by Michael Pergolani, *Playmen* [Italy], c. 1971, Warhol Studio Scrapbook, Vol. 1971–1972 small, page 11

Although undated, this piece is most likely from 1971. Warhol's play *Pork* was staged in London in August of that year and involved, as this article suggests, a great deal of nudity. Legally credited as a work by Warhol, *Pork* actually reflected substantial intervention by Anthony Ingrassia, who drastically boiled down transcriptions of about twenty-four hours' worth of Warhol's audiotapes. Characters were based on people in Warhol's circle who appeared on the recordings, made in 1967/1968. Each had a pseudonym: Warhol was "B. Marlowe," played by Tony Zanetta; Brigid Polk (Brigid Berlin) was the title character, "Amanda Pork," played by Kathy Dorritie in London. Later Dorritie became Cherry Vanilla, got a job with David Bowie (as did several of *Pork*'s cast and crew), and fronted a band whose members eventually became The Police (Stewart Copeland and Sting).[11]

"What's Andy Warhol Doing with That Cookie Jar? Claude Picasso Knows," photographs by Claude Picasso, *Saturday Review* [New York], October 1972, Warhol Studio Scrapbook, Vol. 8 small, page 11

Scouring flea markets and antique shops, Warhol assembled a collection of nearly 150 ceramic cookie jars that were commercially produced and wildly popular from the 1930s into the 1950s. After this article appeared, the price of such cookie jars skyrocketed. Warhol's were sold in small lots at his estate auction in 1988, bringing nearly $250,000. As noted here, Warhol referred to the humble crocks as "time pieces." He purchased most of them at a shop called "Pieces of Time," where Claude Picasso, son of Pablo Picasso, shot these photographs. Claude had also photographed Warhol for *Esquire* in 1969.

Long before the James Bond or Star Wars film franchises, there was Andy Hardy. This headline plays on a Hollywood character portrayed by Mickey Rooney in a series of fifteen phenomenally popular MGM feature films made between 1937 and 1946 (a sixteenth appeared in 1958). Warhol would have been quite familiar with these idealized, sentimental comedies from his youth.[12] Rooney starred in all of the Hardy films, and his occasional costars included Judy Garland, Lionel Barrymore, Esther Williams, and Lana Turner. These films often focused on young Hardy's teenaged romantic troubles, and the *Town & Country* article is illustrated with a photograph of Warhol surrounded by a coterie of New York ladies (and a blow-by-blow description of those who decided they did not want to be included).

"Le dernier avatar d'Andy Warhol" (The latest incarnation of Andy Warhol), by Patrick Thévenon, photographs by *New York Times*, Jacques Violet, Cahiers du Cinema, Francesco Scavullo, Vezio Sabatini, David Bailey, and Elisabeta Catalano, *L'Express* [Paris], June 4–10, 1973, Warhol Studio Scrapbook, Vol. 8 small, page 22

This headline alludes to Warhol's frequent reinvention of his public persona: when he arrived in New York from Pittsburgh in 1949, he honed a pathetic "Raggedy Andy" image (rumpled clothes and worn-through loafers), which charmed art directors; this was superseded in the mid-1950s by the uptown sophisticate (tailored cashmere suits), then the downtown underground (Cuban-heeled Beatle boots, striped sailor's shirt, perpetual sunglasses, and a leather jacket) of his mid-1960s Silver Factory. At the time of this article, he pioneered a business-casual look: seersucker jacket, denim jeans, and tasseled loafers.[13]

"The Liz and Andy Show," by Robert Colacello, photographs by Tazio Secchiaroli, *Vogue* [New York], January 1974, Warhol Studio Scrapbook, Vol. 8 small, page 31

Warhol actually appeared in a movie with Hollywood legend Elizabeth Taylor. Based on the novel *The Driver's Seat* by Muriel Spark,[14] the film was produced by Franco Rossellini and directed by Giuseppe Patroni Griffi but was not highly acclaimed. Taylor was divorcing Richard Burton at the time, a fact mentioned often here by Bob Colacello, who worked for Warhol from 1970 to 1983. A colorful diary of the shooting of Warhol's scenes, the article begins by observing that life in Rome "is like The Late Show," which inspired the headline. Colacello reveals that Warhol's character in the film was meant to be "a rich creep of undisclosed nationality and occupation"; that Taylor's intentionally bizarre costume was designed by Valentino; and that when Warhol muffed his few lines, Taylor tried to relax him with tales of her riches lost and found.

This headline seems to refer to Warhol's persistent interest in mirroring and recording the culture around him. He shot tens of thousands of photographs — and recorded nearly 4,000 audiotapes and more than 2,000 videotapes — and it was through these creative explorations that Warhol "discovered" America. One might also say that he was "discovering America" through his frequent shopping excursions to antique shops and flea markets, as described in the "cookie jar" piece in *Saturday Review* (see p. 73).

As shown in Bill Cahill's photograph, Warhol also was discovering France (or, at least classic works of French art deco furniture); the brass-and-marble desk at which he sits was bought for Warhol by his manager Fred Hughes during a trip to Paris in 1970. By his death, Warhol had formed one of the best collections of art deco in the world, equal in quality to that of many great museums (the same was true for his collection of Native American art and artifacts).

"Secrets of My Life," by Andy Warhol,
cover photograph by Carl Fischer,
New York, March 31, 1975, Warhol
Studio Scrapbook, Vol. 1974–1975
small, page 9

Brief excerpts from Warhol's forth-coming book, THE *Philosophy of Andy Warhol: From A to B (and Back Again)*, fill eleven illustrated pages of this magazine. As with nearly all of Warhol's literary efforts, audiotapes formed the basis for the book, and quite a few of the most salient statements were in fact spoken by one of his numerous paid assistants.[15] Curiously, the first hardcover edition used all capital letters for the title's initial word, and archival documents reveal that Warhol wanted to use THE alone as his title but the publisher balked.[16] While the idea seems related to that for titling his earlier "novel" simply *a* (1968), this proposed title may in fact have been an homage to Marcel Duchamp.[17]

"Confidenze di Andy Warhol: Rinomata fabbrica opere d'arte" (The secrets of Andy Warhol: Famous Factory works of art), by Romano Giachetti, photograph from the set of Agnès Varda's film *Lions Love* (1969) with Viva, James Rado, and Jerome Ragni, *L'Espresso* [Rome], October 5, 1975, Warhol Studio Scrapbook, Vol. 8 small, page 35

This article presents an interesting and seemingly thorough dialogue, though it is entirely imaginary, as Warhol would likely have preferred; yet the headline suggests an exclusive interview with him. Giachetti claimed to borrow the technique from Warhol's *Philosophy* book. The strange editorial use of an image related to Varda's film might be explained by the fact that Viva was one of Warhol's superstars in the late 1960s and *Lions Love* was on the cover of the first issue of Warhol's *Interview* magazine in 1969.

"Ich liebe altes Geld und neue Schecks" (I love old money and new checks), by Eva Windmoller and Max Schultze-Vorberg Jr., photographs by Robert J. Levin, *Stern* [Hamburg], October 8, 1981, Warhol Studio Scrapbook, Vol. 12 small, page 36

With a title that reads like a quotation from Warhol's *Philosophy* book, the article includes a brief, casual interview with Warhol and Robert Colacello. Topics include American authors Tennessee Williams, Truman Capote, and Gore Vidal; Warhol's use of "diamond dust" in his paintings; his frequent attendance at church; his unrealized plan for the "Andymat" restaurant chain; and his use of Minox and Polaroid cameras.

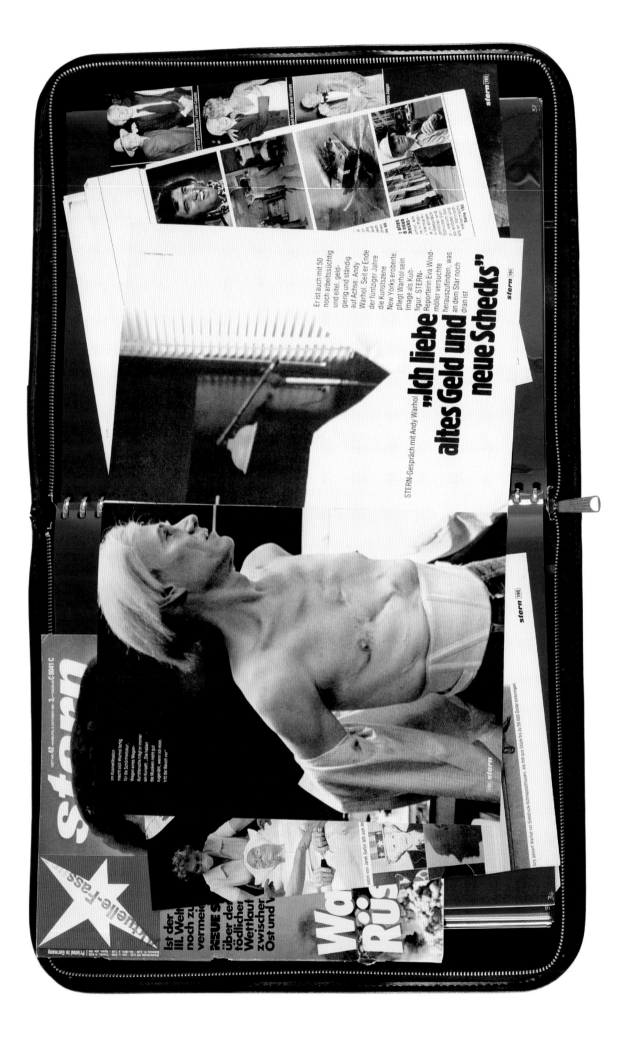

"Andy Warhol: A Dossier; How Julia Warhola's son achieved fame for more than fifteen minutes," by Carter Ratcliff, photographs by Victor Skrebneski, *TWA Ambassador* [St. Paul], October 1981, Warhol Studio Scrapbook, Vol. 12 small, page 33

The subtitle here alludes to Warhol's famous quotation about fame (although Olle Granath, who assembled the exhibition catalogue in which the quote first appeared, has written recently that it may have been invented by his own supervisor).[18] Ratcliff attempts to chronicle Warhol's life and career up to that point and does this well, citing no fewer than five possible years and four possible locations that the artist gave for his birth. Ratcliff did omit the rarest and most entertaining option (Honolulu) and noted recent "general agreement" that McKeesport, Pennsylvania, seemed to be the favorite place and August 6, 1928, the likely date of Warhol's birth. Warhol's certificate of baptism agrees with this date but records Pittsburgh as the location. Both of Warhol's brothers have concurred with the baptismal certificate.[19] Nonetheless, Warhol's many years of deliberately clouding the facts of his birth created great confusion, no doubt to his amusement.[20]

"The Rise of Andy Warhol," by Robert Hughes, illustration by David Levine, *The New York Review of Books*, February 18, 1982, Warhol Studio Scrapbook, Vol. 12 small, page 20

Ostensibly a review of the first catalogue raisonné of Warhol's prints,[21] this article instead attacks Warhol personally and artistically; it thus provides a look back on an earlier period of cultural polarization.[22] Hughes initially refutes Warhol's relative fame, popularity,[23] and other aspects of his career. He abuses art critics for supporting Warhol's art[24] and attacks his *Ten Portraits of Jews of the Twentieth Century*.[25] He reproaches *Interview* magazine for its fondness for the Iranian royals and the Reagan White House,[26] inaccurately predicting that Warhol was fated "to play Bernini to Reagan's Urban VIII."[27] Unable to accept transformations that are not to his liking, Hughes portrays Warhol as a cultural bogeyman, which Levine's illustration of the artist in a Disney dwarf's hat reinforces.[28] Claims such as "Warhol was the first American artist to whose career publicity was truly intrinsic" undermine Hughes's argument. Hughes eventually tempered his views, but not until after publishing a barbed obituary for Warhol in *Time* magazine;[29] artist Keith Haring sent a scathing protest to the magazine in response, and copies of both documents reside in another of Warhol's scrapbooks.

"Forged Image," paintings by Andy Warhol, photograph by Christopher Makos, *Artforum* [New York], February 1982, Warhol Studio Scrapbook, Vol. 12 small, page 24

One of Warhol's best-known quotations is "Being good in business is the most fascinating kind of art. Making money is art and working is art and good business is the best art." Warhol wrote his own headline for this article, with a triple gatefold layout of his new Dollar Sign paintings and a portrait of himself in semi-drag. The piece can be seen as uniting his oft-declared "business art" with a further declaration of his sexuality.

"Der Kaiser als Kunstwerk" (The emperor as a work of art), by Edgar Fuchs, photograph by Ulli Skoruppa, *Bunte* (Colorful) [Offenburg], June 3, 1982, Warhol Studio Scrapbook, Vol. 12 small, page 7

Although Warhol was often called by imaginary honorifics such as "the Pope of Pop" (see pp. 70–71), the "emperor" in this headline refers to another icon of popular culture: German soccer star Franz Beckenbauer, who had just recently had his portrait painted by Warhol. The painting was commissioned by Hubert Burda, the publisher of *Bunte* and about 250 other periodicals, and this story is notable for appearing under the rubric of "Gesellschaft" (society). The following year, Burda—who was trained as an art historian—also commissioned Warhol's paintings and edition of prints entitled *Magazine and History*, a loose grid of some twenty-five of the magazine's most memorable covers. Burda is said to have pursued his interest in the artist even further, apparently stating that *Bunte*'s modern layout was inspired by Warhol.

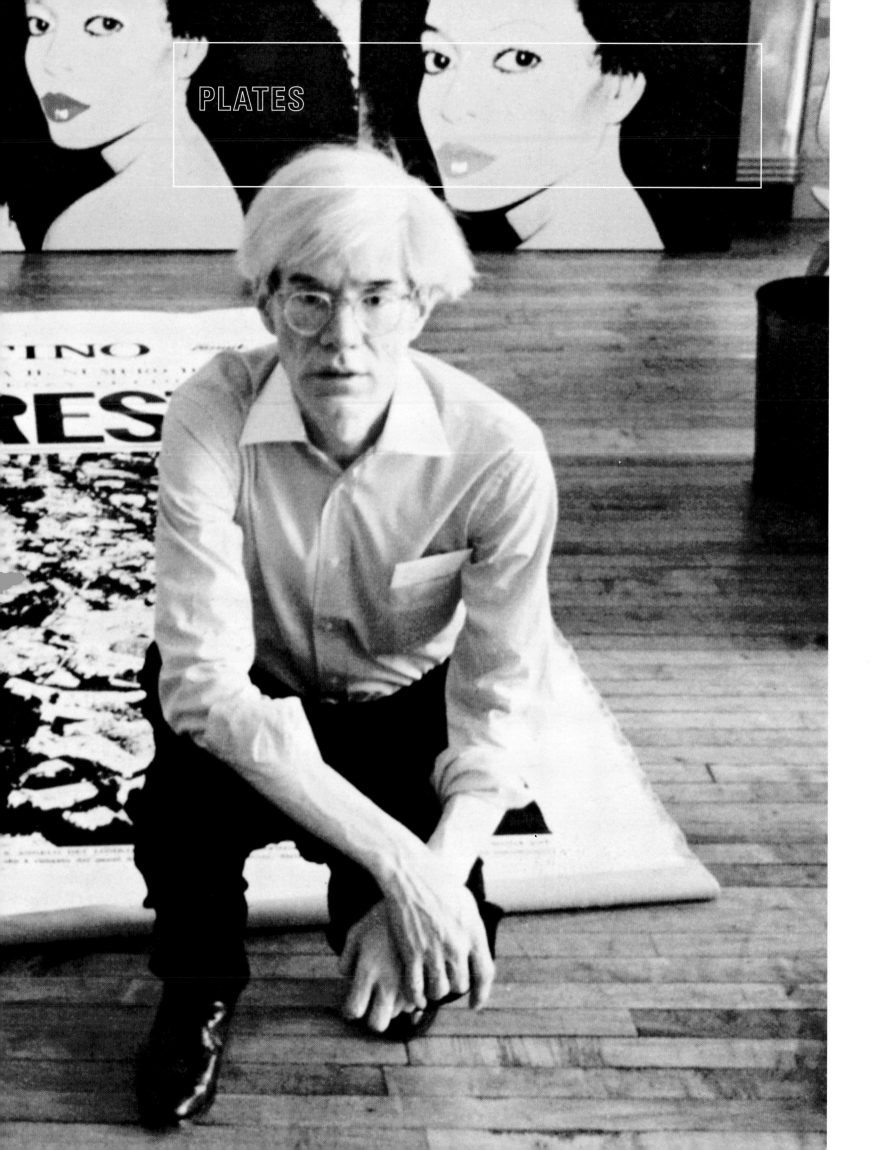

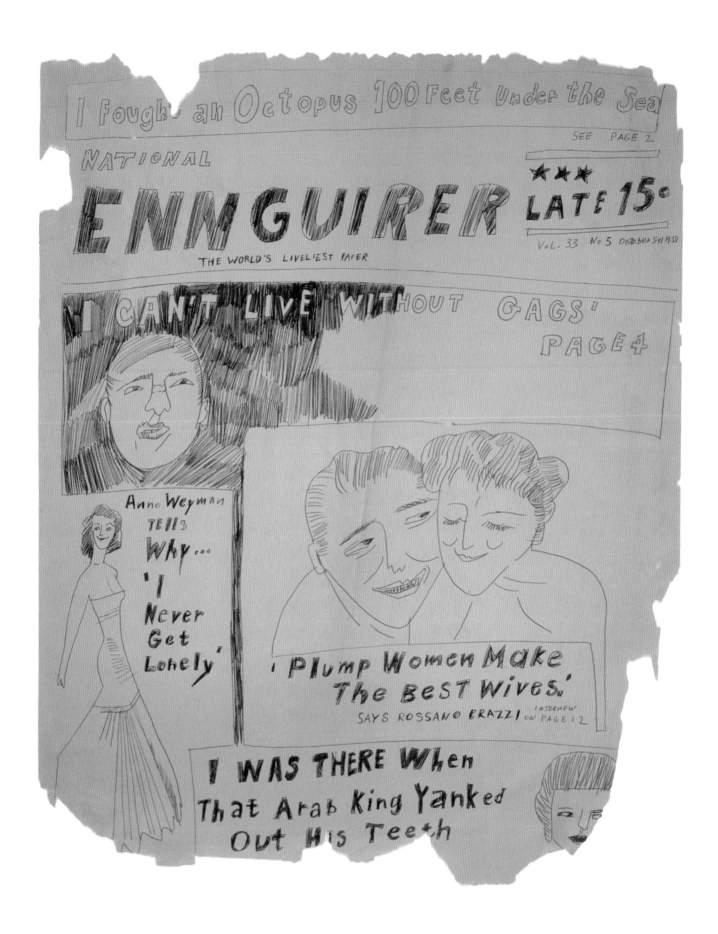

NATIONAL ENNGUIRER 1958, BALLPOINT INK ON PAPER, 56.5 x 44.8 (22 ¼ x 17 ⅝),
THE ANDY WARHOL MUSEUM, PITTSBURGH; FOUNDING COLLECTION,
CONTRIBUTION THE ANDY WARHOL FOUNDATION FOR THE VISUAL ARTS, INC.

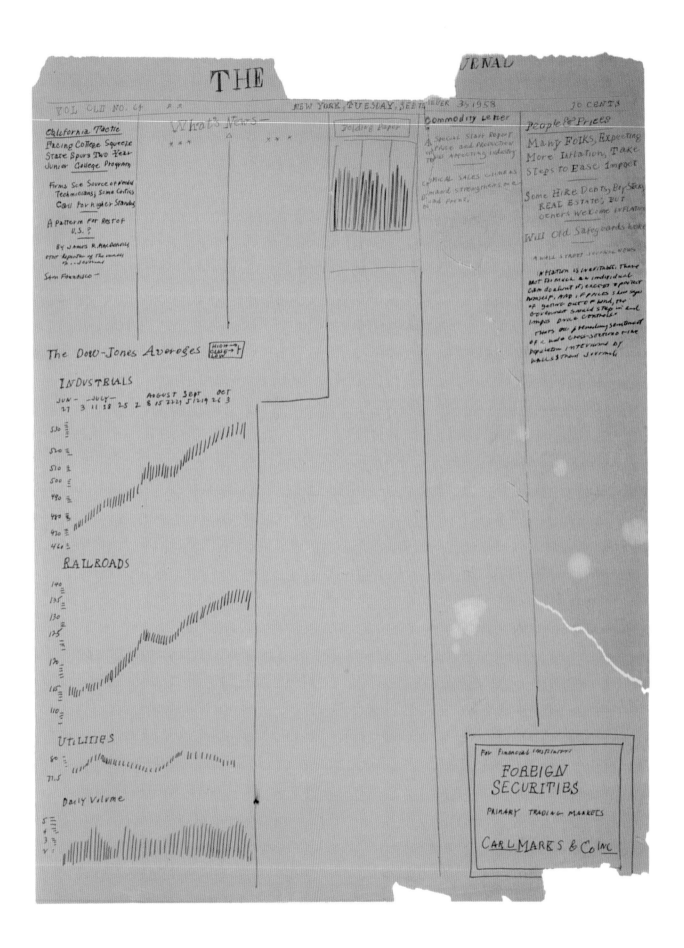

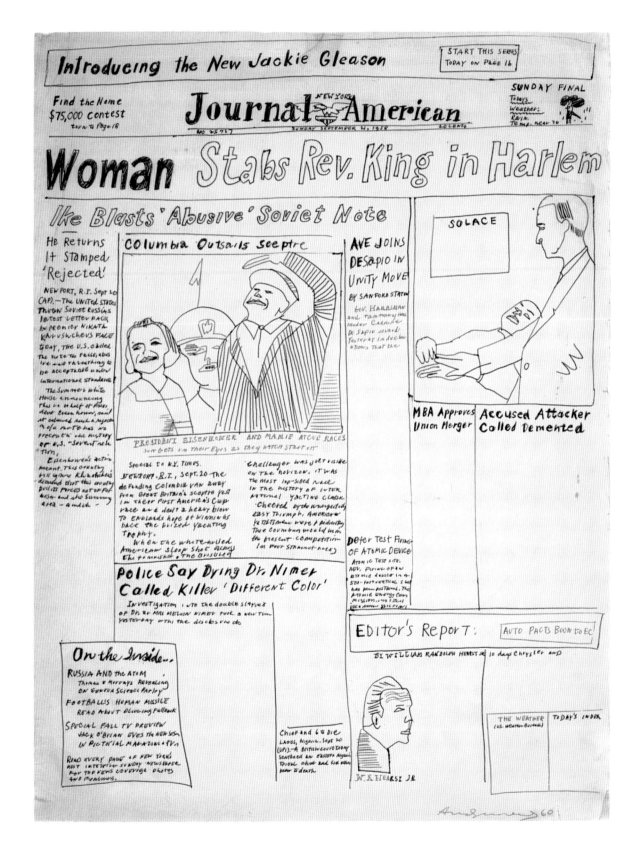

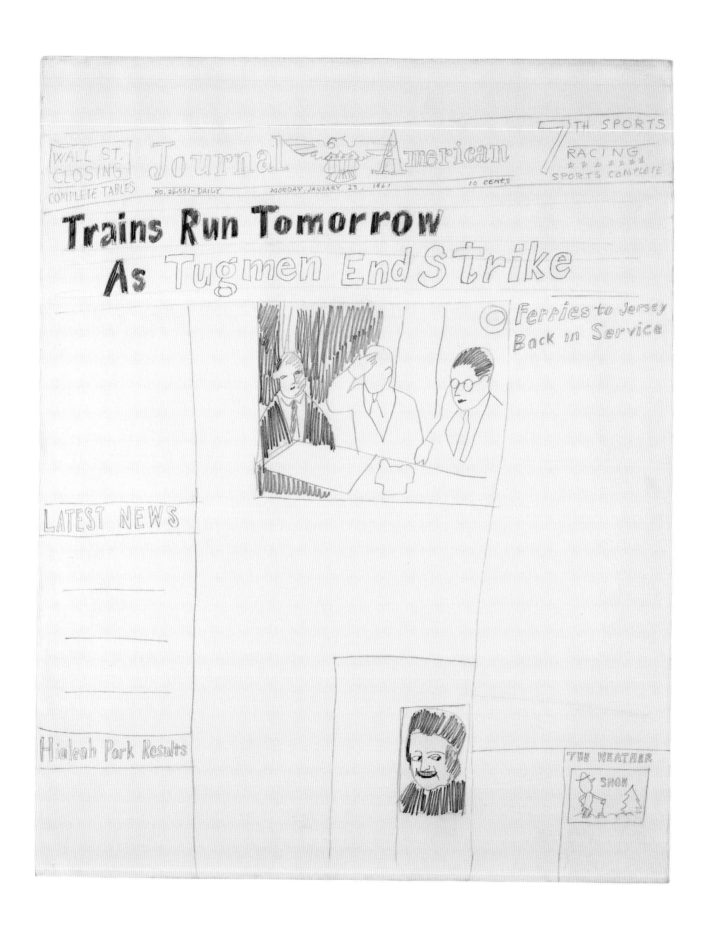

5 UNTITLED (JOURNAL AMERICAN) 1961, GRAPHITE ON STRATHMORE PAPER, 73.7 x 58.4 (29 x 23), BAYERISCHE STAATSGEMÄLDESAMMLUNGEN MÜNCHEN, UDO UND ANETTE BRANDHORST STIFTUNG. *WASHINGTON ONLY*

6 PIRATES SIEZE SHIP 1961, GRAPHITE ON STRATHMORE PAPER, 73.7 x 58.4 (29 x 23),
THE ANDY WARHOL MUSEUM, PITTSBURGH; FOUNDING COLLECTION,
CONTRIBUTION THE ANDY WARHOL FOUNDATION FOR THE VISUAL ARTS, INC.

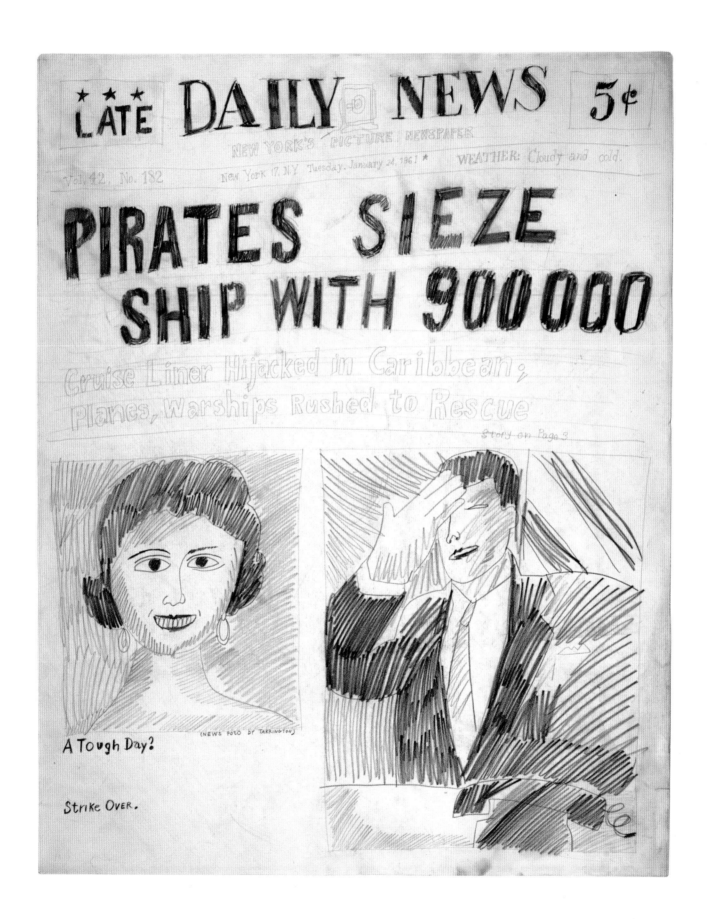

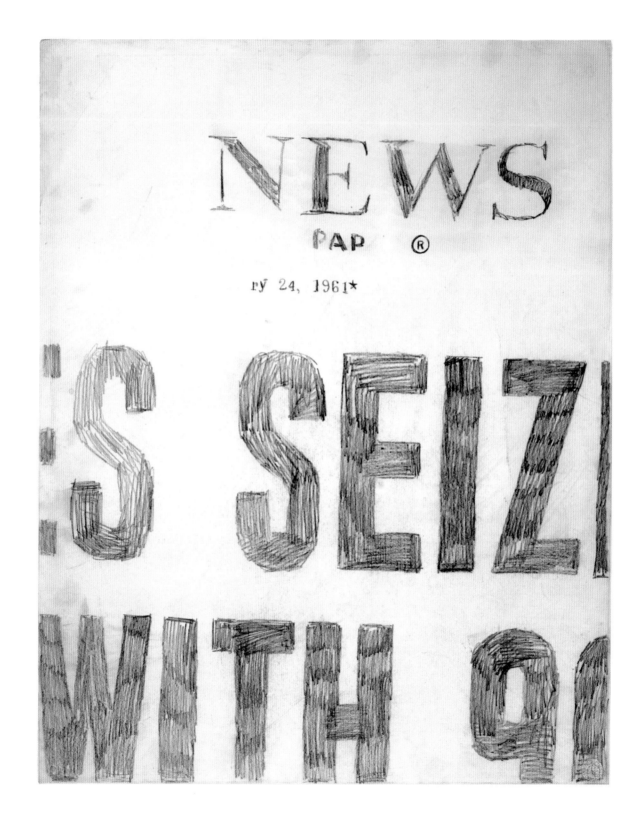

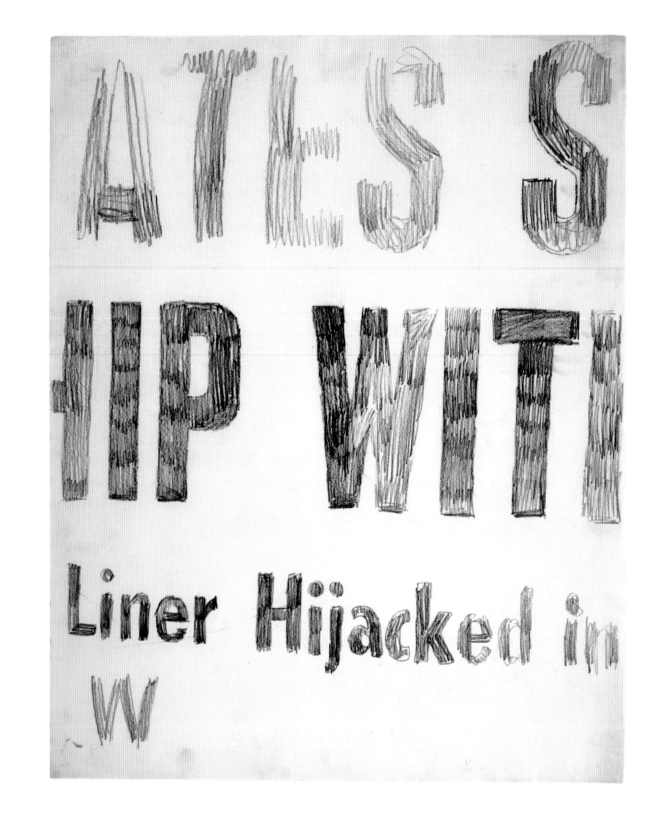

LINER HIJACKED 1961, GRAPHITE ON STRATHMORE PAPER, 73.7 x 58.4 (29 x 23), THE ANDY WARHOL MUSEUM, PITTSBURGH; FOUNDING COLLECTION, CONTRIBUTION THE ANDY WARHOL FOUNDATION FOR THE VISUAL ARTS, INC.

8

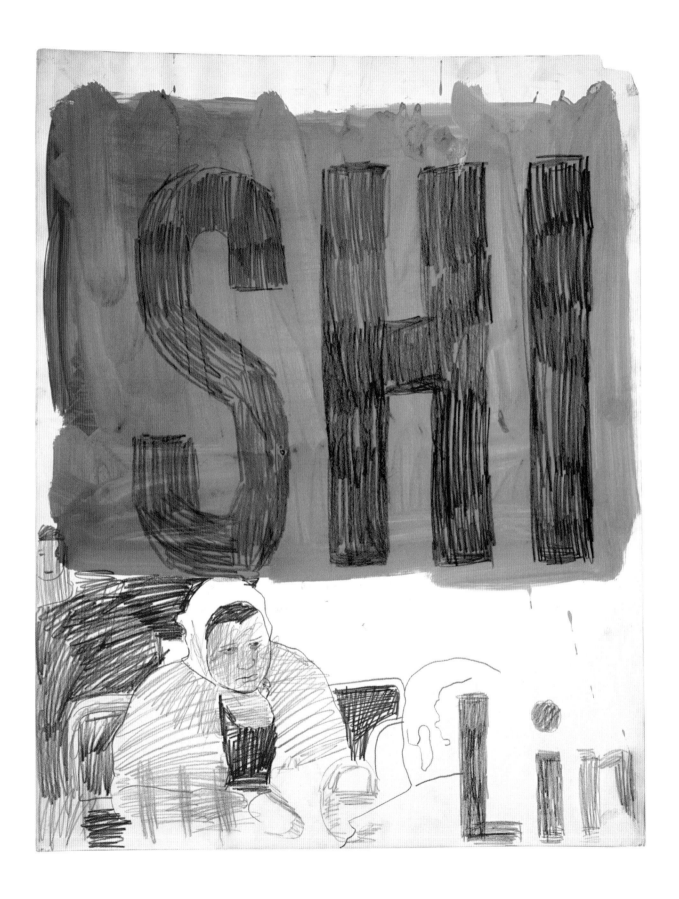

10 CITY C. 1962, PENCIL AND GOUACHE ON PAPER, 73.7 x 58.4 (29 x 23), THE MUSEUM OF MODERN ART, NEW YORK. PURCHASED WITH FUNDS GIVEN BY THE EDWARD JOHN NOBLE FOUNDATION AND PURCHASE FUND, 1999

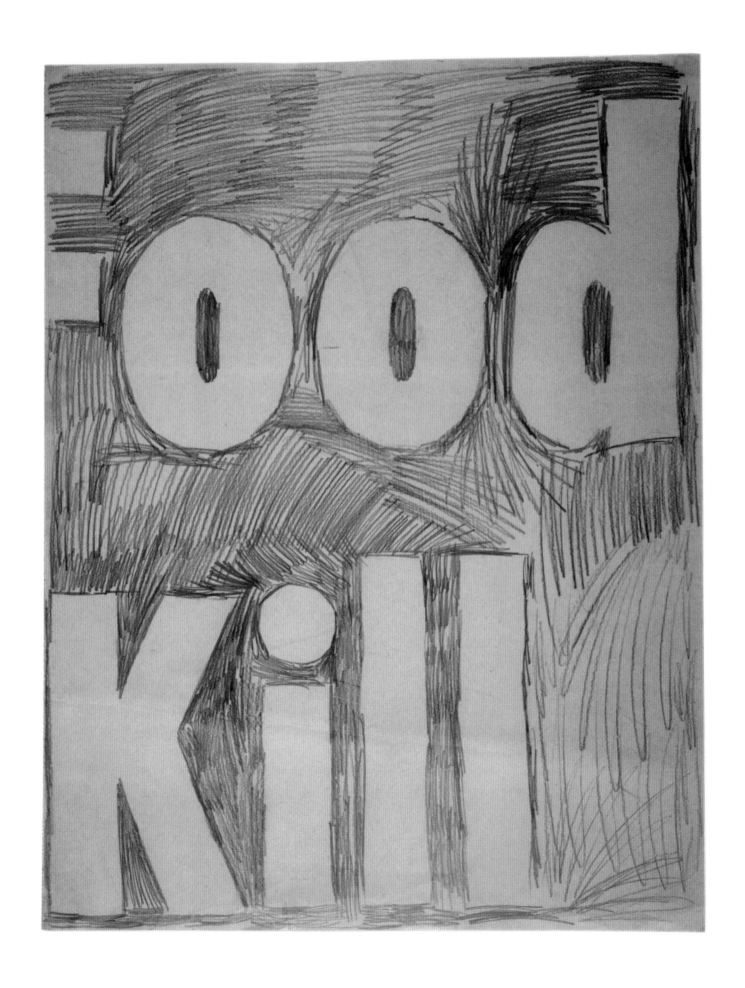

11 FOOD KILL C. 1962, PENCIL AND INK ON PAPER,
71.1 x 55.9 (28 x 22), COURTESY GAGOSIAN GALLERY

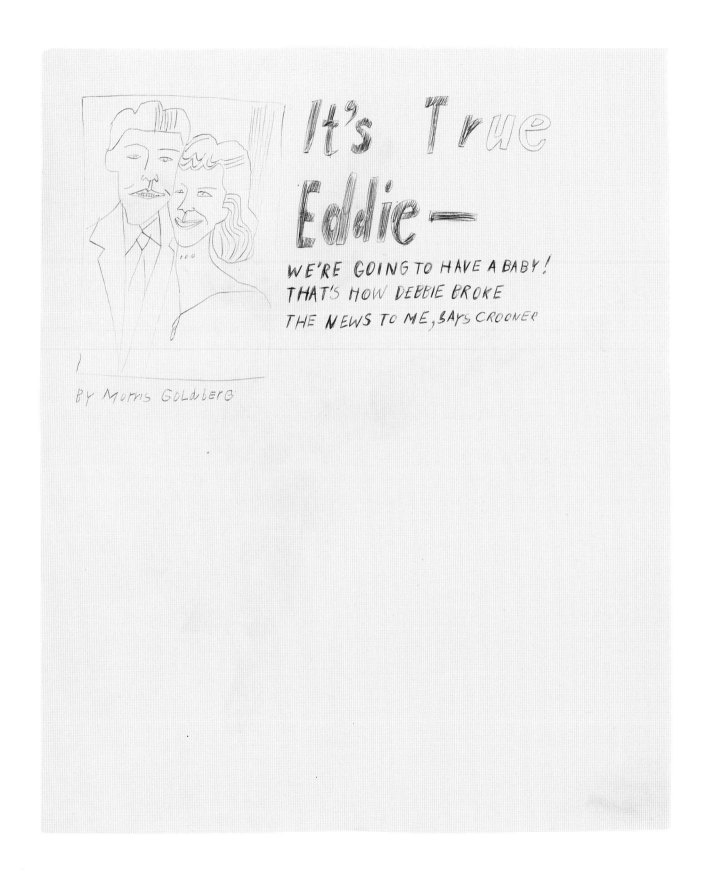

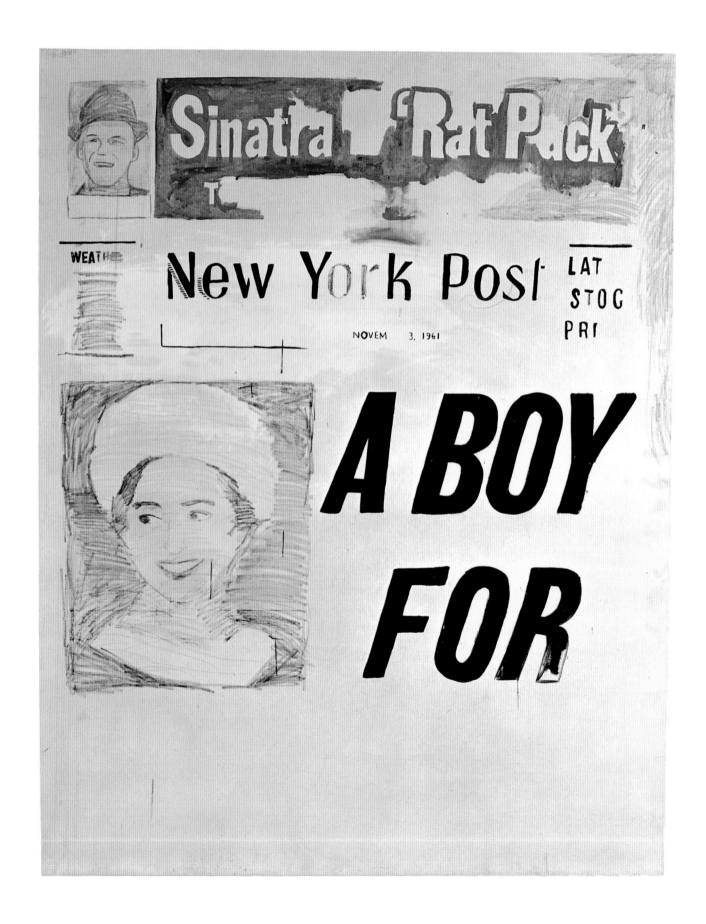

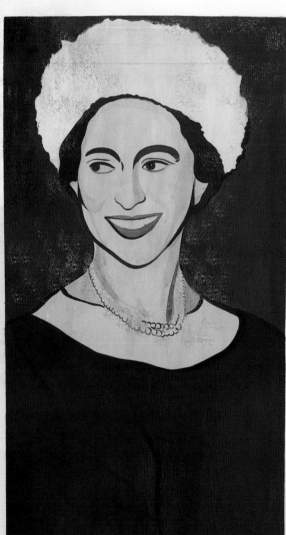

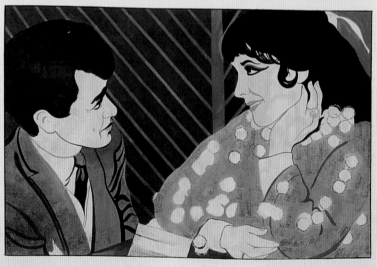

15 DAILY NEWS 1962, ACRYLIC AND PENCIL ON CANVAS, 183.5 x 254 (72 ¼ x 100), MUSEUM FÜR MODERNE KUNST, FRANKFURT AM MAIN, FORMERLY COLLECTION KARL STRÖHER, DARMSTADT, 1981

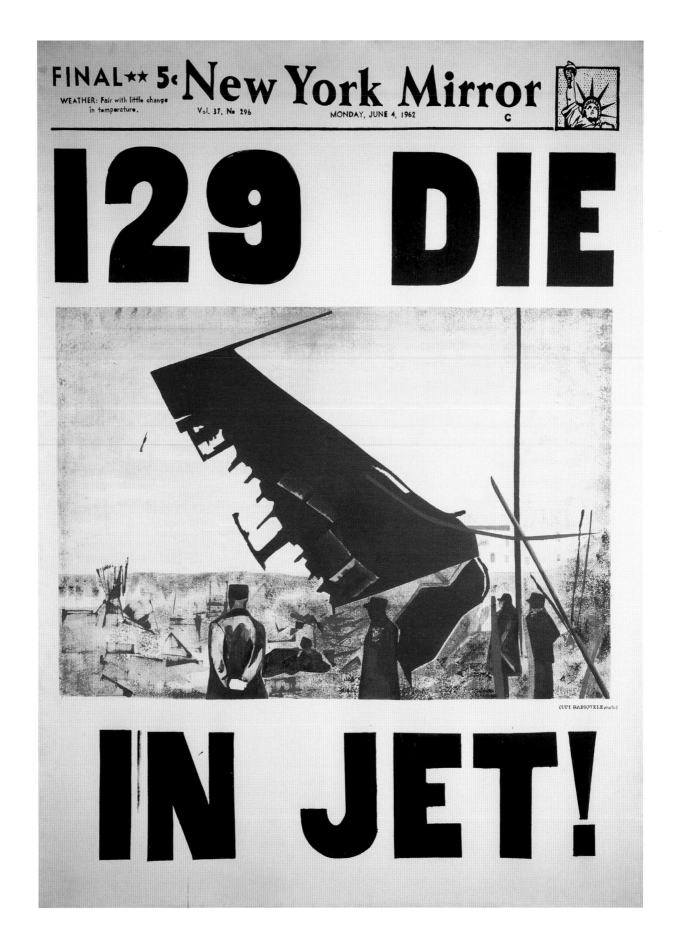

16 129 DIE IN JET 1962, ACRYLIC AND PENCIL ON CANVAS, 254 x 182.9 (100 x 72). MUSEUM LUDWIG, COLOGNE

17 WRITER SANDRA HOCHMAN POSING FOR *HARPER'S BAZAAR*, "NEW FACES, NEW FORCES, NEW NAMES IN
THE ARTS," JUNE 1963, FROM *TIME CAPSULE 21* 1963, THREE PHOTO-BOOTH STRIPS, GELATIN SILVER PRINTS,
EACH STRIP: 20 x 4.1 (7⅞ x 1⅝), THE ANDY WARHOL MUSEUM, PITTSBURGH; FOUNDING COLLECTION,
CONTRIBUTION THE ANDY WARHOL FOUNDATION FOR THE VISUAL ARTS, INC.

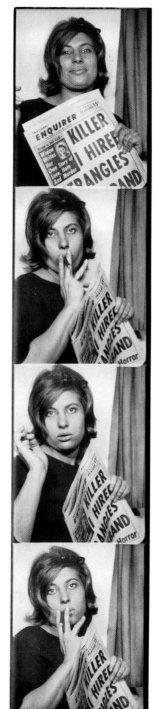

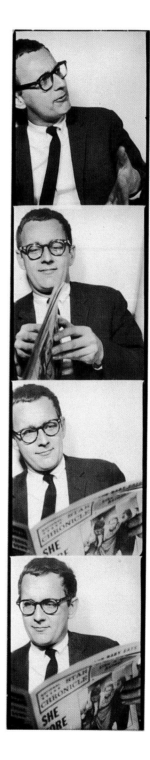
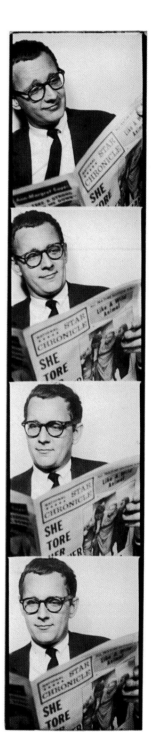

18 WRITER DONALD BARTHELME POSING FOR *HARPER'S BAZAAR*, "NEW FACES, NEW FORCES, NEW NAMES IN THE ARTS," JUNE 1963, FROM *TIME CAPSULE 21* 1963, FIVE PHOTO-BOOTH STRIPS, GELATIN SILVER PRINTS, EACH: 20 x 4.1 (7 7/8 x 1 5/8), THE ANDY WARHOL MUSEUM, PITTSBURGH; FOUNDING COLLECTION, CONTRIBUTION THE ANDY WARHOL FOUNDATION FOR THE VISUAL ARTS, INC.

TUNAFISH DISASTER 1963, SILKSCREEN INK AND SILVER PAINT ON LINEN, 254 x 200 (100 x 78 ¾). ANDREW AND DENISE SAUL. *WASHINGTON ONLY*

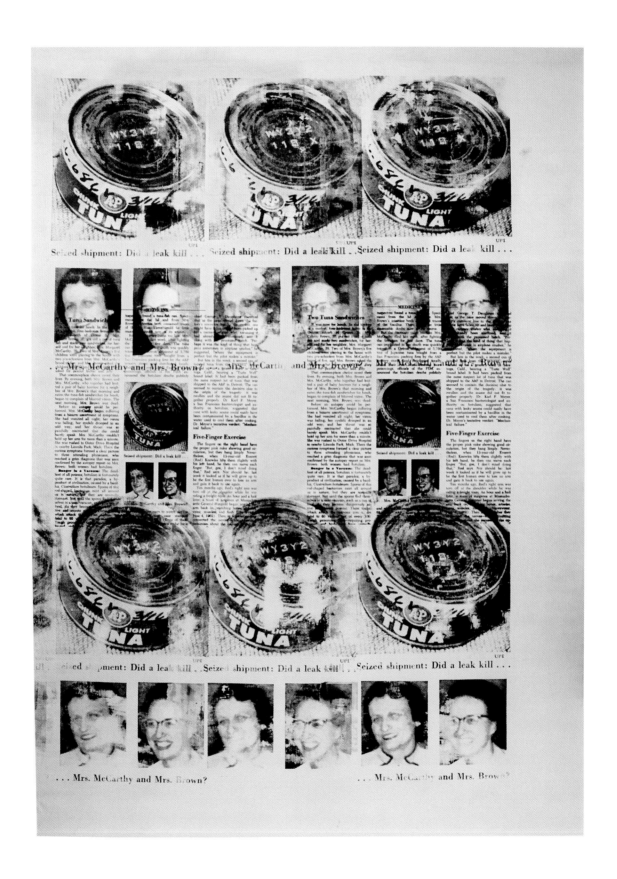

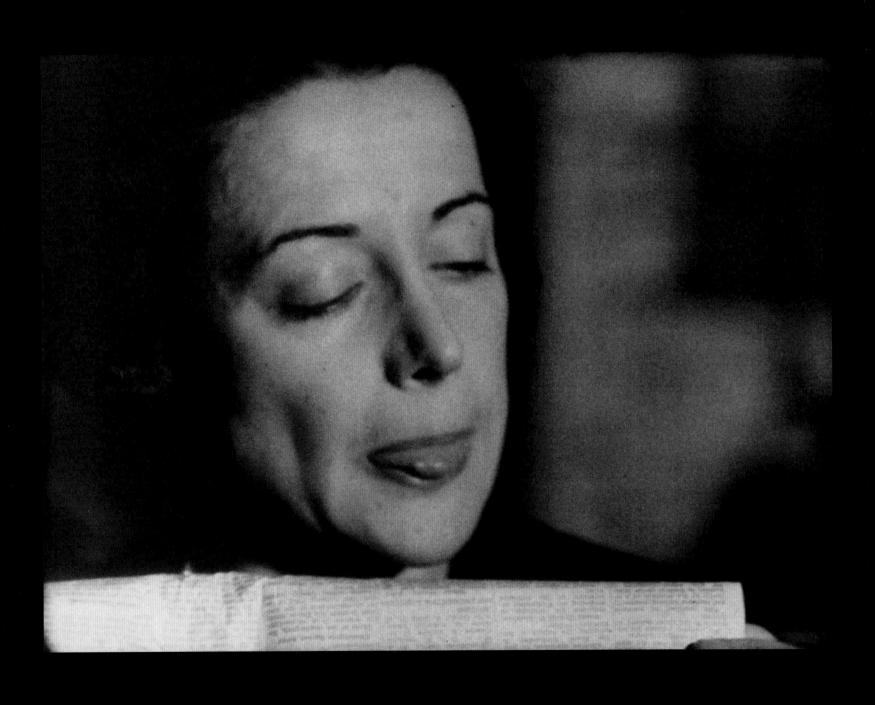

21 FRAME ENLARGEMENT FROM ~~SCREEN TEST: GRACE GLUECK~~ 1964, 16MM FILM, BLACK AND WHITE, SILENT (4 MINUTES AT 16 FRAMES PER SECOND), THE ANDY WARHOL MUSEUM, PITTSBURGH

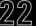

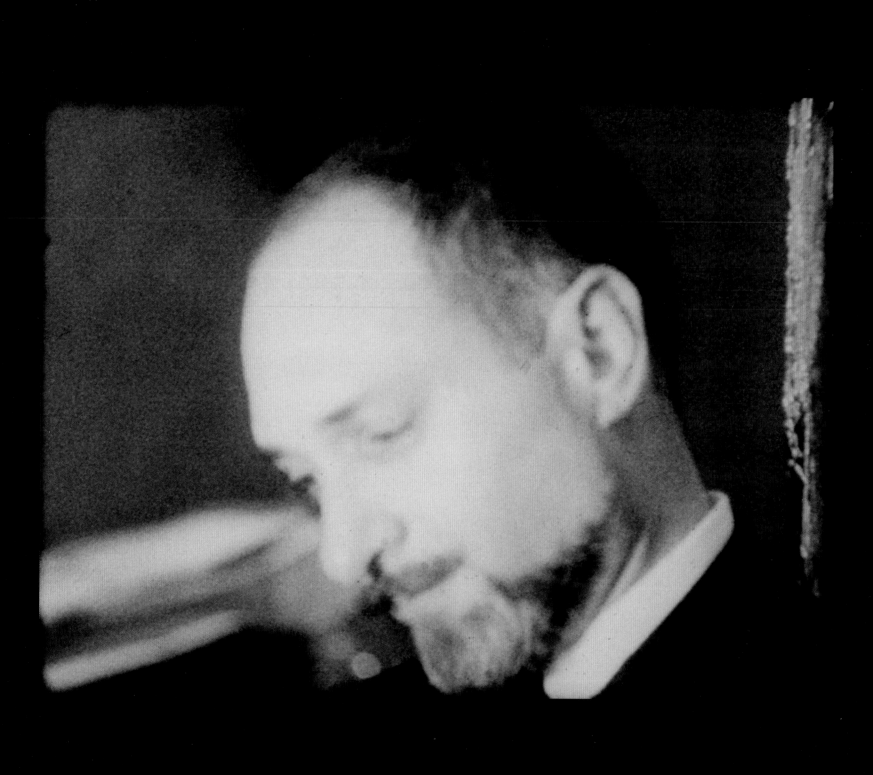

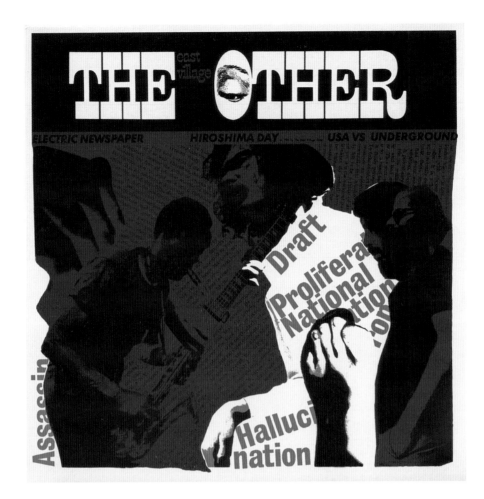

ELECTRIC NEWSPAPER
HIROSHIMA DAY

STEREO
1034

ESP-DISK'

Microphones are knee deep in people. Hair sucks up the smoke of nervous habit. Steve Weber crouches in the corner of the room like an amphetamine spider strumming erratically at his guitar. Marion Brown and Ishmael Reed prepare to wrestle at the edge of the universe. They have all stepped out of the Guttenberg Galaxy into the emperor's clothes of sonic words. How to make a record album? But it already has; the radio reveals the events of the day and takes us into the innermost ear of the presidential marriage. Tuli Kupferberg enters the room; twenty-one years later and the radio-active screams of bombdoom have turned into voices to be recorded on tape.

Ken Weaver sits in the back of the room chewing the eternal fingernail of shyness. How to make a record album? Allen Ginsberg, Peter Orlovsky, and Ed Sanders are sprawled across the floor. Mantras mix with the mushrooming of smoke. Andy Warhol and the Velvet Underground are expecting. The recording session will take three days. Nothing has been planned but creation has taken the necessary precautions. It is becoming: The first electric newspaper.

Newsprint flashes to our ears and the world, sounding through our veins, is unleashed through the eye of a needle. The MOMENTOUS OCCASION! To those of us who are blind, the truth is now written on the wind. EXTRA! EXTRA! READ ALL ABOUT IT! LUCI GETS HERS - FINALLY; HIRO-SHIMA DAY, AUGUST 6; U.S.A. VS UNDERGROUND. Somewhere planes fly low strafing viet purple people

with napalm nectar; the jolly jowled poison of a president's smile splashes across the mass media conscience of America; and the underground files through the echo chamber of total technocracy to pay homage to history. All the news unfit to print is precipated in the ear. Brain valves open, zone vectors are bombarded by reportage.

The East Village Other guides you through the inner sanctum of facts to a new level of consciousness. EVIL? HARDLY! DISTURBING? YES! If your stomach is tied up in symbolic knots or your mind buried in the materialistic mud of utter confusion, then don't take this trip. But if you have a mind or even half a mind, then TURN ON! TUNE IN! and delve into the depths of a culture's corrosion. Watch carefully, listen intently for the movement is not a sleight of hand but the palsy of prophecy. The Bones rattle. The Blood boils over. FLASH FLASH FLASH the inundation of the technology of Doom, the collage and montage of Mystery: Hiroshima Day, August 6

Allan Katzman

COVER: Walter Bowart
EDITED BY: Richard Alderson, Allen Katzman, Betsy Klein, and Walter Bowart

A COLLAGE OF:

SIDE ONE

LUCI'S WEDDING by plastic clock radio
IF I HAD A HALF A MIND by Steve Weber*
GOSSIP by Gerard Malanga and Ingrid Superstar
NOISE by The Velvet Underground*
JAZZ IMPROV by Marion Brown, Scott Holt, and Ron Jackson
MANTRAS by Allan Ginsberg and Peter Orlovsky
LUCI'S WEDDING by plastic clock radio
LOVE AND ASHES by Tuli Kupferberg* sung by Kupferberg and Viki Pollon with Peter Rawson on guitar.
THE FREE LANCE PALL BEARERS c copyright 1966 Ishmael Reed
SILENCE by Andy Warhol c copyright 1932

SIDE TWO
Engraved side with a lot of saxophones

This edition licensed from © VIA Records, The Netherlands

We tried to keep the artwork as keen as possible to the original ESP edition.

GET 1012

℗ 1998 ABRAXAS srl Piazza Malcesi, 16 - 50065 Pontassieve (FIRENZE ITALY) - E-Mail: abraxasp@tin.it Fax +39.55.8323155 "/" Distributed in North America by RUNT P.O. Box 2947 San Francisco, CA 94126 USA
MADE IN ITALY

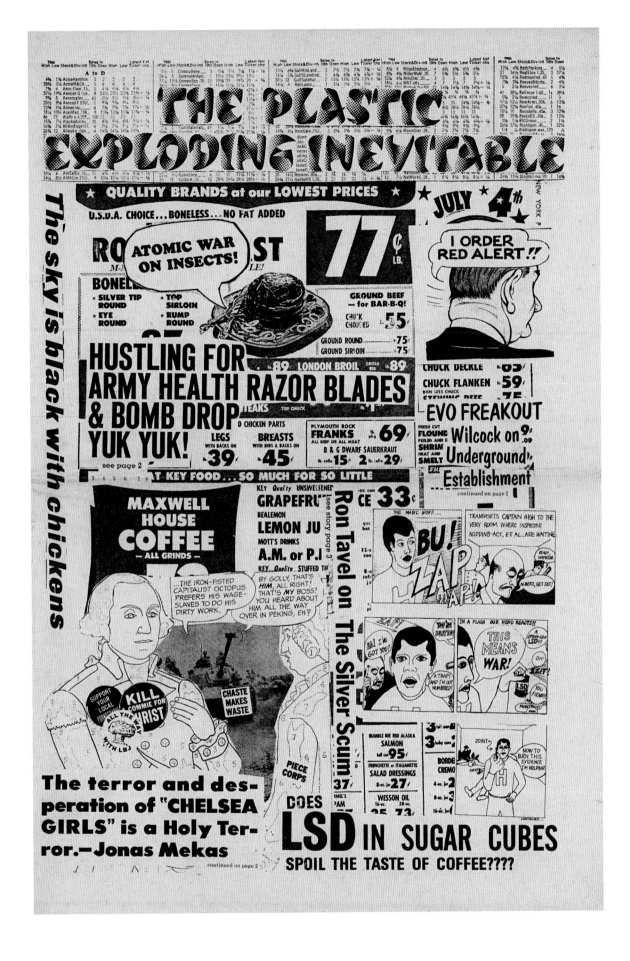

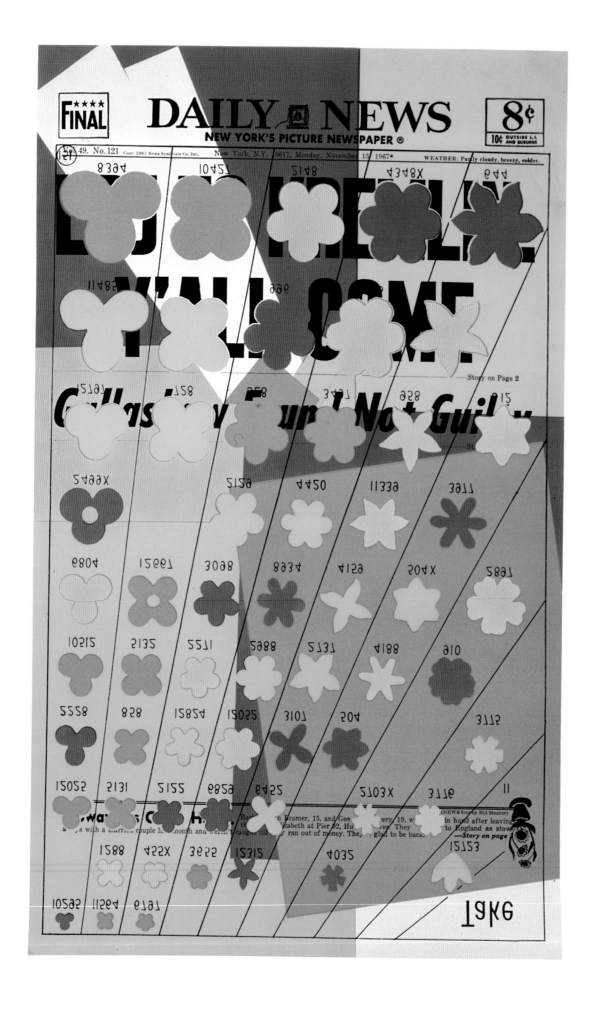

FLASH — NOVEMBER 22, 1963 1968, PORTFOLIO OF ELEVEN SCREENPRINTS AND ELEVEN CORRESPONDING WRAPPERS WITH TELETYPE TEXT BY PHILLIP GREER, PLUS THREE ADDITIONAL SCREENPRINTS AND CLOTH COVER, EACH SCREENPRINT: 53.3 x 53.3 (21 x 21), EACH WRAPPER: 54.5 x 53.8 (21 ½ x 21 ¼), COVER: 57.2 x 113.7 (22 ½ x 44 ¾), NATIONAL PORTRAIT GALLERY, SMITHSONIAN INSTITUTION [PAGES 113–119]. *WASHINGTON ONLY*

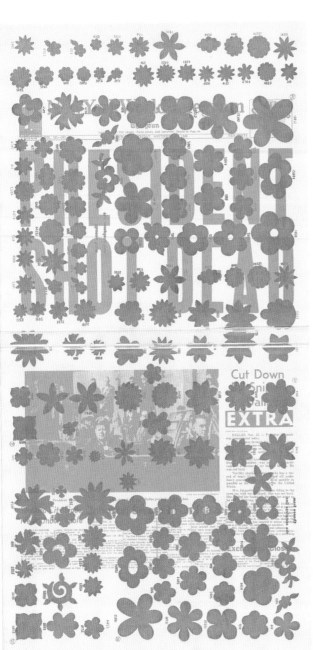

FIRST DAY -- 11/22/63

FIRST LEAD KENNEDY
 DALLAS, NOV. 22 -- PRESIDENT AND MRS. KENNEDY ARRIVEDX HERE TODAY IN THE SECOND DAY OF THEIR SWING THROUGH TEXAS.
 FOLLOWING TUMULTUOUS RECEPTION IN SAN ANTONIO, HOUSTON AND FORT WORTH YESTERDAY, THE PRESIDENT WAS XXXX SCHEDULED TO SPEAK TODAY TO A DEMOCRATIC LUNCHEON, AFTER A MOTORCADE TO THE DALLAS TRADE MART.
 THOUSANDS OF TEXANS XXXXX RIMMED THE LANDING AREA AT LOVE FIELD AS THE PRESIDENT'S PLANE, AIR FORCE ONE, TOUCHED DOWN AT 11:37 A.M.(CST).
 EDL152ACS

FLASH
 DALLAS -- SHOTS AT KENNEDY MOTORCADE.
 CJ1235PCS

BULLETIN -- PRECEDE KENNEDY
 DALLAS, NOV. 22 -- THREE SHOTS WERE FIRED AT PRESIDENT KENNEDY'S MOTORCADE IN DOWNTOWN DALLAS TODAY. XXXXXXXX THE PRESIDENT'S CAR, WITH MRS. KENNEDY AND GOV. AND MRS. JOHN B. CONNALLY, JR., SPED OFF IMMEDIATELY IT WAS UNCLEAR WHETHER THERE WERE ANY CASUALTIES.XXXX XXXXXXXXXXXXXX
 CJ1236PCS

BULLETIN -- 1ST ADD SHOTS
 XXXXXX THE SHOTS RANG OUT AS THE PRESIDENT'S CAR WAS APPROACHING AN OVERPASS EN ROUTE TO THE TRADE MART, WHERE HE WAS TO DELIVER A SPEECH. THEY APPEARED TO COME FROM BEHIND THE MOTORCADE. (PICKUP 1ST LEAD....FOLLOWING TUMULTUOUS XXXX TO END)

-2-

 CJI 237PCS

FLASH
 DALLAS -- KENNEDY WOUNDED.
 KT1240PCS

 BULLETIN 2ND LEAD KENNEDY
 DALLAS, NOV. 22 -- PRESIDENT JOHN F. KENNEDY AND TEXAS GOVERNOR JOHN B. CONNALLY, JR., WERE WOUNDED TODAY AS THEY RODE IN A MOTORCADE THROUGH DOWNTOWN DALLAS. THE PRESIDENT'S CAR SPED OUT IMMEDIATELY IN THE DIRECTION OF PARKLAND HOSPITAL, NEAR THE SCENE OF THE SHOOTING.
 KT1242PCS

 BULLETIN XXXXXXX X 1ST ADD 2ND LEAD KENNEDY XXXXSHOOTING
 WHEN THE PRESIDENT'S CAR ARRIVED AT THE HOSPITAL, MR. KENNEDY'S LIMP BODY WAS CRADLED IN HIS WIFE'S ARMS. BOTH HE AND GOV. CONNALLY WERE RUSHED INTO THE HOSPITAL.
 AS THE PRESIDENT WAS LIFTED FROM HIS FAMOUS "BUBBLETOP" CAR, CLINT HILL, A SECRET SERVICE AGENT ASSIGNED TO MRS. KENNEDY, SAID, "HE'S DEAD."
 THERE WAS NO CONFIRMATION FROM WHITE HOUSE SPOKESMEN.
 EJ1245PCS

 BULLETIN 2ND ADD 2ND LEAD KENNEDY XXXXSPOKESMEN.
 THE HOSPITAL WAS IN PANDEMONIUM. VICE PRESIDENT LYNDON B. JOHNSON, WHO WAS RIDING THREE CARS BEHIND THE PRESIDENT AND WAS UNINJURED, ARRIVED WITHIN MINUTES AFTER PRES. KENNEDY AND GOV. CONNALLY.

-3-

THE TWO WOUNDED MEN WERE RUSHED TO EMERGENCY ROOMS AND THE HOSPITAL'S PUBLIC ADDRESS SYSTEM RANG WITH CALLS FOR ALL STAFF DOCTORS.

 EJ1248PCS

FLASH
DALLAS -- TWO PRIESTS SUMMONED TO KENNEDY X IN EMERGENCY ROOM.

 EJ1250PCS

BULLETIN 3RD ADD 2ND LEAD KENNEDY XXXDOCTORS.
TWO PRIESTS ENTERED THE EMERGENCY ROOM WHERE THE PRESIDENT WAS BEING TREATED AT 1249 P.M.(CST).
THERE WAS STILL NO OFFICIAL WORD ON THE PRESIDENT'S CONDITION. ASSISTANT WHITE HOUSE PRESS SECRETARY MALCOLM XXXX KILDUFF SAID, "I JUST CAN'T SAY. I JUST CAN'T SAY."

 KT1255PCS

FLASH --
DALLAS -- PRIESTS SAY KENNEDY DEAD.

 KT1257PCS

FLASH
DALLAS -- PRESIDENT KENNEDY DIED AT 1 P.M.(CST)

 KT102PCS

BULLETIN 3RD LEAD KENNEDY
DALLAS, NOV. 22 -- PRESIDENT JOHN F. KENNEDY WAS SHOT AND KILLED TODAY AS HE RODE IN A MOTORCADE THROUGH DOWNTOWN DALLAS. TEXAS GOVERNOR JOHN B. CONNALLY, JR., RIDING IN FRONT OF THE PRESIDENT, WAS SERIOUSLY WOUNDED.

-4-

THE SHOOTING OCCURRED AT XXXX12:30 P.M. (CST) AND THE PRESIDENT WAS PRONOUNCED DEAD AT PARKLAND XXX HOSPITAL AT 1 P.M.(CST).

 EJ105PCS

BULLETIN 1ST ADD 3RD LEAD KENNEDY
GOVERNOR CONNALLY'S WOUNDS WERE DESCRIBED AS SERIOUS, BUT NOT CRITICAL. VICE PRESIDENT LYNDON B. JOHNSON, WHO WAS RIDING THREE CARS BEHIND THE XXX PRESIDENT AND THE GOVERNOR, WAS UNHURT.

 EJ108PCS

NEW YORK, NOV. 22 -- HEAVY SELLING SWAMPED THE NEW YORK STOCK EXCHANGE AFTER WORD OF PRESIDENT KENNEDY'S ASSASSINATION.
THE EXCHANGE'S BOARD OF GOVERNORS CALLED A HASTY MEETING TO CONSIDER CLOSING THE EXCHANGE.

 XXXXXX10207PCS

BULLETIN -- STOCKS
NEW YORK, NOV. 22 -- THE BOARD OF GOVERNORS OF THE NEW YORK STOCK EXCHANGE ORDERED ALL TRADING HALTED AT 2:07 P.M. (EST).
HEAVY SELLING HAD SWAMPED THE EXCHANGE FLOOR AFTER NEWS OF PRESIDENT KENNEDY'S ASSASSINATION.

 10209PCS

BULLETIN
WASHINGTON, NOV. 22 -- THE SENATE ADJOURNED SHORTLY BEFORE 2:15 P.M. (EST). MAJORITY LEADER MIKE MANSFIELD (D-MONT.) SAID THE SENATE WOULD RECONVENE ON MONDAY, UNLESS PRESIDENT KENNEDY'S ASSASSINATION.

 GD216PCS

-5-

WASHINGTON, NOV. 22 -- AN AIR FORCE JET CARRYING SIX CABINET MEMBERS TO CONFERENCES IN TOKYO TURNED BACH TO WASHINGTON AFTER RECEIVING NEWS OF THE ASSASSINATION, THE STATE DEPARTMENT ANNOUNCED. THE PLANE IS EXPECTED IN WASHINGTON AT 1 A.M. (EST) TOMORROW.

 GD230PCS

FLASH
DALLAS -- POLICE ARREST "HOT SUSPECT".

BULLETIN 1ST LEAD SUSPECT
DALLAS, NOV. 22 -- DALLAS POLICE ANNOUNCED THEY HAVE ARRESTED A "HOT SUSPECT" IN THE ASSASSINATION OF PRESIDENT KENNEDY.
HE WAS IDENTIFIED AS LEE H. OSWALD, 24, AN EMPLOYEE OF THE TEXAS BOOK DEPOSITORY, ADJACENT TO THE SITE WHERE THE PRESIDENT WAS SHOT DOWN. OSWALD, WHO HAD BEEN ARRESTED EARLIER IN CONNECTION WITH THE SHOOTING OF A DALLAS POLICEMAN, FORMERLY LIVED IN THE SOVIET UNION AND WAS ACTIVE IN THE FAIR PLAY FOR CUBA COMMITTEE.

 KT210PCS

BULLETIN
DALLAS, NOV. 22 -- LYNDON BAINES JOHNSON WAS SWORN IN AS THE 36TH PRESIDENT OF THE UNITED STATES AT 2:39P.M.(CST) ABOARD THE PRESIDENTIAL JET AIR FORCE ONE ON A RUNWAY AT LOVE FIELD.

-6-

THE CEREMONY TOOK PLACE WITHIN MOMENTS AFTER THE COFFIN CONTAINING THE BODY OF SLAIN PRESIDENT JOHN F. KENNEDY WAS LOADED ABOARD THE PLANE. MRS. JOHNSON, MRS. KENNEDY AND A GROUP OF WHITE HOUSE AIDES ATTENDED THE OATH-TAKING, WHICH WAS ADMINISTERED BY FEDERAL JUDGE SARAH T. HUGHES, WHO WAS APPOINTED TO OFFICE BY PRESIDENT KENNEDY IN OCTOBER, 1961.

 KT250PCS

WASHINGTON, NOV. 22 -- THE XXXX AIR FORCE JET CARRYING PRESIDENT LYNDON B. JOHNSON AND THE BODY OF ASSASSINATED PRESIDENT JOHN F. KENNEDY LANDED AT ANDREWS AIR FORCE BASE SHORTLY AFTER 6 P.M. (EST).
THE PLANE WAS MET BY AN HONOR GUARD OF AIRMEN IN DRESS UNIFORM, WITH RIFLES AND BAYONETS, AND BY HIGH-RANKING GOVERNMENT OFFICIALS.
AS SOON AS THE PLANES ENGINES STOPPED, ATTORNEY GENERAL ROBERT F. KENNEDY, THE SLAIN PRESIDENT'S BROTHER, BOUNDED UP THE STEPS AND INTOTHE CABIN. WITHIN A FEW MINUTES, HE REAPPEARED AT THE DOORWAY WITH MRS. JACQUELINE KENNEDY AND THE TWO WATCHED, HAND IN HAND, AS THE COFFIN WAS LOWERED TO A WAITING NAVAL AMBULANCE, TO BE TAKEN TO BETHESDA NAVAL HOSPITAL.
MRS. KENNEDY, HERX DRESS AND STOCKINGS STILL SMEARED WITH HERX HUSBAND'S BLOOD, APPEARED COMPOSED. SHE RODE IN THE AMBULANCE TO THE HOSPITAL.

 CD515PCS

NITE LEAD KENNEDY
DALLAS, NOV. 22 -- PRESIDENT JOHN F. KENNEDY WAS ASSASSINATED HERE TODAY.

-7-

THE PRESIDENT WAS KILLED BY A BULLET THROUGH THE BRAIN FIRED AS HE RODE IN A MOTORCADE THROUGH DOWNTOWN DALLAS. TEXAS GOVERNOR JOHN B CONNALLY, JR., RIDING IN THE SAME CAR, WAS SHOT IN THE CHEST, RIBS AND ARM. HIS CONDITION WAS DESCRIBED AS XXX SERIOUS, BUT NOT CRITICAL.

VICE PRESIDENT LYNDON BAINES JOHNSON, RIDING THREE CARS BACK, WAS UNINJURED. MR. JOHNSON WAS SWORN IN AS THE 36TH PRESIDENT OF THE UNITED STATES 99 MINUTES AFTER XXXX MR. KENNEDY WAS PRONOUNCED DEAD AT 1:00 P.M.(CST). MR. JOHNSON IS 55 YEARS OLD; MR. KENNEDY WAS 46.

SHORTLY AFTER 2 P.M. DALLAS POLICE ANNOUNCED THEY HAD ARRESTED A "HOT SUSPECT " IN THE ASSASSINATION. HE WAS IDENTIFIED AS LEE HARVEY OSWALD, 24, WHO IS EMPLOYED AT THE TEXAS BOOK DEPOSITORY, ADJACENT TO THE MURDER SCENE. OSWALD, WHO FORMERLY LIVED IN THE SOVIET UNIOJ, WAS ARRESTED IN CONNECTION WITH THE SLAYING OF J.B. TIPPIT, A X DALLAS PATROLMAN, SHORTLY AFTER PRESIDENT KENNEDY WAS KILLED.

THE PRESIDENT WAS STRUCK DOWN AS HE RODE IN AN OPEN CAR XXXX ON HIS WAY TO THE DALLAS TRADE MART, WHERE HE WAS TO DELIVER A SPEECH TO A GROUP OF THE CITY'S LEADING CITIZENS. HE HAD ARRIVED IN DALLAS FROM FORT WORTH AT 11:37 A.M. (CST) TODAY.

-8-

THE THREE SHOTS RANG OUT IN QUICK SUCCESSION AT 12:30 P.M.(CST), JUST AS THE PRESIDENT'S CAR WAS APPROACHING A TRIPLE OVERPASS. MR. KENNEDY, WHO WAS WAVING AT THE THINNED OUT CROWDS, CLUTCHED AT HIS THROAT AND TOPPLED OVER ONTO THE X LAP OF HIS WIFE, WHO JUMPED UP AND SHOUTED. "OH, NO!" SECRET SERVICE AGENT CLINT HILL LEAPED ONTO THE BACK OF THE PRESIDENT'S CAR AND ORDERED THE DRIVER TO SPEED AHEAD TO PARKLAND HOSPITAL, THREE AND A HALF MILES DOWN THE ROAD.

ARRIVING AT THE HOSPITAL, MR. KENNEDY AND GOV. CONNALLY, WHO WAS ALSO BEING HELD BY HIS WIFE, WERE RUSHED INTO EMERGENCY ROOMS. SOON AFTER THEIR ARRIVAL, TWO PRIESTS WERE SUMMONED TO PRESIDENT KENNEDY'S SIDE. ON LEAVING THE EMERGENCY ROOM, THE PRIESTX REPORTED THAT THE PRESIDENT HAD DIED OF HIS WOUNDS. WHITE HOUSE AIDES, AT FIRST UNCERTAIN, CONFIRMED THE REPORT AT 1:33 P.M. (CST).
EJ1155PCS

WASHINGTON, NOV. 22 -- FOLLOWING IS THE TEXT OF A STATEMENT BY PRESIDENT LYNDON BAINES JOHNSON ON ARRIVAL AT ANDREWS AIR FORCE BASE IN THE PLANE CARRYING THE BODY OF PRESIDENT JOHN F. KENNEDY:

"THIS IS A SAD TIME FOR ALL PEOPLE. WE HAVE SUFFERED A LOSS THAT CANNOT BE WEIGHED. FOR ME IT IS A DEEP PERSOIIAL TRAGEDY. I KNOW THE WORLD SHARES THE SORROW THAT MRS. KENNEDY AND HERXX FAMILY BEAR. I WILL DO MY BEST. THAT IS ALL I CAN DO. I ASK FOR YOUR HELP -- AND XXXX GOD'S."
LG610PCS

-9-

SECOND DAY - 11/23/63

DALLAS, NOV. 23 -- DALLAS XXXXX POLICE SAID TODAY THEY HAVE ENOUGH EVIDENCE TO CONVICT LEE HARVEY OWSALD OF THE ASSASSINATION OFOF PRESIDENT KENNEDY.

"WE'RE CONVINCED BEYOND ANY DOUBT THAT HE KILLED THE PRESIDENT, CAPT. WILL FITZ, CHIEF OF THE HOMICIDE BUREAU XXX SAID TODAY AFTER QUESTIONING OSWALD. "I THINK THE CASE XX IS CINCHED," HE SAID, EXHIBITING THE RIFLE SAID TO HAVE KILLED MR. KENNEDY.

ALTHOUGH OSWALD HIMSELF STOUTLY DENIES COMMITTING THE MURDER, DALLAS COUNTY DISTRICT ATTORNEY HENRY WADE SAID: "I THINK WE HAVE ENOUGH EVIDENCE TO CONVICT HIM NOW. BUT WE ANTICIPATE A LOT MORE EVIDENCE IN THE NEXT FEW DAYS."
KT1124ACS

WASHINGTON, NOV. 23 -- PRESIDENT JOHN FITZGERALD KENNEDY RETURNED TO THE WHITE HOUSE THIS MORNING.

A GRAY NAVAL AMBULANCE FROM BETHESDA NAVAL HOSPITAL GLIDED QUIETLY BEHIND A MARINE HONOR GUARD ONTO THE WHITE HOUSE GROUNDS SHORTLY BEFORE DAWN, XXXXX CARRYING THE BODY OF THE ASSASSINATED PRESIDENT.

THE PRESIDENT'S XXXXXX FLAG-DRAPED CASKET WAS TAKEN TO THE EAST ROOM AND PLACED ON A XXXX CATAFLAQUE SIMILAR TO THE ONE USED FOR PRESIDENT LINCOLN ALMOST 100 YEARS AGO.

AN HONOR GUARD OF ONE MARINE, ONE SAILOR, ONE AIRMAN AND ONE SOLDIER STOOD AT EACH CORNER OF THE CASKET. TWO PRIESTS KNEELED IN CONSTANT PRAYER.
LG 1135AES

-10-

WASHINGTON, NOV. 23 -- PRESIDENT LYNDON B. JOHNSON TODAY ISSUED A PROCLAMATION DESIGNATING MONDAY, THE DAY OF PRESIDENT JOHN F. KENNEDY'S FUNERAL, A DAY OF NATIONAL MOURNING.

THE WHITE HOUSE ANNOUNCED THAT THE SLAIN PRESIDENT WILL BE BURIED IN ARLINGTON NATIONAL CEMETERY. THE BODY WILL X LIE IN THE EAST ROOM OF THE WHITE HOUSE UNTIL TOMORROW, WHEN IT WILL BE TAKEN TO THEX CAPITOL ROTUNDAXX AT 1 $\frac{1}{2}$.M. (EST). ON MONDAY,THE PROCESSION WILL RETURN TO THE WHITE HOUSE, WHERE IT WILL BE MET BY MOURNERS INCLUDING X HEADS OF STATE FROM AROUND THE WORLD. FROM THERE, IT WILL PROCEDE TO ST. MATTHEW'S ROMAN CATHOLIC XXXX CATHEDRAL, WHERE A PONTIFICAL REQUIEM MASS WILL BE SAID BY RICHARD CARDINAL CUSHING OF BOSTON A LONG-TIME FRIEND OF THE KENNEDY FAMILY.
LG135PES

WASHINGTON, NOV. 23 -- PRESIDENT JOHNSON ASSUMED CONTROL OF THE GOVERNMENT TODAY AND RECEIVED PLEDGES OF SUPPORT FROM LEADERS OF BOTH PARTIES, AS WELL AS HEADS OF STATE FROM THROUGHOUT THE NON-COMMUNIST WORLD.

THE PRESIDENT MET WITH HIS CABINET THIS AFTERNOON XXX AND ASKED ALL MEMBERS TO REMAIN ON THEIR POSTS. THOSE PRESENT INCLUDED THE SIX MEMBERS WHO HAD BEEN FLYING TO JAPAN WHEN NEWS OF THE ASSASSINATION WAS RECEIVED, AS WELL AS ATTORNEY GENERAL ROBERT F. KENNEDY, THE SLAIN PRESIDENT'S BROTHER.

THE WHITE HOUSE ANNOUNCED PRESIDENT JOHNSON WILL ADDRESS A JOINT SESSION OF CONGRESS AT 12:30 P.M. (EST) WEDNESDAY.
LG200PES

-11-

THIRD DAY

WASHINGTON, NOV. 24 -- THE BODY OF PRESIDENT JOHN F. KENNEDY WAS BORNE TO THE ROTUNDA OF THE CAPITOL TODAY ON THE SAME CAISSON USED FOR PRESIDENT FRANKLIN D. ROOSEVELT ALMOST 20 YEARS AGO.

WITH CROWDS ESTIMATED AT 300,000 PEOPLE LINING THE STREETS OF WASHINGTON, THEX PROCESSION MOVED OUT OF THE WHITE HOUSE GROUNDS AT 1:00 P.M. (EST), UNDER MASSED STATE FLAGS DIPPED IN XXXXX HOMAGE.

THE PROCESSION, WITH MRS. JACQUELINE KENNEDY, HER TWO CHILDREN AND OTHER MEMBERS OF THE XXXX KENNEDY FAMILY RIDING IN LIMOUSINES, MOVED TOWARD THE CAPITOL TO THE CADENCE OF MUFFLED DRUMS REPRESENTING ALL FOUR SERVICES.

WHEN THE CORTEGE REACHED THE CAPITOL STEPS, AN HONOR GUARD OF SERVICE-MEN CARRIED THE CASKET INTO THE GREAT ROTUNDA,XXXX FOLLOWED BY THE LATE PRESIDENT'S FAMILY.

AFTER THE CASKET WAS PLACED ON A CATAFALQUE, SENATE MAJORITY LEADER MIKE MANSFIELD (MONT.) HOUSE SPEAKER JOHN W. MC CORMACK (MASS.) AND CHIEF JUSTICE EARL WARREN READ EULOGIES. AFTER THE BRIEF CEREMONY, THE KENNEDY FAMILY LEFT THE CAPITOL AND THE XXX CROWDS OF PUBLIC MOURNERS, SOME OF WHOM HAD WAITED SINCE EARLY SATURDAY EVENING, XXXX BEGAN TO FILE PAST THE BIER.
IT115PES

XXXXXXX FLASH
DALLAS -- OSWALD SHOT
KT1125ACS

-12-

BULLETIN 1ST LEAD OSWALD
DALLAS, NOV. 24 -- LEE HARVEY OSWALD, ACCUSED SLAYER OF PRESIDENT KENNEDY, WAS SHOT AND SERIOUSLY WOUNDED IN THE BASEMENT OF DALLAS POLICE HEADQUARTERS TODAY.
KT1128ACS

BULLETIN 1ST ADD 1ST LEAD OSWALD XXX TODAY.
OSWALD WAS BEING TAKEN FROM POLICE HEADQUARTERS TO THE DALLAS COUNTY JAIL. AS HE WALKED THROUGH THE BASEMENT TO A WAITING VAN, FLANKED BY TWO POLICEMEN, A MAN XXXXX IDENTIFIED AS JACK RUBY, A DALLAS NIGHTCLUB OWNER, PUSHED THROUGH THE CROWD OF NEWSMEN, PUT

A GUN TO OSWALD'S MIDSECTION AND PULLED THE TRIGGERX. THE ACCUSED ASSASSIN SLUMPED TO THE FLOOR WHILE POLICE WRESTLED THE GUN FROM RUBY'S HAND. ONE OF THE OFFICERS SHOUTED, "JACK, YOU SON OF A BITCH."
OSWALD WAS PUT IN AN AMBULANCE AND RUSHED TO PARKLAND HOSPITAL, WHERE PRESIDENT XX KENNEDY DIED TWO DAYS AGO.
KT1140ACS

BULLETIN 2ND ADD 1ST LEAD OSWALDXXXAGO.
THE SHOOTING TOOK PLACE IN A XXXX BASEMENT GARAGE JAMMED WITH NEWSMEN AND TELEVISION CAMERAS. ONE NETWORK, IN FACT, HAD LIVE CAMERAS TRAINED ON OSWALD AT THE INSTAND OF THE SHOOTING.
RUBY, WHO WAS APPARENTLY KNOWN TO POLICE, WAS HUSTLED INTO AN ELEVATOR AND TAKEN UPSTAIRS.
KT1145ACS

-13-

BULLETIN 2ND LEAD OSWALD
DALLAS, NOV. 24 -- LEE HARVEY OSWALD, ACCUSED SLAYER OF PRESIDENT JOHN F. KENNEDY, DIED TODAY IN PARKLAND HOSPITAL, WHERE THE LATE PRESIDENT WAS PRONOUNCED DEAD XXXX TWO DAYS AGO.

WASHINGTON, NOV X 24 -- AS GREAT LINES OF PEOPLE FILED PAST THE BIER OF PRESIDENT JOHN F. KENNEDY -- LONG PAST THE SCHEDULED 9:00 P.M. CLOSING TIME -- MRS. JACQUELINE KENNEDY AND HER XXX BROTHER-IN-LAW, ATTORNEY XXXXX GENERAL ROBERT F. KENNEDY, RETURNED TO THE CAPITOL ROTUNDA TONIGHT.

MRS. KENNEDY WALKED THROUGH THE HUGE THRONG, PAUSED FOR A MOMENT IN FRONT OF THEX CATAFALQUE AND THEN LEFT. ON HER WAY OUT, SHE PAUSED AGAIN AND STARED AT THE XXXXX HUSHED THRONG. THEN SHE AND THE ATTORNEY GENERAL WALKED DOWN CAPITOL HILL AND ACROSS A LAWN TO A WAITING LIMOUSINE.
CY1105PES

FOURTH DAY

WASHINGTON, NOV. 23 -- PRESIDENT JOHN FITZGERALD KENNEDY WAS BURIED TODAY IN ARLINGTON NATIONAL CEMETERY.
THE XXX SLAIN PRESIDENT WAS LAID TO REST AT 3:34 P.M.(EST) ON A GRASSY SLOPE WITHIN VIEW OF THE LINCOLN MEMORIAL AND THE CAPITOL.

-14-

MR. KENNEDY'S BODY, WHICH HAD BEEN CARRIED FROM THE CAPITOL ROTUNDA THIS MORNING WAS XXXX TAKEN FIRST TO ST. MATTHEW'S ROMAN CATHOLIC CATHEDRAL, WHERE A PONTIFICAL XXX REQUIEM MASS WAS SAID BY RICHARD CARDINAL CUSHING OF BOSTON. FROM THERE, THE CORTEGE PROCEEDED TO THE NATIONAL CEMETERY, WHERE CARDINAL CUSHING INTOLED THE ANTIENT LATIN PHRASES AND REFERRED TO THE ASSASSINATED PRESIDENT AS "THIS WONDERFUL MAN, JACK KENNEDY."

THE DAY STARTED AT 10:41 A.M., WHEN MRS. JACQUELINE KENNEDY, ACCOMPANIED BY ATTORNEY GENERAL ROBERT F. KENNEDY, AND SENATOR EDWARD XXX M. KENNEDY, ENTERED THE ROTUNDA AND KNELT FOR A MOMENT BESIDE THE SLAIN PRESIDENT'S CASKET. EIGHT XX PALLBEARERS THEN CARRIED THE CASKET DOWN THE CAPITOL STEPS THROUGH LINES OF SENTINELS FROM ALL ARMED SERVICES, AND PLACED IT ON THE CASSON THAT HAD BROUGHT IT TO THE CAPITOL ON SUNDAY. SIX GRAY HORSES PULLED THE CAISSON, FOLLOWED BY A SAILOR CARRYING THE PRESIDENTIAL FLAG AND A RIDERLESS HORSE, WITH BOOTS REVERSED IN THE STIRRUPS, TO SIGNIFY THE LOSS OF A LEADER.

THE PROCESSION MOVED PAST THE WHITE HOUSE, WHERE WORLD LEADERS WHO HAD COME TO WASHINGTON FOR THE FUNERAL, WAITED XX FOR MRS. KENNEDY TO COME OUT OF THE WHITEHOUSE AND THEN FELL INTO LINE BEHIND THE CORTEGE. ABOUT FIVE YARDS BEHIND THE KENNEDY FAMILY WERE PRESIDENT AND MRS. JOHNSON, WHO WERE SURROUNDED BY SECURITY AGENTS.

26 FLASH — NOVEMBER 22, 1963 1968, PORTFOLIO OF ELEVEN SCREENPRINTS AND ELEVEN CORRESPONDING WRAPPERS WITH TELETYPE TEXT BY PHILLIP GREER, PLUS THREE ADDITIONAL SCREENPRINTS AND CLOTH COVER, EACH SCREENPRINT: 53.3 x 53.3 (21 x 21), EACH WRAPPER: 54.5 x 53.8 (21 ½ x 21 ¼), COVER: 57.2 x 113.7 (22 ½ x 44 ¾), NATIONAL PORTRAIT GALLERY, SMITHSONIAN INSTITUTION [PAGES 113–119]. *WASHINGTON ONLY*

FIRST DAY -- 11/22/63

FIRST LEAD KENNEDY
DALLAS, NOV. 22 -- PRESIDENT AND MRS. KENNEDY ARRIVEDX HERE TODAY IN THE SECOND DAY OF THEIR SWING THROUGH TEXAS.
FOLLOWING TUMULTUOUS RECEPTION IN SAN ANTONIO, HOUSTON AND FORT WORTH YESTERDAY, THE PRESIDENT WAS XXXX SCHEDULED TO SPEAK TODAY TO A DEMOCRATIC LUNCHEON, AFTER A MOTORCADE TO THE DALLAS TRADE MART.
THOUSANDS OF TEXANS XXXXX RIMMED THE LANDING AREA AT LOVE FIELD AS THE PRESIDENT'S PLANE, AIR FORCE ONE, TOUCHED DOWN AT 11:37 A.M.(CST).
EDL152ACS

FLASH
DALLAS -- SHOTS AT KENNEDY MOTORCADE.
CJ1235PCS

BULLETIN -- PRECEDE KENNEDY
DALLAS, NOV. 22 -- THREE SHOTS WERE FIRED AT PRESIDENT KENNEDY'S MOTORCADE IN DOWNTOWN DALLAS TODAY. XXXXXXXX THE PRESIDENT'S CAR. WITH MRS. KENNEDY AND GOV. AND MRS. JOHN B. CONNALLY, JR., SPED OFF IMMEDIATELY IT WAS UNCLEAR WHETHER THERE WERE ANY CASUALTIES.XXXX XXXXXXXXXXXXXXX

CJ1236PCS

BULLETIN -- 1ST ADD SHOTS
XXXXXX THE SHOTS RANG OUT AS THE PRESIDENT'S CAR WAS APPROACHING AN OVERPASS EN ROUTE TO THE TRADE MART, WHERE HE WAS TO DELIVER A SPEECH. THEY APPEARED TO COME FROM BEHIND THE MOTORCADE. (PICKUP 1ST LEAD....FOLLOWING TUMULTUOUS XXXX TO END)

-2-

CJI 237PCS

FLASH
DALLAS -- KENNEDY WOUNDED.
KT1240PCS

BULLETIN 2ND LEAD KENNEDY
DALLAS, NOV. 22 -- PRESIDENT JOHN F. KENNEDY AND TEXAS GOVERNOR JOHN B. CONNALLY, JR., WERE WOUNDED TODAY AS THEY RODE IN A MOTORCADE THROUGH DOWNTOWN DALLAS. THE PRESIDENT'S CAR SPED OUT IMMEDIATELY IN THE DIRECTION OF PARKLAND HOSPITAL, NEAR THE SCENE OF THE SHOOTING.
KT1242PCS

BULLETIN XXXXXX X 1ST ADD 2ND LEAD KENNEDY XXXXSHOOTING WHEN THE PRESIDENT'S CAR ARRIVED AT THE HOSPITAL, MR. KENNEDY'S LIMP BODY WAS CRADLED IN HIS WIFE'S ARMS. BOTH HE AND GOV. CONNALLY WERE RUSHED INTO THE HOSPITAL.
AS THE PRESIDENT WAS LIFTED FROM HIS FAMOUS "BUBBLETOP" CAR, CLINT HILL, A SECRET SERVICE AGENT ASSIGNED TO MRS. KENNEDY, SAID, "HE'S DEAD."
THERE WAS NO CONFIRMATION FROM WHITE HOUSE SPOKESMEN.
EJ1245PCS

BULLETIN 2ND ADD 2ND LEAD KENNEDY XXXXSPOKESMEN.
THE HOSPITAL WAS IN PANDEMONIUM. VICE PRESIDENT LYNDON B. JOHNSON, WHO WAS RIDING THREE CARS BEHIND THE PRESIDENT AND WAS UNINJURED, ARRIVED WITHIN MINUTES AFTER PRES. KENNEDY AND GOV. CONNALLY.

-3-

THE TWO WOUNDED MEN WERE RUSHED TO EMERGENCY ROOMS AND THE HOSPITAL'S PUBLIC ADDRESS SYSTEM RANG WITH CALLS FOR ALL STAFF DOCTORS.
EJ1248PCS

FLASH
DALLAS -- TWO PRIESTS SUMMONED TO KENNEDY X IN EMERGENCY ROOM.
EJ1250PCS

BULLETIN 3RD ADD 2ND LEAD KENNEDY XXXDOCTORS.
TWO PRIESTS ENTERED THE EMERGENCY ROOM WHERE THE PRESIDENT WAS BEING TREATED AT 1249 P.M.(CST).
THERE WAS STILL NO OFFICIAL WORD ON THE PRESIDENT'S CONDITION. ASSISTANT WHITE HOUSE PRESS SECRETARY MALCOLM XXXX KILDUFF SAID, "I JUST CAN'T SAY. I JUST CAN'T SAY."
KT1255PCS

FLASH
DALLAS -- PRIESTS SAY KENNEDY DEAD.
KT1257PCS

FLASH
DALLAS -- PRESIDENT KENNEDY DIED AT 1 P.M.(CST)
KT102PCS

BULLETIN 3RD LEAD KENNEDY
DALLAS, NOV. 22 -- PRESIDENT JOHN F. KENNEDY WAS SHOT AND KILLED TODAY AS HE RODE IN A MOTORCADE THROUGH DOWNTOWN DALLAS.
TEXAS GOVERNOR JOHN B. CONNALLY, JR., RIDING IN FRONT OF THE PRESIDENT, WAS SERIOUSLY WOUNDED.

-4-

THE SHOOTING OCCURRED AT XXXXX12:30 P.M. (CST) AND THE PRESIDENT WAS PRONOUNCED DEAD AT PARKLAND XXX HOSPITAL AT 1 P.M.(CST).
EJ105PCS

BULLETIN 1ST ADD 3RD LEAD KENNEDY
GOVERNOR CONNALLY'S WOUNDS WERE DESCRIBED AS SERIOUS, BUT NOT CRITICAL. VICE PRESIDENT LYNDON B. JOHNSON, WHO WAS RIDING THREE CARS BEHIND THE XXX PRESIDENT AND THE GOVERNOR, WAS UNHURT.
EJ108PCS

NEW YORK, NOV. 22 -- HEAVY SELLING SWAMPED THE NEW YORK STOCK EXCHANGE AFTER WORD OF PRESIDENT KENNEDY'S ASSASSINATION.
THE EXCHANGE'S BOARD OF GOVERNORS CALLED A HASTY MEETING TO CONSIDER CLOSING THE EXCHANGE.
XXXXXX10207PCS

BULLETIN -- STOCKS
NEW YORK, NOV. 22 -- THE BOARD OF GOVERNORS OF THE NEW YORK STOCK EXCHANGE ORDERED ALL TRADING HALTED AT 2:07 P.M. (EST).
HEAVY SELLING HAD SWAMPED THE EXCHANGE FLOOR AFTER NEWS OF PRESIDENT KENNEDY'S ASSASSINATION.
10209PCS

BULLETIN
WASHINGTON, NOV. 22 -- THE SENATE ADJOURNED SHORTLY BEFORE 2:15 P.M. (EST). MAJORITY LEADER MIKE MANSFIELD (D-MONT.) SAID THE SENATE WOULD RECONVENE ON MONDAY, UNLESS PRESIDENT KENNEDY'S FUNERAL IS HELD THAT DAY.
GD216PCS

-5-

WASHINGTON, NOV. 22 -- AN AIR FORCE JET CARRYING SIX CABINET MEMBERS TO CONFERENCES IN TOKYO TURNED BACH TO WASHINGTON AFTER RECEIVING NEWS OF THE ASSASSINATION, THE STATE DEPARTMENT ANNOUNCED. THE PLANE IS EXPECTED IN WASHINGTON AT 1 A.M. (EST) TOMORROW.
GD230PCS

FLASH
DALLAS -- POLICE ARREST "HOT SUSPECT".

BULLETIN 1ST LEAD SUSPECT
DALLAS, NOV. 22 -- DALLAS POLICE ANNOUNCED THEY HAVE ARRESTED A "HOT SUSPECT" IN THE ASSASSINATION OF PRESIDENT KENNEDY.
HE WAS IDENTIFIED AS LEE H. OSWALD, 24, AN EMPLOYEE OF THE TEXAS BOOK DEPOSITORY, ADJACENT TO THE SITE WHERE THE PRESIDENT WAS SHOT DOWN. OSWALD, WHO HAD BEEN ARRESTED EARLIER IN CONNECTION WITH THE SHOOTING OF A DALLAS POLICEMAN, FORMERLY LIVED IN THE SOVIET UNION AND WAS ACTIVE IN THE FAIR PLAY FOR CUBA COMMITTEE.
KT210PCS

BULLETIN
DALLAS, NOV. 22 -- LYNDON BAINES JOHNSON WAS SWORN IN AS THE 36TH PRESIDENT OF THE UNITED STATES AT 2:39P.M.(CST) ABOARD THE PRESIDENTIAL JET AIR FORCE ONE ON A RUNWAY AT LOVE FIELD.

-6-

THE CEREMONY TOOK PLACE WITHIN MOMENTS AFTER THE COFFIN CONTAINING THE BODY OF SLAIN PRESIDENT JOHN F. KENNEDY WAS LOADED ABOARD THE PLANE. MRS. JOHNSON, MRS. KENNEDY AND A GROUP OF WHITE HOUSE AIDES ATTENDED THE OATH-TAKING, WHICH WAS ADMINISTERED BY FEDERAL JUDGE SARAH T. HUGHES, WHO WAS APPOINTED TO OFFICE BY PRESIDENT KENNEDY IN OCTOBER, 1961.
KT250PCS

WASHINGTON, NOV. 22 -- THE XXXX AIR FORCE JET CARRYING PRESIDENT LYNDON B. JOHNSON AND THE BODY OF ASSASSINATED PRESIDENT JOHN F. KENNEDY LANDED AT ANDREWS AIR FORCE BASE SHORTLY AFTER 6 P.M. (EST).
THE PLANE WAS MET BY AN HONOR GUARD OF AIRMEN IN DRESS UNIFORM, WITH RIFLES AND BAYONETS, AND BY HIGH-RANKING GOVERNMENT OFFICIALS.
AS SOON AS THE PLANES ENGINES STOPPED, ATTORNEY GENERAL ROBERT F. KENNEDY, THE SLAIN PRESIDENT'S BROTHER, BOUNDED UP THE STEPS AND INTOTHE CABIN. WITHIN A FEW MINUTES, HE REAPPEARED AT THE DOORWAY WITH MRS. JACQUELINE KENNEDY AND THE TWO WATCHED, HAND IN HAND, AS THE COFFIN WAS LOWERED TO A WAITING NAVAL AMBULANCE, TO BE TAKEN TO BETHESDA NAVAL HOSPITAL.
MRS. KENNEDY, HERX DRESS AND STOCKINGS STILL SMEARED WITH HERX HUSBAND'S BLOOD, APPEARED COMPOSED. SHE RODE IN THE AMBULANCE TO THE HOSPITAL.
CD515PCS

NITE LEAD KENNEDY
DALLAS, NOV. 22 -- PRESIDENT JOHN F. KENNEDY WAS ASSASSINATED HERE TODAY.

-7-

THE PRESIDENT WAS KILLED BY A BULLET THROUGH THE BRAIN FIRED AS HE RODE IN A MOTORCADE THROUGH DOWNTOWN DALLAS. TEXAS GOVERNOR JOHN B CONNALLY, JR., RIDING IN THE SAME CAR, WAS SHOT IN THE CHEST, RIBS AND ARM. HIS CONDITION WAS DESCRIBED AS XXX SERIOUS, BUT NOT CRITICAL.

VICE PRESIDENT LYNDON BAINES JOHNSON, RIDING THREE CARS BACK, WAS UNINJURED. MR. JOHNSON WAS SWORN IN AS THE 36TH PRESIDENT OF THE UNITED STATES 99 MINUTES AFTER XXXX MR. KENNEDY WAS PRONOUNCED DEAD AT 1:00 P.M.(CST). MR. JOHNSON IS 55 YEARS OLD; MR. KENNEDY WAS 46.

SHORTLY AFTER 2 P.M. DALLAS POLICE ANNOUNCED THEY HAD ARRESTED A "HOT SUSPECT" IN THE ASSASSINATION. HE WAS IDENTIFIED AS LEE HARVEY OSWALD, 24, WHO IS EMPLOYED AT THE TEXAS BOOK DEPOSITORY, ADJACENT TO THE MURDER SCENE. OSWALD, WHO FORMERLY LIVED IN THE SOVIET UNIOJ, WAS ARRESTED IN CONNECTION WITH THE SLAYING OF J.B. TIPPIT, A X DALLAS PATROLMAN, SHORTLY AFTER PRESIDENT KENNEDY WAS KILLED.

THE PRESIDENT WAS STRUCK DOWN AS HE RODE IN AN OPEN CAR XXXX ON HIS WAY TO THE DALLAS TRADE MART, WHERE HE WAS TO DELIVER A SPEECH TO A GROUP OF THE CITY'S LEADING CITIZENS. HE HAD ARRIVED IN DALLAS FROM FORT WORTH AT 11:37 A.M. (CST) TODAY.

-8-

THE THREE SHOTS RANG OUT IN QUICK SUCCESSION AT 12:30 P.M.(CST), JUST AS THE PRESIDENT'S CAR WAS APPROACHING A TRIPLE OVERPASS. MR. KENNEDY, WHO WAS WAVING AT THE THINNED OUT CROWDS, CLUTCHED AT HIS THROAT AND TOPPLED OVER ONTO THE X LAP OF HIS WIFE, WHO JUMPED UP AND SHOUTED, "OH, NO!" SECRET SERVICE AGENT CLINT HILL LEAPED ONTO THE BACK OF THE PRESIDENT'S CAR AND ORDERED THE DRIVER TO SPEED AHEAD TO PARKLAND HOSPITAL, THREE AND A HALF MILES DOWN THE ROAD.

ARRIVING AT THE HOSPITAL, MR. KENNEDY AND GOV. CONNALLY, WHO WAS ALSO BEING HELD BY HIS WIFE, WERE RUSHED INTO EMERGENCY ROOMS. SOON AFTER THEIR ARRIVAL, TWO PRIESTS WERE SUMMONED TO PRESIDENT KENNEDY'S SIDE. ON LEAVING THE EMERGENCY ROOM, THE PRIESTX REPORTED THAT THE PRESIDENT HAD DIED OF HIS WOUNDS. WHITE HOUSE AIDES, AT FIRST UNCERTAIN, CONFIRMED THE REPORT AT 1:33 P.M. (CST).

EJ1155PCS

WASHINGTON, NOV. 22 -- FOLLOWING IS THE TEXT OF A STATEMENT BY PRESIDENT LYNDON BAINES JOHNSON ON ARRIVAL AT ANDREWS AIR FORCE BASE IN THE PLANE CARRYING THE BODY OF PRESIDENT JOHN F. KENNEDY:

"THIS IS A SAD TIME FOR ALL PEOPLE. WE HAVE SUFFERED A LOSS THAT CANNOT BE WEIGHED. FOR ME IT IS A DEEP PERSONAL TRAGEDY. I KNOW THE WORLD SHARES THE SORROW THAT MRS. KENNEDY AND HERXX FAMILY BEAR. I WILL DO MY BEST. THAT IS ALL I CAN DO. I ASK FOR YOUR HELP -- AND XXXX GOD'S."

LG610PCS

-9-

SECOND DAY - 11/23/63

DALLAS, NOV. 23 -- DALLAS XXXXX POLICE SAID TODAY THEY HAVE ENOUGH EVIDENCE TO CONVICT LEE HARVEY OWSALD OF THE ASSASSINATION OFOF PRESIDENT KENNEDY.

"WE'RE CONVINCED BEYOND ANY DOUBT THAT HE KILLED THE PRESIDENT, CAPT. WILL FITZ, CHIEF OF THE HOMICIDE BUREAU XXX SAID TODAY AFTER QUESTIONING OSWALD. "I THINK THE CASE XX IS CINCHED," HE SAID, EXHIBITING THE RIFLE SAID TO HAVE KILLED MR. KENNEDY.

ALTHOUGH OSWALD HIMSELF STOUTLY DENIES COMMITTING THE MURDER, DALLAS COUNTY DISTRICT ATTORNEY HENRY WADE SAID: "I THINK WE HAVE ENOUGH EVIDENCE TO CONVICT HIM NOW. BUT WE ANTICIPATE A LOT MORE EVIDENCE IN THE NEXT FEW DAYS."

KT1124ACS

WASHINGTON, NOV. 23 -- PRESIDENT JOHN FITZGERALD KENNEDY RETURNED TO THE WHITE HOUSE THIS MORNING.

A GRAY NAVAL AMBULANCE FROM BETHESDA NAVAL HOSPITAL GLIDED QUIETLY BEHIND A MARINE HONOR GUARD ONTO THE WHITE HOUSE GROUNDS SHORTLY BEFORE DAWN, XXXXX CARRYING THE BODY OF THE ASSASSINATED PRESIDENT.

THE PRESIDENT'S XXXXXX FLAG-DRAPED CASKET WAS TAKEN TO THE EAST ROOM AND PLACED ON A XXXX CATAFLAQUE SIMILAR TO THE ONE USED FOR PRESIDENT LINCOLN ALMOST 100 YEARS AGO.

AN HONOR GUARD OF ONE MARINE, ONE SAILOR, ONE AIRMAN AND ONE SOLDIER STOOD AT EACH CORNER OF THE CASKET. TWO PRIESTS KNEELED IN CONSTANT PRAYER.

LG 1135AES

-10-

WASHINGTON, NOV. 23 -- PRESIDENT LYNDON B. JOHNSON TODAY ISSUED A PROCLAMATION DESIGNATING MONDAY, THE DAY OF PRESIDENT JOHN F. KENNEDY'S FUNERAL, A DAY OF NATIONAL MOURNING.

THE WHITE HOUSE ANNOUNCED THAT THE SLAIN PRESIDENT WILL BE BURIED IN ARLINGTON NATIONAL CEMETERY. THE BODY WILL X LIE IN THE EAST ROOM OF THE WHITE HOUSE UNTIL TOMORROW, WHEN IT WILL BE TAKEN TO THEX CAPITOL ROTUNDAXX AT 1 ½.M. (EST). ON MONDAY,THE PROCESSION WILL RETURN TO THE WHITE HOUSE, WHERE IT WILL BE MET BY MOURNERS INCLUDING X HEADS OF STATE FROM AROUND THE WORLD. FROM THERE, IT WILL PROCEDE TO ST. MATTHEW'S ROMAN CATHOLIC XXXX CATHEDRAL, WHERE A PONTIFICAL REQUIEM MASS WILL BE SAID BY RICHARD CARDINAL CUSHING OF BOSTON A LONG-TIME FRIEND OF THE KENNEDY FAMILY.

LG135PES

WASHINGTON, NOV. 23 -- PRESIDENT JOHNSON ASSUMED CONTROL OF THE GOVERNMENT TODAY AND RECEIVED PLEDGES OF SUPPORT FROM LEADERS OF BOTH PARTIES, AS WELL AS HEADS OF STATE FROM THROUGHOUT THE NON-COMMUNIST WORLD.

THE PRESIDENT MET WITH HIS CABINET THIS AFTERNOON XXX AND ASKED ALL MEMBERS TO REMAIN ON THEIR POSTS. THOSE PRESENT INCLUDED THE SIX MEMBERS WHO HAD BEEN FLYING TO JAPAN WHEN NEWS OF THE ASSASSINATION WAS RECEIVED, AS WELL AS ATTORNEY GENERAL ROBERT F. KENNEDY, THE SLAIN PRESIDENT'S BROTHER.

THE WHITE HOUSE ANNOUNCED PRESIDENT JOHNSON WILL ADDRESS A JOINT SESSION OF CONGRESS AT 12:30 P.M. (EST) WEDNESDAY.

LG200PES

-11-

THIRD DAY

WASHINGTON NOV. 24 -- THE BODY OF PRESIDENT JOHN F. KENNEDY WAS BORNE TO THE ROTUNDA OF THE CAPITOL TODAY ON THE SAME CAISSON USED FOR PRESIDENT FRANKLIN D. ROOSEVELT ALMOST 20 YEARS AGO.

WITH CROWDS ESTIMATED AT 300,000 PEOPLE LINING THE STREETS OF WASHINGTON, THEX PROCESSION MOVED OUT OF THE WHITE HOUSE GROUNDS AT 1:00 P.M. (EST), UNDER MASSED STATE FLAGS DIPPED IN XXXXX HOMAGE. THE PROCESSION, WITH MRS. JACQUELINE KENNEDY, HER TWO CHILDREN AND OTHER MEMBERS OF THE XXXX KENNEDY FAMILY RIDING IN LIMOUSINES, MOVED TOWARD THE CAPITOL TO THE CADENCE OF MUFFLED DRUMS REPRESENTING ALL FOUR SERVICES.

WHEN THE CORTEGE REACHED THE CAPITOL STEPS, AN HONOR GUARD OF SERVICE-MEN CARRIED THE CASKET INTO THE GREAT ROTUNDA,XXXX FOLLOWED BY THE LATE PRESIDENT'S FAMILY.

AFTER THE CASKET WAS PLACED ON A CATAFALQUE, SENATE MAJORITY LEADER MIKE MANSFIELD (MONT.) HOUSE SPEAKER JOHN W. MC CORMACK (MASS.) AND CHIEF JUSTICE EARL WARREN READ EULOGIES. AFTER THE BRIEF CEREMONY, THE KENNEDY FAMILY LEFT THE CAPITOL AND THE XXX CROWDS OF PUBLIC MOURNERS, SOME OF WHOM HAD WAITED SINCE EARLY SATURDAY EVENING, XXXX BEGAN TO FILE PAST THE BIER.
IT115PES

XXXXXXX FLASH
DALLAS -- OSWALD SHOT
KT1125ACS

-12-

BULLETIN 1ST LEAD OSWALD
DALLAS, NOV. 24 -- LEE HARVEY OSWALD, ACCUSED SLAYER OF PRESIDENT KENNEDY, WAS SHOT AND SERIOUSLY WOUNDED IN THE BASEMENT OF DALLAS POLICE HEADQUARTERS TODAY.
KT1128ACS

BULLETIN 1ST ADD 1ST LEAD OSWALD XXX TODAY.
OSWALD WAS BEING TAKEN FROM POLICE HEADQUARTERS TO THE DALLAS COUNTY JAIL. AS HE WALKED THROUGH THE BASEMENT TO A WAITING VAN, FLANKED BY TWO POLICEMEN, A MAN XXXXX IDENTIFIED AS JACK RUBY, A DALLAS NIGHTCLUB OWNER, PUSHED THROUGH THE CROWD OF NEWSMEN, PUT

A GUN TO OSWALD'S MIDSECTION AND PULLED THE TRIGGERX. THE ACCUSED ASSASSIN SLUMPED TO THE FLOOR WHILE POLICE WRESTLED THE GUN FROM RUBY'S HAND. ONE OF THE OFFICERS SHOUTED, "JACK, YOU SON OF A BITCH."

OSWALD WAS PUT IN AN AMBULANCE AND RUSHED TO PARKLAND HOSPITAL, WHERE PRESIDENT XX KENNEDY DIED TWO DAYS AGO.
KT1140ACS

BULLETIN 2ND ADD 1ST LEAD OSWALDXXXAGO.
THE SHOOTING TOOK PLACE IN A XXXX BASEMENT GARAGE JAMMED WITH NEWSMEN AND TELEVISION CAMERAS. ONE NETWORK, IN FACT, HAD LIVE CAMERAS TRAINED ON OSWALD AT THE INSTAND OF THE SHOOTING.
RUBY, WHO WAS APPARENTLY KNOWN TO POLICE, WAS HUSTLED INTO AN ELEVATOR AND TAKEN UPSTAIRS.
KT1145ACS

-13-

BULLETIN 2ND LEAD OSWALD
DALLAS, NOV. 24 -- LEE HARVEY OSWALD, ACCUSED SLAYER OF PRESIDENT JOHN F. KENNEDY, DIED TODAY IN PARKLAND HOSPITAL, WHERE THE LATE PRESIDENT WAS PRONOUNCED DEAD XXXX TWO DAYS AGO.

WASHINGTON, NOV X 24 -- AS GREAT LINES OF PEOPLE FILED PAST THE BIER OF PRESIDENT JOHN F. KENNEDY -- LONG PAST THE SCHEDULED 9:00 P.M. CLOSING TIME -- MRS. JACQUELINE KENNEDY AND HER XXX BROTHER-IN-LAW, ATTORNEY XXXXX GENERAL ROBERT F. KENNEDY, RETURNED TO THE CAPITOL ROTUNDA TONIGHT.

MRS. KENNEDY WALKED THROUGH THE HUGE THRONG, PAUSED FOR A MOMENT IN FRONT OF THEX CATAFALQUE AND THEN LEFT. ON HER WAY OUT, SHE PAUSED AGAIN AND STARED AT THE XXXXX HUSHED THRONG. THEN SHE AND THE ATTORNEY GENERAL WALKED DOWN CAPITOL HILL AND ACROSS A LAWN TO A WAITING LIMOUSINE.
CY1105PES

FOURTH DAY

WASHINGTON, NOV. 23 -- PRESIDENT JOHN FITZGERALD KENNEDY WAS BURIED TODAY IN ARLINGTON NATIONAL CEMETERY.
THE XXX SLAIN PRESIDENT WAS LAID TO REST AT 3:34 P.M.(EST) ON A GRASSY SLOPE WITHIN VIEW OF THE LINCOLN MEMORIAL AND THE CAPITOL.

-14-

MR. KENNEDY'S BODY, WHICH HAD BEEN CARRIED FROM THE CAPITOL ROTUNDA THIS MORNING WAS XXXX TAKEN FIRST TO ST. MATTHEW'S ROMAN CATHOLIC CATHEDRAL, WHERE A PONTIFICAL XXX REQUIEM MASS WAS SAID BY RICHARD CARDINAL CUSHING OF BOSTON. FROM THERE, THE CORTEGE PROCEEDED TO THE NATIONAL CEMETERY, WHERE CARDINAL CUSHING INTOLED THE ANTIENT LATIN PHRASES AND REFERRED TO THE ASSASSINATED PRESIDENT AS "THIS WONDERFUL MAN, JACK KENNEDY."

THE DAY STARTED AT 10:41 A.M., WHEN MRS. JACQUELINE KENNEDY, ACCOMPANIED BY ATTORNEY GENERAL ROBERT F. KENNEDY AND SENATOR EDWARD XXX M. KENNEDY, ENTERED THE ROTUNDA AND KNELT FOR A MOMENT BESIDE THE SLAIN PRESIDENT'S CASKET. EIGHT XX PALLBEARERS THEN CARRIED THE CASKET DOWN THE CAPITOL STEPS THROUGH LINES OF SENTINELS FROM ALL ARMED SERVICES, AND PLACED IT ON THE CASSON THAT HAD BROUGHT IT TO THE CAPITOL ON SUNDAY. SIX GRAY HORSES PULLED THE CAISSON, FOLLOWED BY A SAILOR CARRYING THE PRESIDENTIAL FLAG AND A RIDERLESS HORSE, WITH BOOTS REVERSED IN THE STIRRUPS, TO SIGNIFY THE LOSS OF A LEADER.

THE PROCESSION MOVED PAST THE WHITE HOUSE, WHERE WORLD LEADERS WHO HAD COME TO WASHINGTON FOR THE FUNERAL, WAITED XX FOR MRS. KENNEDY TO COME OUT OF THE WHITEHOUSE AND THEN FELL INTO LINE BEHIND THE CORTEGE. ABOUT FIVE YARDS BEHIND THE KENNEDY FAMILY WERE PRESIDENT AND MRS. JOHNSON, WHO WERE SURROUNDED BY SECURITY AGENTS.

AS ON SUNDAY, WHEN THE FALLEN PRESIDENT WAS TAKEN TO THE CAPITOL, THE FLAGS OF ALL 50 STATES LINING XXXX THE WHITE HOUSE DRIVE WERE DIPPED AS THE CAISSON PASSED.

BEHIND THE PRESIDENT AND MRS. JOHNSON, A LIMOUSINE CARRIED MR. XXXXX KENNEDY'S CHILDREN, CAROLINE, 6 AND JOHN, JR., 3.

OTHERS IN THE GROUP INCLUDED FORMER PRESIDENTS HARRY S. TRUMAN AND DWIGHT D. EISENHOWER, BRITISH PRIME MINISTER SIR XXX ALEC DOUGLAS-HOME, PRESIDENT EAMON DE VALERA OF IRELAND, WILLY BRANDT, MAYOR OF WEST BERLIN, JESS OTTO KRAG, PREMIER OF DENMARK, CROWN PRINCESS BEATRIX OF THE NETHERLANDS, PRINCE JEAN OF LUXEMBOURG AND DOZENS OF OTHER XXXXX LEADERS OF STATE.

AFTER THE LIMOUSINE CAME THE PROCESSION OF DIGNITARIES, WITH FRENCH PRESIDENT CHARLES DE GAULLE, KING BAUDOUIN OF BELGIUM, EMPEROR HAILE SELASSIE OF ETHIOPIA, PRESIDENT DIOSDADO MACAPAGAL OF THE PHILIPPINES, GEN. CHUNG HEE PARK, PRESIDENT-ELECTX OF SOUTH KOREA, QUEEN FREDERIKA OF GREECE AND WEST GERMAN PRESIDENT HEINRICH LUBKE IN THE FRONT RANK.

AT THE CATHEDRAL, THE PROCESSION STOPPED FOR THE REQUIEM MASS, WHICH ENDED AT XXXX 1:15 P.M. AFTER THE PROCESSION OF PRELATES FOLLOWED THE CROSS UP THE AISLE, THE PALLBEARERS CARRIED PRESIDENT KENNEDY'S COFFIN BEHIND THEM, THEN MRS. KENNEDY, HOLDING CAROLINE'S HAND, CAME OUT OF THE CHURCH AND WAITED WHILE THE CASKET WAS PLACED ON THE CAISSON. ERECT AND UNMOVING, BUT OBVIOUSLY WEEPING BEHIND HER BLACK XXX VEIL, MRS. KENNEDY FINALLY MOVED DOWN THE STEPS AND INTO A WAITING LIMOUSINE, FOLLOWED BY OTHER MEMBERS OF THE KENNEDY FAMILY. CARDINAL CUSHING WAS WEEPING AS HE LEFT THE CHURCH. GEN. EISENHOWER AND MR. TRUMAN BOTH STOPPED FOR BRIEF WORDS WITH MRS. KENNEDY BEFORE THEY RODE TOGETHER IN THE PROCESSION.

WHEN THE CORTEGE WAS FINALLY FORMED -- THE KENNEDY FAMILY GROUP WAS SO LARGE THAT PRESIDENT AND MRS. JOHNSON, RIDING DIRECTLY BEHIND THEM, WERE IN THE 10TH CAR -- SLOW MOVEMENT TO ARLINGTON BEGAN, REACHING THE CEMETERY MORE THAN AN HOUR LATER. JUST AS THE CORTEGE REACHED THE GRAVESITE, 50 AIRFORCE JETS -- REPRESENTING THE 50 STATES -- ROARED OVERHEAD, FOLLOWED BY THE PRESIDENT'S PERSONAL PLANE, AIR FORCE ONE.

AS THE COFFIN WAS LOWERED XXTO THE GROUND, CARDINAL CUSHING INTOLED THE ANCIENT CATHOLIC RITES AND THREE CANNONS BOOMED A 21-GUN SALUTE IN THE DISTANCE. THEN THREE RIFLEMEN FIRED THREE VOLLIES EACH INTO THE SKY AND X ANX ARMY BUGLER, SGT. KEITH CLARK, SOUNDED TAPS.

THE FLAG WHICH HAD DRAPED THE COFFIN FOR THREE DAYS WAS FOLDED X CAREFULLY BY THE PALLBEARERS AND GIVEN TO MRS. KENNEDY. SHE AND HER HUSBAND'S TWO BROTHERS THEN LIGHTED THE XX ETERNAL FLAME WHICH WILL BURN ABOVE THE GRAVE.

AT 3:34 P.M., THE SERVICE WAS OVER. MRS. KENNEDY, WITH ROBERT KENNEDY ALONGSIDE, XXX WALKED SLOWLY BACK TO THE LIMOUSINE FOR HER RETURN TO THE WHITE HOUSE. SHE ALMOST TRIPPED ONCE, BUT RECOVERED HER BALANCE UNASSISTED.

AND SO THE 35TH PRESIDENT OF THE UNITED STATES WAS LAID TO REST. XX THE FOUR DAYS THAT SHOCKED THE WORLD CAME TO AN END, AND THE GREAT AND NEAR-GREAT FROM AROUND THE WORLD TURNED BACK TO THEIR OWN WORLDS. AND IN ALL THE SPEECHES, IN ALL THE EULOGIES, IN ALL THE COMFORTING MESSAGES, NOWHERE WAS THE WORLD'S SENTIMENT MORE CLEARLY EXPRESSED THAN IN A BRIEF INSCRIPTION ON THE BACK OF A PICTURE OF THE LATE PRESIDENT, WHICH WAS HANDED OUT X AT XXXX ST. MATTHEWS CATHEDRAL: "DEAR GOD, PLEASE TAKE CARE OF YOUR SERVANT, JOHN FITZGERALD KENNEDY."

GV220PCS

FORT WORTH XXXXX NOV. 25 -- LEE HARVEY OSWALD, ACCUSED KILLER OF PRESIDENT KENNEDY, WHO WAS HIMSELF MURDERED YESTERDAY, WAS BURIED HERE TODAY IN AN ISOLATED SECTION OF ROSE HILL CEMETERY. THE SERVICE WAS ATTENDED BY OSWALD'S MOTHER, MRS. MARGUERITA OSWALD, HIS WIFE, MARINE, HIS TWO CHILDREN AND HIS BROTHER ROBERT. SECRET SERVICE AGENTS RINGED THE GROUP.

DETERMINED TO AVIOD THE EYES OF THE CURIOUS, THE FUNERAL WAS CONDUCTED WITH SUCH SECRECY THAT NOT EVEN THE GRAVEDIGGERS KNEW THE IDENTITY OF THE DECEASED UNTIL THE SERVICE WAS OVER.

1W305PCS

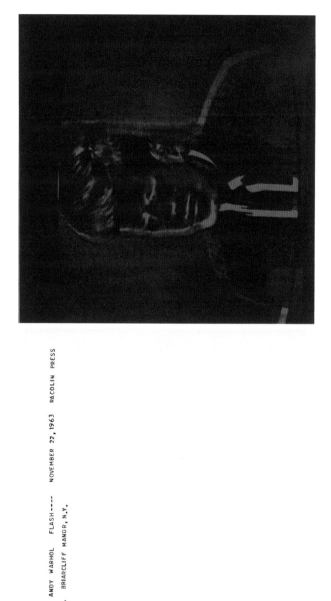

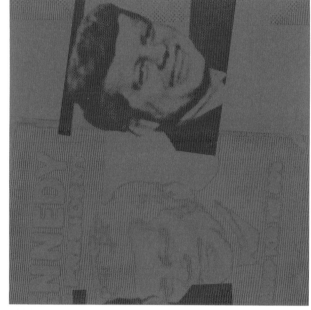

ANDY WARHOL FLASH---- NOVEMBER 22,1963 RACOLIN PRESS
INC. BRIARCLIFF MANOR, N.Y.

SILKSCREENS AND COVER -- ANDY WARHOL XXXX TEXT -- COLOPHON
TITLE PAGE -- ALSO SILKSCREENS PULLED -- AETNA SILKSCREEN
PRODUCTS INC. 1968 PERSONAL SUPERVISION -- ANDY WARHOL. TEXT --
PHILLIP GREER XXX ENTIRE EDITION - 236 COPIES XXXXX 1-200 FOR
SALE XXX IO A-J 3 ADDITIONAL SILKSCREENS FOR SALE XXXX
26 I-XXVI NOT FOR SALE.
 NUMBER

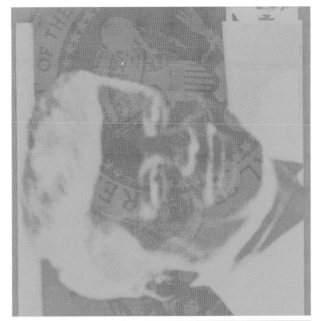

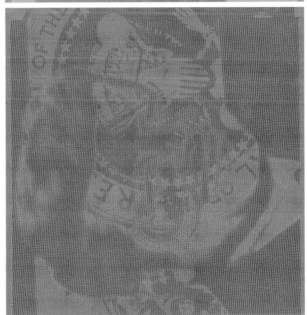

28 **FRAME ENLARGEMENT FROM** BRIGID POLK ON MONEY — MORE TALK SHOW PRACTICE, JUNE 10, 1974
½-INCH REEL-TO-REEL VIDEOTAPE, COLOR, SOUND (30 MINUTES), THE ANDY WARHOL MUSEUM, PITTSBURGH

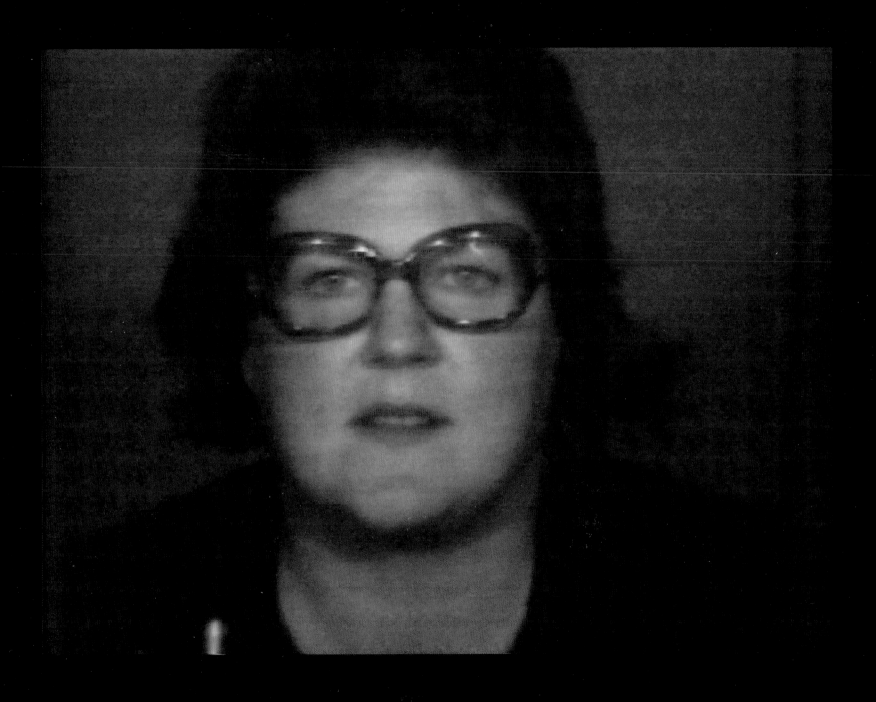

½-INCH REEL-TO-REEL VIDEOTAPE, COLOR, SOUND (30 MINUTES), THE ANDY WARHOL MUSEUM, PITTSBURGH

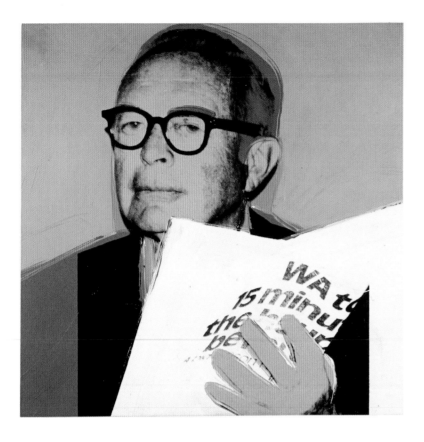
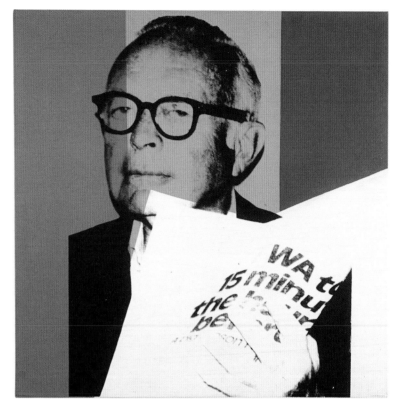
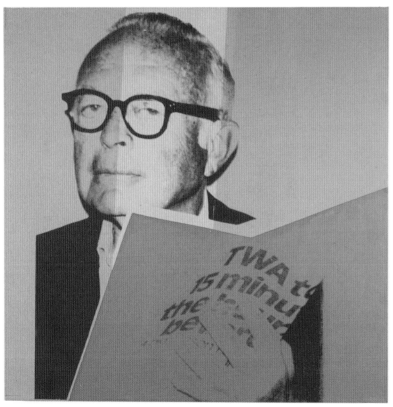
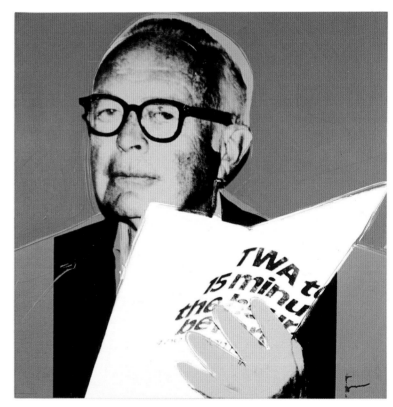

31 GARDNER COWLES 1977, SYNTHETIC POLYMER PAINT AND SILKSCREEN INK ON CANVAS, FOUR PANELS,
EACH 101.6 x 101.6 (40 x 40), THE ANDY WARHOL FOUNDATION FOR THE VISUAL ARTS, INC.

EPH BEUYS ESEGUITI DA ANDY WARHOL EPH BEUYS ESEGUITI DA ANDY WARHOL EPH BEUYS ESEGUITI DA ANDY WARHOL

altro è in posa altro è in posa altro è in posa

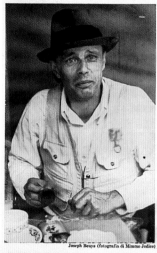 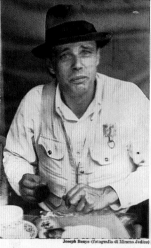 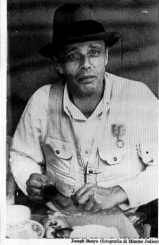

Joseph Beuys (fotografia di Mimmo Jodice) Joseph Beuys (fotografia di Mimmo Jodice) Joseph Beuys (fotografia di Mimmo Jodice)

rtista, cioè un politico rtista, cioè un politico rtista, cioè un politico

Vestito di feltro, di Beuys (1970)

Pagina a cura di
MICHELE BONUOMO

32 TRIPLE PORTRAIT OF BEUYS 1980, SCREENPRINT AND FELT-TIP PEN ON ACETATE,
55.5 x 42 (21 7/8 x 16 1/2), COLLECTION MICHELE BONUOMO, MILAN

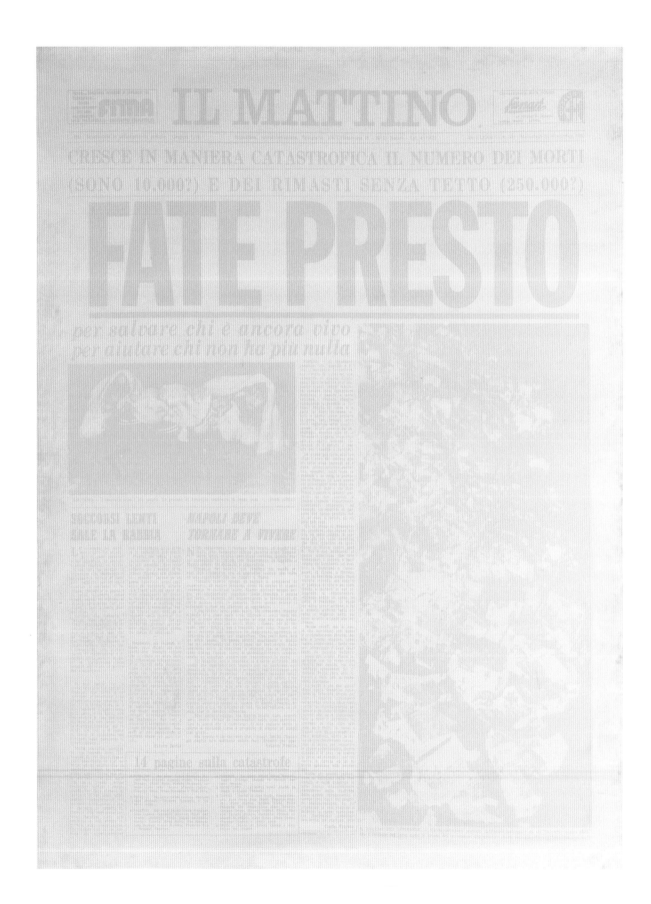

34 ANDY WARHOL AT 860 BROADWAY C. 1978, GELATIN SILVER PRINT, 20.3 x 25.4 (8 x 10),
THE ANDY WARHOL FOUNDATION FOR THE VISUAL ARTS, INC.

35 INTERIOR DATE UNKNOWN, GELATIN SILVER PRINT, 25.4 x 20.3 (10 x 8), COLLECTION FRIENDS OF THE NEUBERGER MUSEUM OF ART, PURCHASE COLLEGE, STATE UNIVERSITY OF NEW YORK, GIFT FROM THE ANDY WARHOL FOUNDATION FOR THE VISUAL ARTS, INC.

36 FRED HUGHES 1982, GELATIN SILVER PRINT, 20.3 x 25.4 (8 x 10), BRAUER MUSEUM OF ART,
VALPARAISO UNIVERSITY, GIFT OF THE ANDY WARHOL FOUNDATION FOR THE VISUAL ARTS, INC.

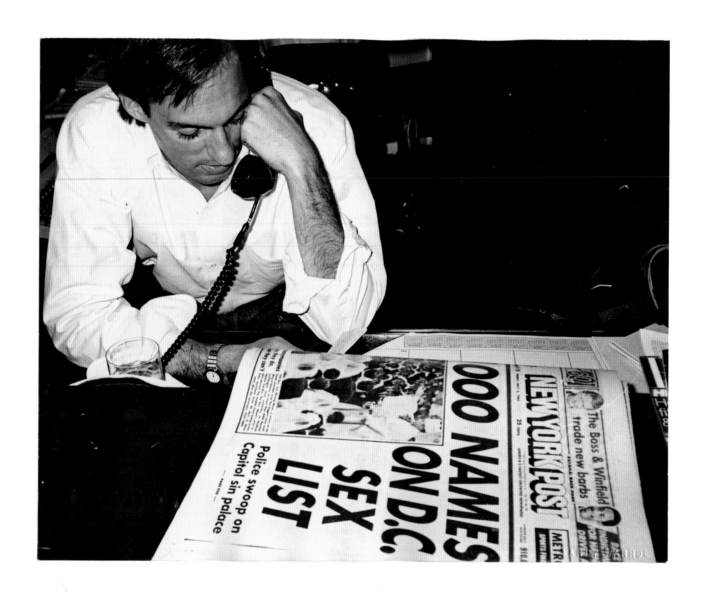

38 NEWSPAPER 1982, GELATIN SILVER PRINT, 25.4 x 20.3 (10 x 8), THE ANDY WARHOL MUSEUM, PITTSBURGH; CONTRIBUTION THE ANDY WARHOL FOUNDATION FOR THE VISUAL ARTS, INC.

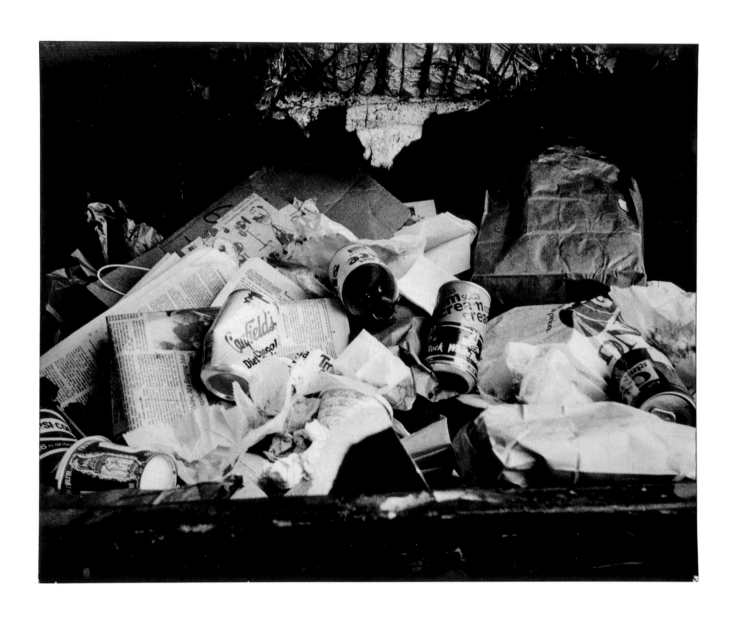

40 TRASH DATE UNKNOWN, GELATIN SILVER PRINT, 20.3 x 25.4 (8 x 10), THE ANDY WARHOL MUSEUM, PITTSBURGH; CONTRIBUTION THE ANDY WARHOL FOUNDATION FOR THE VISUAL ARTS, INC.

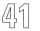

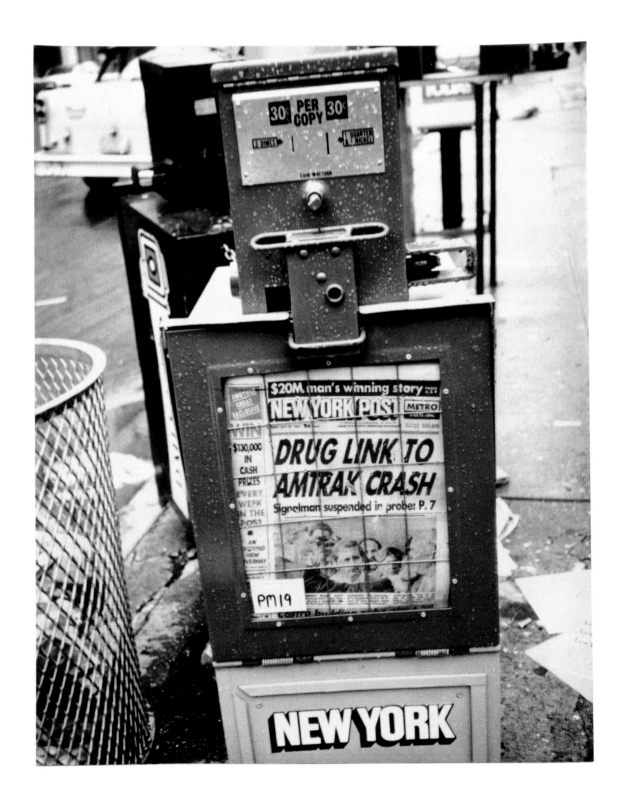

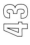
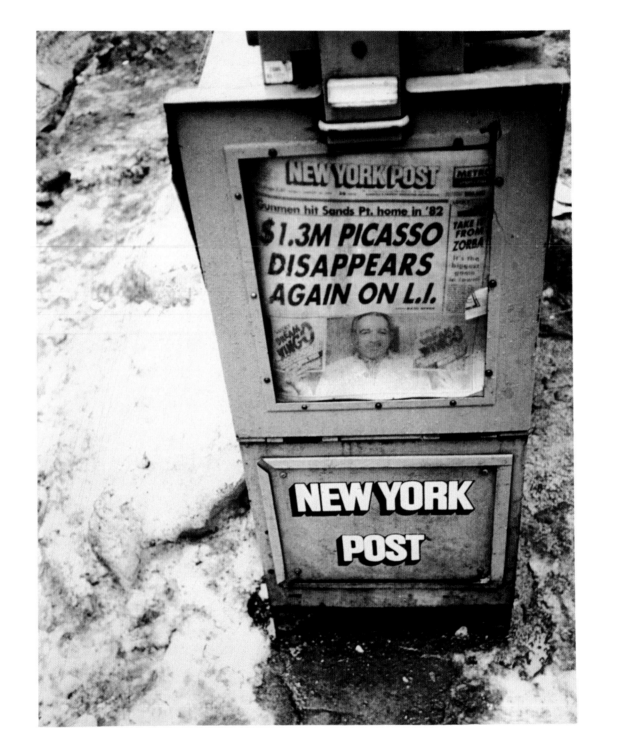

45 THE BIG SNOW C. 1982–1986, FOUR GELATIN SILVER PRINTS SEWN TOGETHER WITH THREAD,
70 x 54 (27 ½ x 21 ¼), PRIVATE COLLECTION

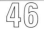

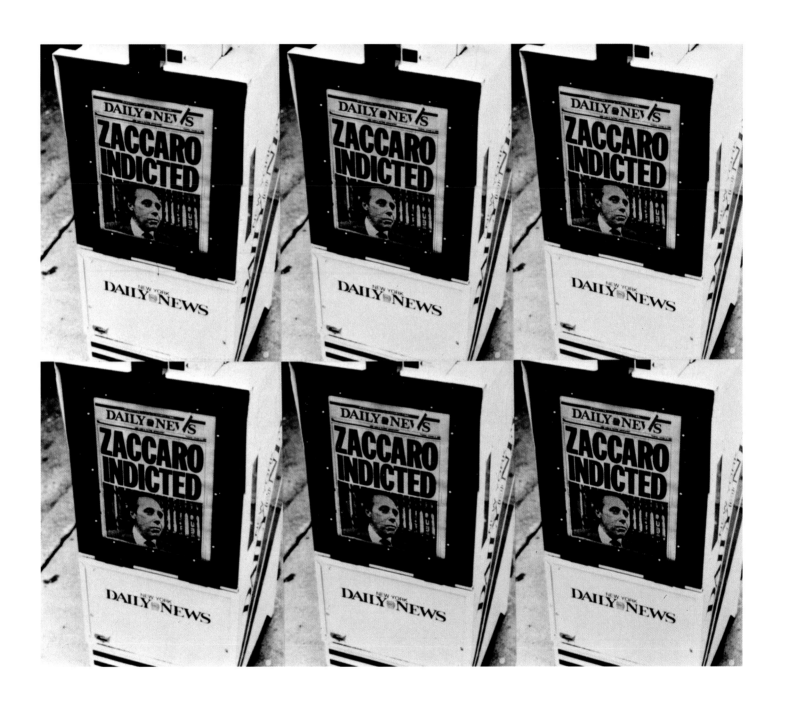

47 ZACCARO INDICTED C. 1985–1986, SIX GELATIN SILVER PRINTS SEWN TOGETHER WITH THREAD, 69.4 x 80.5 (27 3/8 x 31 3/4), BISCHOFBERGER COLLECTION, SWITZERLAND

49 ADIEU ROMY C. 1986, FOUR GELATIN SILVER PRINTS SEWN TOGETHER WITH THREAD, 54.3 x 69.9 (21 ³/₈ x 27 ½), THE ANDY WARHOL MUSEUM, PITTSBURGH; FOUNDING COLLECTION, CONTRIBUTION THE ANDY WARHOL FOUNDATION FOR THE VISUAL ARTS, INC.

50

51 UNIDENTIFIED MAN DATE UNKNOWN, GELATIN SILVER PRINT, 25.4 x 20.3 (10 x 8), THE ANDY WARHOL MUSEUM, PITTSBURGH; CONTRIBUTION THE ANDY WARHOL FOUNDATION FOR THE VISUAL ARTS, INC.

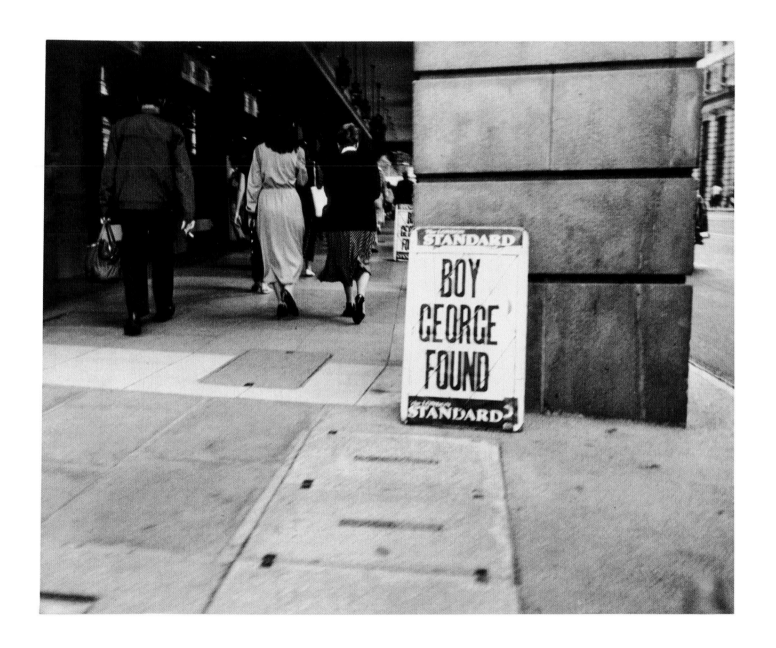

53 SIGNAGE C. 1986, GELATIN SILVER PRINT, 20.3 x 25.4 (8 x 10), THE ANDY WARHOL MUSEUM, PITTSBURGH; CONTRIBUTION THE ANDY WARHOL FOUNDATION FOR THE VISUAL ARTS, INC.

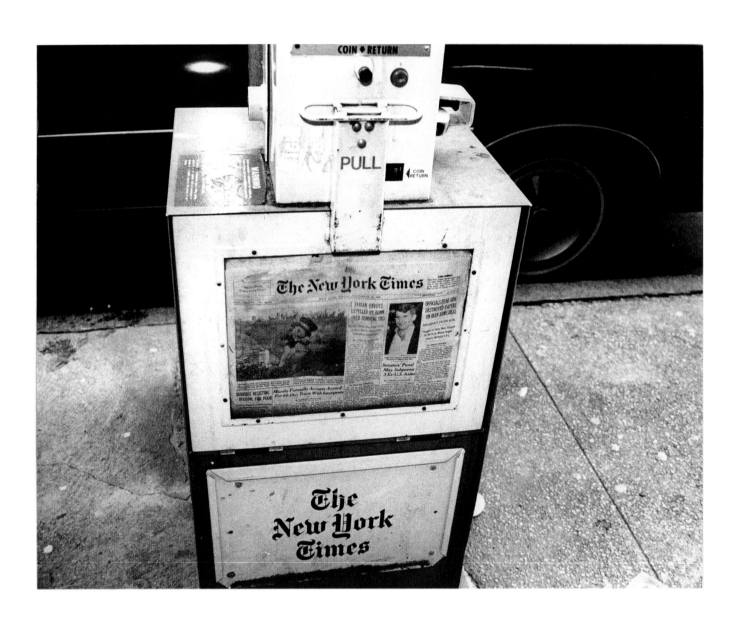

54 NEWSPAPER MACHINE (THE NEW YORK TIMES) DATE UNKNOWN, GELATIN SILVER PRINT,
20.3 x 25.4 (8 x 10), GALERIE BRUNO BISCHOFBERGER, ZURICH

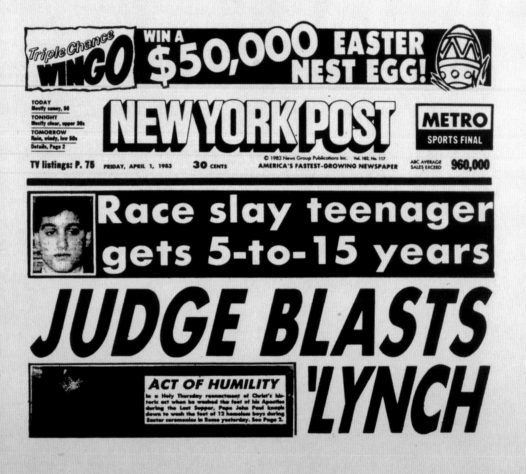

NEW YORK POST

METRO
SPORTS FINAL

Triple Chance **WINGO** | **WIN A $50,000 EASTER NEST EGG!**

TODAY
Mostly sunny, 50

TONIGHT
Mostly clear, upper 30s

TOMORROW
Rain, windy, low 50s
Details, Page 2

© 1983 News Group Publications Inc. Vol. 182, No. 117

TV listings: P. 75 FRIDAY, APRIL 1, 1983 **30** CENTS AMERICA'S FASTEST-GROWING NEWSPAPER

ABC AVERAGE
SALES EXCEED **960,000**

 Race slay teenager gets 5-to-15 years

JUDGE BLASTS 'LYNCH

ACT OF HUMILITY

In a Holy Thursday reenactment of Christ's historic act when he washed the feet of his Apostles during the Last Supper, Pope John Paul kneels down to wash the feet of 12 homeless boys during Easter ceremonies in Rome yesterday. See Page 2.

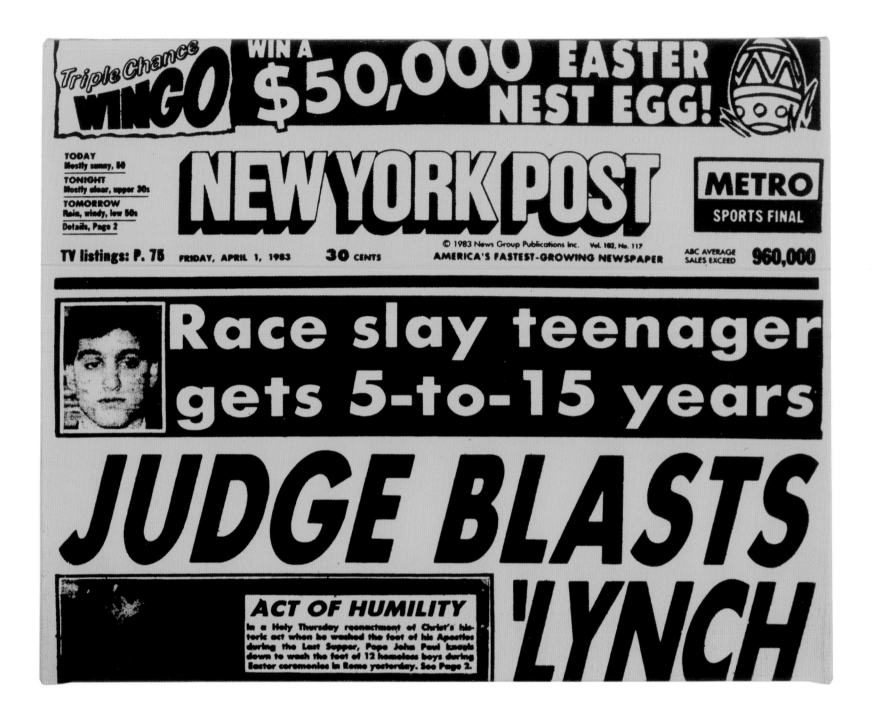

Artist could have been choked: doc

Further tests on the body of a graffiti artist who lapsed into a coma and died after he was taken to Bellevue Hospital by police show the man's blood flow and breathing were restricted by a force like that of "a choke hold," a physician hired by the victim's family said yesterday.

Tests were performed on the eyes, neck tissue, brain and spinal cord of Michael Stewart, 25, of Brooklyn, who died Sept. 28, two weeks after he was taken to the hospital.

Last week, city Medical Examiner Elliot Gross said preliminary autopsy reports indicated Stewart died of cardiac arrest. Further information would be presented to the Manhattan district attorney's office, Gross said.

Attorneys for the victim have alleged Stewart was beaten by Transit Authority police. Police have denied the allegationss, saying Stewart became violent and had to be restrained.

Dr. Robert Wolf, an internist and cardiologist at Mount Sinai Hospital hired by the family to monitor the autopsy and tests, was present Monday at Gross' office, which conducted the additional tests.

Wolf said the tests showed that Stewart had sustained a force like that of "a choke hold." A final report on the autopsy could come in about 10 days, Wolf said. Gross' office had no immediate comment on the latest tests.

Brandt joins nuke protest

Bonn (Combined Dispatches)—Nobel Peace Prize laureate Willy Brandt will join the tens of thousands

October 19, 1983

25% off misses' sweaters............6.67-13.47
Reg. 8.99-$18. Pullovers in crews, turtle or boatnecks. (D.863,882)

25% off ALL junior skirts............10.47-25.47
Reg. 13.99-$34. Terrific fall looks in solids and stripes. 5-13. (D.868)

30% off ALL misses' loungers............7.67-10.47
Reg. 10.99-14.99. All long styles in easy-care polyester. (D.896)

25% off ALL misses' thermals............5.99-6.99
Reg. 4.47-5.17. Warm tops and bottoms in solids, prints. (D.885)

30% off misses' flannel pj's............7.67-8.37
Reg. $11-$12. Tailored styles in cotton flannel. Fashion colors. (D.884)

30% off ALL Park Ave. hosiery............1.37-1.67
Reg. $2-2.50. Stock up and save, control top hose, too. (D.823)

25% off ALL Cupid foundations............5.17-12.37
Reg. 6.99-16.50. All briefs, girdles, all-in-ones, more! (D.675)

25% off ALL small leather goods............2.97-6.67
Reg. 3.99-$9. Wallets, coin and cosmetic cases, more. (D.800)

25% off women's coordinates............11.97-25.47
Reg. $16-$34. Find pants, jackets, skirts and blouses. (D.862)

30% off selected fall pants............9.07-11.17
Reg. 12.99-$16. Misses' and women's acrylic & polyester pull-on pants. (D.862,865,866)

25% off fashion coordinates............11.97-25.47
Reg. $16-$34. Misses' and women's pants, skirts, jackets, blouses. (D.862,864,865)

25% off misses', skirts............11.97-14.97
Reg. $16-$20. Selected new fall skirts in many styles, colors, fabrics. (D.862,865,866)

25% off ALL women's blouses............13.47-16.47
Reg. $18-$22. Solids, prints and stripes. Newest fall styles and fabrics. (D.865)

30% off jr. blouses, shirts............6.97-18.17
Reg. 9.99-$26. Woven shirts and all blouses. Fashion skirts. Great styles. (D.867,868)

25% off ALL junior sweaters............7.47-19.47
Reg. 9.99-$26. Entire stock on sale. Classic crews, cardigans, argyles, novelties. (D.867)

25% off ENTIRE STOCK of handbags..6.67-13.47
Reg. $9-17.99. Leather, vinyl hobos, tote bags, organizers, clutches and more. (D.810)

25% off ALL felt hats, small leather..2.97-12.67
Reg. $4-$17. Profile hats, cloches and more. Wallet, cosmetic cases & more. (D.800)

25% off ALL Cupid and Lovable............2.17-12.37
Reg. 2.99-16.50. Our entire stock of bras, briefs, all-in-ones and more. (D.875)

25% off ALL thermals and slips............3.67-8.97
Reg. $5-$12. Entire stock of full and half slips, warm thermal underwear. S-XL. (D.885)

25% off children's outerwear............13.47-44.97
Reg. $18-$60. For infants, toddlers, girls 4-14.

25%

30%

33%

25%

25%

25%

25%

25%

25%

25%

25%

50%

50%

Deferre
Wedn

With yo
may,
reque

TV's Jessica Savitch killed in car crash

LATE-BREAKING STORY: PAGE 13

TONIGHT
Rain or drizzle, upper 40s

TOMORROW
Mostly cloudy, mid 50s

Details, Page 2

NEW YORK POST

FINAL
LATE PRICES

TV listings: P. 83 MONDAY, OCTOBER 24, 1983 **30** CENTS R © 1983 News Group Publications Inc. Vol. 182, No. 293 AMERICA'S FASTEST-GROWING NEWSPAPER ABC AVERAGE SALES EXCEED **960,000**

MARINE DEATH TOLL HITS 172
— and could top 200

INSIDE: 10 more pages of dramatic stories and photos on the Beirut atrocity

GRIM MARINE TOLL HITS

At least 50 still buried in shattered barracks

Hurt Marine is rushed to ambulance after landing at the U.S. airbase in Frankfurt, West Germany.

Post Wire Services

THE GRIM toll of American servicemen slaughtered in the bombing of U.S. Marine headquarters in Beirut stood at 172 today — and officials said it could rise to over 200.

Officials said at least 50 more U.S. soldiers were missing and probably buried under a mountain of tons of wreckage.

"There's nobody alive in there now. It would be a miracle," said Marine spokesman Maj. Robert Jordan as he stood beside the remains of the airport command center leveled by a suicidal terrorists yesterday morning.

The bombing was part of twin kamikaze attacks early yesterday by what officials called Iranian-backed terrorists.

The terrorists crashed loaded trucks packed with thousands of pounds of explosives into the Marine barracks at the city's airport and — minutes later — into the French paratrooper barracks three miles to the north.

The trucks careened past security points and crashed into the buildings—destroying both.

At least 39 French soldiers were killed in the attack. Several more were still believed trapped in the rubble and feared dead.

Most of the dead were killed as they slept.

At least 90 U.S. Marines and Navy personnel who survived the blast injured — most of them seriously.

Air ambulances flew dozens of severely wounded Marines to U.S. and British military hospitals in West Germany,

Italy and Cyprus.

The first C-9 transport landed at Frankfurt last night, carrying 24 Marines.

They were rushed to three hospitals by helicopter and ambulance.

A second Air Force plane carrying 13 wounded Marines and the bodies of 34 who died landed early today.

The dead will be identified and processed at Frankfurt's Rhine Main Airport before being shipped back to the U.S.

Meanwhile, hundreds of rescue workers combed over the remains of both bombed buildings.

A wounded French soldier was pulled out early today, more than 24 hours after the blast, and the French still hope to find more survivors.

France airlifted trained dogs and special cutting blades to saw through the rubble.

No American survivors had been found since yesterday afternoon.

But Jordan said rescuers — many of them Marines who has goen without sleep for days — will not give up.

"We plan to continue going as long as there is hope of pulling out someone," he said.

Tons of concrete from the upper two floors were pancaked together, and Jordan said many bodies were crushed in the layers.

A crater, 40 feet across by 20 feet deep, was left

Airlift rushes wounded out

Post Wire Services

MORE than 80 Marines wounded in yesterday's terror blast were being treated today in Lebanon, and military hospitals in Cyprus, Italy and West Germany.

At least 80 have been flown out and are being treated at U.S. and British military hospitals in Cyprus, Italy and West Germany.

A U.S. Air Force transport jet airlifted 13 of the wounded and the bodies of 36 Marines killed in the blast to West Germany today.

The 13 were loaded into U.S. Army Black Hawk helicopters and flown to military hospitals.

The bodies, en route to the U.S. for burial, were

taken off the C-141 transport plane at a secluded area of the Rhine-Main Air Base.

Yesterday a group of 23 wounded Marines arrived at the air base.

One of those Marines died during the flight to West Germany.

U.S. Air Force medical spokesman Lt. Col. Bill Johnson said 13 Marines were operated on immediately and were reported in "serious but stable condition."

Others were suffering from shock and some had only minor injuries, spokesmen said.

In Cyprus, a British C-130 Hercules transport flew 21 Marines to Britain's Akrotiri Air Base for treatment at Princess

Mary's Royal Air Force Hospital.

One of the injured men died shortly after arriving in Cyprus

A U.S. Navy plane also flew 12 wounded Americans to Naples in southern Italy to be treated at a Navy hospital on the outskirts of the city.

Eight of the wounded flown to Naples left the aircraft unaided. Two were being fed intravenously or what appeared to be pajamas, had their garments torn where medics had ripped them to dress wounds.

Associated Press Photo

Injured Marine is carried from plane to waiting ambulance in Naples last night.

And, oh what a birthday bash they had at the Met!
— Page 21

INDEX

THE WEATHER

Periods of light rain or drizzle tonight, lows in the upper 40s. Mostly cloudy and cool tomorrow, highs in the mid 50s.

Winds: Easterly tonight at 10 to 15 mph.

Outlook: Cloudy Wednesday with a chance of showers. Partly cloudy Thursday. Daytime highs will be in the 60s; overnight lows will average in the 40s.

The highest temperature reported Sunday by the National Weather Service, excluding Alaska and Hawaii, was 98 degrees at Thermal, Calif. The low was 17 degrees at Gunni-

Yesterday's temperatures

	Hi	Lo		Hi	Lo
Alb'que	76	42	Am'dam	54	43
Atlanta	67	47	Athens	64	18
Bismarck	61	48	Beirut	73	63
Boston	51	42	Berlin	48	36
Buffalo	57	39	B'Aires	64	52
Ch'go	58	40	Cairo	84	64
Clev'ld	56	41	Dublin	50	37
Dallas	81	48	Havana	86	75
Denver	61	32	Jeruslm	70	54
Detroit	57	41	Lima	72	61
H'ford	50	39	Lisbon	75	55
H'lulu	88	75	London	59	41
H'ston	79	49	Madrid	77	43
Las Vgs	83	52	Manila	91	72
L.A.	90	65	M'scw	43	36
M'phis	67	48	Nw Dlhi	89	60
Miami	86	70	Oslo	54	39
Minn.	57	37	Paris	57	37
N.Orlns	75	50	Peking	61	41
N.Y.C.	55	46	Rio	91	73
Phila	59	45	Rome	64	41
Pitts	54	40	Seoul	54	39
S.F.	75	52	St'khlm	50	41
Seattle	62	45	Tokyo	50	46
Wash	63	53	Vienna	48	41

LOTTERY

SUNSET: 6:03
SUNRISE TOMORROW: 7:18

— NEW YORK —
Daily no. for Sun.: 375
Daily no. for Sat.: 399
Win-4 no. for Sun.: 2551
Lotto nos. for Sat.:
36, 21, 27, 28, 7, 20
Supplementary no.: 28
1st prize for 10/29:
$6,000,000
— NEW JERSEY —
Daily no. for Sat.: 981
Straight payoff: $218
Box payoff: $36
Pairs payoff: $21.50
Pick-4 no. for Sat.: 2122
Straight payoff: $1,414
Box payoff: $353.50

WINGO

TODAY'S WINNING
NUMBERS — PAGE 14

Those other numbers: P.14

THE NEW YORK POST
Classified Advertising 212-962-3700
Display Advertising 212-349-5000
Editorial, Circulation 212-349-5000

Main Office, 210 South St.,
New York, N.Y. 10002
212-349-5000

Queens-Long Island Office,
175-61 Hillside Av., Jamaica, N.Y.
11432, 212-658-1234

FOR HOME DELIVERY
Queens, Brooklyn, Staten I'lland,
Bronx, Nassau, call 800-522-5413,
All other areas call 212-658-1234

The New York Post (USPS 383 700) is published daily except Sunday. 2d class postage paid at New York, N.Y.

MAIL SUBSCRIPTION RATES
U.S. and Possessions

	Daily	Daily	Sat.
1 yr.	$120.00	$100.00	$22.00
6 mos.	64.50	53.50	12.00
3 mos.	34.50	28.50	6.50
1 mo.	12.00	10.25	2.50

For all orders, changes and inquiries, contact: Kingston Newspaper Mailing Co., P.O. Box 1517, Kingston, N.Y. 12401, Phone in N.Y. State: 800 942-6909, National 800 431-6052

Canadian, Pan American and foreign rates available on request.

TODAY IN HISTORY

In 1901, Anna Edison Taylor became the first person to go over Niagara Falls in a barrel.

172 — COULD TOP 200

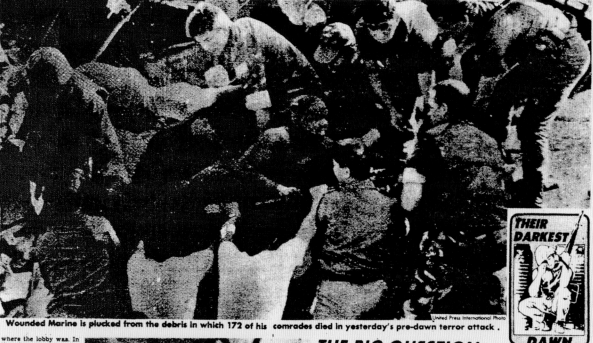

THEIR
DARKEST

DAWN

United Press International Photo

Wounded Marine is plucked from the debris in which 172 of his comrades died in yesterday's pre-dawn terror attack.

Associated Press Photo

Shocked Marine is helped from plane after being air-lifted from Lebanon to Naples, Italy, last night.

where the lobby was. In the bottom was the crankshaft of the truck, the only apparent piece left of the terror vehicle.

President Reagan, vowing that international terrorists would not "drive us out" of Lebanon, ordered Marine Commandant Paul X. Kelley to fly to Beirut to undertake a "full review" of how U.S. forces could be protected from further atrocities.

He ordered U.S. flags flown at half-staff today.

Reagan said the U.S. was prepared to respond to the "heinous" slayings once the perpetrators are identified.

White House officials did not indicate what steps might be taken or against whom.

But a senior official, briefing reporters on the condition he not be named, said there was "very strong circumstantial evidence and bits and pieces of hard evidence" that Iranians were involved in the bombing.

One of the possibilities being explored is that the attack was carried out by Iranian nationals at the direction of Syria.

Iran today denied any involvement in the tragedy.

According to the national news agency, a Foreign Ministry spokesman said U.S. officials named Iran as a

Continued on Page 8

THE BIG QUESTION:

Could this happen again?

Post Dispatches

THE DEVASTATING suicide attack on the U.S. Marines in Beirut left military officials facing two critical questions today:

Could any precautions have been taken to prevent it?

And how can they keep a similar tragedy from happening in the future?

Despite official contentions that the attack could not have been prevented, questions were raised about the way the Marines' positions were laid out.

According to initial reports, the explosive-laden truck that crashed into the barracks encountered only two sentries.

It was 6:20 a.m. Beirut time when disaster struck.

"It was a Sunday morning. We normally sleep in Sunday morning," Maj. Robert Jordan of Shenendoah, Ga., said later.

One sentry reported the truck on his telephone and another heroically tried to throw himself in front of the vehicle.

If the reports turn out to be correct, officials will want to know why more sentries were not on duty.

The vehicle smashed through a steel gate, a 20-foot-deep barbed wire barricade, a chain

Continued on Page 8

BEIRUT ⬆

Route of suicide truck

CHECKPOINT

MAIN GATE

MARINE OPERATIONS BUILDING

MARINE ADMINISTRATION BUILDING

FENCE

TERMINAL

BEIRUT AIRPORT

THE POST'S DRAMATIC COVERAGE OF THE BEIRUT TRAGEDY CONTINUES ON PAGES 4, 5, 7, 8, 9, 10, 32 and 33

63 **NEW YORK POST, PAGE THREE (172 — COULD TOP 200) C. 1983, SYNTHETIC POLYMER PAINT AND SILKSCREEN INK ON CANVAS, 61 x 50.8 (24 x 20), PRIVATE COLLECTION**

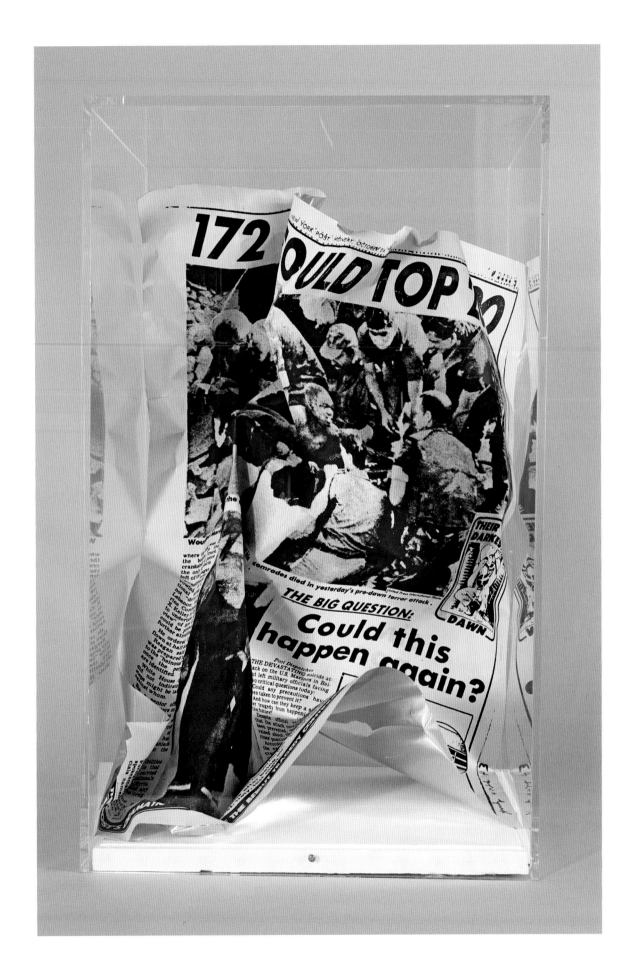

65 FRAME ENLARGEMENT FROM ANDY WARHOL'S T.V. (EPISODE 2) 1983, 1-INCH VIDEOTAPE, COLOR, SOUND (30 MINUTES), THE ANDY WARHOL MUSEUM, PITTSBURGH

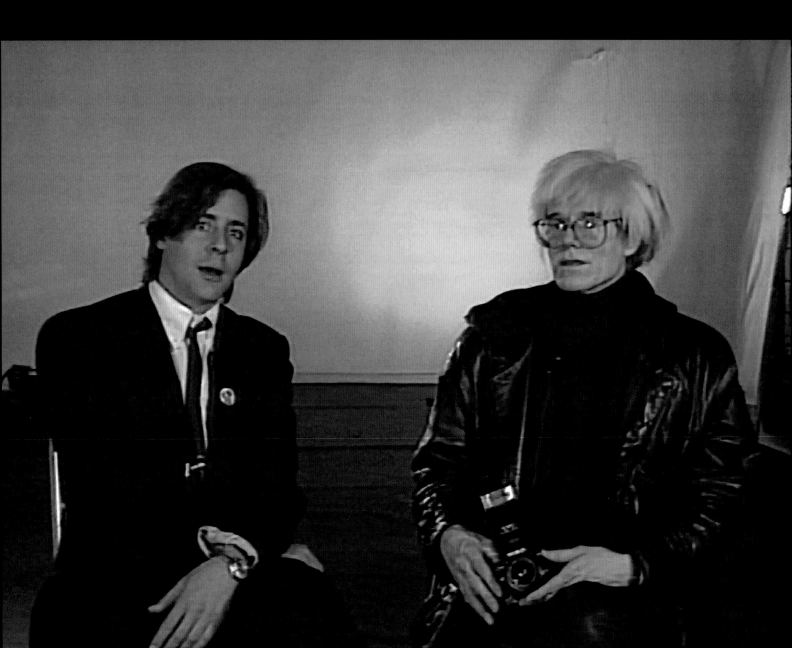

FRAME ENLARGEMENT FROM ANDY WARHOL'S FIFTEEN MINUTES [EPISODE 3] **1987, 1-INCH VIDEOTAPE, COLOR, SOUND (30 MINUTES), THE ANDY WARHOL MUSEUM, PITTSBURGH**

69 JEAN-MICHEL BASQUIAT AND ANDY WARHOL, PLUG PULLED ON COMA MOM 1984–1985, ACRYLIC AND OIL STICK ON LINEN, 193 x 264.5 (76 x 104 ⅛), THE ANDY WARHOL MUSEUM, PITTSBURGH; FOUNDING COLLECTION, CONTRIBUTION THE ANDY WARHOL FOUNDATION FOR THE VISUAL ARTS, INC.

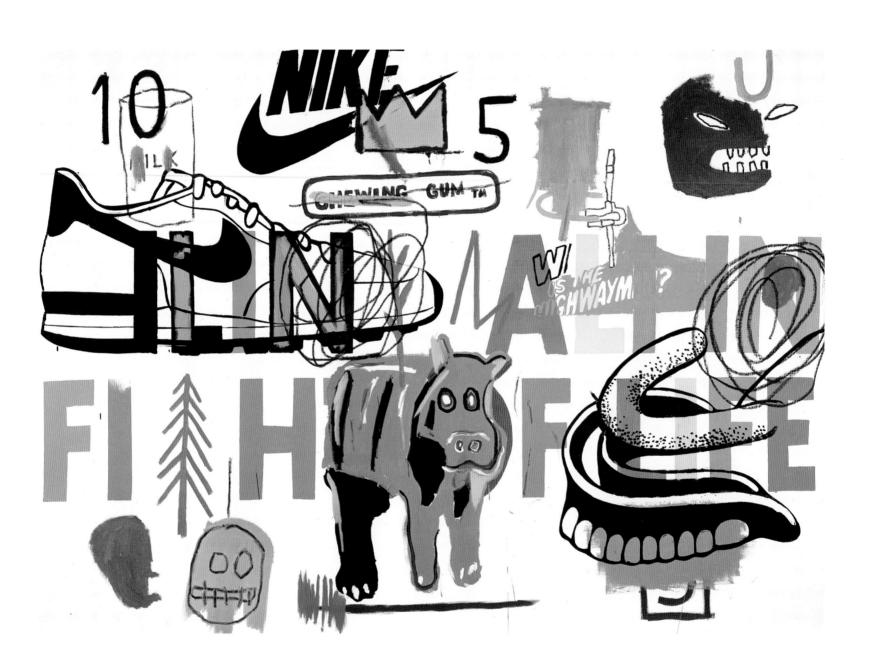

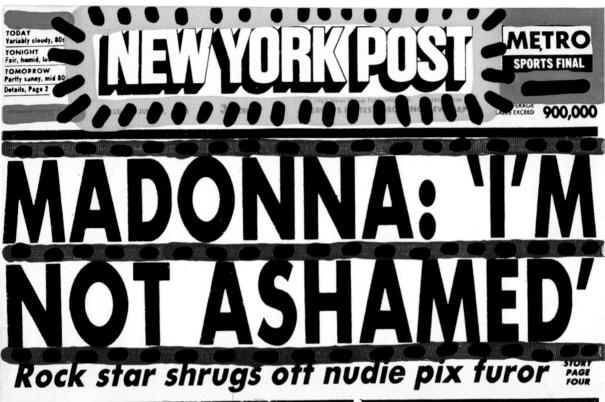

NEW YORK POST

TODAY
Variably cloudy, 80s
TONIGHT
Fair, humid, low
TOMORROW
Partly sunny, mid 80
Details, Page 2

METRO
SPORTS FINAL

AVERAGE
SALES EXCEED 900,000

MADONNA: 'I'M NOT ASHAMED'

Rock star shrugs off nudie pix furor

STORY
PAGE
FOUR

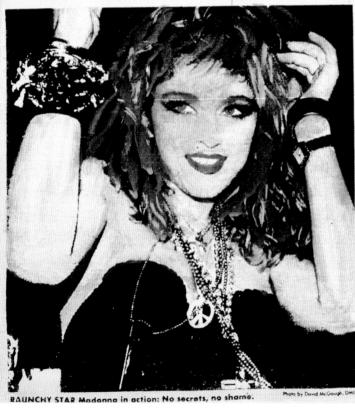

RAUNCHY STAR Madonna in action: No secrets, no shame.

Photo by David McGough; DMI

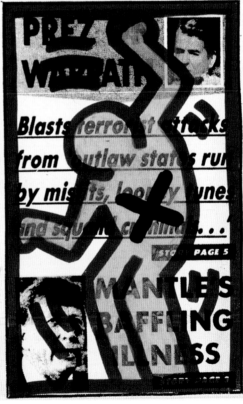

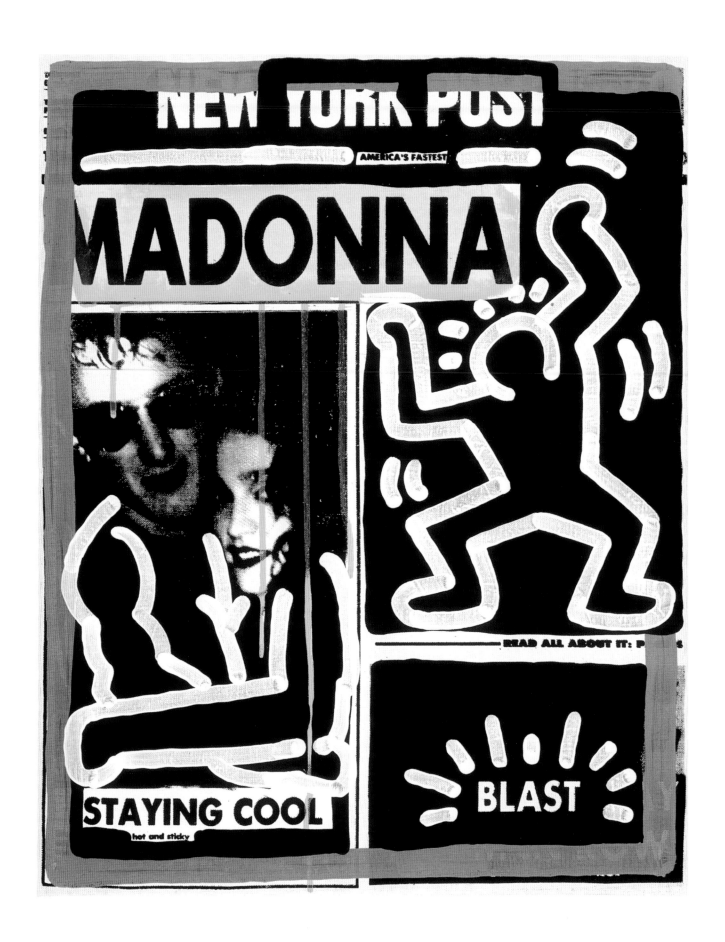

72 ANDY WARHOL AND KEITH HARING, *NEW YORK POST (MADONNA)* 1985, ACRYLIC AND SILKSCREEN INK ON LINEN, 50.8 x 40.6 (20 x 16), THE ANDY WARHOL MUSEUM, PITTSBURGH; FOUNDING COLLECTION, CONTRIBUTION THE ANDY WARHOL FOUNDATION FOR THE VISUAL ARTS, INC.

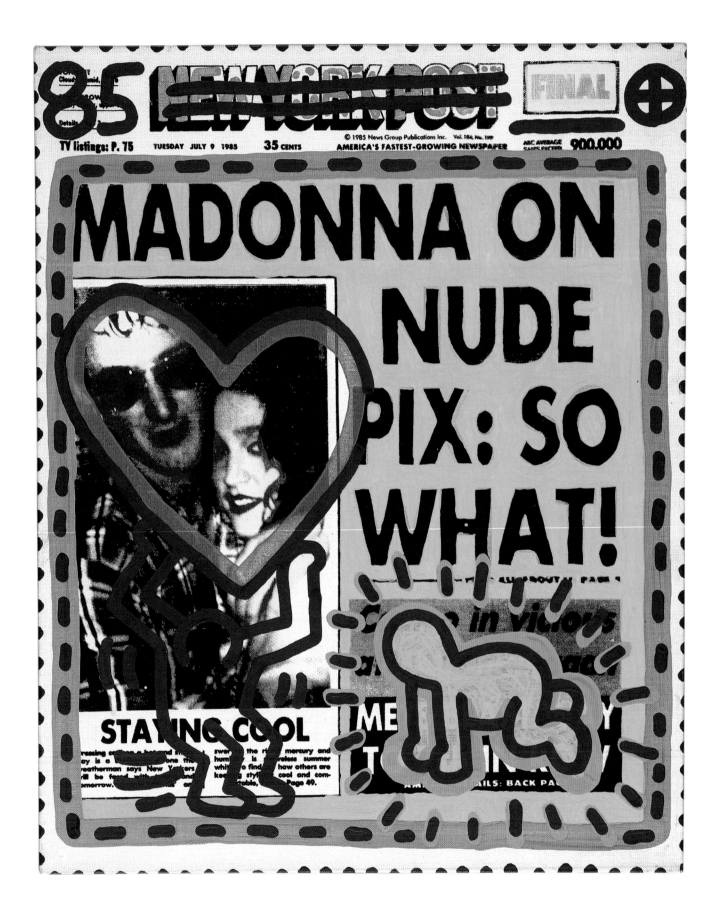

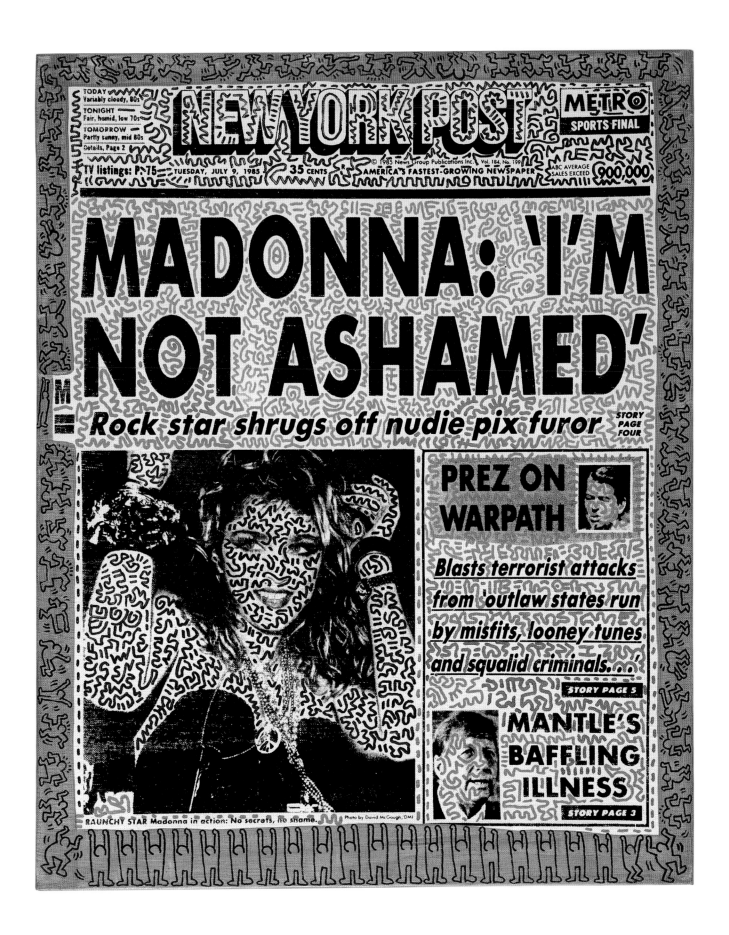

74 ANDY WARHOL AND KEITH HARING, UNTITLED 1985, ACRYLIC AND SILKSCREEN INK ON LINEN,
50.8 x 40.6 (20 x 16), PRIVATE COLLECTION. *WASHINGTON ONLY*

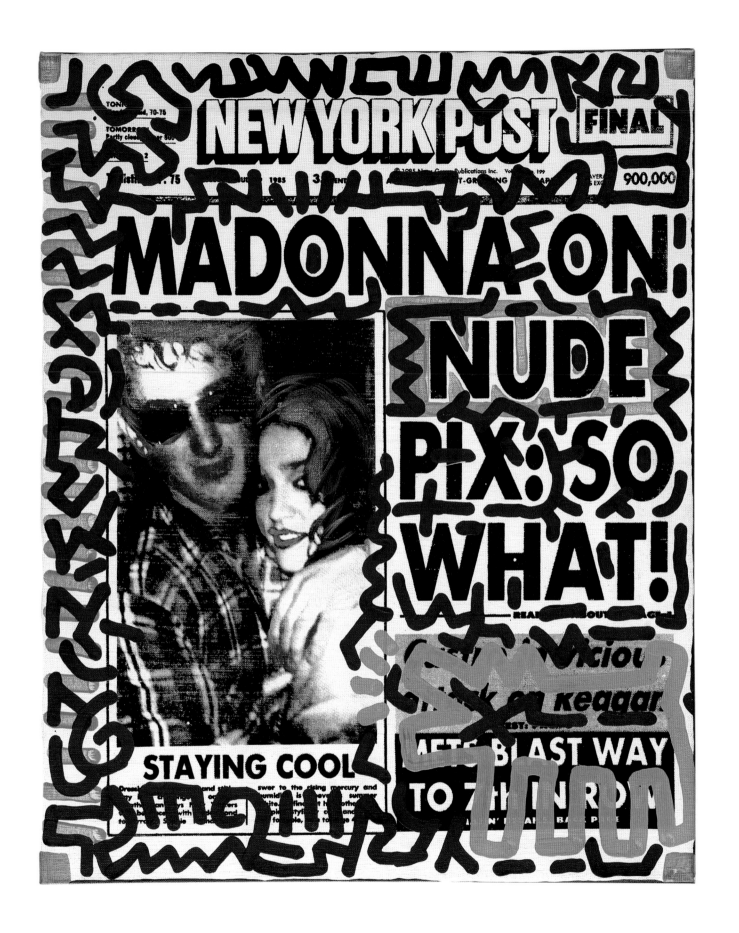

76 ANDY WARHOL AND KEITH HARING, UNTITLED 1985, ACRYLIC AND SILKSCREEN INK ON LINEN, 50.8 x 40.6 (20 x 16), PRIVATE COLLECTION

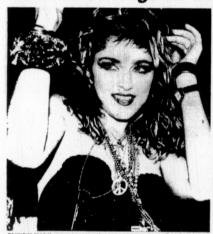

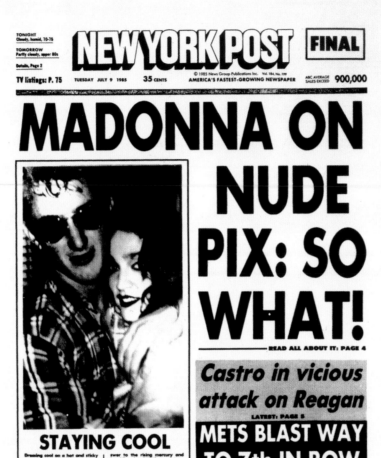

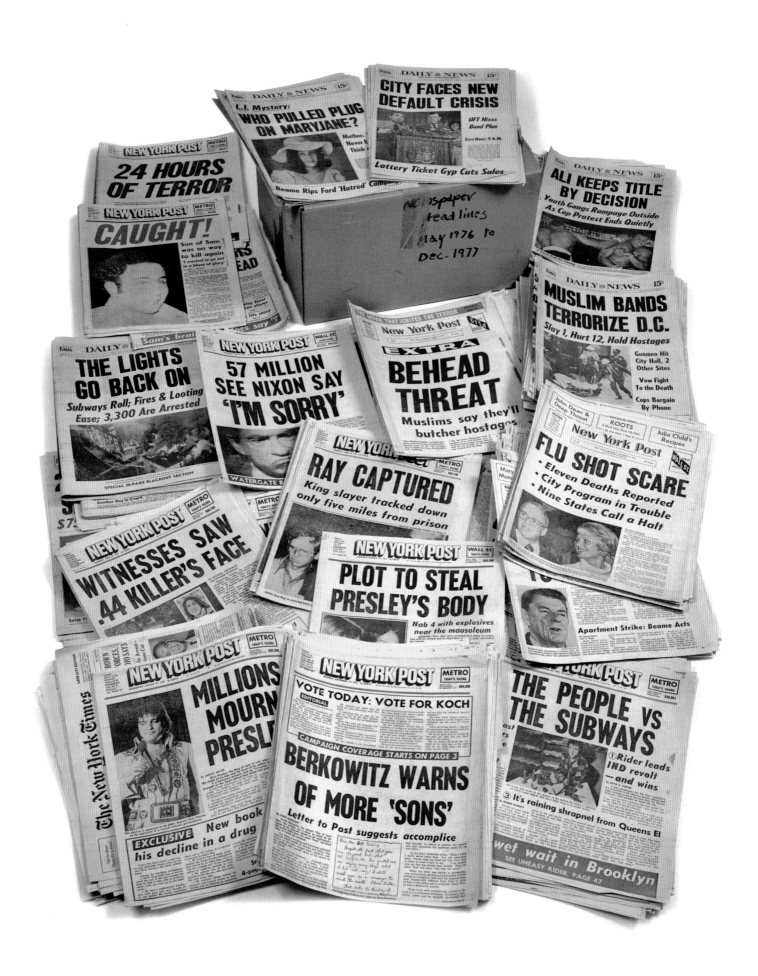

79 TIME CAPSULE 170 MAY 1976 – DECEMBER 1977, NEWSPAPERS AND CLIPPINGS FROM NEW YORK – BASED PAPERS, AND ONE EXHIBITION CATALOGUE, THE ANDY WARHOL MUSEUM, PITTSBURGH; FOUNDING COLLECTION, CONTRIBUTION THE ANDY WARHOL FOUNDATION FOR THE VISUAL ARTS, INC.

SOURCE DOCUMENTS

DOC. 1 / PL. 1

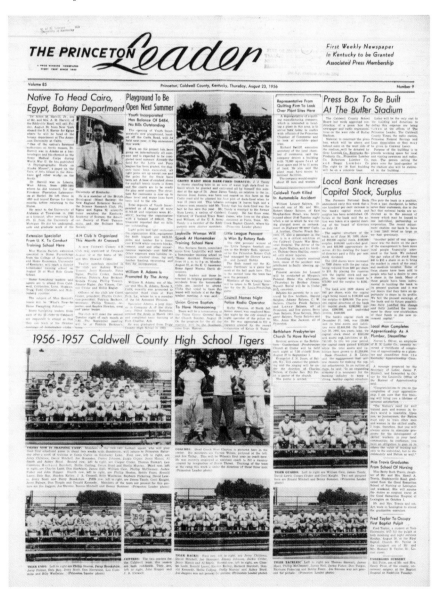

FRONT PAGE OF *THE PRINCETON LEADER* [PRINCETON, KY], AUGUST 23, 1956, SCAN FROM MICROFILM.
COMPARE TO PL. 1

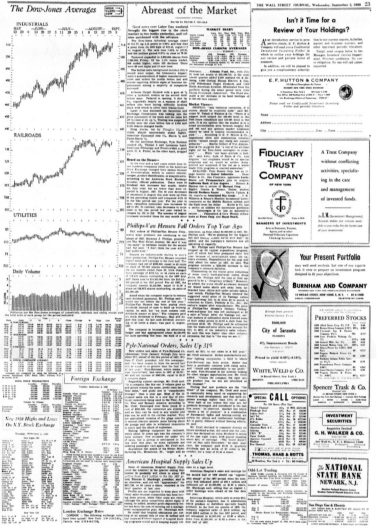

FRONT PAGE AND PAGE 23 OF *THE WALL STREET JOURNAL* [NEW YORK, NY], SEPTEMBER 3, 1958, SCANS FROM MICROFILM. COMPARE TO PL. 3

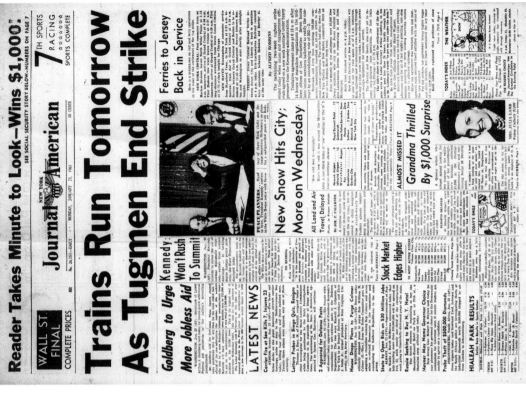

FRONT PAGE OF *NEW YORK JOURNAL AMERICAN*, JANUARY 23, 1961, SCAN FROM MICROFILM.

COMPARE TO PL. 5

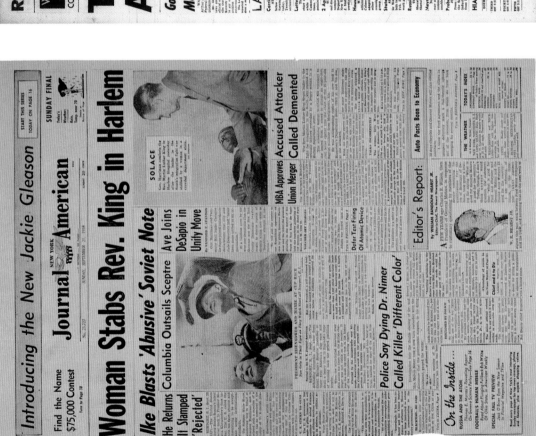

FRONT PAGE OF *NEW YORK JOURNAL AMERICAN*, SEPTEMBER 21, 1958, THE ANDY WARHOL
MUSEUM, PITTSBURGH; FOUNDING COLLECTION, CONTRIBUTION THE ANDY WARHOL
FOUNDATION FOR THE VISUAL ARTS, INC. COMPARE TO PL. 4

DOC. 5 / PLS. 6–9

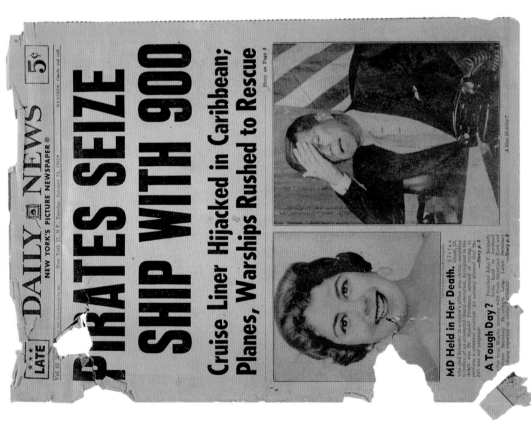

FRONT PAGE OF *NEW YORK DAILY NEWS*, JANUARY 24, 1961, THE ANDY WARHOL MUSEUM, PITTSBURGH; FOUNDING COLLECTION, CONTRIBUTION THE ANDY WARHOL FOUNDATION FOR THE VISUAL ARTS, INC. COMPARE TO PLS. 6–9

DOC. 6 / PL. 11

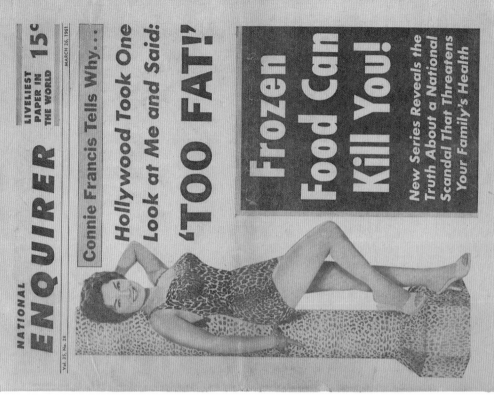

FRONT PAGE OF *NATIONAL ENQUIRER*, MARCH 26, 1961, COLLECTION OF FRANCESCA K. MCLIN. COMPARE TO PL. 11

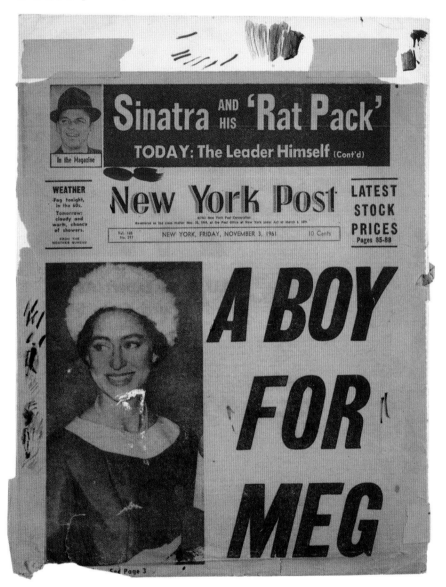

COLLAGE (A BOY FOR MEG), 1961, FRONT PAGE OF *NEW YORK POST*, NOVEMBER 3, 1961, TAPED AND WRAPPED AROUND PHOTOGRAPH WITH PAINT AND INK ADDITIONS, 36.8 x 28.3 (14 ½ x 11 ⅛), THE ANDY WARHOL MUSEUM, PITTSBURGH; FOUNDING COLLECTION, CONTRIBUTION THE ANDY WARHOL FOUNDATION FOR THE VISUAL ARTS, INC. COMPARE TO PLS. 13–14

COLLAGE (DAILY NEWS), 1962, BACK PAGE OF NEW YORK DAILY NEWS, MARCH 29, 1962, TAPED AND WRAPPED AROUND CARDBOARD WITH PAINT ADDITIONS (RECTO AND VERSO), 28.3 x 35.6 (11 1/8 x 14), THE ANDY WARHOL MUSEUM, PITTSBURGH; FOUNDING COLLECTION, CONTRIBUTION THE ANDY WARHOL FOUNDATION FOR THE VISUAL ARTS, INC. COMPARE TO PL. 15

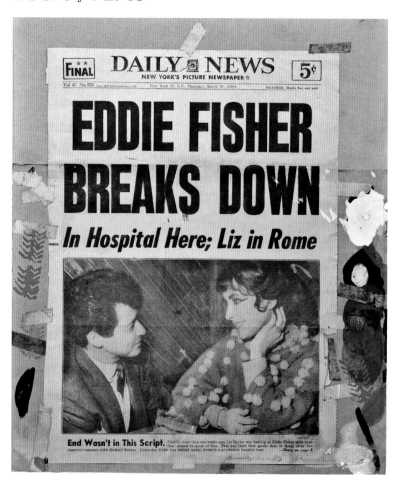

COLLAGE (DAILY NEWS), 1962, FRONT PAGE OF NEW YORK DAILY NEWS, MARCH 29, 1962, TAPED TO CARDBOARD WITH PAINT ADDITIONS AND STAMPING, 43.2 x 35.6 (17 x 14), COLLEZIONE FRAGIÒ. COMPARE TO PL. 15

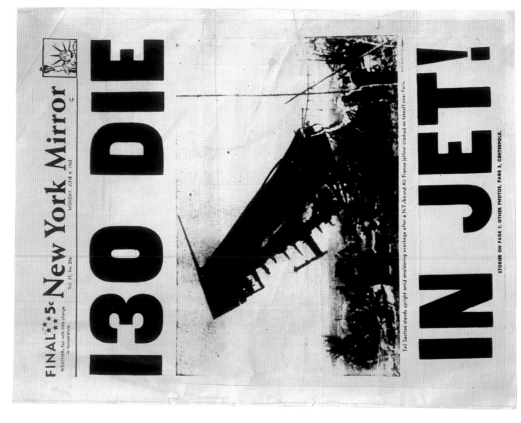

PHOTOSTAT OF FRONT PAGE OF *NEW YORK MIRROR*, JUNE 4, 1962, FINAL 5-STAR EDITION. THE ANDY WARHOL MUSEUM, PITTSBURGH; FOUNDING COLLECTION, CONTRIBUTION THE ANDY WARHOL FOUNDATION FOR THE VISUAL ARTS, INC. COMPARE TO PL. 16

FRONT PAGE OF *NEW YORK MIRROR*, JUNE 4, 1962, FINAL 2-STAR EDITION. THE ANDY WARHOL MUSEUM, PITTSBURGH; FOUNDING COLLECTION, CONTRIBUTION THE ANDY WARHOL FOUNDATION FOR THE VISUAL ARTS, INC. COMPARE TO PL. 16

PAGES 64–67 FROM *HARPER'S BAZAAR* [NEW YORK, NY], JUNE 1963, NATIONAL GALLERY OF ART LIBRARY, DAVID K. E. BRUCE FUND.
COMPARE TO PLS. 17–18

New York World-Telegram
The Sun

PRESIDENT SHOT DEAD

EXTRA

Cut Down
By Sniper
In Dallas

Stunned City Find News 'Unbelievable'

Exchanges Close
On Bad News

MEDICINE

Two Tuna Sandwiches

Five-Finger Exercise

Newsweek

PAGE 76 FROM *NEWSWEEK*, APRIL 1, 1963, PRIVATE COLLECTION. COMPARE TO PL. 19

FRONT PAGE OF *NEW YORK WORLD-TELEGRAM*, NOVEMBER 22, 1963, PRIVATE COLLECTION. COMPARE TO PL. 26

DOC. 15A / PL. 25

DOC. 15B / PL. 26

DESIGNER'S SOURCE SILHOUETTE SHAPES (RECTO), PRINTED INK ON COATED PAPER. 41.9 x 33 (16½ x 13), THE ANDY WARHOL MUSEUM, PITTSBURGH; FOUNDING COLLECTION, CONTRIBUTION THE ANDY WARHOL FOUNDATION FOR THE VISUAL ARTS, INC. COMPARE TO PL. 25

DESIGNER'S SOURCE SILHOUETTE SHAPES (VERSO). COMPARE TO PL. 26

DESIGNER'S SOURCE SILHOUETTE SHAPES, PRINTED INK ON PAPER, 35.6 x 27.9 (14 x 11), THE ANDY WARHOL MUSEUM, PITTSBURGH; FOUNDING COLLECTION, CONTRIBUTION THE ANDY WARHOL FOUNDATION FOR THE VISUAL ARTS, INC. COMPARE TO PL. 26

COLLAGE (MECHANICAL OF PRESIDENTIAL SEAL FOR "FLASH" PORTFOLIO), 1967, GELATIN SILVER PRINT, HANDWRITTEN INK ON COATED PAPER WITH PRESSURE SENSITIVE TAPE, 41.9 x 25.4 (16 ½ x 10), THE ANDY WARHOL MUSEUM, PITTSBURGH; FOUNDING COLLECTION, CONTRIBUTION THE ANDY WARHOL FOUNDATION FOR THE VISUAL ARTS, INC. COMPARE TO PL. 26

PAGE 5 OF *IL MATTINO* [NAPLES, ITALY], APRIL 1, 1980, SCAN FROM MICROFILM. COMPARE TO PL. 32

SMALL POSITIVE ACETATE FOR *FATE PRESTO*, C. 1981, PRINTED INK ON ACETATE, 30.5 x 22.2 (12 x 8¾), THE ANDY WARHOL MUSEUM, PITTSBURGH; FOUNDING COLLECTION, CONTRIBUTION THE ANDY WARHOL FOUNDATION FOR THE VISUAL ARTS, INC. COMPARE TO PL. 33

SMALL NEGATIVE ACETATE FOR *FATE PRESTO*, C. 1981, PRINTED INK ON ACETATE, 30.5 x 23.5 (12 x 9¼), THE ANDY WARHOL MUSEUM, PITTSBURGH; FOUNDING COLLECTION, CONTRIBUTION THE ANDY WARHOL FOUNDATION FOR THE VISUAL ARTS, INC. COMPARE TO PL. 33

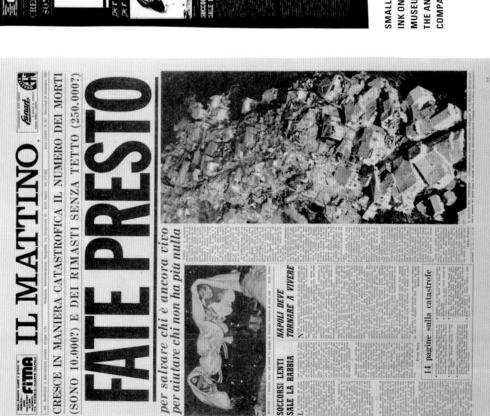

FRONT PAGE OF *IL MATTINO*, NOVEMBER 26, 1980, THE ANDY WARHOL MUSEUM, PITTSBURGH; FOUNDING COLLECTION, CONTRIBUTION THE ANDY WARHOL FOUNDATION FOR THE VISUAL ARTS, INC. COMPARE TO PL. 33

PAGE 36 OF *NEW YORK DAILY NEWS*, OCTOBER 19, 1983, SCAN FROM MICROFILM. COMPARE TO PLS. 58—60

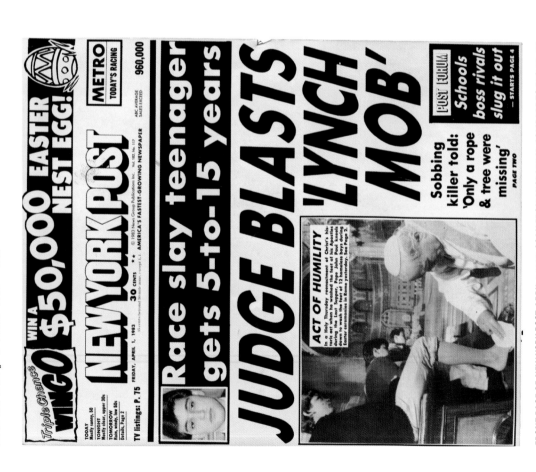

FRONT PAGE OF *NEW YORK POST*, APRIL 1, 1983, SCAN FROM MICROFILM. COMPARE TO PLS. 55—57

FRONT PAGE OF *NEW YORK POST*, SEPTEMBER 19, 1984, SCAN FROM TRANSPARENCY.
COMPARE TO PL. 70

NEW YORK POST

TODAY
Variably cloudy, 80s
TONIGHT
Fair, humid, low 70s
TOMORROW
Partly sunny, mid 80s
Details, Page 2

METRO
TODAY'S RACING

TV listings: P. 75

TUESDAY JULY 9 1985 **35 CENTS** ★
40 cents beyond 50-mile zone, except L.I.

© 1985 News Group Publications Inc. Vol. 184, No. 199

AMERICA'S FASTEST-GROWING NEWSPAPER

ABC AVERAGE
SALES EXCEED **900,000**

MADONNA: 'I'M NOT ASHAMED'

Rock star shrugs off nudie pix furor STORY PAGE FOUR

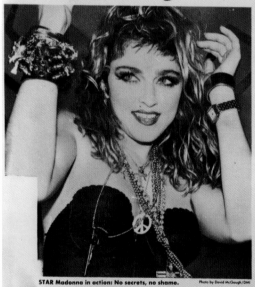

STAR Madonna in action: No secrets, no shame. Photo by David McGough/DMI

REAGAN ON THE WARPATH

Blasts 'outlaw states run by misfits, looney tunes & squalid criminals. . .'

PREZ HITS BACK: PAGE 5

FRONT PAGE OF *NEW YORK POST*, JULY 9, 1985, METRO EDITION, SCAN FROM TRANSPARENCY.
COMPARE TO PLS. 71, 74, 75, 77

PHOTOSTAT OF A POLAROID OF SEAN PENN AND MADONNA ATTRIBUTED TO KEITH HARING, 1985, THE ANDY WARHOL MUSEUM, PITTSBURGH: FOUNDING COLLECTION, CONTRIBUTION THE ANDY WARHOL FOUNDATION FOR THE VISUAL ARTS, INC. COMPARE TO PLS. 72–73, 76, 78

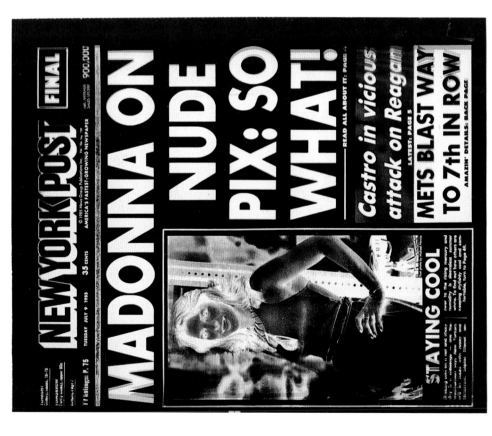

SMALL NEGATIVE ACETATE, 1985, OF FRONT PAGE OF *NEW YORK POST*, JULY 9, 1985, FINAL EDITION, PRINTED INK ON ACETATE, 30.5 x 25.4 (12 x 10), THE ANDY WARHOL MUSEUM, PITTSBURGH: FOUNDING COLLECTION, CONTRIBUTION THE ANDY WARHOL FOUNDATION FOR THE VISUAL ARTS, INC. COMPARE TO PLS. 72–73, 76, 78

NOTES

**WHERE'S WARHOL?
TRIANGULATING THE ARTIST
IN THE HEADLINES**
MOLLY DONOVAN

1. See "The Sweet Assassin," *Newsweek*, June 17, 1968, 87.

2. The exhibition that has focused most exclusively on Warhol's interest in and use of the newspaper headlines is *"Extra! Sensational! Headlines!"* shown at the Archives Study Center of the Andy Warhol Museum, Pittsburgh, August 10, 2001, through February 24, 2002, organized by archivist, Matt Wrbican. The two other exhibitions that have most prominently touched on Warhol's headline works are Jonathan P. Binstock, *Andy War-hol: Social Observer* (Pennsylvania Academy of the Fine Arts, Philadelphia, 2000); and Walter Hopps et al., *Andy Warhol: Death and Disasters* (Menil Collection and Houston Fine Art Press, Houston, 1988).

3. See Marshall McLuhan, *Understanding Media: The Extensions of Man,* ed. W. Terence Gordon, critical edition (Corte Madera, CA, 2003), 17–35.

4. W. Terence Gordon, in his introduction to the critical edition of McLuhan's *Understanding Media* (pp. xiv–xv), broke down McLuhan's oft-quoted phrase by explaining that McLuhan emphasized the medium over the content: "Media come in pairs, one 'containing' the other. So, telegraph contains the printed word, which contains writing, which contains speech. The contained medium is the message of the containing one, but the effects of the latter are obscured for the user, who focuses on the former. Because

those effects are so powerful, any message, in the ordinary sense of 'content' or 'information,' has far less impact than the medium itself. Thus, the medium is the message."

5. Neal Gabler, "The Greatest Show on Earth: In Defense of Our Brangelina-Loving, Jon and Kate–Hating, Tiger-Taunting, Tawdry Tabloid Culture," *Newsweek*, December 21, 2009: http://www.newsweek.com/2009/12/11/the-greatest-show-on-earth.html. The idea of narrative in Warhol's art is longstanding. Of note, see Neil Printz, "Painting Death in America," in *Andy Warhol: Death and Disasters* (The Menil Collection, Houston, 1988), 11: "The narrative conventions inherent to photo-journalism are decisive in determining why Warhol's Death and Disaster paintings look the way they do…. Every picture tells a story, whether commonplace, criminal or historical…. Other subjects — from poisoned tunafish, the electric chair…do not depict events, so much as referencing them within the context of a narrative not directly shown." See also Ann Wagner, "Warhol Paints History, or Race in America," *Representations*, no. 55, special issue, *Race and Representation: Affirmative Action* (Summer 1996), 110. Wagner asserts the idea of narrative in Warhol's Race Riot work, given "the care exerted, in *Red Race Riot*, for example, to use three screens in strict narrative sequence, with repetitions for emphasis: a mini-morality play." The discussion of narrative, however, focuses largely on the pictorial and not the text.

6. See Andy Warhol's interview with Gretchen Berg in the summer of 1966, "Andy Warhol: My True Story," in *I'll Be Your Mirror: The Selected Andy Warhol Interviews 1962–1987*, ed. Kenneth Goldsmith (New York, 2004), 90.

7. Charles Lisanby quoted in Patrick Smith, *Andy Warhol's Art and Films* (Ann Arbor, 1981), 379.

8. Stephen Koch, *Stargazer: The Life, World and Films of Andy Warhol* (New York, 2002), xi.

9. Warhol rarely dated these works; when no date is noted on the drawing, approximate dates (for example, "c. 1961") have been assigned and published, although occasionally the date of the original source is known, making clear the earliest possible date for the drawing.

10. An opaque projector shines light on an opaque two-dimensional object from above and projects an image of that object on a viewing surface by means of mirrors, prisms, or special lenses.

11. It is likely the drawing was made around the time of the source material, August 23, 1956, given its proximity to the time Warhol spent with Lisanby.

12. Charles Lisanby in conversation with the author, October 20, 2010.

13. David Bourdon, *Warhol* (New York, 1989), 47.

14. Many have written on Warhol's own political beliefs. For example, see Julia Ann Weekes, in "Warhol's Pop Politic: Andy Warhol's Political Portraits Antici-

pated Today's Blurred Boundaries Between Public Office and Stardom," *Smithsonian Magazine*, October 31, 2008 (http://www.smithsonianmag.com/arts-culture/Warhol-Pop-Politics.html): "Warhol's official position was political neutrality, but his party leanings are evident in one piece he made after the Democrats asked him for a contribution to George McGovern's presidential race against Nixon, the Republican incumbent. Titled *Vote McGovern, 1972*, the work depicts Nixon with blazing yellow-rimmed eyes, lime-tinted lips suggesting foaming at the mouth, and a ghoulish green-blue facial cast. Warhol's handwritten words beneath Nixon's face read: 'Vote McGovern.'" In *The Andy Warhol Diaries*, ed. Pat Hackett (New York, 1989), 355, Warhol noted after attending Ronald Reagan's inauguration in Washington, DC, on Tuesday, January 20, 1981: "Listening to the inaugural address you get fired up and I felt like being a Republican. But then when it was over and you looked around at the faces on all the Republicans, I was glad I'm a Democrat — there really is a difference." Yet also see Koch 2002, xi: "Warhol did his best to look 'apolitical,' although in practical fact, like that love of books he so carefully concealed, he was a practicing Catholic a bit to the right of center."

15. According to Matt Wrbican, archivist at the Andy Warhol Museum, Andrej Warhola's employment card for Eichleay Engineers, a Pittsburgh company, read "building mover," which meant that he moved large-scale architectural structures.

16. Benjamin Buchloh uses the word "deskilling" in "Drawing Blanks: Notes on Andy Warhol's Late Works," *October* 127 (Winter 2009), 3. In this text he refers to Warhol's omissions in these early drawings as "blanks."

17. Bourdon 1989, 47.

18. René Girard, *Deceit, Desire, and the Novel: Self and Other in Literary Structure*, trans. Yvonne Freccero (Baltimore, 1965), 1–4. Yve-Alain Bois applies Girard's theory of mimetic desire to the rivalry between Matisse and Picasso. See *Matisse and Picasso* (Kimbell Art Museum, Fort Worth, 1998), 20–22.

19. Girard 1965, 2.

20. See Shiva Kumar Srinivasan, "René Girard," in *A Dictionary of Cultural and Critical Theory* (Cambridge, MA, 1996), 222–223.

21. Berg in Goldsmith 2004, 90.

22. See Cécile Whiting, "Andy Warhol, the Public Star and the Private Self," *Oxford Art Journal* 10, no. 2, *The 60s* (1987), 58–75. Eva Meyer-Hermann writes about Warhol's many sides in her essay, "Other Voices, Other Rooms: Cosmos," in *Andy Warhol: A Guide to 706 Items in 2 Hours 56 Minutes* (Stedelijk Museum, Amsterdam, 2008), 17. My own view of Warhol's public and private selves also owes much to my conversations with Callie Angell from 2007 to 2010.

23. Truman Capote and Andy Warhol later became good friends, with the artist trading a portrait of the writer for a year of contributions to his monthly publication, *Interview*. In the early 1960s, the so-called age of disillusionment, Warhol would be attracted to the key figures in "new nonfiction reportage" or literary journalism: writers like Capote, Tom Wolfe, Joan Didion, Jimmy Breslin, Gay Talese, and Norman Mailer. See Michael Emery, Edwin Emery, and Nancy L. Roberts, *The Press and America: An Interpretive History of the Mass Media* (Boston, rev. ed., 2000), 423.

24. Ovid, *Metamorphoses*, trans. Frank Justus Miller, book 3 (Cambridge, MA, 1944), 1:149–161.

25. Among the many sources on this subject is the exhibition catalogue by Kerry Brougher and Russell Ferguson, *Art and Film since 1945: Hall of Mirrors* (Los Angeles, 1996), which discusses the use of mirrors by Warhol and others in painting and film in the postwar era. See also Graham Bader, *Hall of Mirrors: Roy Lichtenstein and the Face of Painting in the 1960s* (Cambridge and London, 2010).

26. The author would like to acknowledge the help of Greg Pierce and Geralyn Huxley in compiling this list of films.

27. Most accounts give Lou Reed from the Velvet Underground credit for this line, but Nico also claimed authorship (http://www.youtube.com/watch?v=6ouuc5tqs2E). Yet others give credit to Warhol. See William Wilson, "Prince of Boredom: The Repetitions and Passivities of Andy Warhol," in *Art and Artists* 2, no. 12 (1968), 12–15. "Intermedia" was a concept employed in the mid-1960s by Fluxus artist Dick Higgins to describe the interdisciplinary activities that occurred between genres that became prevalent in that decade. It is a term used to describe Warhol's EPI extravaganzas. For further discussion, see Branden W. Joseph, "'My Mind Split Open': Andy Warhol's Exploding Plastic Inevitable," *Grey Room,* no. 8 (Summer 2002), 80–107.

28. The *New York Daily Mirror* closed on October 16, 1963, after the 114-day New York City newspaper strike of 1962.

29. Marshall McLuhan, "The Gadget Lover: Narcissus as Narcosis," in Gordon ed. 2003, 61–70.

30. Brian O'Doherty, "Narcissus in Hades," *Art and Artists* 1, no. 11 (February 1967), 14.

31. Andy Warhol, *THE Philosophy of Andy Warhol: From A to B and Back Again* (London, 1975), 7.

32. Berg in Goldsmith 2004, 86.

33. See Todd Gitlin, *The Whole World Is Watching: Mass Media in the Making and Unmaking of the New Left* (Berkeley and Los Angeles, 2003), 49.

34. See Whiting 1987, 58–75, which discusses Warhol's use of media imagery as eliding the private self and asserts that for him personally the "absence of the private constituted his public persona" (p. 71).

35. Hal Foster, "Death in America," *October* 75 (Winter 1996), 36–38, offers "traumatic realism" as an option in which to incorporate both the simulacral and referential views. He also describes the two views in his "Survey," in *Pop*, ed. Mark Francis (New York and London, 2005), 29, aligning Roland Barthes's essay "That Old Thing, Art" (1980) with the simulacral reading, and Thomas Crow's essay "Saturday Disasters: Trace and Reference in Early Warhol" (1987) (see note 47 below) with the referential view.

36. Graham Bader discusses Echo's role in Roy Lichtenstein's painting *Look Mickey* (1961), collection of the National Gallery of Art, in his essay "Donald's Numbness" (Bader 2010, 65).

37. See Patricia Berry, "Echo and Beauty," in *Carl Gustav Jung: Critical Assessments*, ed. Renos K. Papadopoulos, vol. 11, *The Structure and Dynamics of the Psyche* (London and New York, 1992), 423.

38. Callie Angell in conversations with the author.

39. Bourdon 1989, 6.

40. In a review of Warhol's first exhibition in 1952, James Fitzsimmons described Warhol's drawings (based on the writings of Truman Capote) as "less amusing, less impressive" than those of Irving Sherman, shown at the Hugo Gallery at the same time. See *Art Digest* 26, no. 18 (July 1952), 19.

41. Dore Ashton, "New York Report," in *Das Kunstwerk* 5–6, no. 16 (November/December 1962), 70.

42. David Bourdon calls the newspaper a "preflattened" subject in "All the Newsprint That's Fit to Paint," in *Breakthroughs: Avant-Garde Artists in Europe and America, 1950–1990* (New York, 1991), 50.

43. Michael Fried, "New York Letter," *Art International* 6, no. 10 (December 1962), 57.

44. The *New York Times* slogan, "All the News That's Fit to Print," still adorns the masthead today, having been coined in 1897 by founder Adolph S. Ochs to differentiate his publication from the sensationalism of Joseph Pulitzer's *World* and William Randolph Hearst's *Journal*, both also published in New York. As Ochs's declaration for his paper stated: "It will be my earnest aim that the New York Times give the news, all the news, in concise attractive form, in language that is parliamentary in good society." See Emery, Emery, and Roberts 2000, 235–237.

45. See http://www.fundinguniverse.com/company-histories/EnquirerStar-Group-Inc-Company-History.html.

46. W. Joseph Campbell, professor of communication at American University, writes a blog in which he debunks inaccuracies and exaggerated or false media legends: "Media Myth Alert," http://mediamythalert.wordpress.com/about/.

47. Thomas Crow, "Saturday Disasters: Trace and Reference in Early Warhol," in *Andy Warhol*, ed. Annette Michelson (Cambridge, MA, 2001), 60.

48. Gene R. Swenson, "What Is Pop Art: Answers from Eight Painters, Part 1: Jim Dine, Robert Indiana, Roy Lichtenstein, and Andy Warhol," *Art News* 62, no. 7 (1963), 60.

49. See Emery, Emery, and Roberts 2000, 413 and 433: "The credibility gap as an institution became painfully apparent in American life by 1970. There were gaps between president and people, president and press, press and people."

50. For a discussion of Students for a Democratic Society, see Gitlin 2003, 42–43. For relevant treatment of Abbie Hoffman, see David Joselit, "Yippie Pop: Abbie Hoffman, Andy Warhol, and Sixties Media Politics," in *Grey Room,* no. 8 (Summer 2002), 62–79.

51. The use of the newspaper in art made its modern debut in 1909, when the historical avant-garde artist, Filiippo Tomasso Marinetti, printed his "Manifeste du futurisme" in the pages of *Le Figaro* on February 20 of

that year. In a continuum of twentieth-century art, the newspaper and the headlines have received considerable attention as a conceptual and formal tool for artists, a container and medium for their message.

52. Paul Morrissey, quoted in John Leonard, "The Return of Andy Warhol," *New York Times Magazine*, November 10, 1968, 151.

53. For more on this, see Donna M. De Salvo, ed., *"Success Is a Job in New York…": The Early Art and Business of Andy Warhol* (New York, 1989).

54. Many conflicting accounts surround Warhol's abandonment of comics as a subject, all relating to their intersection with Roy Lichtenstein's paintings of comics. See Calvin Tomkins, "Raggedy Andy," in John Coplans, *Andy Warhol* (New York, 1970), 12: "From Ivan Karp, the associate director of Castelli Gallery, he had learned about Roy Lichtenstein's comic-strip paintings. Lichtenstein had done some paintings based on Nancy and Sluggo and Mickey Mouse, among others, and Ivan and Leo Castelli and Andy himself agreed that Lichtenstein's were much more authoritative than Andy's." See also Kynaston McShine, "Introduction," *Andy Warhol: A Retrospective* (Museum of Modern Art, New York, 1989), 14: "Warhol appears to have abandoned the cartoon, not wanting to share the subject with a competitor. However, he had already grasped the larger implications of using such popular subject matter—and of the comic-strip structure, grounded as it is in serial imagery—for his budding aesthetic."

55. He misspelled the same publication differently in another drawing, with "Nationl Innguirer" appearing in the banner of *Strictly Personal*, 1956 (see fig. 14 in the present essay).

56. Wayne Koestenbaum, *Andy Warhol* (London, 2003), 30–31, and Tony Scherman and David Dalton, *Pop: The Genius of Andy Warhol* (New York, 2009), 9–10, both claim Warhol was dyslexic; others maintain there is no medical evidence to support this claim.

57. Examining this drawing at the Andy Warhol Museum in Pittsburgh on January 25, 2010, Michelle Facini, National Gal-

lery paper conservator, and I believed the "tears" were cut deliberately, given their clean linear breaks.

58. Three paintings from this group (*A Boy for Meg [2]*, *Daily News*, and *129 Die in Jet*) found owners by 1969, the latter two in German collections. *A Boy for Meg [1]* was not recorded during the artist's lifetime and remained in his possession, along with countless other works, until his death.

The painted medium in *A Boy For Meg [2]* was analyzed by the National Gallery of Art scientific research department in the summer of 2007. Studies to that date list the medium as casein. The following report, however, determines it is an egg-oil emulsion: "Analysis of the white, gray, blue, and black paint using gas chromatography/mass spectrometry confirmed that all samples contain both amino acids and fatty acids, suggesting proteinaceous and drying oil components. Large amounts of drying oil were found in the white and gray samples, with lesser amounts in the blue and black samples, and the paint has been characterized as an egg-oil emulsion. The absence of a large proline peak clearly indicates that the paint is not casein." (NGA, Scientific Research Department, no. 827, August 7, 2007)

59. In a twist of art world fate, this child, David Albert Charles Armstrong-Jones, Viscount Linley, would become the United Kingdom's chairman of the art and antiques auction house Christie's in 2006.

60. Andy Warhol and Pat Hackett, POPism: *The Warhol Sixties* (New York, 1980), 6.

61. Warhol and Hackett 1980, 8–9.

62. Warhol and Hackett 1980, 28.

63. Donna M. De Salvo, unpublished interview with Andy Warhol, September 22, 1986, New York (De Salvo in conversation with the author, December 17, 2010).

64. André Breton, *Dictionnaire abrégé du surréalisme* (Paris, 1938), 18.

65. See, for example, *Fountain* of 1917. For Duchamp's "Specifications for Readymades," see his "The Green Box," in *Salt Seller: The Writings of Marcel Duchamp*, ed. Michel Sanouillet and Elmer Peterson (New York, 1973), 32: "by planning for a moment to come (on such a day, such a date such a minute), 'to *inscribe* a readymade'—The readymade can later be looked for." See also David Joselit, *Feedback: Television against Democracy* (Cambridge, MA, 2007), 52: "It is the inscription—whether rendered as an actual text applied to the readymade physically, or projected onto it virtually as a title—that makes the snow shovel in Duchamp's *In Advance of the Broken Arm* (1915), for instance, not a snow shovel but a work of art."

66. Henry Geldzahler, in Patrick Smith, *Warhol: Conversations about the Artist* (Michigan, 1988), 184, claimed *129 Die in Jet* was the last of Warhol's hand-painted canvases.

67. Warhol and Hackett 1980, 17.

68. Taylor Mead, in John Wilcock et al., *The Autobiography and Sex Life of Andy Warhol* (New York, 1971), unpaginated. Callie Angell (in conversation with the author) also recounted that Warhol's mother, Julia Warhola, was said to have made a headlinelike statement in broken English, "Mike Todd Die in Sky," to her son and Henry Geldzahler as they prepared to fly somewhere. Mike Todd, killed in a plane crash, March 22, 1958, was the third husband of Elizabeth Taylor and the best friend of Eddie Fisher, who married Taylor after Todd's death.

69. Warhol applied gestural brushstrokes over his silkscreened Mao paintings and portraits in late 1972, a practice that extended until September 1974. See Neil Printz, *The Andy Warhol Catalogue Raisonné*, vol. 3, *Paintings and Sculpture 1970–1974* (London and New York, 2010), 11.

70. George Frei and Neil Printz, *The Andy Warhol Catalogue Raisonné*, vol. 1, *Paintings and Sculpture 1961–1963* (London and New York, 2002), 10, uses Warhol's comment to Swenson in 1963 about his silkscreen paintings to describe the difficulty in defining Warhol's corpus and establishing authorship.

71. The Swenson interview was given sometime after September 22, 1963, and was followed a few months later by Warhol's Tunafish Disaster paintings, made by early May 1963.

72. Callie Angell, *Andy Warhol Screen Tests: The Films of Andy Warhol, Catalogue Raisonné*, vol. 1 (Whitney Museum of American Art, New York, 2006), 30, 32, 84–85, 186–187.

73. For more on Warhol and surveillance, see Branden W. Joseph, "Nothing Special: Andy Warhol and the Rise of Surveillance," in Thomas Y. Levin, Ursula Frohne, and Peter Weibel, eds., CTRL [SPACE]: Rhetorics of Surveillance from Bentham to Big Brother (Cambridge, MA, 2002), 119–133.

74. Peter Gidal, *Andy Warhol: Blow Job* (London, 2008).

75. George Frei and Neil Printz, *The Andy Warhol Catalogue Raisonné*, vol. 2A, *Paintings and Sculpture 1964–1969* (London and New York, 2004), 25.

76. Many of these alternative publications were supported by the Beat writers and poets Jack Kerouac, William S. Burroughs, and Allen Ginsberg. Included among them were the first homophilic magazines, *Mattachine Review* and *One Magazine*. A copy of the latter is in Warhol's archive.

77. McLuhan in Gordon ed. 2003, 12.

78. See Christin J. Mamiya, "The Mass Media in an Age of Publicity," in *Pop Art and Consumer Culture: American Super Market* (Austin, 1992), 72–111.

79. See Frei and Printz 2002, 20.

80. See Hugh M. Cannon and David L. Williams, "Toward a Hierarchical Taxonomy of Magazine Readership," in *Journal of Advertising* 17, no. 2 (1988), 15–25. See also Anthony Grudin's essay in the present catalogue.

81. Frayda Feldman and Claudia Defendi, *Andy Warhol Prints: A Catalogue Raisonné 1962–1987*, 4th ed., rev. and expanded (New York, 2003), 256: "Created for an unrealized *New York Daily News* advertising campaign." David Segal, who worked as associate director of advertising and promotion at Metro-Goldwyn-Mayer

(MGM) television in 1967, relayed his recollection of the *Daily News* screenprints in a telephone conversation with the author, March 9, 2010.

82. These commercial designs would also be used in Warhol's *Lincoln Center Ticket* (1967) and *SAS Passenger Ticket* (1968).

83. Warhol and Hackett 1980, 77.

84. Martin Luther King Jr. was assassinated on April 4, 1968, two months before Warhol was shot. Robert F. Kennedy was assassinated June 5, two days after Warhol was shot.

85. Warhol and Hackett 1980, 345 – 346.

86. Warhol and Hackett 1980, 277.

87. The article is kept temporarily in "miscellaneous box" no. 173, marked "Alternative Newspapers" in the Archives of the Andy Warhol Museum, Pittsburgh.

88. Warhol 1975, 91.

89. Joselit 2007, 116 – 117.

90. Warhol and Hackett 1989, 743.

91. Arthur Danto, "Andy Warhol's *Before and After*," in *Andy Warhol: The Early Sixties: Paintings and Drawings 1961 – 1964*, ed. Bernhard Mendes Bürgi and Nina Zimmer (Kunstmuseum Basel, 2011), 18.

92. See Jonathan Flatley's essay on the 2001 World Trade Center terrorist attack, "'All That Is Solid Melts into Thin Air': Notes on the Logic of the Global Spectacle," *Afterimage* 30, no. 2 (September / October 2002), 4 – 5, citing Walter Benjamin, "The Storyteller," in *Illuminations* (New York, 1968), 101: "What draws the reader to the novel is the hope of warming his shivering life with a death he reads about."

93. Gordon ed. 2003, xii.

94. Theodor W. Adorno and Max Horkheimer, "Odysseus, or Myth and Enlightenment," *New German Critique*, no. 56, special issue on Theodor W. Adorno, trans. Robert Hullot-Kentor (Spring–Summer 1992; repr. 1995), 109 – 114.

95. According to an article in the *Boston Globe* of January 2, 2011, "The Incredible Shrinking

Sound Bite: It's Not Just a Modern Problem — and May Not Be Such a Bad Thing After All," by Craig Fehrman, the increasingly abbreviated style of newspaper quotations and televised sound bites in the past century results largely from a complex relationship between the media and politicians: http://www.boston.com/bostonglobe/ideas/articles/2011/01/02/the_incredible_shrinking_sound_bite/.

96. Olle Granath, "With Andy Warhol 1968," in Meyer-Hermann 2007, 13.

97. Phyllis Tuchman, "POP! Interviews with George Segal, Andy Warhol, Roy Lichtenstein, James Rosenquist, and Robert Indiana," *Art News* 73, no. 5 (May 1974), 26.

98. Sherri Geldin, director of the Wexner Center for the Arts, Columbus, OH, in conversation with the author, February 6, 2009.

99. Bob Colacello, *Holy Terror: Andy Warhol Close Up* (New York, 1990), 6.

100. This discussion is based on a conversation between Brigid Berlin and the author, April 27, 2010.

101. Visitors would encounter Berlin deeply involved in making needlepoint works, often portraits of her beloved pugs, which she made into pillows. More recently, Berlin turned to the tabloid headlines as the subject of her needlepoint pillows.

102. Barbara Walters, known for her probing yet relaxed interviewing style, was a mainstay on NBC's *Today* show by 1974 and was on her way to becoming the first woman to coanchor a network evening news program (ABC) in 1976. See Emery, Emery, and Roberts 2000, 410.

103. Despite her open rebellion against her well-to-do family, Berlin identified with its Republican leanings, declaring that she would never buy a *New York Times* owing to its liberal politics. Conversation with the author, April 27, 2010.

104. Jane Curtin hosted *Saturday Night Live*'s "Weekend Update" from 1976 to 1980.

105. Vincent Fremont, "Reel-to-Real Video: Warhol and TV" in *Andy Warhol* (Queensland Art Gallery, Brisbane, Australia, 2007).

106. Vincent Fremont, introduction to *Andy Warhol Polaroids: 1971 – 1986* (Pace/MacGill Gallery, New York, 1992), 6, noted that Warhol's portraits of men often included the subject's hands.

107. Julia Draganovic, former artistic director of the Palazzo delle Arti Napoli, in conversation with the author, June 7, 2009.

108. See Feldman and Defendi 2003, 246.

109. Warhol would go on to include the partial headline, "Grim Marine Toll Hits," from page 2 (pl. 62) in an unfinished collaborative work with Jean-Michel Basquiat and Francesco Clemente, entitled *Abstract Sculpture*, at the Andy Warhol Museum, and in a group of paintings of the same name by Warhol alone.

110. See the frontispiece to William V. Ganis, *Andy Warhol's Serial Photography* (Cambridge, 2004).

111. See "Straight Photographs and Queer Threads," in Ganis 2004, 100 – 121.

112. Valerie Solanas shot not only Warhol but also Mario Amaya in 1968.

113. Jonathan Flatley writes of Warhol's *AIDS/Jeep/Bike* painting in "Warhol Gives Good Face: Publicity and the Politics of Prosopopoeia," in *Pop Out: Queer Warhol*, eds. Jennifer Doyle, Jonathan Flatley, and José Esteban Muñoz (Durham, NC, 1996), 122.

114. A cropped copy of the source is kept in the Archives of the Andy Warhol Museum. Corinna Thierolf writes of the various sources in her essay on Warhol's *AIDS/Jeep/Bike* painting in *Amerikanische Kunst des 20. Jahrhunderts in der Pinakothek der Moderne* (Munich, 2002), 474 – 480.

115. Keith Haring, "Painting the Third Mind," in *Warhol – Basquiat: Collaborations* (Paris, 1989), n.p.

116. Several exhibitions have taken Burroughs's and Gysin's *The Third Mind* as a point of departure, including "The Third Mind: Carte Blanche to Ugo Rondinone" (Palais de Toyko, Paris, 2007 – 2008, curated by Ugo Rondinone); "The Third Mind: American Artists Contemplate Asia, 1860 – 1989" (Solo-

mon R. Guggenheim Museum, New York, 2009); and "Richard Hawkins: Third Mind" (Art Institute of Chicago, 2010 – 2011).

117. Haring's prodigious talent and output were cut short by his death in 1990 from AIDS-related complications.

118. Warhol 1975, 146 – 148.

119. Keith Haring in *Andy Warhol's T.V.* (episode 5), 1983, in outtake no. 2, with Keith Haring and Kenny Scharf.

120. See http://www.allmusic.com/album/break-through-in-grey-room-r541727.

121. Warhol had autographed copies of several Burroughs books in his library, including *Ticket That Exploded*, *Exterminator!* and *Dead Fingers Talk*, now in the Archives of the Andy Warhol Museum in Pittsburgh.

122. Warhol and Hackett 1989, 667.

123. The name of the woman in the photograph is Sophie Ktenas.

124. Archives of the Andy Warhol Museum, Pittsburgh.

125. See footage from Madonna's "Ciao Italia! — Live from Italy" concert in Turin, September 1987: http://www.youtube.com/watch?v=kwo2x1QOcqU.

126. Gordon ed. 2003, xiii – xiv.

127. The baby, Carrie Fisher, was born to Reynolds and Fisher on October 21, 1956, giving the unknown source for this drawing a date of 1956.

128. John Clark Gable, Clark Gable's only son, was born on March 20, 1961, four months after his father died from coronary thrombosis (November 16, 1960), at age fifty-nine.

129. Among many examples, the front page headline from *Life & Style Weekly*, July 21, 2008, reads: "Baby Album: 16 of Hollywood's Cutest Babies Inside." The headline from the tabloid *OK Magazine*, April 19, 2010: "Confirmed: Finally, a Baby for Jen." And the cover of *People Magazine*, May 10, 2010: "Sandra Bullock: 'Meet My Baby': 3 Months after Secret Adoption."

130. "'I'm Not Ashamed of My Stripper Past': Channing Tatum Shows Off His Gym-Honed Physique for GQ Photo Shoot": http://www.dailymail.co.uk/tvshowbiz/article-1357383/Channing-Tatum-says-Im-ashamed-stripper-past-GQ-photo-shoot.html.

131. See "Sen. John Edwards Caught with Mistress and Love Child!" and "John Edwards Confession to Dying Wife: 'It's My Baby!'": http://www.nationalenquirer.com/sen_john_edwards_caught_with_mistress_and_love_child_in_la_hotel/celebrity/65193; and http://www.nationalenquirer.com/celebrity/66289.

132. See "Bill O'Reilly Apologizes to Shirley Sherrod for 'Not Doing My Homework'": http://latimesblogs.latimes.com/showtracker/2010/07/bill-oreilly-apologizes-to-shirley-sherrod-for-not-doing-my-homework.html.

133. In the article, "America Is a Joke: The Worst of Times for Politics and Media Has Been the Best of Times for *The Daily Show*'s Host — and Unfortunately Things Are Getting Even Funnier," by Chris Smith in *New York Magazine* (September 12, 2010), a profile on Jon Stewart, describes the *Daily Show* strategy to derail the news media narrative: http://nymag.com/arts/tv/profiles/68086/.

134. The article, "Is Jon Stewart the Most Trusted Man in America?" by Michiko Kakutani, was published in the *New York Times* on August 15, 2008: http://www.nytimes.com/2008/08/17/arts/television/17kaku.html.

135. Colbert's neologism "truthiness" was awarded the sixteenth annual Word of the Year by the American Dialect Society in 2005, followed by Merriam-Webster's No. 1 Word of the Year for 2006. See http://www.merriam-webster.com/info/06words.htm. An earlier listing for "truthiness" appears in *The Oxford English Dictionary*, vol. 18, 2nd ed. (Oxford, 1989), 629, under "truthy," meaning "characterized by truth; truthful, true. Hence truthiness, truthfulness, faithfulness." It lists the earliest usage of "truthy" as "c. 1800."

136. See *Alessandra Stanley*, "Bringing Out the Absurdity of the News," *New York Times*, October 25, 2005, http://www.nytimes.com/2005/10/25/arts/television/25watc.html?_r=1.

137. Mark Lancaster, "Warhol Remembered," *Burlington Magazine* 131, no. 1032 (March 1989), 198.

BREAKING IT DOWN: WARHOL'S NEWSPAPER ALLEGORIES
JOHN J. CURLEY

David Joselit, Christine Mehring, and Alexander Nemerov have been instrumental in helping me develop my ideas about Warhol's paintings. Thanks are also due to Morna O'Neill for her ideas and insightful suggestions regarding the text.

1. The *Pittsburgh Sun-Telegraph* published a picture of Warhol on the same day, but not a story. See reproduction in the Andy Warhol Museum's *Andy Warhol, 365 Takes: The Andy Warhol Museum Collection* (New York, 2004), n.p., no. 9. In both newspapers his last name was given as "Warhola," as the artist did not change his name until 1949.

2. I am indebted to Walter Benjamin's discussion of the term "allegory" in *The Origins of German Tragic Drama* (1928), trans. John Osborne (London, 1998). Susan Buck-Morss's writings on Benjamin have also been helpful. See her *The Dialectic of Seeing: Walter Benjamin and the Arcades Project* (Cambridge, MA, 1989), esp. 160 – 201.

3. These years are best explored in Donna M. De Salvo, ed., *"Success Is a Job in New York…": The Early Art and Business of Andy Warhol* (New York, 1989); and Nan Rosenthal, "'Let Us Now Praise Famous Men': Warhol as Art Director," in *Dia Art Foundation Discussion in Contemporary Culture*, no. 3: *The Work of Andy Warhol*, ed. Gary Garrels (Seattle, 1989), 34 – 51.

4. Peter Palazzo, quoted in Tony Scherman and David Dalton, *Pop: The Genius of Andy Warhol* (New York, 2009), 22.

5. Warhol won the 1957 Art Director's Club Medal for one of his I. Miller advertisements. See Patrick S. Smith, *Andy Warhol's Art and Films* (Ann Arbor, 1986), 23. The Sunday circulation of the *New York Times* in March 1957 was 1,277,140. This statistic is courtesy of the Audit Bureau of Circulations, obtained through the *New York Times* circulation department.

6. Donna M. De Salvo, "Learning the Ropes: Some Notes about the Early Work of Andy Warhol," in De Salvo 1989, 9.

7. Marshall McLuhan, "Press," in *Understanding Media: The Extensions of Man* (1964) (Cambridge, 2002), 210. Emphasis his.

8. Such relationships between Warhol's advertisements and editorial content go back to the early 1950s. On September 13, 1951, the *New York Times* published a full-page advertisement, featuring a Warhol drawing, for a CBS radio program called "Our Nation's Nightmare" that chronicled the country's growing heroin problem. A story entitled "Biggest Dope Peddler in Harlem Receives Stiffest Narcotics Sentence — 15 to 20 Years" appeared on the opposite page.

9. Although *Journal American* is securely dated to 1960, Warhol did complete other drawings based on newspaper front pages from the 1950s, including *The Princton Leader* from 1956 and *The (Wall Street) Journal* from about 1958 (see pls. 1 – 3). These works demonstrate an artistic interest in the formal aspects of the newspaper page at this earlier moment.

10. Izola Ware Curry stabbed and seriously injured Martin Luther King Jr. with a letter opener at a Harlem department store. The Soviet letter that Eisenhower deemed "abusive" concerned the American defense of Taiwan (then called Formosa). Additionally, the iconic presence of the word "solace" in Warhol's drawing hovering over a recumbent Martin Luther King distinctly recalls the positioning of the word "silence" in his later silkscreen paintings of the electric chair.

11. Benjamin H. D. Buchloh has convincingly argued this position, adding that Warhol used avant-garde art strategies (those of Rauschenberg and Johns, for example) in his commercial work of the 1950s. See his "Andy Warhol's One-Dimensional Art," in Kynaston McShine, ed., *Andy Warhol: A Retrospective* (Museum of Modern Art, New York, 1989), 39 – 61.

12. An artist's statement published in a 1962 edition of *Art in America* hints at Warhol's criticality: "I adore America and these [paintings] are some comments on it. My image [*Storm Door, 1960*] is a statement of the symbols of the harsh, impersonal products and brash materialistic objects on which America is built today. It

is a projection of everything that can be bought and sold, the practical but impermanent symbols that sustain us." See "New Talent U.S.A.," *Art in America* 50, no. 1 (1962), 42.

13. Georg Frei and Neil Printz, *The Andy Warhol Catalogue Raisonné*, vol. 1, *Paintings and Sculpture 1961–1963* (London and New York, 2002), 19–48. These paintings, nos. 1–29 in the catalogue raisonné, use small newspaper advertisements and cartoon strips as subject matter.

14. Identification of Nasser and Patterson from caption, *Daily News*, March 29, 1962. See *Time Capsule 472*, in the Andy Warhol Museum, Pittsburgh.

15. Unfortunately, Warhol's painting is based on an edition (2-Star final) that is not in the New York Public Library microfilm reel. I consulted the 5-Star final, which would certainly be a close match to Warhol's copy.

16. This interpretation builds upon Thomas Crow's influential understanding of Warhol's work as expressive of the dark side of consumerism. See his "Saturday Disasters: Trace and Reference in Early Warhol" (1987), in *Modern Art in the Common Culture* (New Haven, 1996), 49–65.

17. For example, in the late 1950s Allan Kaprow located Jackson Pollock's radicalism in the painter's engagement with everyday life, not Greenbergian notions of painterly flatness or medium specificity. See his "The Legacy of Jackson Pollock," *Art News* 57, no. 6 (1958), 24–26, 55–57.

18. These ideas famously are articulated in Clement Greenberg's, "Avant-Garde and Kitsch" (1939); see *Clement Greenberg: The Collected Essays and Criticism*, vol. 1, *Perceptions and Judgments, 1939–1944*, ed. John O'Brian (Chicago, 1986), 5–22.

19. Greenberg discusses art more specifically in "Toward a Newer Laocoön" (1940); see O'Brian ed. 1986, 1:23–38.

20. For a discussion of Greenberg's political shifts, see John O'Brian, "Introduction," in *Clement Greenberg: The Collected Essays and Criticism*, vol. 3, *Affirmations and Refusals, 1950–1956*, ed. John O'Brian (Chicago, 1993), xv–xxxiii.

21. Greenberg addresses "opticality" in "Modernist Painting" (1960); see *Clement Greenberg: The Collected Essays and Criticism*, vol. 4, *Modernism with a Vengeance, 1957–1969,* ed. John O'Brian (Chicago, 1993), 85–93.

22. See Robert Rosenblum, "Pop Art and Non-Pop Art" (1965), in *Pop Art: A Critical History*, ed. Steven Henry Madoff (Berkeley, 1997), 133. For more recent work on Warhol's engagement with Greenberg's understanding of abstraction, see Michael Lüthy, "The Apparent Return of Representation," in *Andy Warhol: Painting 1960–1986* (Kunstmuseum Luzern, Stuttgart, 1995), 43–53; and Sebastian Egenhofer, "Subjectivity and the Production of Meaning in Warhol's Early Work," in *Andy Warhol: The Early Sixties, Paintings and Drawings 1961–1964* (Kunstmuseum Basel, Ostfildern, 2010), 32–45.

23. They called their newspaper *The Plastic Exploding Inevitable*, after Warhol multimedia spectacles produced with the Velvet Underground in 1966–1967.

24. For a longer discussion of photography's conflicted role in the Cold War and the ways in which Warhol's paintings allegorize this condition, especially relative to mass media practices, see my doctoral dissertation, "The Art That Came in from the Cold: Andy Warhol and Gerhard Richter, 1950–1968" (Yale University, 2007). Through the work of Warhol and Richter, I theorize a "Cold War visuality" that structured vision on both sides of the ideological divide.

25. Frei and Printz 2002, 175.

26. The caption in the original source reads: "End Wasn't in This Script: Slightly more than two weeks ago, Liz Taylor was looking at Eddie Fisher with eyes that seemed to speak of love…. Yesterday, Eddie was behind locked doors in a psychiatric ward here [New York]."

27. Roland Barthes, "The Photographic Message" (1961), in *Image-Music-Text*, trans. Stephen Heath (New York, 1977), 15–31. The first lines of the essay refer explicitly to the newspaper image: "The press photograph is a message. Considered overall this message is formed by a source of emission, a channel of transmission and a point of reception."

28. This valuable information is from Mario Kramer, chief curator at the Museum für Moderne Kunst, Frankfurt, conveyed in correspondence with Molly Donovan, October 2010.

29. Anne Wagner has argued that Warhol's image choices "must be resonant—and empty enough—to allow the process of allegorizing to occur." See her "Warhol Paints History, or Race in America," *Representations* 55 (1996), 104.

30. Warhol first transferred, then overpainted, the caption "You See Me in the Derby" beneath the picture of the horse. This information is also from Mario Kramer (see note 28).

31. Warhol was certainly aware of Poons's work at this time. Warhol's archives contain photographs of the two of them together in 1962, and both artists were members of a short-lived pop music band, The Druds, in 1963. Additionally, according to the catalogue for his estate auction (Sotheby's 1988), Warhol owned a dozen small abstract drawings by Poons, though only one is dated (1956) and none is reproduced. I would like to thank Matt Wrbican for the above information as well as for years of helping me navigate Warhol's vast archives. For more information on The Druds, see Branden W. Joseph, "No More Apologies: Pop Art and Pop Music, ca. 1963," in *Warhol Live: Music and Dance in Andy Warhol's Work* (Montreal Museum of Fine Arts, 2008), 122–129.

32. See Warhol's 1962 datebook, at the Andy Warhol Museum, Pittsburgh. At the time of Stella's retrospective at MOMA in 1970, *Point of Pines* was in the collection of the artist. It is possible, then, that Warhol might have seen the canvas during his studio visit.

33. See Lawrence Rubin, *Frank Stella Paintings 1958 to 1965: A Catalogue Raisonné* (New York, 1986), 135, 140–141. Rubin relates that Stella painted six small versions (one-foot squares) of larger canvases expressly for Warhol, all from 1962, which are nos. 114–120 in the catalogue raisonné. Warhol himself briefly mentions this purchase in his memoir of the 1960s, *POPism*, and he refers to one of Stella's black paintings that hung in the home of his close friend Emile de Antonio in 1962. This painting was likely

Stella's *Reichstag* from 1958, as the work's provenance lists de Antonio as a previous owner (Rubin 1986, 60). See Andy Warhol and Pat Hackett, *POPism: The Warhol Sixties* (New York, 1980), 9. Egenhofer also mentions Warhol's purchase of the Stella paintings, but his date of 1961 is incorrect, as the canvases were not produced until the following year (Egenhofer 2010, 33). Thanks to Jennifer Roberts at the National Gallery of Art for her help with this information.

34. Other Warhol paintings also seem to refer to the work of specific artists. Rosalind E. Krauss has understood Warhol's *Dance Diagram* series as acknowledging Jackson Pollock's much publicized "dancing" around the canvas. See her *The Optical Unconscious* (Cambridge, MA, 1993), 275.

35. For a highly informative look at the various processes of reproducing photographs in ink, including halftones, see Richard Benson, *The Printed Picture* (Museum of Modern Art, New York, 2008), 210–239. He writes: "No matter how well a letterpress halftone is printed, the image will have a somewhat rough appearance and the resolution will be low when compared to an actual photographic print" (p. 222).

36. See Stanley B. Burns and Sara Cleary-Burns, *News Art: Manipulated Photographs from the Burns Archive* (New York, 2008), 11. Gerry Beegan also discusses this concept in *The Mass Image: A Social History of Photomechanical Reproduction in Victorian London* (London 2008), 12–13.

37. See Marianne Fulton, *Eyes of Time: Photojournalism in America* (Boston, 1988), 108–114. The first transmitted wirephoto dates to 1906.

38. Barbie Zelizer, "Journalism's 'Last' Stand: Wirephoto and the Discourse of Resistance," *Journal of Communications* 45, no. 2 (1995), 84.

39. McLuhan 2002, 165.

40. See Burns and Cleary-Burns 2008, 13.

41. Fulton 1988, 112–113.

42. The original crash took place in Paris, emphasizing the distance the photograph traveled. The full caption reads: "Tail sec-

tion stands upright amid smoldering wreckage after a N.Y.-bound Air France jetliner crashed on take-off near Paris."

43. Frei and Printz 2002, 175.

44. Frei and Printz 2002, 175. The authors argue that the gray wash approximates the appearance of the newspaper halftone process.

45. See John J. Curley, "Gerhard Richter's Cold War Vision," in *Gerhard Richter: Early Work*, ed. Christine Mehring et al. (Los Angeles, 2011) 11–15, for a discussion of the Cuban Missile Crisis photographs.

46. Jackson Pollock, "Interview with William Wright" (1950), in *Theories and Documents of Contemporary Art*, eds. Kristine Stiles and Peter Selz (Berkeley, 1996), 22.

47. This same idea of contingency also fueled abstract expressionism, according to critics like Harold Rosenberg, in "The American Action Painters," *Art News* 51, no. 8 (1952), 22–23, 48–50.

48. Warhol has said that his friend and Metropolitan Museum curator Henry Geldzahler suggested the subject, but this does not detract from its larger significance. Warhol received many ideas; it is those he pursued — and, crucially, *how* he pursued them — that matters when discussing a work like *129 Die in Jet*.

49. This information comes from articles about the crash in the *New York Mirror*, June 4, 1962.

50. This story was widely covered. See *Life*, June 15, 1962, 30–31.

51. See Walter Benjamin, "The Work of Art in the Age of Mechanical Reproduction" (1936), in *Illuminations*, ed. Hannah Arendt, trans. Harry Zohn (London, 1973), 211–244, where the author famously discussed the waning of artistic aura.

52. Rosenthal 1989, 46. Leonardo's *Mona Lisa* arrived in New York from Paris with much fanfare in December 1962. Warhol used promotional materials for the painting's exhibition as the source for his series of paintings. See also Warhol's images of U.S. airmail stamps from early 1962

(also featuring an image of a jet), emphasizing his interest in image mobility.

53. Wagner 1996, 98–119, discusses Warhol and history painting relative to contemporary mass media practices — especially in terms of race — but not in the terms of image transmission.

54. For a discussion of history painting and the public, see Thomas Crow, "The Birth and Death of the Viewer: On the Public Function of Art," in *Dia Art Foundation Discussions in Contemporary Culture*, no. 1, ed. Hal Foster (Seattle, 1987), 1–8. Crow situates Kenneth Noland's abstractions as history paintings of the early 1960s. Along these lines, Mario Kramer has interpreted the stacked arrangements of photographs in Warhol's *Daily News* as reminiscent of a Salon-style hanging. Conversation with Molly Donovan, October 2010.

55. Jeremi Suri, in *Power and Protest: Global Revolution and the Rise of Détente* (Cambridge, MA, 2005), 165, writes that the "harmfully exaggerated" rhetoric of the opposed Cold War sides forced regimes to make too many "false promises" in the years leading up to 1968.

56. I received this information about Warhol's collection of photographs from Matt Wrbican, the archivist of the Andy Warhol Museum. Ray Johnson (an artist and longtime friend of Warhol's), speaking by phone in 1995 shortly before his death, suggested to Wrbican that Warhol obtained these images when a defunct New York newspaper had put its photograph collection on the street as trash. Conversation with the author, September 2005.

57 Benjamin 1998, 177, 188.

58. For an example of Warhol's press attention in 1962, see "Products," *Newsweek*, November 12, 1962, 94, which illustrated a detail from Warhol's *100 Campbell's Soup Cans* (1962).

59. See Walter Benjamin, "The Author as Producer" (1934), in *Reflections: Essays, Aphorisms, Autobiographical Writings*, ed. Peter Demetz, trans. Edmund Jephcott (New York, 1978), 220–238.

60. See Warhol and Hackett 1980, 277.

61. The 1983 bombing eventually killed 241 Americans. Jessica Savitch was the weekend anchor for NBC Nightly News.

MYTH AND CLASS IN WARHOL'S EARLY NEWSPRINT PAINTINGS
ANTHONY E. GRUDIN

1. In addition to Michael Fried and Arthur Danto, mentioned below, see Donna M. De Salvo, "'Subjects of the Artists': Towards a Painting without Ideals," in *Hand-Painted Pop: American Art in Transition, 1952–1962*, ed. Russell Ferguson (Los Angeles, 1992), 86, 92; and Jean Baudrillard, *The Consumer Society: Myths and Structures*, trans. Chris Turner (Thousand Oaks, CA, 1998), 116 (published in French as *La société de consommation: Ses mythes et ses structures*, 1970).

2. Robert Smithson, "Production for Production's Sake" (1972), in *Robert Smithson: The Collected Writings*, ed. Jack Flam (Berkeley, 1996), 378.

3. See Michael Fried, "New York Letter," *Art International* 6, no. 10 (December 1962), 57.

4. On the status of predilections, see Clement Greenberg, "Review of the Whitney Annual," *The Nation*, December 28, 1946; reprinted in *Clement Greenberg: The Collected Essays and Criticism*, vol. 2, *Arrogant Purpose, 1945–1949*, ed. John O'Brian (Chicago, 1986), 118: "very few know, feel, or suspect what makes painting great anywhere and at any time — that it is necessary to register what the artist makes of himself and his experience in the world, not merely to record his intentions, foibles, and predilections."

5. Although Danto does not cite Fried's article in this text, he mentions it approvingly in his recent *Andy Warhol* (New Haven, 2009), 45.

6. Arthur Danto, "Warhol and the Politics of Prints," in *Andy Warhol Prints: A Catalogue Raisonné, 1962–1987*, 4th rev. ed., ed. Frayda Feldman and Jörg Schellmann (New York, 2003), 10–11. Danto's effort to see these myths as purely affirmative and innocuous is exemplified by his description of another print in the Myths series, the segregation-era Mammy, "as the emblem of our daily bread" (p. 11).

7. Danto 2003, 13.

8. Danto 2003, 13.

9. This refusal to analyze class persists in Danto's most recent work on Warhol, where he can describe "the bare declarative aesthetic of the proletarian representations [Warhol] began to favor" but still claim, pages later, that Warhol's "mandate" was to "*paint what we are*" (Danto 2009, 13, 16; emphasis original). The questions of who "we" are and whether "our" enthusiasms may vary, or be expected to vary, with our class are not addressed.

10. David Antin, "Warhol: The Silver Tenement," *Art News* 65, no. 4 (Summer 1966), 59.

11. See, in particular, Jonathan Flatley, "Warhol Gives Good Face: Publicity and the Politics of Prosopopoeia," and José Esteban Muñoz, "Famous and Dandy like B. 'n' Andy: Race, Pop, and Basquiat," in *Pop Out: Queer Warhol*, ed. Jennifer Doyle, Jonathan Flatley, and José Esteban Muñoz (Durham, NC, 1996), 101–133 and 144–179. See also Gavin Butt, "Dishing on the Swish, or, the 'Inning' of Andy Warhol," in *Between You and Me* (Durham, NC, 2005), 106–135.

12. For analyses of the problem of class in pop art, see Roger Cook, "Andy Warhol, Capitalism, Culture, and Camp," *Space and Culture* 6, no. 1 (February 2003), 66–76; Sara Doris, *Pop Art and the Contest over American Culture* (Cambridge, 2007); Christin J. Mamiya, *Pop Art and Consumer Culture: American Super Market* (Austin, 1992); Peter Schjeldahl, "Warhol and Class Content," *Art in America* (May 1980), 112–129; and Cécile Whiting, *A Taste for Pop: Pop Art, Gender, and Consumer Culture* (Cambridge, 1997). On the role of class in postwar art and culture, see T. J. Clark, "In Defense of Abstract Expressionism," in *Farewell to an Idea* (New Haven, 1999).

13. Max Kozloff, "'Pop' Culture, Metaphysical Disgust, and the New Vulgarians," *Art International* (March 1962), 35–36.

14. Roland Barthes, "Myth Today," in *Mythologies*, trans. Annette Lavers (New York, 1972), 125, 156 (published in French as *Mythologies*, 1957).

15. "The bourgeoisie wants to keep reality without keeping the appearances: it is therefore the very negativity of bourgeois appearance, infinite like every negativity, which solicits myth infinitely" (Barthes 1972, 149).

16. Quoted in Victor Bockris, *Warhol* (New York, 2003), 136.

17. Georg Frei and Neil Printz, *The Andy Warhol Catalogue Raisonné*, vol. 1, *Paintings and Sculpture 1961–1963* (London and New York, 2002), 57.

18. Arthur Danto, "Warhol," in *Encounters and Reflections: Art in the Historical Present* (Berkeley, 1997), 287.

19. For more on this displacement, see Anthony E. Grudin, "'Unnatural Talent': Andy Warhol's Newsprint Artworks," in *October*, forthcoming.

20. Michael Tomasello, "The Human Adaptation for Culture," *Annual Review of Anthropology* 28 (1999), 509–529.

21. Frei and Printz 2002, 20.

22. Mark Pendergrast, *For God, Country and Coca-Cola* (New York, 1993), 259.

23. Bockris 2003, 114.

24. This source is identified in *Pop: Themes and Movements*, ed. Mark Francis (New York, 2005), 85.

25. See, for example, the inside back cover of *Life with Millie*, December 1961; and *Amazing Adult Fantasy*, November 1961, 33.

26. See Glenn O'Brien's "Interview: Andy Warhol," *High Times*, August 24, 1977; reprinted in *I'll Be Your Mirror: The Selected Andy Warhol Interviews 1962–1987*, ed. Kenneth Goldsmith, Reva Wolf, and Wayne Koestenbaum (New York, 2004), 234–235.

27. Kant distinguished "liberal art" from "remunerative art" and argued that the former had to be "an occupation that is agreeable in itself" rather than being "attractive only because of its effect (e.g., the remuneration)." See Immanuel Kant, *The Critique of the Power of Judgment*, trans. Paul Guyer and Eric Matthews (Cambridge, 2000), §43, 182–183 (published in German as *Kritik der Urteilskraft*, 1790).

28. Warhol's own art education at Carnegie Tech emphasized similar benefits. See Nan Rosenthal, "'Let Us Now Praise Famous Men': Warhol as Art Director," in *Dia Art Foundation Discussion in Contemporary Culture*, no. 3: *The Work of Andy Warhol*, ed. Gary Garrels (Seattle, 1989), 38.

29. These paired advertisements also appeared in the *Cleveland Plain Dealer* and the *Pittsburgh Press*; see "Art and Food," *New York Times*, February 25, 1960, 47. The ads discussed in this essay were found through intensive searches of newspaper, comic book, and magazine archives and databases and are not, to my knowledge, discussed elsewhere in the scholarship on Warhol.

30. Most such comics had one or two pages like this per issue as well as multiple "reader-created" and credited outfits and/or hairstyles. The November 1961 issue of *Linda Carter, Student Nurse* devoted four of its thirty-six pages to these competitions.

31. Anne Wagner has pointed out to me that both Sylvia Plath and Eva Hesse entered and won fashion magazine talent contests (at *Mademoiselle* and *Seventeen*, respectively), which helped to launch their careers. Matt Wrbican has remarked that Warhol's *Interview* magazine published a "Coloring Contest" in 1972, with the winner promised Warhol's signature on the winning entry. The source image was a cartoon line drawing of Tarzan, Jane, Cheetah, and Boy. The editors ultimately selected a childishly slapdash entry; see the Da Capo reprint of Peter Gidal, *Andy Warhol Films and Paintings: The Factory Years* (Cambridge, 1991), 3.

32. *Popular Science*, May 1943, 26; March 1944, 28; and December 1947, 45.

33. *Popular Science*, March 1944, 26.

34. *Los Angeles Times*, September 13, 1959, 17; emphasis original. Two additional examples are given. Similar advertisements appeared frequently in comic books; see the back cover of *Fantastic Four*, November 1961, for example.

35. *New York Times Magazine*, August 4, 1957, 5. This ad was widely and prominently disseminated; see also *Los Angeles Times*, June 16, 1957, G5, and *Life*, August 5, 1957, 9. Ads with similar text appeared in comic books that were contemporary with Warhol's sources. See, for example, the back cover of *Amazing Adult Fantasy*, December 1961.

36. *Washington Post and Times Herald*, February 3, 1957, AW5.

37. Matt Wrbican informs me that the Andy Warhol Museum has two projectors in its collection that belonged to Warhol: a Beseler Vu-Lyte (c. 1960) and a Beseler Vu-Lyte III (c. 1983).

38. Norton Products advertisement, *Kathy*, October 1961, 25. See a similar ad in *Linda Carter, Student Nurse*, November 1961, 7; the device was also regularly advertised in the back pages of *Cool*, *Popular Mechanics*, *Popular Science*, the *New York Times*, and the *Los Angeles Times*.

39. The first interpretation can be traced back to Emile de Antonio; the second is defended in David Cowart and Bradford R. Collins, "Through the Looking-Glass: Reading Warhol's Superman," *American Imago* 53, no. 2 (Summer 1996), 107–137.

40. See Bruce Glaser, "Oldenburg, Lichtenstein, Warhol: A Discussion," *Artforum* 4, no. 6 (February 1966), 22.

41. As Roger Cook has put it, "By virtue of his marginalized ethnic and class origins in the social field, Andy Warhol was, like many on the margins, hypersensitively aware of his lack of these forms of monetary, cultural, and social capital" (Cook 2003, 69).

42. I have argued elsewhere that the branded commodities that Warhol reproduced in the early 1960s were anything but classless or universal. See Anthony E. Grudin, "'A Sign of Good Taste': Andy Warhol and the Rise of Brand Image Advertising," *Oxford Art Journal* 33, no. 2 (2010), 211–232.

43. Guy Debord, "The Decline and Fall of the Spectacle-Commodity Economy," in *Situationist International Anthology*, rev. ed., ed. Ken Knab (Berkeley, 2007), 200.

DEEP GOSSIP: THE FILM, VIDEO, AND TELEVISION WORLDS OF ANDY WARHOL
JOHN G. HANHARDT

1. Andy Warhol, *THE Philosophy of Andy Warhol: From A to B and Back Again* (New York, 1975), 78.

2. See John G. Hanhardt, *Andy Warhol's Video & Television* (Whitney Museum of American Art, New York, 1991).

3. Henry Abelove, *Deep Gossip* (Minneapolis, 2003), xii.

4. Andy Warhol and Pat Hackett, *POPism: The Warhol Sixties* (New York, 1980), 17.

5. Callie Angell, *Andy Warhol Screen Tests: The Films of Andy Warhol Catalogue Raisonné*, vol. 1, Whitney Museum of American Art (New York, 2006).

6. Claire Henry, curatorial assistant to the Andy Warhol Film Project, in multiple conversations with the author. Claire, who worked closely with Callie Angell, has been an invaluable source of information for this essay.

7. Based on Claire Henry's conversations with Callie Angell and her study of Angell's research.

8. The Whitney Museum of American Art is planning for the second volume of the Warhol film catalogue raisonné, and it will feature a survey of the films from 1963 on. The material Angell has written will be the basis for this second volume.

9. This provided a favorite film still of Angell's (see fig. 1), documenting the moment Warhol gets the idea for his film *Hedy*, which was shot, amazingly enough, the very next weekend, with a script by Ronald Tavel.

10. Art Simon, *Dangerous Knowledge: The JFK Assassination in Art and Film* (Philadelphia, 1996), 48.

11. Hanhardt 1991, 4.

12. See David Antin, "Video: The Distinctive Features of the Medium," in *Video Culture*, ed. John G. Hanhardt (Rochester, NY, 1986), 147–166.

13. Walter Benjamin, *The Arcades Project*, trans. Howard Eiland and Kevin McLaughlin (Cambridge, MA, 1999), 802.

HEAPS OF HEADLINES: THE WARHOL STUDIO SCRAPBOOKS
MATT WRBICAN

1. Andy Warhol, *THE Philosophy of Andy Warhol: From A to B and Back Again* (New York, 1975), 10.

2. There are at least six more scrapbooks in Warhol's archives at the Andy Warhol Museum: one maintained for guests to his house, Eothen, in Montauk, New York, from about 1972 to 1977; another given to Warhol to celebrate his series of portraits of athletes of 1977; another commemorating his portrait of German soccer star Franz Beckenbauer in 1982; and three more that present — in careful alphabetical order — American actors of the stage and screen in the early twentieth century (which he probably acquired at a flea market or antique shop).

3. The Andy Warhol Museum received a grant for the preservation of the Warhol Studio Scrapbooks from the National Endowment for the Humanities in 2001.

4. As far as can be determined, the earliest printing of this piece was in the *East Village Other* (New York), November 1–15, 1966 (as "Andy Warhol: My True Story"). It was also published in the *Los Angeles Free Press*, March 17, 1967 (again as "Andy Warhol: My True Story"), and in *The Rat* (New York), June 15, 1967 (as "Andy Warhol").

5. Berg generously donated her original audio recording and related ephemera to the Andy Warhol Museum in 2007. An exhibition devoted to her interview and photographs, *Gift of Gretchen Berg: The True Story of "My True Story," and Troublemakers*, opened in the summer of that year. The original recording was transcribed by Robert Bailey of the University of Pittsburgh and compared with the published interview, all of which were presented in the exhibition. This was later summarized and published in *Andy Warhol: A Guide to 706 Items in 2 Hours 56 Minutes*, the catalogue for *Andy Warhol: Other Voices, Other Rooms*, curated for the Stedelijk Museum, Amsterdam, and Moderna Museet, Stockholm, by Eva Meyer-Hermann (Rotterdam, 2007).

6. The letter and silkscreened print were discovered in Warhol's *Time Capsule -2*, in the collection of the Andy Warhol Museum.

7. On June 3, 1968, the writer Valerie Solanas shot Warhol while he was talking on the telephone in his office. One bullet entered his chest, causing damage to many vital organs, possibly due to his physical posture at the time.

8. Earlier references to Warhol and the dark side of the sacred include Gene Swenson's reference to an Old Testament archangel in "The Darker Arial," published in *Collage* in Italy in 1964.

9. Ondine had his own column in the short-lived alternative periodical *KISS*, published by artist Al Hansen (grandfather of pop musician Beck), with the memorable title "Beloved Ondine's Advice to the Shopworn."

10. Sylvia Miles was nominated for an Academy Award as Best Actress in a Supporting Role for her work in *Midnight Cowboy* (1969) and *Farewell, My Lovely* (1975).

11. Taking an entirely different tack on *Pork*, an article in the British *Art and Artists* (October 1971) has the headline "You Know I'm Really Tired Now."

12. Warhol owned a biography of Mickey Rooney from the Big Little Books series for children, which he likely acquired near the time this article was published.

13. This coincided with his brief residency in Rome on the sets of the Warhol productions *Flesh for Frankenstein* and *Blood for Dracula* (both directed by Paul Morrissey and coproduced by Carlo Ponti).

14. *The Driver's Seat* was short-listed for the 1970 Man Booker Prize in 2010 owing to a retrospective change in the rules for 1970/1971.

15. The real secrets of Warhol's life — which appeared in heavily edited form in *The Andy Warhol Diaries* — would not be published until after his death. See *The Andy Warhol Diaries*, ed. Pat Hackett (New York, 1989).

16. Both Warhol and his publisher seem to have agreed to an unusual typographical compromise, thus the odd rendering of the published original title.

17. In 1915 Duchamp created a brief nonsensical text titled *The*. The original is in the collection of the Philadelphia Museum of Art. Further description can be found in Matt Wrbican, *The Warhol Evening Telegraph/Twisted Pair* (Andy Warhol Museum, Pittsburgh, 2010). Warhol again caused his publisher to worry in 1979 when he proposed "Social Disease" as the title of another book; they compromised on "Exposures."

18. See Olle Granath, "With Andy Warhol 1968," in Meyer-Hermann 2007. Granath was responsible for many aspects of the exhibition *Andy Warhol* at Stockholm's Moderna Museet in 1968, which was curated by Pontus Hultén.

19. Warhol's eldest brother, Paul, remembers being sent for the doctor when his mother went into labor in the family's two-room apartment. John Warhola, the middle of the three sons of Andrei and Julia Warhola, died on December 24, 2010, at the age of eighty-five. Since the opening of the Andy Warhol Museum in May 1994, he was a frequent visitor and a tremendous help in passing down his memories of his famous brother.

20. This included the publication of an official birth certificate for an "Andrew Warhola" in Forest City, PA, but with a date of October 28, 1930, and with the mother's name, unusually, censored. The surname Warhola (Warhol's true family name) is unusual but not uncommon. There are some who are convinced that they knew Andy Warhol in his youth under quite implausible circumstances, including at a Boy Scout Jamboree in Wisconsin (Warhol was not a Scout, nor had he ever left the Pittsburgh area until his college days).

21. See *Andy Warhol: Das Graphische Werk, 1962–1980*, ed. Hermann Wünsche, to which Hughes devotes precisely one paragraph (the thirty-second of forty paragraphs).

22. This article, published fifteen months after the election of Ronald Reagan as U.S. president in November 1980, coincided with the first wave of the so-called culture wars, marked by sustained argument against public funding for the arts. As of this writing, a second wave of antagonism toward the arts has hit with the controversy over the inclusion of David Wojnarowicz's video *A Fire*

in My Belly (1987) in an exhibition at the National Portrait Gallery in Washington, DC (*Hide/ Seek: Difference and Desire in American Portraiture*). The Portrait Gallery's removal of the video, under pressure from a few members of Congress, was strongly protested by the Andy Warhol Foundation for the Visual Arts, Inc.— an early sponsor of the exhibition — which threatened to withdraw all of its funding for Smithsonian programs. In his letter to the Smithsonian of December 13, 2010, Warhol Foundation president Joel Wachs stated, "For the arts to flourish the arts must be free, and the decision to censor this important work is in stark opposition to our mission to defend freedom of expression wherever and whenever it is under attack."

23. In quick succession Hughes first scoffs at Warhol's stature as a "famous artist" (judging him to rank third in America), describes his physical appearance as that of a "cashiered Latin teacher," then denigrates his popularity and a recent exhibition of his work in Los Angeles, doubts Warhol's humanity, and disingenuously scorns his Superstars. Throughout his review Hughes sprinkles critiques of nearly all of Warhol's mass market books. He also misidentifies the generally accepted source for Warhol's drawing style of the 1950s (Hughes names Saul Steinberg, rather than Ben Shahn), and, in a bizarre irony, quotes novelist Ronald Firbank to support his views (Warhol's illustration of a cupid was featured on the dust jacket of Firbank's *Three More Novels* [New York, 1950]).

24. In order of their mention: Hans Gerd Eichner, Peter Schjeldahl, Peter Gidal, Barbara Rose, John Coplans, Rainer Crone, Carter Ratcliff, and Robert Rosenblum.

25. A commission from Ronald Feldman Fine Art in 1980, this portfolio was inspired by a recent exhibition devoted to the Nobel Prize – winning physicist Albert Einstein. Warhol chose as his subjects Einstein, entertainer Sarah Bernhardt, philosopher/ theologian Martin Buber, Supreme Court justice Louis Brandeis, the founder of psychoanalysis Sigmund Freud, composer George Gershwin, writer Franz Kafka, entertainers the Marx Brothers, political leader Golda Meir, and writer

Gertrude Stein. Like many of Warhol's later works, the series has recently enjoyed a reappraisal in several exhibitions and essays, notably that of Richard Meyer, *Warhol's Jews: Ten Portraits Reconsidered*, New York, 2009.

26. In dismissing Jimmy Carter (one of his three sentences describing Carter's Administration: "They gave dull parties and talked about human rights"), Hughes fails to understand that Warhol was interested in every current Administration — to be near the power, not for an individual's specific politics. Warhol painted portraits of Carter as well as his mother, Lillian, and visited their peanut farm in Georgia. Gerald Ford's White House was also featured in *Interview*, and Warhol painted Ford's portrait. None-the-less, his best-known portrait of a U.S. president is probably the unflattering depiction of Richard Nixon, created on behalf of his overwhelmed opponent in the 1972 election, Senator George McGovern; it is said to have earned him an annual audit of his taxes.

27. While Hughes may sound authoritative, Warhol did not formally paint Ronald Reagan's portrait (though Reagan's image does appear in a few of Warhol's works from the mid-1980s). Before he started his political career, Reagan was a thespian best remembered for his role as a tragic football player, numerous B-Westerns and war-themed movies, and for costarring with a chimpanzee. In Warhol's print portfolio *Ads* (1985), Reagan's image was reproduced from an advertising campaign for Van Heusen shirts in the 1950s (with their slogan, "Won't Wrinkle... Ever!"); in his Black and White Ads series (1984 – 1986), several paintings are based on a recent newspaper graphic of government budget figures that is dominated by Reagan's silhouette.

28. In a previous caricature (*New York Review of Books*, April 24, 1969: http://www.nybooks. com/galleries/david-levine-illustrator/1969/apr/24/andy-warhol/ [accessed January 2011]), Levine portrayed Warhol with the facial features of cartoon figure Alfred E. Neuman (*Mad* magazine's perpetually mischievous idiot/mascot often depicted with the phrase "What, me worry?"). Levine added further insult by giving Warhol the

unmistakable cloven hooves of a swine. It may be coincidental, but following Levine's depiction, Warhol produced a number of works referencing pigs: his play *Pork* (1971), an editioned print *Fiesta Pig* (1979), and even George Lois's photo of Warhol superstar Eric Emerson on the cover of *Esquire* magazine (September 1969) all reference the ubiquitous farm animal (traditionally held in low regard for its hygiene, pigs have been found in recent studies to have relatively superior intelligence among domesticated animals). A prerelease title for Warhol's film *Women in Revolt!* (directed by Paul Morrissey in 1971, a satire of the women's liberation movement) was *P.I.G.S.* — an acronym for "Politically Involved Girls." Yet another example of Warhol's interest in pigs predates Levine's drawing: he painted colorful flowers onto a (live) pig and had it photographed for a mass-produced poster that advertised RCA color scanners in 1968. Perhaps Levine was quoting Warhol's pig? Then again, the RCA poster bears the phrase "Bank by Andy Warhol," and his archives hold many examples of piggy banks. For more on the theme of money in Warhol's art and life, see *Andy Warhol Enterprises*, ed. Allison Unruh and Sarah Urist Green (Ostfildern and Indianapolis, 2010).

29. See Robert Hughes, "Art – A Caterer of Repetition and Glut: Andy Warhol, 1928 – 1987," *Time*, March 9, 1987.

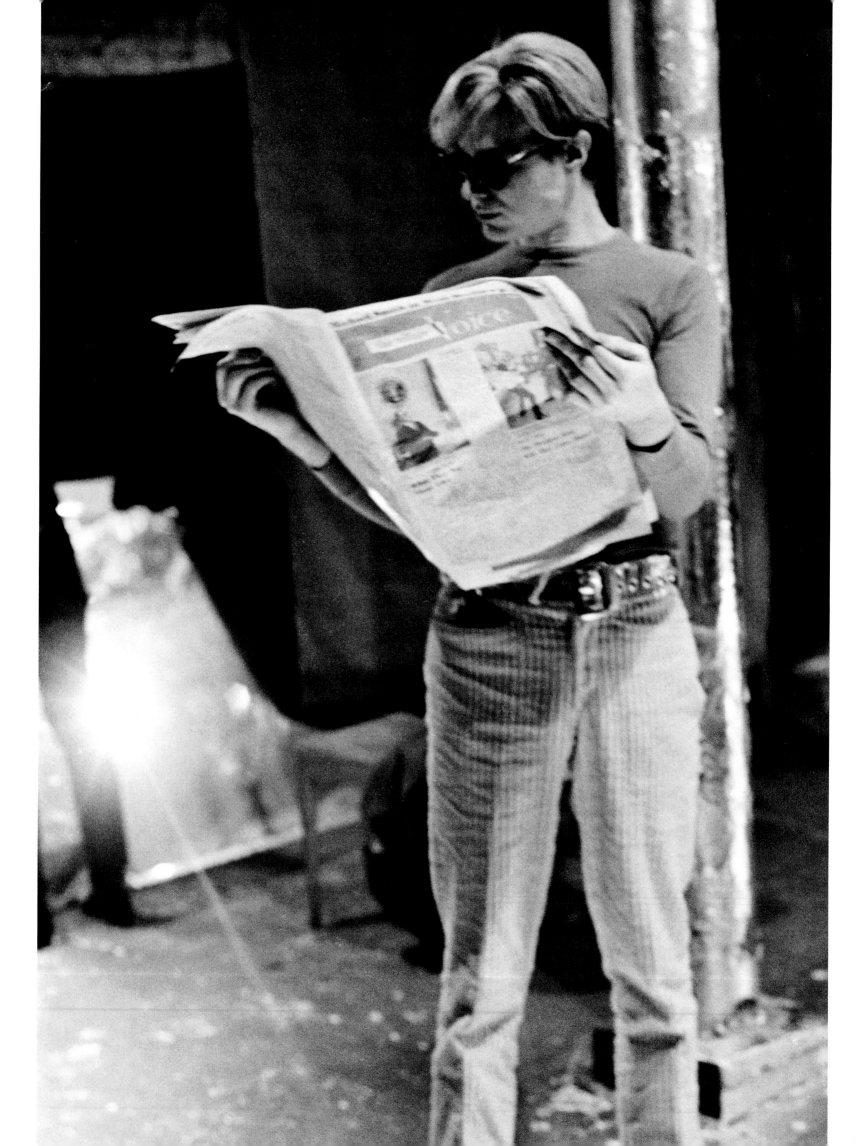

LENDERS TO THE EXHIBITION

The Andy Warhol Foundation for the Visual Arts, Inc.

The Andy Warhol Museum, Pittsburgh

Bayerische Staatsgemäldesammlungen München,
Udo und Anette Brandhorst Stiftung

Bill Bell

Bischofberger Collection, Switzerland

Michele Bonuomo, Milan

The Brant Foundation, Greenwich, Connecticut

Brauer Museum of Art, Valparaiso University, Indiana

Jean O. and Gary L. Cohen

Collection Christopher Makos

Collection Donny Deutsch

Collezione FraGiò

Collezione Terrae Motus, Reggia di Caserta, Italy

Courtesy Gagosian Gallery

Galerie Bruno Bischofberger, Zürich

The Keith Haring Foundation, New York

Francesca K. McLin

Museum für Moderne Kunst, Frankfurt am Main

Museum Ludwig, Cologne

Museum of Contemporary Photography at Columbia
College Chicago

The Museum of Modern Art, New York

National Gallery of Art, Washington

National Gallery of Art Library, Washington

National Portrait Gallery, Smithsonian Institution,
Washington

Neuberger Museum of Art, Purchase College,
State University of New York

Private collections

Donald Rosenfeld, St. Louis, Missouri

Andrew and Denise Saul

ACKNOWLEDGMENTS

Every news story begins with investigation of an idea, and it seems fitting that the *Warhol: Headlines* show involved a high degree of sleuthing. To identify the headlines in Warhol's prolific body of art — whether in plain sight or hidden in the shadows — and to track down the source materials, I worked with a team of top-notch researchers in the Gallery's department of modern and contemporary art. Research associate Jennifer Roberts laid essential groundwork by organizing critical information and collecting photographs of Warhol in relation to newspapers, the "smoking gun" that establishes the artist's lifelong obsession with the news. Former intern Alexandra Gregg began to identify and obtain many of the source documents and combed the literature for references to Warhol's use of headlines. Assuming a wide range of responsibilities, curatorial assistant Sydney Skelton Simon brought her keen intellect, efficiency, and energy to the final realization of the project. The team's collaborative spirit has been an invaluable asset.

I am indebted to Harry Cooper, curator and head of modern and contemporary art at the Gallery, for his constant support, especially in providing expert commentary on the catalogue texts. James Meyer, associate curator in the department, also offered helpful feedback. I am fortunate to work alongside such talented and generous colleagues.

It was a privilege to discuss Warhol's artistic practice with Callie Angell, the late curator of the Andy Warhol Film Project at the Whitney Museum of American Art. Together, we came to understand that the headline theme provided an ideal framework through which to explore the artist's intermedia work. Full appreciation of Warhol's paintings, prints, and drawings depends on awareness of his films, and Callie became my guide. She was writing an essay about time-based media for the catalogue until her tragic death on May 5, 2010. I am most grateful to John Hanhardt, a close colleague of Callie's and a noted scholar of Warhol's moving images in his own right, for agreeing to take over writing the essay. He consulted with Claire Henry, Callie's able assistant at the Whitney, who referred to Callie's notes and who lent her own extensive knowledge to the effort. The institutional support of the Whitney Museum was essential, and I would like to thank director Adam Weinberg and deputy director Donna De Salvo for permitting Callie's work to be carried forward. John's essay thus presents Callie's research on the films at the time of her death, includes excerpts from a lecture she gave on the film *Since* at Princeton University in November 2002, then goes on to discuss his own insights into Warhol's work in video and television.

Also contributing to the catalogue, John J. Curley wrote an essay on the visual and textual allegories of Warhol's newspaper works and their Cold War affinities; Anthony E. Grudin considered Warhol's early newsprint paintings in terms of myth and class; and Matt Wrbican, archivist at the Andy Warhol Museum, prepared a photo-essay on Warhol's own scrapbooks, with clippings that feature the artist as the subject of the headlines. Owing to their fragility, these scrapbooks have never been published. Matt is nothing short of a walking encyclopedia on all things Warholian, an invaluable resource on whom all Warhol scholars have come to rely.

Indeed, this exhibition would not have been possible without the full support of the Andy Warhol Museum in Pittsburgh, whose former director, Thomas Sokolowski, and acting director and Milton Fine Curator of Art, Eric C. Shiner, were instrumental in committing the museum's considerable expertise and unrivaled trove of art and archival material to this endeavor. I thank particularly Greg Pierce and Geralyn Huxley, both curators in the film and video department, as well as registrar Heather Kowalski, and director of exhibitions Jesse Kowalski.

Joel Wachs, president of the Andy Warhol Foundation for the Visual Arts, provided early guidance into the complex world of Warhol, and I am grateful to him and to chief curator Claudia Defendi for their time, good counsel, and loans of the Warhol Foundation's important

works. The Andy Warhol Catalogue Raisonné staff also gave knowledgeable and thoughtful responses to every request for information. I offer deepest thanks to Sally King-Nero and Neil Printz for their countless consultations.

For facilitating my study of works in various public collections, I thank Kasper König and Stephen Diederich of the Museum Ludwig, Cologne; Mario Kramer of the Museum für Moderne Kunst, Frankfurt; Kathy Curry and Jodi Hauptman of the Museum of Modern Art, New York; Wendy Wick Reaves and Anne Goodyear of the National Portrait Gallery, Washington; and Ferdinando Creta of the Palazzo Reale, Caserta. For access to works in private collections, I owe great debts of gratitude to Jean Bickley, Michele Bonuomo, Allison Brant, Jean and Gary Cohen, Cherol Derrick, Denise and Andrew Saul, and several anonymous lenders and their assistants.

Individuals who assisted in securing critical loans include Charlotte Eyerman, Nora Halpern, Jason Herrick, Rafael Jablonka, Lorcan O'Neill, Raffaella Resch, Donald Rosenfeld, Rachel Whiteread, and Peter Wise. At the Galerie Bruno Bischofberger, director Tobias Müller, registrar Gabriella Bachmann, and technician Sven Gehrke provided essential help.

Numerous scholars, artists, colleagues, and Warhol associates have shared with me their experiences and insights, which have greatly enriched the project: Brigid Berlin, Lauren Boyle, Thomas Crow, Hal Foster, Vincent Fremont, Sherri Geldin, Laura Harris, Jenny Holzer, Maggie Michael, Lucy Mitchell-Innes, Alexander Nagel, André Papp, Sean Scully, Dan Steinhilber, Corinna Thierolf, John Waters, and Mechtild Widrich. Trish Deveneau, Leah Dickerman, and Sarah Greenough read parts of my essay and offered excellent suggestions. Roger Rosenblatt offered inspiration and encouragement during the writing process. Judith Brodie, curator and head of modern prints and drawings at the Gallery, and I have benefited from our discussions of art based on newspapers and our development of complementary exhibitions on the subject. Curators Charles Ritchie and Carlotta Owens have been similarly collegial in sharing information and expertise.

National Gallery of Art director Earl A. Powell III and deputy director and chief curator Franklin Kelly have provided solid support for this show. Chief of exhibitions D. Dodge Thompson offered crucial backing, while Ann Bigley Robertson, exhibition officer, coordinated the international tour with her usual diplomacy and skill, ably assisted by Hillary Lord. Susan Arensberg and Lynn Matheny were responsible for didactic materials, and chief of design Mark Leithauser led his talented creative team, including Gordon Anson, Jamé Anderson, Abby Bysshe, and Lisa Farrell, to design and execute a riveting installation that presents a wide range of Warhol's art and source materials. Registrar Michelle Fondas arranged for the safe transport of this diverse group of objects,

working with conservators Michelle Facini, Bethann Heinbaugh, Jay Krueger, Suzanne Lomax, Christopher Maines, Connie McCabe, Hugh Phibbs, Jenny Ritchie, and division chief Mervin Richards. I have also relied on Vicki Toye and John Conway from audiovisual services, Gregory Swift from data processing, Peggy Parsons and Joanna Raczynska from film programs, Stephen Ackert from the music department, Faya Causey from academic programs, and Lynn Russell from the education division.

Editor in chief Judy Metro deserves thanks for her effective leadership and support of the catalogue, along with deputy publisher Chris Vogel, who oversaw its production. Editor Tam Curry Bryfogle balanced the particular concerns of editing an art book with sensitivity to Warhol's own integration of words and images. Designer Wendy Schleicher translated the headline theme into a dynamic catalogue design that facilitates the study and comparison of the works of art and their sources. Sara Sanders-Buell performed the herculean task of assembling images and obtaining reproduction rights for works in the exhibition. Mariah Shay collected images for comparative figures, working with Ira Bartfield and Kate Mayo. John Long and Daniella Berman coordinated copublishing arrangements for German and Italian editions. I am also grateful to executive librarian Neal Turtell, who acquired source material for the exhibition, and to Lamia Doumato, John Hagood, Ted Dalziel, and Thomas McGill.

Associate general counsel Julian Saenz vetted all legal and contractual matters for this project. Head of external affairs Joseph Krakora and his deputy, Ellen Bryant, offered constant encouragement, and chief development and corporate relations officer, Christine Myers, along with Patty Donovan, Jeanette Crangle Beers, Cathryn Scoville, and Kristi Maiselman pursued fruitful efforts to support the exhibition. Lastly, thanks go to chief press and public information officer Deborah Ziska and deputy Anabeth Guthrie, who have put *Warhol: Headlines* in an appropriate spotlight.

Most important, I wish to express my heartfelt thanks to Dirk Young, my husband, and our children, Aidan and Eliza, superstars in their own right, for enabling my creative and time-intensive attention to this project.

MOLLY DONOVAN